Sir David Wilkie
of Scotland

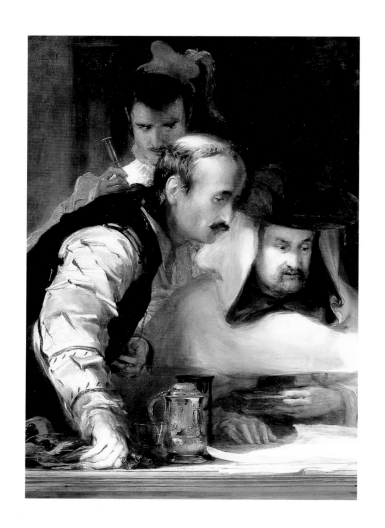

Sir David Wilkie of Scotland (1785–1841)

Organized by William J. Chiego

Catalogue by H.A.D. Miles and David Blayney Brown

with contributions by
Sir Ivor Batchelor, Lindsay Errington
and Arthur S. Marks

North Carolina Museum of Art, Raleigh

This catalogue is published with the assistance of the J. Paul Getty Trust. Additional funding has been provided by the National Endowment for the Arts, a federal agency, and by the North Carolina Museum of Art Foundation.

The North Carolina Museum of Art is an agency of the State of North Carolina, James G. Martin, Governor, and of the Department of Cultural Resources, Patric Dorsey, Secretary.

Edited by Paul Betz
Designed by the North Carolina Museum of Art Design Department
Typeset in Goudy by Marathon Typography Service, Inc., Durham, North Carolina
Printed by Dai Nippon Printing Co., Ltd., Tokyo

Cover
The Chelsea Pensioners (detail), 1822. Courtesy of the Trustees of the Victoria and Albert Museum.

Frontispiece
Columbus in the Convent of La Rábida (detail), 1834. North Carolina Museum of Art.

Contents

List of Lenders

Public Collections—Great Britain and Ireland
Aberdeen, Aberdeen Art Gallery and Museum
Birmingham, City Museum and Art Gallery
Blackburn, Blackburn Museum and Art Gallery
Cambridge, Syndics of the Fitzwilliam Museum
Dublin, National Gallery of Ireland
Dundee, University of Dundee
Edinburgh, Faculty of Advocates
 National Gallery of Scotland
 Scottish National Portrait Gallery
Fife, Fife Regional Council, from the County
 Hall, Cupar
Glasgow, Glasgow Museums and Art Gallery
 Hunterian Art Gallery, University of Glasgow
Kirkcaldy, Kirkcaldy Museum and Art Gallery
Leicester, Leicestershire Museums and Art
 Galleries
London, Commissioners of the Royal Hospital,
 Chelsea
 National Portrait Gallery
 The Tate Gallery
 Victoria and Albert Museum, Apsley House
Nottingham, Castle Museum and Art Gallery
Oxford, The Visitors of the Ashmolean Museum
Paisley, Renfrew District Council Museum and
 Art Gallery

Public Collections—North America
Minneapolis, Minneapolis Institute of Arts
New Haven, Yale Center for British Art
Norfolk, The Chrysler Museum
Ottawa, National Gallery of Canada
Philadelphia, Philadelphia Museum of Art
Raleigh, North Carolina Museum of Art

Private Collections—Great Britain
Her Majesty Queen Elizabeth II
M. C. C. Armitage
The Duke of Atholl

Dr. D. B. Brown
Lord Denham
Sir Andrew G. Forbes-Leith, Bt.
Lord Glenconnor
Dr. Joan MacKinnon
S. C. Whitbread, Esq.
Anonymous Lenders (4)

Private Collections—North America
FORBES Magazine Collection, New York
Alexander B. V. Johnson / Roberta J. M. Olson
The Mellon Bank, Pittsburgh
Charles Ryskamp
Mr. and Mrs. Fayez Sarofim

Foreword

"My ambition is got beyond all bounds, and I have the vanity to hope that Scotland will one day be proud of David Wilkie." Those were the words of the confident young painter, written from London to his father in Fife in May 1806. Subsequent events confirmed his optimism; in 1823 he became King's Limner for Scotland, in 1830 Painter in Ordinary to His Majesty King George IV, and in 1836 he was knighted by King William IV. Yet Wilkie's reputation paled rapidly after his premature death in 1841. His romantic vision, with all of its contradictions and appealing uncertainties, did not survive the Victorian era. The heir to Lawrence and the younger contemporary of Turner faded from comparison.

This exhibition is designed to set the record straight. We owe it to William J. Chiego, who proposed the exhibition three years ago from the position he then held as Chief Curator of the North Carolina Museum of Art. His initiative was encouraged both by his home institution and by the Yale Center for British Art. From the outset he planned to incorporate into the exhibition and the catalogue which accompanies it the latest research on the artist and his times. We join him in thanking Professor Hamish Miles, Director of the Barber Institute of Fine Arts, University of Birmingham, England; Dr. David Blayney Brown of the Tate Gallery, London; Dr. Lindsay Errington of the National Gallery of Scotland; Professor Arthur S. Marks of the University of North Carolina at Chapel Hill; and Sir Ivor Batchelor, Professor Emeritus, the University of Dundee. Their contributions to the catalogue have ensured that it will provide the basic text for Wilkie studies for many years to come. The publication appears thanks to the generosity of the J. Paul Getty Trust; we wish to thank the Trust, together with the National Endowment for the Arts, whose initial grant helped to launch the exhibition. Dr. Chiego's acknowledgments detail his and our debts of gratitude to colleagues on both sides of the Atlantic. In New Haven we single out Malcolm Cormack, Curator of Paintings, who took overall responsibility for the showing at the Yale Center for British Art. At the North Carolina Museum of Art, special appreciation is extended to Kerry Boyd, Head Exhibition Designer, and Dr. David Steel, Curator of Italian and Spanish Art, who coordinated the presentation of the exhibition there with Dr. Chiego's advice.

Finally, we would like to emphasize our profound debt to all of our lenders, whose cooperation has enabled us to assemble on this side of the Atlantic so many highlights from the surviving works of Sir David Wilkie. We have done so in the knowledge that the paintings, prints, and drawings will speak for themselves; collectively they attest to the extraordinary support we have received from individuals and institutions worldwide.

Duncan Robinson, Director
Yale Center for British Art

Richard S. Schneiderman, Director
North Carolina Museum of Art

Introduction and Acknowledgements

"There is a raw, tall, pale queer Scotsman come—there is something in him." wrote the painter John Jackson in 1805 on the arrival of the twenty-year old David Wilkie in London. There was, indeed, something in him, for within a year he became a popular and critical success and over the succeeding decade, a leader of the modern school in Britain. Wilkie's phenomenal rise as a painter of genre subjects was, however, only the beginning of one of the most remarkable careers of the 19th century. Early on he attracted most of the leading patrons of British art, for some of whom Wilkie's Teniers-like pictures were a natural complement to their collecting of Old Master paintings. Among this notable group were Sir George Beaumont, who commissioned Wilkie's *Blind Fiddler*, and John Julius Angerstein, who commissioned *The Village Festival*. Wilkie was named an Associate of the Royal Academy in 1807 and was elected to full membership in 1811. He also won the loyal patronage of the Prince Regent, the future George IV, whose support was so crucial to his future career. The exhibition in 1822 of *The Chelsea Pensioners*, painted for the Duke of Wellington, saw barriers erected to protect the painting when exhibited at the Royal Academy. In this brilliant conflation of genre and history painting, Wilkie had reached the pinnacle of success at the age of thirty-seven.

Official honors now began to crowd in upon him and were decidedly a mixed blessing. George IV, who had ascended the throne in 1820, named him King's Limner for Scotland in 1823, with all the responsibilities for state portraiture that entailed. Wilkie, who had already grown more interested in historical subjects, was now buffeted by a series of family tragedies which caused a complete breakdown in his health, followed by a long convalescence

Fig. 1 Andrew Geddes, *David Wilkie*, 1816 , Scottish National Portrait Gallery

abroad. Three years in Europe further aroused his interest in historical subjects and the novelty of foreign themes. His precarious health also required a less laborious technique and pushed him further toward a more painterly style. Under extended exposure to the Italian and Spanish masters, as well as Rubens and Rembrandt, Wilkie achieved a new rapidity of execution. From this time his production was to increase dramatically despite the pressure of new responsibilities and his chronic health problems.

His return to England and the Royal Academy exhibitions was a triumph, largely thanks to the generous patronage of George IV, who acquired most of his new paintings. With this royal endorsement Wilkie was able to survive the disappointment of many of the critics and public who lamented his now complete change from the "miniature" style and genre subjects of his early career. A most public painter since his burst upon the scene in 1806, he could escape neither the constant criticism nor the honors and responsibilities that increasingly came to him. In 1830 George IV named Wilkie his Painter in Ordinary, and in 1836 he

was knighted by William IV. The prolific production of Wilkie's later years was weighted toward history paintings, but he continued to paint genre subjects and many portraits. He delved into the near and distant past, depicting the history and customs of a variety of nations. The Spanish, the French, the Italians and the Irish were treated in turn, as well as his native Scots. Only with the accession to the throne of Queen Victoria in 1837 did Wilkie's favor with the Crown begin to fade. Once again his health suffered as his difficulties grew, and he sought relief in travel abroad. This time his goal was the Holy Land, to see the people and places of the Bible in the hope of beginning a new, more authentic school of religious painting in Britain. Wilkie created some of the most beautiful drawings and sketches of his entire career in his travels in the Near East, but was never to fulfill this great ambition. His fragile health gave way, and he died on the return voyage to England, and was buried at sea off Gibraltar.

The main events and significant dates of Wilkie's life are outlined in the chronology provided after this introduction, and each of the introductory essays discusses his life in greater detail from a different perspective. For a thorough biography of Wilkie and his work we must still turn to Allan Cunningham's classic three volume monograph, published shortly after Wilkie's death. It forms the basis for all subsequent study to this day.

The motivation for organizing a comprehensive exhibition of the work of David Wilkie is quite simple. He is the least known of all the leading British artists of the early nineteenth century, and his work is worthy of more attention. Although several Wilkie exhibitions of varying scope and importance have been organized in Britain over the last thirty years, there has never been a Wilkie exhibition in America. Moreover, the only full retrospective of his work in this century was the pioneering show organized by John Woodward in 1958 for the Royal Academy and the National Gallery of Scotland. A remarkable succession of exhibitions and publications have appeared on Wilkie's peers, Turner and Constable above all, but also Blake, West, Fuseli, Lawrence and even his younger contemporaries such as Mulready and Linnell. However, comparatively little has appeared on Wilkie.

The high reputation and position of respect that Wilkie enjoyed in his lifetime, and well into the Victorian era in Britain, did not last into our own century. Indeed, it is not much of an exaggeration to say, as one writer recently did, that Turner's memorial painting *Peace: Burial at Sea (The Death of Sir David Wilkie)*, was for a time perhaps the only reason Wilkie was remembered at all. This moving tribute, certainly one of the finest ever paid by one artist to another, is not, however, without a certain irony, for as Turner's reputation was to grow ever greater, Wilkie's was in continuous decline almost from his death in 1841.

In a sense, the very strength of Wilkie's example which so influenced the next generation of genre and history painters in Britain was the source of his critical eclipse. Wilkie's ability to tell a story and convey the thoughts of his characters, and their psychological relationships, was developed in a much more sentimental and melodramatic direction by his followers. Although Wilkie was seldom guilty of such excesses himself, he seems to have suffered guilt by association. As Victorian genre and history painting went into critical decline, so too did Wilkie's reputation.

Wilkie's innovations in subject matter also

Fig. 2 J. M. W. Turner, *Peace: Burial at Sea (The Death of Sir David Wilkie)*, 1842, Tate Gallery

became increasingly unimportant as the subject began to take a back seat to purely formal elements. Whereas Constable and Turner, as landscape artists, were already dealing with a genre of painting that lent itself to abstraction, Wilkie was essentially a narrative painter. Whereas they were constantly exploring the boundaries of their art, even if we may trace their roots back to Claude or the Dutch masters, Wilkie was essentially a conservative artist, a retrospective master, emulating the style of the Old Masters and selecting subjects which look back to the near or distant past, whether they be genre or history or a conflation of the two. Even in portraiture, where Lawrence, for all his roots in the Van Dyck tradition, was quite modern in his attention to a lively and fashionable image, Wilkie again looked back, weighing down his sitters with Old Master trappings and parallels that some could bear successfully, but others could not.

Above all matters of subject and style Wilkie was a master of the human face and form, and it is this that finally makes him worth a thorough look, beyond his innovations in subject matter or the historical significance of his eclecticism. He was often a brilliant painter, demonstrating a considerable range of style over his career, and underlying all his gifts as a painter was his extraordinary draftsmanship. Wilkie's drawings are certainly one of the high points of draftsmanship in the nineteenth century and, indeed, they hold their own with the great drawings of earlier times, which they often emulate in style.

The primary purpose of this exhibition, therefore, is to give the public, specifically in America, an opportunity to see a major artist's works, and, in this catalogue, to provide a multi-faceted introduction for both a general audience and for scholars. The selection of objects has been guided by a desire to present as balanced as possible a view of the various eras in Wilkie's career and the full variety of his subjects. A considerable effort has been made to procure the loan of key, important pictures, as their suitability for loan permitted. However, an equal effort has been made to show works that are much less familiar and in some cases unpublished since Cunningham's biography. There is a particularly fine representation of Wilkie's portraits, which have generally been neglected. Wilkie's drawings have been given an equal representation in the exhibition, befitting their quality and their importance to his creative process. And a small selection of the engravings after Wilkie's works have been included to underscore the major role they played in spreading his reputation and his influence. The works selected show Wilkie to be a distinctive and exceptional artist, and at times a great one. But ultimately the works must speak for themselves.

I would like to express my particular thanks to Professor H.A.D. Miles, Director of the Barber Institute of Fine Arts at the University of Birmingham, without whose help this exhibition would have been impossible. The fruits of his many years of research on Wilkie are amply displayed in the catalogue entries for all the paintings exhibited, and in his essay on Wilkie as a portraitist. Professor Miles was the principal advisor on selections for the exhibition and was extraordinarily generous in sharing his research files for my own essay on Wilkie's history paintings. To Hamish and Jean Miles I owe a debt of gratitude also for their hospitality on my three visits to Birmingham. To David Blayney Brown, now Assistant Keeper at the Tate, I also owe particular thanks for his advice and enthusiasm for this project, and for his sensitive appreciation of Wilkie as a draftsman, clearly displayed in his introductory essay and his entries for the exhibited drawings. I would also like to express my thanks to Lindsay Errington, Associate Keeper of British Art, The National Gallery of Scotland, for her advice and help, and for her willingness to undertake an essay on Wilkie's genre paintings so shortly after her recent exhibition and catalogue, A Tribute to Wilkie, which focused on his influence on the next generation of artists in Britain. Lastly, I would like to thank Arthur S. Marks, Professor of Art History, the University of North Carolina at Chapel Hill, for undertaking his essay on Wilkie's reproductive prints, so important to an understanding of his career, and Sir Ivor Batchelor, Professor Emeritus of Psychiatry, the University of Dundee, for his brief note on Wilkie's psychiatric state, which suggests some new areas for future research through his concise diagnosis of the cause of Wilkie's chronic health problems.

Many individuals and public collections have been extraordinarily generous in the loan of important paintings and drawings. I would particularly like to thank Her Majesty Queen Elizabeth II, the Tate Gallery, the Ashmolean Museum, the National Galleries of Scotland and the Victoria and Albert Museum, Apsley House, for their invaluable cooperation. Without their help, this exhibition would have no claim to comprehensiveness.

I would also like to thank the following individuals for their help and services: D.S. Allan, Depute Director of Administration, Fife Regional Council; Brian Allen, Deputy Director of Studies at the Paul Mellon Centre for Studies in British Art; Alisdair Auld, Director, Glasgow Museums and Art Gallery; Alan Bowness, Director, The Tate Gallery; Patrick Boylan, Director, Leicestershire Museums and Art Galleries; Dr. David Blayney Brown, The Tate Gallery; Duncan Bull, Acting Keeper of Prints and Drawings, National Gallery of Scotland; Timothy Clifford, Director, National Galleries of Scotland; Roger D. Clisby, Deputy Director/Chief Curator, The Chrysler Museum; Lindsay Errington, Associate Keeper of British Art, National Gallery of Scotland; the Knight of Glin; Miss Ann V. Gunn, Keeper of Fine Art, Castle Museum and Art Gallery, Nottingham; Anne d'Harnoncourt, Director, Philadelphia Museum of Art; John Hayes, Director, National Portrait Gallery, London; James Holloway, Assistant Keeper, Scottish National Portrait Gallery; Francina Irwin, Keeper of Fine Art, Aberdeen Art Gallery and Museum; Michael Jaffé, Director, Fitzwilliam Museum; Raymond Keaveney, Assistant Director, National Gallery of Ireland; Margaret Kelly, Curator, FORBES Magazine Collection; Andrea Kerr, Curator, Kirkcaldy Museum and Art Gallery; Jane Lane, Curator, The Mellon

Bank; Susan Liddell, The Tate Gallery; Richard Lockett, Keeper of Art, City Museum and Art Gallery, Birmingham; Hugh Macandrew, Keeper, National Gallery of Scotland; Joseph Martin, Director, National Gallery of Canada; Jonathan Mason, Registrar, The Tate Gallery; Sir Oliver Millar, Surveyor of the Queen's Pictures; Michael Millward, Curator, Blackburn Museum and Art Gallery; Mrs. R.M. Paisey, Curator of Fine Art, Leicestershire Museum and Art Galleries; Nicholas Penny, Keeper of Western Art, Ashmolean Museum; Ann Percy, Curator of Drawings, Philadelphia Museum of Art; Homan Potterton, Director, National Gallery of Ireland; William D. Prosser, Q.C., Dean, Faculty of Advocates, Edinburgh; James Ryan, Deputy Secretary, University of Dundee; David E. Scrase, Keeper of Paintings and Drawings, Fitzwilliam Museum; David Shearer, Chief Curator of Museum and Art Galleries, Renfrew District Council; Alan Shestack, Director, The Minneapolis Institute of Arts; David Steadman, Director, The Chrysler Museum; Sir Roy Strong, Director, The Victoria and Albert Museum; Sheena Smith, Assistant Keeper of Art, Glasgow Museums and Art Gallery; D.R.J. Stephen, Assistant Secretary, Royal Hospital, Chelsea; Duncan Thomson, Director, Scottish National Portrait Gallery; Christopher White, Director, Ashmolean Museum; Professor Frank Willett, Director, Hunterian Art Gallery, University of Glasgow; K.K. Yung, Registrar, National Portrait Gallery, London.

The staff of the Yale Center for British Art deserve special thanks for their cooperation in this exhibition project. I am especially grateful to Duncan Robinson, Director, for his enthusiastic support of the exhibition from our very first discussions. Malcolm Cormack, Curator of Paintings, who coordinated the exhibition at New Haven, and Susan Casteras, Assistant Curator of Painting, have been similarly supportive. Patrick J. Noon, Curator of Prints and Drawings, who first suggested the exhibition, and his staff: Scott Wilcox, Assistant Curator, and Randi Joseph, Assistant, have been very helpful throughout. I am grateful to Anne-Marie Logan, Librarian, and Betty Muirden, Reference Librarian, for their assistance with my research. Lastly, I would especially like to thank Tim Goodhue, Registrar of the Yale Center, for his major effort in coordinating the loans with the North Carolina Museum of Art, and for taking charge of the packing, shipping and insurance arrangements.

At the North Carolina Museum of Art I owe particular thanks to Edgar Peters Bowron, former director of the museum, presently director of the Harvard University Art Museums, and his successor, Richard S. Schneiderman, for their continuous support of this project. I am deeply grateful to Peggy Jo D. Kirby, Registrar, and Carrie Hastings, Assistant Registrar, for their careful and dedicated work in coordinating all the loan requests and photographs for the catalogue, and for their cooperation with the Yale Center for British Art in arranging the packing, shipping and insurance. I am equally indebted to Jenny Malcolm, Head Graphic Designer, for her patience and her handsome design of the catalogue. Lastly, I wish to thank Patricia Baxter, Roberta Edwards and Paula Melhop, who served successively as Curatorial Secretary, preparing everything from initial grant requests to loan forms and the final manuscript.

I am also grateful to Paul Betz, now of the University of North Carolina Press, who served as copy editor until the last stages of the

project, and Jennifer Rinehart, my secretary at the Allen Memorial Art Museum, Oberlin College, who prepared certain key sections of the manuscript after I took up my new position as director of that institution.

William J. Chiego

Editorial note. The forms of reference used in this catalogue are self-explanatory and, we hope, consistent. Only two special points need to be made here: 1) Catalogue numbers given in the *Drawings* sections of the painting entries refer to the present catalogue only and are not meant to indicate that this is the only drawing for the painting under discussion at this museum. 2) Catalogue numbers given for the Wilkie exhibition held in Edinburgh and London in 1958 refer to the London, Royal Academy version of the catalogue only.

Chronology

1785 Birth of David Wilkie, third son of the Reverend David Wilkie, Minister of Cults.

1799 Wilkie enters the Trustee's Academy, Edinburgh and studies with John Graham.

1804 Paints *Pitlessie Fair*.

1805 Moves to London and enters the Royal Academy Schools. Meets Haydon.

1806 For Lord Mansfield he paints *The Village Politicians*, his first painting to be exhibited at the Royal Academy, and gains immediate popular and critical acclaim. Paints *Alfred Reprimanded by the Neatherd's Wife* for Alexander Davison.

1807 Exhibits *The Blind Fiddler*, painted for Sir George Beaumont, his early patron and friend.

1808 Exhibits *The Card Players*, painted for the Duke of Gloucester.

1809 Exhibits *The Cut Finger*, painted for S. C. Whitbread, and *The Rent Day*, painted for the Earl of Mulgrave. Election as Associate of the Royal Academy. Meets Walter Scott.

1810 Enters, then withdraws *Grandmother's Cap (The Wardrobe Ransacked)* from the Royal Academy exhibition. First extended illness. Receives first commission from the Prince Regent, the future George IV.

1811 Election as full member of the Royal Academy. Exhibits *Portrait of a Gamekeeper*, painted for Beaumont.

1812 Organizes his own retrospective exhibition at 87 Pall Mall, including *The Village Festival*, the unfinished *Blind Man's Buff*, and *Alfred Reprimanded by*

the Neatherd's Wife. Death of his father.

1813 Exhibits *Blind Man's Buff*, painted for the Prince Regent, who commissions a companion picture. His mother and his sister, Helen, come to live with him in London.

1814 Exhibits *The Letter of Introduction* and *The Refusal (Duncan Gray)*. With Haydon, he travels to Europe for first time. Sees Rubens' *Marie de' Medici* cycle and Napoleon's fantastically augmented Louvre. Makes first contact with Parisian printsellers.

1815 Exhibits *Distraining for Rent*.

1816 Receives commission from the Duke of Wellington for *The Chelsea Pensioners*. Second European trip, to the Netherlands and the field of Waterloo, and to study Rubens in Antwerp.

1817 Exhibits *The Pedlar* and *Sheepwashing*, his only exhibited landscape, at the British Institution.

1819 Exhibits *The Penny Wedding*, painted for the Prince Regent as a companion to *Blind Man's Buff*.

1820 Exhibits *The Reading of the Will*, commissioned by the King of Bavaria. Exhibits *The Veteran Highlander* at the British Institution.

1821 Géricault visits Wilkie in his studio and sees *The Chelsea Pensioners*. Wilkie exhibits *The Death of the Red Deer* at the British Institution. Travels to Paris for third time.

1822 Exhibits *The Chelsea Pensioners* to the greatest acclaim of his career. Visits Edinburgh to view George IV's historic visit to Scotland and to plan a com-

memorative painting. Gathers information for *The Preaching of Knox*.

1823 George IV appoints Wilkie King's Limner for Scotland, succeeding Raeburn, at the urging of Sir Robert Peel. Exhibits the portrait of *Frederick, Duke of York*. Chooses *The Entrance of George IV at Holyrood House* to commemorate the King's visit to Scotland.

1824 Death of his mother, his brother James, and his sister Helen's fiancé.

1825 Delacroix visits Wilkie and sees sketch of *The Preaching of Knox*. Death of his brother John, in India. Wilkie's health breaks down and he begins three years of convalescence and travel in Europe.

1826 Spends several months in Rome, and travels in Italy, Germany and Central Europe. Begins to paint *The Pifferari* and other Italian genre subjects at end of year.

1827 In Rome most of year, and elsewhere in Italy, France and Switzerland. Travels to Spain late in the year.

1828 In Madrid, and also Seville, for nearly half the year, with Washington Irving his frequent companion. Begins series of pictures on the Spanish war of independence: *The Spanish Posada*, *The Defence of Saragossa*, and *The Guerilla's Departure*. Returns to London in the summer.

1829 Wilkie's triumphant reappearance at the Royal Academy exhibitions. Shows his Italian and Spanish paintings, and his portrait of the *Earl of Kellie*. George IV purchases five works and commissions a sixth, reestablishing Wilkie's reputation.

1830 George IV names Wilkie Painter in Ordinary to the King on the death of Sir Thomas Lawrence. Exhibits *The Entrance of George IV at Holyrood House*. Death of George IV.

1832 Exhibits *The Preaching of Knox*, his greatest success as a history painter, painted for Sir Robert Peel.

1833 Exhibits his portrait of *William IV*.

1834 Exhibits *The Duke of Wellington as Constable of the Tower* and *The Spanish Mother*. Visits Scotland to begin work on a new commission: *Sir David Baird Discovering the Body of Tippoo Saib*.

1835 Exhibits *Christopher Columbus in the Convent of La Rabida*, *Sancho Panza in the Days of His Youth*, and *The First Earring*.
Visits Ireland in search of new subjects.

1836 William IV confers a knighthood on Wilkie. Exhibits *The Peep-o'-Day Boy's Cabin* and *Napoleon and the Pope*.

1837 Exhibits *The Empress Josephine and the Fortune Teller* and *Mary Queen of Scots Escaping from Loch Leven Castle*. Queen Victoria ascends the throne, commissions a painting of her First Council.

1838 Exhibits *The First Council of Queen Victoria* which disappoints critics and the Queen. Visits Scotland to begin *John Knox Dispensing the Sacrament at Calder House*.

1839 Exhibits *Sir David Baird Discovering the Body of Tippoo Saib* and *Grace Before Meat*.

1840 Leaves for the Holy Land and spends end of the year in Constantinople. Many drawings and sketches, including *The Turkish Letter Writer*.

1841 Travels to Jerusalem and then to Alexandria where he paints *Mehemet Ali, Pasha of Egypt*. Dies on voyage home and is buried at sea off Gibraltar.

Sir David Wilkie
of Scotland

The Genre Paintings of Wilkie

Lindsay Errington

DURING Wilkie's early years in London, two apparently contradictory explanations of his work were advanced by contemporary art lovers. The painter Northcote observed of *The Village Politicians* (for the engraving, see cat. no. 90) that he thought Wilkie "painted it in a room filled with the pictures of Teniers,"[1] and the painter Westall had already made a similar criticism, mentioning "its appearance of pictures which Wilkie may have studied, that is, as if made up more from the study of *pictures* than of *nature*."[2] In other words, Wilkie was an ingenious pasticheur, without personal vision or imagination.

To Hazlitt, on the other hand, writing a number of years later, it seemed absurd to postulate Wilkie's works as the hybrid offspring of Teniers and Hogarth. On the contrary, "Mr. Wilkie's pictures, generally speaking, derive almost their whole value from their *reality*, or the truth of the representation, . . . his pictures may be considered as diaries, or minutes of what is passing constantly about us."[3] Hazlitt possessed of course the advantage over Northcote and Westall of having seen more work by Wilkie, and he was not actuated by stings of professional jealousy. Nevertheless,

exactly the same kind of criticism the two artists were making in 1806 was restated by Roger Fry as recently as our own century: "He studied the Dutch masters with extreme assiduity, but rather too much with a view to making use of them and not enough to enrich his own vision. Perhaps, indeed, he had no very marked personal vision."[4] Wilkie the faithful student of nature, or Wilkie the eclectic and assiduous plagiarist of Old Masters —which of these views is the true one? It may seem perverse to suggest that both are equally true, and that there was no period in Wilkie's career when, in one and the same painting, one cannot discover evidences of both the study and fresh observation of life, and of the redeployment of designs and painterly techniques learned from earlier artists.

However, Wilkie's appropriations from the Old Masters were, pace Fry, nearly always creative appropriations, of the kind recommended by Reynolds in his *Discourses*. According to Burnet the engraver, who had known Wilkie from student days in Edinburgh, he was in the habit of taking some particular Old Master as a model while working on his own compositions, and attempting to emulate

or surpass his exemplar in the process. Burnet cites the use of Terborch's *Messenger* as a source for *The Letter of Introduction*.[5] We know too that George Beaumont lent or gave Wilkie a Teniers to keep beside his easel while he painted *The Blind Fiddler*, and that, much later in his career he used a copy of Rembrandt's *Woman Taken in Adultery* as assistance for the historical picture of *Knox Preaching*. His models were employed both as guides to the technical use of paint and as suggestions for structural patterns. It is important to be aware that, in selecting his Old Master models, Wilkie seems to have been actuated as much by his perception of an affinity between their themes or stories and those he purposed to relate in his own pictures, as by their abstract qualities of surface or design. His reordering of borrowed designs always had the effect of tightening and clarifying the narrative context, so that the abstract elements of his art can never fully be separated from, or examined while ignoring, his skills as a storyteller. Even during his first years in London it was noticed that he told stories much better than Teniers had done. Even at this early point in his career he was far from being the artistically uneducated innocent that Sir George Beaumont liked to think him. The painter Haydon recognized that Wilkie already possessed five years' start in study and practice over his fellows at the Royal Academy schools, and an informed and "exquisite" knowledge of composition. That knowledge had first been tried out in Scotland, in the painting of *Pitlessie Fair* (cat. no. 4).

Although the subject and treatment of character in *Pitlessie Fair* recall Dutch and Flemish seventeenth-century pictures, the color, especially the predominant red tint, and the handling do not, the handling being a miniaturized version of Raeburn's. Wilkie's Nether-

landish sources were evidently mainly prints,[6] especially probably copies after Ostade prints by David Deuchars, and it is noticeable that after Wilkie had been exposed to numbers of real paintings by Teniers in London his handling and color changed markedly from what we see in *Pitlessie*. Genre paintings that Wilkie might have known before he left Scotland are the small scenes of life in Edinburgh and Midlothian produced by Ibbetson while on his Scottish visit of 1800. Certainly Wilkie was familiar with Ibbetson's little book on art, which he transcribed by hand from a borrowed copy.

A source much nearer to hand for Wilkie than either Netherlandish pictures or the work of Ibbetson lay in the racecourse and fair scenes of his precursor David Allan and in the watercolors of his older contemporary Alexander Carse, who had been Allan's pupil. Carse's *Oldhamstock's Fair* (fig. 3) exists—as do many of his compositions—in more than one version, and at least one of these must have been known to Wilkie. The National Gallery of Scotland's version, dated 1796, has the same elongated format as *Pitlessie* and is arranged in a similar way, with distant new arrivals to the fair plodding down a slope in the upper right corner, and a tidal flow of movement from a densely clustered crowd on the far left passing diagonally downward across the center to a more loosely dispersed set of groupings in the bottom right corner. Carse's picture subdivides into numerous small self-contained constellations of activity, each telling its own story, and many of these little episodes are repeated by Wilkie. Thus we have in the Carse a family of gentry distinguished by their superior clothes—a top-hatted man and two women—facing away toward a tented stall, and a similar group occurs centrally in the Wilkie. Carse's teapot

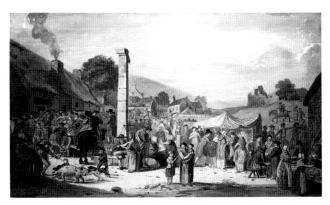

Fig. 3 Alexander Carse, *Oldhamstock's Fair*, 1796, National Gallery of Scotland

and crockery stall appears on the extreme right; Wilkie puts his on the extreme left. Carse has an episode involving a man raising a stick to an approaching pig, which a small boy is urging his dogs to chase; in Wilkie the stick, the boy, and the dog are invoked against a stubborn cow. Carse's sheet or blanket seller appears in the mid-distance; so does Wilkie's. Carse's fiddler is on the right, Wilkie's on the left. In the center right both artists have placed a family group, with a mother holding her baby and her son holding a toy. A conspicuous difference between the two fairs, apart of course from the relative sophistication of the Wilkie and the naïveté of the Carse, lies in the recruiting scene that Carse does not have. Although there is probably an intended allusion by Wilkie to contemporary recruitment for the French wars, there was also an artistic source for the recruitment—a source that was not a picture but a poem. Robert Fergusson's "Hallow-Fair" was written in 1772 in Scots vernacular, following a stanza form that goes back through Allan Ramsay's (the poet's) roistering additions to the traditional poem "Christ's Kirk on the Green." Fergusson's tone of voice, at once

sympathetic, amused, and knowing, as he stands aside and watches his rather foolish fairgoers being tricked in various ways, resembles what we can gather of Wilkie's attitude toward his creation. By Wilkie, as by Fergusson, we are invited to observe how

> . . . country John in bonnet blue,
> And eke his Sunday's claes on,

is persuaded by his Meg to buy her a fairing. Elsewhere on the ground,

> Here chapmen billies tak their stand,
> And shaw their bonny wallies;
> Wow! but the lie fu' gleg off hand
> To trick the silly fallows:
> Hey, sirs! What cairds and tinklers come,
> And ne'er-do-weel horse-coupers . . .

Precisely in the center of Fergusson's poem is Wilkie's own central event

> The dinlin drums alarm our ears;
> The sergeant screeches fu' loud,
> A' gentlemen and volunteers
> That wish your country gude,
> Come here to me, and I sall gie
> Twa guineas and a crown;
> A bowl o' punch, that, like the sea,
> Will soom a lang dragoon
> Wi ease this day

As has often been observed, the numerous little subplots in *Pitlessie*, from the blind fiddler to the recruiting scene, provided Wilkie with the germ of many of his later pictures. Each of these minor figure groupings revolves around the axis of its own separate theme, and no single one establishes any hierarchical importance over the others. Wilkie never again, even in his most elaborate works, painted so loosely organized a narrative as his *Fair*. From now on one ruling idea would spread focal control over

each of his pictures, so that they possessed—as Reynolds had advocated—their main group with subordinate groups attached in a supportive role, like subordinate clauses in a sentence. Another feature of *Pitlessie* that dropped from Wilkie's work, never to return, was the crudity of its humor. The lavatorial corner in the far right where, among other similar incidents, a passing collie casually lifts its leg on the artist's signature, might have seemed less amusing to genteel metropolitan connoisseurs like Sir George Beaumont than it had seemed in rural Fife.

The elements of sound and time—what Wilkie later called "that *one instant* to which our elaborate art is limited"[7]—can only be represented in a painting by allusion. *Pitlessie* is, by implication, a casually cacaphonous scene, with more noise in it than listeners. Its time span is similarly dealt with by Wilkie in a casual way. There is, as has already been observed, an eddying flow of movement from the new arrivals at the top left to the fairgoers on the far bottom right who have—quite evidently—been already present for some time. An element of travel is provided also for the viewer by reading across from left to right following this eddy. However, the episodes encountered in succession during such a reading are not necessarily themselves successive. They could just as easily be simultaneous. There is nothing to indicate whether Wilkie intended to present a single moment of time or the condensed experience of a long afternoon, nor does it matter.

By the date when he came to paint *The Blind Fiddler* (cat. no. 5), his second major London picture, he had evidently given thorough consideration to the proper uses that could be made of sound and time within a picture. In this composition, deeply pondered, econom-ical, and controlled, nothing is left to chance. Its subject, deceptively simple and even senti-mental at first glance, ramifies bewilderingly as one pursues it. Home and homelessness, sound and listening, blindness and sight, the extended stages of human experience from babyhood to old age contained in a moment, or the relationship between the imitative arts—all emerge as possible themes, none of which can be discounted. The composition, so much admired by the artist Haydon, rapidly attained the status of classic exemplar for the young artist. Burnet, in his *Practical Hints on Compo-sition in Painting* (1822), engraved it as a model of circular design. Holman Hunt, who had copied it as a student in the British Museum, illustrated it in *Pre-Raphaelitism*, with little dotted triangles inserted by himself, to typify the standard pyramidal academic composition that the Pre-Raphaelites rejected. Even the number of figures in the design attain—if one counts the babies—the twelve that Reynolds regarded as the correct limit for good figurative composition.

Both Burnet's and Hunt's structural analyses miss the friezelike quality of Wilkie's statement, which opens on the left with the unseeing fiddler's notes (which we do not hear), moves across through a range of responses that transform the invisible sounds into thoughts and memories (which we only infer from a visible residue of expressions or actions), and closes on the right with a translation or reversal of the first image (sightlessness making sound) into the concluding image of the small boy with the fire bellows (a silent visual imitation of musical actions). This, Wilkie seems to be saying, is what the painter does with his experience. In the rather later, and now lost, *Rabbit on the Wall*, he amplified the theme of art in the making, but chose to concentrate on

the progressive sophistication of the beholder's understanding of the mechanics as well as the effects of art.

WILKIE'S FIRST London picture, *The Village Politicians*, is related in an obvious way to designs by Teniers. The source of the composition for *The Blind Fiddler*, if it has a source, is more elusive, but it has an odd and tantalizing thematic and structural resemblance to the work of an artist with whom Wilkie was often compared during his early London years—Hogarth's levée scene in the series *Marriage à la Mode* (fig. 4).[8] The relationship between the two works is rather one of opposition than acceptance, an assertion by Wilkie of simple tastes and values that counter Hogarth's cynicism about corrupt family relations, faithlessness, and narcissistic musical performances in fashionable life.

Wilkie's central image is of a family through three generations, their cohesiveness and affection unequivocally established. Hogarth's central group displays a wife wrecking her marriage by an adulterous liaison with the lawyer who had drawn up her marriage contract. To the left, Hogarth's picture opens, as does Wilkie's, with music making, but unlike the fiddler's simple notes received with rapt attention by Wilkie's cottagers, Hogarth's sophisticated music vanishes unheard by a succession of chattering and self-absorbed nonlisteners. On the far right, where Wilkie provides a witness in the innocent young boy who makes his spontaneous and natural visual comment on the scene—a specimen of child-art on the cupboard behind him— Hogarth's sophisticated boy page produces his sly visual comment (with the figurine of Actaeon) revealing a preternatural and precocious awareness of the situation he witnesses.

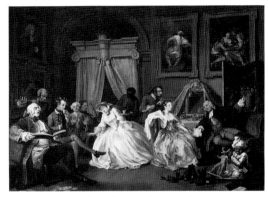

Fig. 4 William Hogarth, *Marriage à La Mode: The Countess's Morning Levee*, 1743(?), National Gallery, London

It is possible that Wilkie was not entirely happy about the equation of his work with Hogarth's, and later pictures—such as *Chelsea Pensioners* (cat. no. 23) if compared with the *March to Finchley*—also suggest a desire to refute the Hogarthian interpretation of life.

Throughout the early part of Wilkie's career connecting threads link picture with picture. The blind fiddler first appears in a minor role in *Pitlessie Fair*. His blindness obviously came to occupy Wilkie's thoughts in a positive way, for a rough study for the painting of *The Blind Fiddler* is scribbled on the same sheet as one for the central figure in *Blind Man's Buff* (fig. 5 and cat. no. 91), a connecting link between pictures otherwise separated in execution by seven years.

Wilkie's *Card Players* (cat. no. 9) was among the few pictures of his that the otherwise critical Roger Fry wholly approved, because "The story interferes no more with the design than it does in Ostade."[9] It is difficult to be certain quite what Fry would have regarded as interference. He may have believed that *The Card Players* possessed no more "story" than

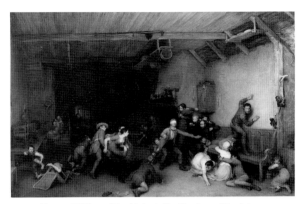

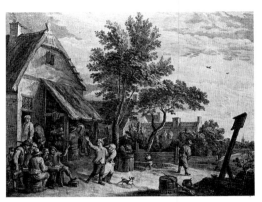

Fig. 5 Wilkie, *Blind Man's Buff*, 1812, Her Majesty Queen Elizabeth II

Fig. 6 Le Bas after Teniers, engraving

Cézanne's *Card Players*, or he may have thought the "story" so accessory a feature to the compositional structure that it could safely be disregarded. In either case he would have been wrong. *The Card Players* belongs to the small group of pictures—commencing with *The Blind Fiddler* and including *The Cut Finger* (cat. no. 11), *The Jew's Harp*, and perhaps the rather later and now lost *Rabbit on the Wall*—that constitute the classics of Wilkie's early career. In these, in contrast to elaborate works like *The Rent Day* (for the sketch, see cat. no. 8) or *Blind Man's Buff*, a single group of people is shown concentrating upon a single action, which stimulates in each participant an appropriate reaction. Wilkie's treatment of these subjects is ordered, lucid, and rigorously disciplined. The Dutch or Flemish appearance of these works is largely a matter of their coloring and low-life settings. The ordering of the narrative, as well as the grouping of the figures and even to a certain extent the reactions of the characters to the central event, seems on the other hand to derive, perhaps via the academic principles of Reynolds's *Discourses*, from Italy. Hazlitt observed that Wilkie's figures

were drawn up in a more regular order than those of Teniers, and Benjamin Robert Haydon, questioning Wilkie, discovered that "The remarks he made to me relative to his own works I looked into Raphael for and found them applied there and then it was evident to me that Wilkie's peasant-pictures concealed deep principles of the 'ponere totem' which I did not know."[10]

In *The Card Players* Wilkie's choice of moment, the "pregnant" moment of academic pictorial theory, dictates the arrangement and behavior of the figures. We are not simply faced with four players of picturesquely random appearance clutching their cards, but with a specific point in a specific game. All the evidence of what has happened, is happening, and may be just about to happen is laid out by Wilkie for us to find. The game seems to be partner whist (or something very similar). The partners sit opposite each other. One couple has been prospering, and these two look happy. The spectacled man appears worried. His partner, with his back to us, scratches the back of his neck and knits his feet in anxiety. He is, we infer, about to play. There are three cards on

8

the table, indicating that the other three have already played their cards. The first player, the aproned man at the far left, who already has several tricks piled in front of him, gestures triumphantly at the top card on the pile, possibly an ace, as if to say, "Trump that if you can." His partner, the player on the right whose card it is, is so confident he will take the trick that he turns to show his remaining cards to the spectator behind him. His hand may include the card that the man with his back to us needs, or it may be that, knowing he will take the trick, and will therefore lead out in the next round, the confident man is gloating over his hand in anticipation. In either case what Wilkie has selected to paint is the crucial moment before the decision that will complete that round of the game.

The moment of — or just before — decision is also, rather surprisingly, the central subject in *The Village Festival* (cat. no. 12).

This is a painting of a curiously ambivalent and disquieting character. It appears, viewed from a little distance, simply as an innocent if lively celebration of rural conviviality in nineteenth-century England treated along the lines of a Flemish or Dutch kermess. Looked at more closely this illusion of harmlessness fades. Some of the episodes — even more, some of the faces, bloated, slobbering, and reddened — verge on the disgusting. On the one hand, the technical execution is extraordinarily delicate — those bloated and tipsy features are touched with the refinement of Watteau; on the other hand, the subject, one senses, repelled the artist with its coarseness, and is intended by him to repel the viewer too. Even those viewers who like Cunningham began by interpreting the picture as a scene of sheer pleasure — "quiet glee bursts into noisy humour" — sometimes ended on a different note, hardly

reconcilable with the first — "The group at the other end of the picture is of darker and more painful meaning."[11]

The central motif, the drunken man being urged homeward by wife and child, seems to have been taken from a Teniers, possibly from the engraving after Teniers by Le Bas (fig. 6). In the Teniers the wife of the tipsy man clasps his left arm and with her own right arm around his shoulders steadies and draws him on. The family dog leaps about and barks excitedly while the man himself, thus reluctantly propelled on his homeward way, turns to wave to his drinking companions, one of whom lifts a glass in teasing toast. Clearly the merriment will still continue unabated long after the husband's departure. It is highly characteristic of Wilkie to borrow a motif like this from an earlier artist and then rework and improve on it. The original motif is used by Teniers decoratively and anecdotally. It has no psychological tension because the decision to go home has already been, however unwillingly, formed and accepted. Wilkie, by contrast depicts the moment before choice. His drunkard is of two minds. He ought to go but he would rather stay, and the pleas and clasps of wife and child are counterweighted by the tipsy clutches of his drunken friends who are hauling him back. We cannot guess what choice he will eventually make, but we are very clearly warned by Wilkie what his destiny will be if he remains. The drinkers round the table may seem temporarily to enjoy a state of splendid elevation, but reading across to the far right corner we encounter a squalidly drunken man who has collapsed into the gutter, an object of misery to himself and derision to the passersby. When Farington saw the sketch for this subject in Wilkie's studio in 1809, the artist made him take particular notice of this stupified figure,

"drunk and laid down, with a few spactators looking at him as an object of disgust & even, he said 'His dog seemed to look ashamed of Him.' This he called the Moral part of His picture."[12] The word "part" here must mean aspect. Wilkie is explaining a moral theme that pervades the whole picture, not asking Farington to believe that the picture only becomes moral in the bottom right corner. The title Farington then used for it, "A Man taken from his Ale House Companions by His Wife & Children," also conveys the idea of a moralizing theme, as does the verse from MacNeill's poem "Scotland's Skaith" that Wilkie chose to accompany the catalogue entry for his one-man exhibition of 1811:

> On ae hand drink's deadly poison,
> Bare ilk firm resolve awa',
> On the i'ther, Jean's condition
> Rave his very heart in twa.

It was the treatment of the drunkard, his family, and his friends that led a critic of 1831 to emphasize the vital distinction between Wilkie and his seventeenth-century Dutch prototypes: "If he paints a fair and introduces a drunkard, it is not in the indecent attitudes of a Dutch picture, but as led home by his wife and daughter, — here even giving allusion to domestic ties and duties."[13] A more perceptive critic of 1824 grasped that the decision for a homeward journey was not yet an accomplished fact, but still hung in the balance: "The centre group represents a contest between two parties—a set of half tipsy merry-makers, and a village housewife and her daughter—as to which shall get possession of the person of an idle husband, whom the latter have come to fetch home. There is a homely and pathetic truth in the expression of the wife that is delightful. Anybody but Wilkie would have

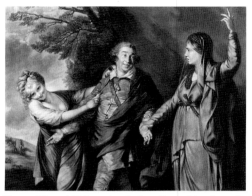

Fig. 7 Edward Fisher after Joshua Reynolds, *Garrick Between Comedy and Tragedy*, mezzotint engraving

made her a shrew."[14] In other words, we have here a reworking—semidisguised because presented in the "low" form of realistic comic genre—of the classic hero's allegorical choice between virtue and vice. Whether Wilkie was familiar with Shaftsbury's discussion of this theme and the appropriate way of dealing with it ("The Choice of Hercules"), we do not know, though the patrons in whose company he was moving, Sir George Beaumont and J. J. Angerstein (for whom *The Village Festival* was painted) might well have introduced him to Shaftsbury's *Characteristics*. It is unnecessary to speculate, for there was an actual painting expounding the theme very near to hand while Wilkie was working on his picture for Angerstein, and which he almost certainly used as the source for his own main group. This painting, which was then in Angerstein's own collection, was Reynolds's *Garrick Between Comedy and Tragedy* (fig. 7). Reynolds had converted the theme of absolute choice between two branches of one art form, neither intrinsically base, but one more austere, demanding, and noble than the other. It has been suggested that his grouping of Garrick and

the two muses derives from an earlier bacchanal by Jordaens and something of Jordaens's tipsy gaiety still survives in the relationship between Garrick and Comedy. This latent tipsiness deriving from its bacchanalian orgin is shrewdly detected, recovered, and exploited by Wilkie in his *Village Festival* group, and Wilkie also restores the choice to that originally posited. It is once more a choice of ways of life, virtue and vice. The relationship between *The Village Festival* and Reynolds's *Garrick* was not likely to have been apparent to any viewers of Wilkie's picture after 1824 when it was acquired as the nucleus of the National Gallery, for *Garrick* did not enter the National Gallery. By the severing of these two pictures, Wilkie's point, at once witty and serious, became a lost secret between himself and his now deceased patron.

WILKIE'S DUAL preoccupation with the formal concerns that he thought only the artist or connoisseur would notice, and with the ostensible subject matter that, he believed, for the average intelligent member of the public made up the whole picture, had led in *The Village Festival* to a situation where the two aspects, compositional and narrative, came near to conflict. It is apparent from this, from *Blind Man's Buff*, and from the small *Grandmother's Cap* that, following his static compositions of circa 1806–1809—compositions in which stationary figures are related by expression or gesture and "read" by the viewer across the picture surface—Wilkie was becoming interested in quite another sort of design—one based on dynamic physical movement with individual figures contributing to the build-up of a major overall rhythm. The game, and later on, the dance, provided a vehicle for this kind of design, in which communal movement was explicable and

appropriate. It may be that Wilkie became attracted by the possibilities of this kind of design after looking—as urged by Sir George Beaumont—more at Ostade and less at Teniers. Certainly the smallish figures, high-level viewpoint, and splayed perspective of *The Village Festival* and *Blind Man's Buff* could have been derived from certain paintings by or prints after Ostade. *The Village Festival* rather unfortunately combines Wilkie's older method of cross-reading with his new interest in movement in depth. It is, from one point of view, a bacchanalian dance. The revelers move as if to the compulsion of imaginary music, especially those who attempt to prize the central man from the grasp of his wife. We do not seem to be watching normally behaved people—even normal drunk people—so much as dancers in a symbolic ballet. All the movements Wilkie created align themselves with a sinuous rhythm that ripples along imaginary perspectival diagonals and weaves the revelers together. His moral meaning, on the other hand, requires the viewer to resist becoming drawn back into this pulsating maze and to read firmly across the foreground from left to right, the evidences of the stages of moral decline and—in the event of a wrong decision—fall.

The two pictures acquired by George IV—*Blind Man's Buff* and *The Penny Wedding* (cat. no. 18)—resolve the problems of this kind of design. In *Blind Man's Buff* the dictates of the game dominate individual human purposes so that subject matter and compositional structure are once more perfectly aligned. The game, which requires the blind man to capture another player, seems to have suggested most naturally the wheeling composition with its radiating spokes converging on the blind man's outspread arms. In their efforts to escape as they revolve round him, the other

players clutch and cling to each other, and shrink against the edges of the room as if impelled by violent contrifugal force. The creation of the moving spokes of this compositional wheel can be explored in Wilkie's preparatory drawings. Uncharacteristically he did not—at least initially—use live models for this painting, and it is possible that the successful achievement of his abstract rhythmic design might have been hampered by the use of actual models—though his friends and contemporaries thought this avoidance of the model a mistake. [15]

Although an interval of some six years, in which Wilkie's style had developed and altered, separates the painting of *The Penny Wedding* from that of *Blind Man's Buff*, the former was, in a variety of ways, truly conceived and constructed as a complementary pendant to the latter. These pictures are virtually of a size, the small difference of less than an inch between them being probably accidental. Both are on panels, which may be less easily standardized than canvases. Each painting depicts a huge room, and the two compositions seem designed by their perspectival arrangements—especially the off-center vanishing points—to hang side by side, with *The Penny Wedding* to the left, so that the main diagonals of the long outer walls in each picture incline inward toward each other. Each picture is concerned with what might be called a typical national pastime, the ancient English game of blind man's buff, and the equally ancient Scottish country dance or reel. Here the similarities end, and the contrasts begin. If *Blind Man's Buff* is, as has already been postulated, an experiment with centrifugal force, *The Penny Wedding* is, equally deliberately, an experiment with centripetal. Unlike *Blind Man's Buff*, where the hub is still and the rim gyrates, the movement in *The*

Penny Wedding is most frenzied and concentrated at the center with the dancing couples who set to each other, their inward glances crossing, their shoulders and feet opposed as the form of the dance requires, and in a way that gives the final tight twist to the knot in the forces of attraction extending out and out to the quiescent seated watchers along the edges, tempting them in with power as of a magnet. The center of *Blind Man's Buff* repels the participants in the game; the center of *The Penny Wedding* draws them.

Although Wilkie would never have described his intentions in quite such language, we need be in no doubt that he was fully conscious of the abstract energies evoked by the complementary patterns of his two designs. Furthermore, the two opposite kinds of movements that he creates are implicit in, rather than simply imposed upon, the game and dance he chooses to portray. It is his perception of these innate forces at work below the random details of the game and dance—forces that sweep individuals together like particles in a larger rhythmic design beyond their comprehension or volition—which makes of his pictures coherent and vivid unities rather than mere accretions of sentimental anecdotes. The various drawings for *The Penny Wedding* reveal Wilkie selecting and refining the groups and gestures that will best convey the gradually quickening impulse toward the center. A very early watercolor drawing of 1817 (fig. 8) locates the center of energy in the crossed hands of two couples spinning round together in a wheel of four. This was discarded in the final work, quite possibly because its dynamic tendency was the opposite of what was required, being exactly the same as that of the blind man's posture in the first picture—the dispersal of energy outward. In contrast to this, the setting couple

Fig. 8 Wilkie, *The Penny Wedding: Study*, 1817, Fitz-william Museum, Cambridge

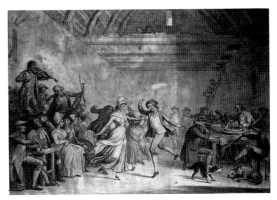

Fig. 9 David Allan, *The Penny Wedding*, watercolor, 1795, National Gallery of Scotland

whom Wilkie substituted for the wheeling four, though not touching, are impelled together. The next movement, after a couple have set to each other in one of these country dances, is usually a joining of hands to turn each other, so that the setting steps precede and imply an even closer conjunction (this is after all a *wedding* dance). Other drawings, in pen and ink, explore the progressive stages in from the left fringes. A shy, reluctant girl is pushed and drawn slowly forward by a seated friend and an equally shy partner.[16] In one of these drawings Wilkie tried the effect of accelerating the pace at this point with a gamboling child, though in the final work he discarded this motif for a stooping girl who adjusts her sandal and acts as a temporary stop to the movement. Reading from left to right in the final picture we have a progressive sequence suggesting a sequence in time and perhaps a symbolic sequence as well. A girl is asked to join the dance, a girl is led by her partner into the dance, a girl and her partner set together in the dance. Appropriately enough the bridal couple seem to belong to the intermediate phase of this progress.

A further test of Wilkie's intentions in *The*

Penny Wedding—tested already against its companion picture and its preparatory drawings —can be made by comparing it with its artistic prototypes. The most obvious of these is David Allan's *Penny Wedding* (fig. 9), which exists both as an original watercolor[17] and as a print by Allan himself, which Wilkie would certainly have known. Allan's ingredients are precisely the same as Wilkie's and are disposed in very nearly the same positions, but they are disposed in three quite separate self-contained blocks, fiddlers and seated couples to the left, dancers center, greedy feasters and dogs on the right. There are none of the transitional elements between these blocks that give Wilkie's work the dynamic character of a process rather than the static one of a tableau. It seems to have been from the kermess and dance scenes of Teniers, Ostade, and Rubens that Wilkie derived his ideas of flow and change, but here again, as with Allan, there is a difference. The dances of Teniers are not organized with a precision that allows for the emergence in the dance patterns of double or secondary meanings suggesting the successive phases of human life—Teniers's dances are affairs of the

moment. It is tempting to suppose some influence on Wilkie, dating perhaps from his visit to France in 1814, of Greuze's betrothal scene *L'Accordée de Village*, which sets up trains of reflection not unlike those evoked in *The Penny Wedding*. Unfortunately we have no evidence to support this, and it must remain for the time being an attractive hypothesis.

THE MULTIFIGURED compositions that begin with *The Village Festival* and culminate in *The Chelsea Pensioners* of 1822 did not comprise the total sum of Wilkie's interests during the second decade of the nineteenth century. He also continued to explore, with increasing subtlety, compositions containing small numbers of figures whose psychological interactions provide the whole subject. This group of pictures, commencing with *The Letter of Introduction* (fig. 10), and culminating in *The Breakfast* (fig. 11), treat unimportant domestic episodes in a reflective and undramatic way. *The Breakfast*,[18] which paradoxically establishes a sense of family cohesion and unity by the silent concentration each family member devotes to his own private breakfast occupation —pouring tea, eating an egg, reading a newspaper, while ignoring companions—shows the furthest point Wilkie was willing to advance in the direction of the picture without a narrative. In, for him, a rare outburst of explanation, he wrote, "It has no story in it, but as it contains a great number of objects that look very pleasing upon canvas & as the family are supposed to be in good circumstances it affords the means of conveying an idea in the Picture of the most complete English comfort."[19]

The first three pictures in this series, *The Letter of Introduction*, the first version of *Duncan Gray* (Victoria and Albert Museum; for the second version, see cat. no. 15), and *The Pedlar*

Fig. 10 Wilkie, *The Letter of Introduction*, 1813, National Gallery of Scotland

(cat. no. 16), reexplore, at closer range, the central moral motif of *The Village Festival*. The theme, presented with varying degrees of success, is persuasion—the way in which one person's hopes and wishes impinge on those of another, and what happens when these wishes run counter to each other. Each picture thus involves an attempt at persuasion on one part, and suspicion, possible yielding or possible rebuttal on the other.

To paint such a theme successfully it must be made very clear to the spectator what the contest is about and why the different parties must necessarily react in the way they do. In *The Letter* the sources of the action are deeply lodged in the irreconcilable differences of age, experience, social standing, and taste that Wilkie shows us. In *Duncan Gray* he deals with what he probably did not understand nearly so well, the different viewpoints of the two sexes. The complexities of the situation were probably harder to convey than the simpler confrontation in *The Letter* because the apparent context is all on the surface. In reality Maggie's and Duncan's wishes tend toward exactly the same end, for she has no real intention of

Fig. 11 Wilkie, *The Breakfast*, 1817, The Sutherland Trust

letting him depart. Burns's poem provides an initial phase of action in which Duncan woos and Maggie refuses, a second phase in which he decides to abandon his suit and she softens toward him, and a third phase in which both are reconciled. The whole is seen by some knowing and detached observer within the family circle who comprehends that a sexual game is being played according to understood rules. Wilkie copes with this by condensing the phases of change and expanding the number of dramatis personae from two to six. The presence of the mocking observer is accounted for by the hands and faces of Maggie's brothers who peer from behind a door. The fuse for her irritation is rather ingeniously supplied by the overzealous attempts of her parents to plead Duncan's case.

One cause of a crucial difference of mood between Burns and Wilkie lies in two slight shifts of fact made by the latter. In the poem the action takes place at night (New Year's Eve) when everyone is drunk ("we were fou") and therefore prone to adopt ludicrous exaggerations of behavior. In addition, the narrator of the poem seems cast in the role of experienced cynic. In Wilkie's picture, a daytime decorum and sobriety prevail; chaperoning parents supervise the courtship; and the observers are children, mocking the lovers' antics out of their own ignorance. Perhaps for this reason *Duncan Gray* offers a more sentimental, if not more naïve view of human relations than does *The Letter of Introduction*.

The combined effect of the expressions and gestures in *Duncan Gray* is not the to-and-fro tennis-singles effect of *The Letter*, but rather a circular one. The circle departs from and returns to Duncan, and Wilkie, exploiting what he had learned from his experiment with indecision and change of mind in *The Village Festival*, allows for a second circular reading to follow the first in which Maggie's refusal can be reread from her tensely clasped hands as a contradictory yearning to give way, and Duncan, poised between contrary states can as easily be supposed to be changing from love toward disdain as from disdain toward returning affection.

Each person's gestures depend on and heighten the supposed attitude of the others. Duncan recoils because Maggie disdains him. She disdains him partly because her parents adopt his cause. Her father's attempt to pat her shoulder pleadingly because he likes Duncan is halted because his daughter is in such a spitfire mood, and so on. In passing one may observe that it was either extraordinarily acute or exceptionally tactless (or perhaps both) in Wilkie to cast his friend the painter Mulready (whose bitter marriage had recently irretrievably collapsed with much mutual recrimination) in the role of the rejected and sulky Duncan. *The Pedlar* offers a similar chain of reactions circling in a repeatable ring.

In these works, as in the novels of Jane Austen, or in Scott's nearly contemporary

Antiquary, complex human emotions and motives are examined in trivial everyday situations by juxtaposing unideal people of incompatible or contrasting character, each with his own quirky inner life. It seems on Wilkie's part to be a reaction to the immense but dehumanized and unindividualized simple passions—the great rages, anguished sorrows, or stoic endurances—the situational extremities that the neoclassicists preferred. Wilkie's treatment, like Scott's, makes his juxtapositions and contrasts anything but trivial.

In *The Errand Boy* of 1818 (cat. no. 19) the transaction that provides the story is reduced to the bare minimum. There is a hint that the small boy on the pony (an urchin like Scott's Davie Mailsetter)[20] has indeed brought the groceries but has failed with something else —possibly the change for the money he first set out with. The appeal of the subject is no longer just in the story per se but as much in the setting, with its pleasant domestic backyard and kitchen door clutter. *The China Menders* of the following year[21] had an almost identical setting—a back door, a yard with brooms and other paraphernalia, and a door through a wall leading around to the smarter garden front of an old double-gabled house. That Wilkie knew a real house of this type and sharing some of the same architectural details there is no doubt, for he painted it in a small oil sketch of circa 1815–16. In this sketch we are looking from the garden side, but the same roller, water butt, and picket fence appear as in *The Errand Boy*. With Wilkie, however, the adoption of real characters or settings never precluded the use of Old Master sources as well, and so it is with *The Errand Boy* and *China Menders*. Both are based on Adriaen van Ostade's *The Cottage Dooryard* (fig. 12), which was exhibited at the British Institution London in 1815, by H. P.

Fig. 12 Adriaen van Ostade, *The Cottage Dooryard*, National Gallery of Art, Washington

Hope, where Wilkie must surely have seen it, even if he did not know it well already. Like *The Errand Boy* and *China Menders* the Ostade shows the backyard of an old creeper-covered brick house, a hen, a dog, a child, a broom, a pail and other clutter, and an open doorway leading through to the far side of the house, with a chimney gable glimpsed over the top. Wilkie's picture is thus neither the simple record of a real location, nor a pastiche of seventeenth-century Dutch art, but rather, it would seem an attempt to translate the cosy domestic atmosphere of Dutch kitchen door life into an English contemporary setting, a recognition of what pleasures and values the two countries had in common.

David Allan, whose *Penny Wedding* was so important a source for Wilkie's, seems to have been much in his mind in the years immediately preceding his journey to Italy. This influence acted as a stimulus toward a Scottish cultural nostalgia that emerges in *The Penny Wedding*, with its eighteenth-century setting, in two small illustrations to Ramsay's pastoral drama *The Gentle Shepherd* (cat. no. 25) and *The Cottage Toilet* (fig. 13), and perhaps even in

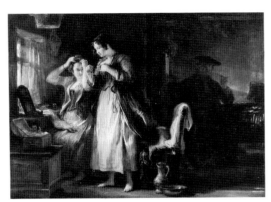

Fig. 13 Wilkie, *The Cottage Toilet*, 1824, Wallace Collection, London

the genrelike group portrait (fig. 40) that Wilkie painted of Sir Walter Scott and his family.[22] In this, Scott's two daughters, Anne and Sophia, are depicted as ewe-milkers, adopting, by virtue of their occupation, some of the characteristics of Ramsay's pastoral heroines Peggy and Jenny. These pictures look backward, with wistful sentiment, upon a long tradition of Border poetry. The episodes Ramsay had described were supposed to have taken place at the Restoration of Charles II in 1660, but *The Gentle Shepherd* itself was written in the early eighteenth century, and was not illustrated by Allan until the end of the eighteenth century. Wilkie's renderings of scenes from the poem avoid too specific a decision about what moment of the past is being shown. It is clear we are not looking at the year 1823, and that is all. The vagueness about historical period that one associates with many of his post-Italian genre paintings was already creeping into his work.

CURIOUSLY enough Wilkie's first mentor for his Roman subjects, just as earlier for his Scottish scenes, was David Allan. Allan had spent many years in Rome and had drawn, etched, or painted scenes of Calabrian shepherds playing a pastorale to the image of the infant Jesus, scenes of confession, scenes with pilgrims, and a series of the Seven Sacraments in the Roman church in a contemporary setting. Calabrian shepherds and a confessional were also among the first subjects tackled by Wilkie when he once more resumed painting in Rome after his long illness. The main difference between his work and Allan's is one of mood. Allan conjures up an atmosphere of whimsical humor. Wilkie is wholly serious. Allan's pictures—we may suspect—are truant relaxations from the onerous task of neoclassical history painting. Wilkie's are a continuation of his lifelong self-dialogue on the relations between art and religion, nationality, history, and tradition.

For the first time perhaps, in his *Cardinals, Priests and Roman Citizens Washing the Pilgrims' Feet* (cat. no. 28) Wilkie constructed a picture with a genuinely architectural basis. Hitherto every one of his compositions, whether taking place indoors or out, gives the impression that he was proceeding from the figurative groups first to fitting around them the space they must occupy, which thus becomes merely accessory. This impression is borne out by most of his pen drawings, which deal with figurative arrangements. The idea that one might begin by constructing a space, either simple or complex, and then fill it with figures at such intervals and in such postures as would clarify the spatial qualities still further, seems to have not been considered by Wilkie during his early London years. It is a measure of his receptiveness and his ability to analyze his sense impressions that

he was able to see the significance of the concept of space in the great High Renaissance frescoes he encountered in Rome, and separate out this treatment of space, enunciated through perspective and chiaroscuro, from the accidents of size and subject matter. The *Cardinals, Priests and Roman Citizens* is only a small painting and it has a genre subject, but its perspective, chiaroscuro, and consequent space are of Raphaelesque grandeur. Behind it looms the ghost of Raphael's *School of Athens*.

Wilkie's grouping of a priest and serving boy in the middle distance, which reads as shadow against the brightly lit foreground figures, but as half light against the dark figures in the distance, shows how well he had learned his lesson on the disciplined treatment of shadow. The scene as a whole has an organizational clarity and symmetry that makes *The Penny Wedding* or *Chelsea Pensioners* appear inchoate, overworked, and bitty. Nevertheless, his gains in respect of order and breadth of conception were not accomplished without a serious loss.

Wilkie seems to have been encouraged to make these major changes in his art by an ingenious application of a theory of art history to the life of the individual painter.

The work of painters antecedent to Raphael and Leonardo — so ran the theory — had been dry (i.e., hard-edged and lacking shadow), detailed, and flat.

With the High Renaissance came chiaroscuro, space, atmosphere, and breadth. The larger progress from one to the other was repeated in Raphael's personal progress from a dry and little manner to one of breadth and softness. Why then should not the painter of *The Blind Fiddler* and *Chelsea Pensioners* submit to the same laws of natural development? What Wilkie overlooked, though some of his home public did not, was that his whole manner of

working from *Pitlessie* to *Chelsea Pensioners* was built on a conception of character and individual behavior. The prophets and sibyls of Michelangelo, like the philosophers, muses, and saints of Raphael, are on the other hand generalized types or abstraction. When looking at Leonardo, and even more when examining the Sistine ceiling, Wilkie was excited by the possibilities inherent in chiaroscuro for conveying thought, change, and the movements of the mind within. Of course he had always been interested in painting attitudes of mind, and had found the means of expressing the invisible by the idiosyncratic gesture, the grimace, the contact one man makes with his neighbor — a visual language based on factual observation. On Michelangelo's ceiling he found a rhetoric of unreal and impersonal gestures used, not by unique individuals, but by personified abstractions, prophets, prophetesses, sibyls "engaged in some nameless unremembered act in sympathy with the workings of the soul. . . . They seem as in a monologue, occupied in reflecting, ruminating, interrogating. . . . " Wilkie's comments on the ceiling, as they occur in his later, unfinished "Remarks on Painting," are cribbed, perhaps unwittingly, image for image, and in some cases almost phrase for phrase, from Fuseli's third Royal Academy lecture on *Invention*, first delivered and published in 1801. To Fuseli the prophets and sibyls were "organs of embodied sentiment." Each scene on the ceiling was "circumscribed by its generic character." Wilkie's unconscious echoing of Fuseli suggests he was now assimilating into his own art a view of character and expression in complete contrast to that which he had held when painting *The Village Festival* or *Chelsea Pensioners*. The results are clearly apparent in his post-Italian pictures. Although he did not entirely cease to paint genre, the

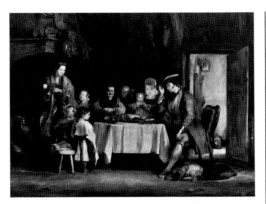

Fig. 14 Wilkie, *Grace Before Meat*, 1839, City Museum and Art Gallery, Birmingham

best of his later work seems to lie in history paintings such as *Knox Preaching* (fig. 17 and cat. no. 96) or the meditative and timeless *Knox Dispensing the Sacrament* (cat. no. 43), or such genre paintings as intentionally verge on history painting (*The Peep-o'-Day Boy's Cabin* [cat. no. 39]), or that equally intentionally verge on sacred art (*The Cottar's Saturday Night* and *Grace Before Meat* [fig. 14]). To such works an Old Master flavor is appropriate, but never again, in simple domestic scenes, did he attain the clarity, wit, and simplicity combined with complexity of *The Blind Fiddler* or *Duncan Gray*.

The Toilet of the Bride (cat. no. 41), for example, is full of elegance and yet betrays a certain laziness of thought about the period represented, the pictorial sources adopted, and the use of motifs. We are here in a kind of eighteenth-century no-man's land. The figure weeping on the left was lifted with few alterations from a Romney portrait of Mrs. Russell that Wilkie copied, and the small dog is identical in pose to that which appears in *Josephine and the Fortune-Teller* (fig. 23).[23] In its somewhat flimsy graces the painting seems to deserve Thackeray's somewhat flimsy criticism:

"Another charming performance of Sir David —a bride dressing, amidst a rout of bridesmaids and relations. Some are crying, some are smiling, some are pinning her gown; a back door is open, and a golden sun shines into a room which contains a venerable looking bed and tester, probably that in which the dear girl is to—but *parlons d'autres choses*."[24]

It was at the same exhibition that Thackeray noticed that Wilkie's men and women now looked "as *if the bodies had been taken out of them and only the surface left*"—a trenchant accusation.

Perhaps the last word on the subject should come from Haydon, so often inaccurate, prejudiced, and misled by jealousy in his judgments on his friend, and again sometimes seeing straight through to the heart of the matter. He spent a couple of hours with Wilkie in July 1828 looking over Wilkie's Spanish pictures and sadly recorded, "Now it is all Spanish and Italian Art. He thinks nothing of his early and beautiful efforts, his Rent Day, his Fiddler, his Politicians. 'They are not carried far enough'—as if anything on earth in point of expression and story was ever carried further."[25]

Notes

1. *The Diary of Joseph Farington*, ed. Kathryn Cave (1982), 8:2750.
2. *Diary of Farington*, 8:2716.
3. Hazlitt, "On the Works of Hogarth—On the Grand and Familiar Style of Painting," Lecture VII in *Lectures on the English Comic Writers*, first pub. 1819.
4. Roger Fry, *Reflections on British Painting* (1934), 96.
5. John Burnet, *Practical Essays on Various Branches of the Fine Arts* (1848), 115. This is discussed by A. S. Marks in "David Wilkie's 'Letter of Introduction,'" *Burlington Magazine*, March 1968, 125.
6. "The pictures by the Dutch and Flemish masters, he had little opportunity of seeing in Scotland, and his knowledge of composition was picked up from the etchings of Ostade and Rembrandt" (Burnet,

108).

7. David Wilkie to Clarkson Stanfield in a letter dated January 1832. A handwritten transcript of this letter was pasted onto the reverse of the picture *Distraining for Rent*.

8. The original paintings were at this date in Angerstein's collection.

9. Fry, 97.

10. *The Life of Benjamin Robert Haydon*, ed. Tom Taylor, 2d ed. (1853), 1:51.

11. Cunningham, *The Life of Sir David Wilkie* (1843), 1:300–302.

12. *Diary of Farington*, 9:3465, entry for 23 May 1809.

13. *Library of the Fine Arts* (1831), 2:137.

14. *British Galleries of Art* (1824), 29.

15. *Life of Haydon*, 1:218–19.

16. This drawing and the next mentioned are both in the National Gallery of Scotland, D 4365 and D 4751.

17. In the National Gallery of Scotland, D 613.

18. Painted 1817 (private collection).

19. Letter from Wilkie to the Earl of Leven, dated 28 November 1816, Scottish Record Office.

20. As described by Scott in his novel *The Antiquary* (1815).

21. Illustrated in William Bayne, *Sir David Wilkie R.A.* (1903), 112. Present whereabouts unknown.

22. In the Scottish National Portrait Gallery.

23. In the National Gallery of Scotland, painted in 1837.

24. Thackeray, *Strictures on Pictures. A Letter from Michael Angelo Titmarsh*, in *Fraser's Magazine*, June 1838.

25. *Life of Haydon*, 2:232.

David Wilkie and History Painting

William J. Chiego

T HE GENERAL PERCEPTION
of decline attached to the later
career of David Wilkie even in his own lifetime
has long discouraged a serious look at his
numerous historical paintings, the vast majority
of which were painted during the last decade
and a half of his life. Recently, in-depth studies
of individual works and exhibition publications
focusing on Wilkie's subjects and themes have
finally begun to rectify this situation.[1] This
essay will attempt to provide a first overview of
his work as a history painter.

The number of historical works Wilkie
painted is small by comparison with his activity
as a genre painter and portraitist, but in char-
acter quite varied. Very few, if any, of Wilkie's
historical pictures fit the eighteenth century's
classical definition of a history painting as a
depiction of a noble story from ancient history
or mythology, or from the Bible, with a moral
theme or message. As one critic wrote percep-
tively of Wilkie in 1861, in a series of articles
on the Royal Collection's holdings of his work:
"Historical painting, in its highest sense was
never within his grasp: whenever he essayed it,
he failed. . . . His mind was altogether of a
different order, and had little or no congeniality

of feeling with such subjects."

One of Wilkie's rare essays in classical history
painting is his *Diana and Callisto* of 1803 (cat.
no. 1), painted during his studies at the
Trustees Academy in Edinburgh under the
tutelage of John Graham. Although established
as a school to train designers for Scottish
industries, under Graham the Trustees Academy
became much more and, in fact, the students
were taught to paint in oils from the antique.
Graham, as Burnet[2] relates, established prizes
for the best original pictures from history and
Diana and Callisto was the prize-winner of 1803,
but not without some pointed criticism from
Graham of Wilkie's too close observation of
nature which was inappropriate for history
paintings. Callisto "was made to blush with so
deep a colour in the ear and the upper part of
the neck as gave Graham an opportunity
. . . for descanting on the difficulty of intro-
ducing the peculiarities of familiar life into the
higher branches of the art." This is especially
problematic, of course, in a painting that is
essentially a *grisaille*. Burnet, however, also
relates how Wilkie's talent at capturing expres-
sion in another early historical essay, a "Scene
from Macbeth," was praised by Graham who

said Wilkie "would arrive at eminence one day for his strong delineation of nature."

In any case, Graham's constructive criticism, not to mention Wilkie's always sensible estimation of his own talents and the knowledge he would have quickly gained of the art market on his arrival in London in 1805, appear to have confirmed him in his early path to success as a painter of genre subjects. Among Wilkie's first friends in London were the painters John Jackson and Benjamin Robert Haydon. Haydon is, of course, famous today for the exquisite frustration he suffered in his futile attempts to win patronage and critical acclaim as a history painter—a frustration chronicled in awful detail in his posthumously published autobiography, journal, and diaries. Ever on the watch for real or imagined rivals to his noble ambitions, he was at first worried about Wilkie's arrival in London, for he had heard from Jackson that Wilkie had painted a picture at Edinburgh from *Macbeth* "which we all agreed must have been a historical one."[3] But Haydon's fears were short-lived. With the exception of copies he made after Barry's pictures at the Adelphi for an engraver in 1805, Wilkie attempted only one other history painting during the early years of his career, his *Alfred Reprimanded by the Neatherd's Wife* 1806 (cat. no. 6). This is a very different sort of history painting from *Diana and Callisto*, which despite its incongruous natural touches is still very much in the classical tradition as to subject and treatment. Rather it can be seen both as a late example of the second half of the eighteenth century's vogue for subjects from early English history and as the first example of Wilkie's special blend of history and genre painting, albeit a rather lonely example for about a decade and a half.

Commissioned by Alexander Davison,[4] a private collector, as part of a series of eight subjects illustrating British history, each to be painted by a different artist, *Alfred* was a new challenge for Wilkie. The choice of subject, which was Wilkie's own, is revealing for its strong domestic genre character and the difficulties it presented. It was based, as was the entire series, on David Hume's *History of England* of 1754, where Alfred the Great was presented as 'the founder of the British Monarchy' and a model of all the kingly virtues.[5] He had already been the subject of several paintings in the late eighteenth century, including Francis Wheatley's 1792 depiction of the same well-known passage in which Hume tells of how the Saxon King, "when his kingdom was overwhelmed by the Danes, concealed himself like a menial in a faithful neatherd's [herdsman's] cottage, where, one day, he neglected to turn a cake at the hearth fire, as he had been desired, but sat shaping a new yew bow, and allowed it to burn, when the neatherd's wife, a sharp woman, exclaimed, 'Sirrah! if you cannot turn a cake you can eat one fast enough!'"[6] Wilkie had clearly set himself quite a task in treating this episode in a convincing yet dignified manner worthy of a history painting. Whatever self-doubts he had were only reinforced by his well-meaning but often overbearing patron Sir George Beaumont. Shortly after Wilkie had sketched in the picture, Beaumont wrote to him: "I have frequently reflected upon your Alfred, as it is a work rather out of the line in which you are known, and attended with very great difficulties, the good-natured critics flatter themselves it will be a delicious morsel for them when it makes its appearance." For the figure of Alfred, Beaumont felt Wilkie had set himself an almost impossible task of painting a face which should express meekness and power at the same time, and suggested Wilkie introduce an expression of

surprise and indignation at the wife's caustic remarks, in order to avoid this problem, while at the same time keeping the peasants' expressions from becoming too broad. Again he warns, "There are too many who are looking forward with malicious eagerness to criticise the painting the moment it makes its appearance."[7] Wilkie's letter of reply to Beaumont frankly admits the truth of the difficulties pointed out and assures Beaumont of his awareness of them, in Wilkie's typically modest and diplomatic way. Yet it makes equally plain his decision to follow his own course and achieve an appropriate distance between Alfred and the peasants by maintaining the King's reserved expression, while agreeing with Sir George's advice to avoid all vulgarity in the peasants.[8] This early indication of Wilkie's preference for subtlety of expression and aversion to the melodramatic should be kept in mind when looking at his later historical pictures, whether or not we think he succeeded with his conception of Alfred as seemingly preoccupied with higher thoughts and oblivious to the commotion about him.

However, despite his adherence to his own point of view, Wilkie did not publicly exhibit the *Alfred* until several years later, after he was more secure in his reputation as a painter of genre subjects. In this regard it is interesting to note the almost challenging tone of the critic of *The National Register* only two years later, when Wilkie exhibited a pure genre picture, *The Card Players* (cat. no. 9), at the Royal Academy exhibition of 1808. After praising the painting the reviewer continues: "but while we are happy to pay our tribute of praise to Mr. Wilkie's talent, we will not, like our contemporary critics, go so far as to dignify that talent with the name of genius." And later: "The figures of Mr. Wilkie certainly have expression,

but it is the lowest kind of expression . . . we shall always call him a clever painter, but while he paints in this way alone, we shall never call him a man of genius."[9] Obviously Wilkie had reason to be cautious.

F ROM HIS FIRST YEAR in London in 1805, Wilkie must have quickly become aware of the somewhat precarious situation of the history painters. The great late eighteenth century patronage by Boydell, for his Shakespeare Gallery, and by Bowyer for his "Historic Gallery" devoted to British history, had come to an end. Barry had just died in poverty after years of neglect. Although the Swiss-born Fuseli was, as professor of painting at the Royal Academy from 1797 to 1825, the first mentor to most of the artists to make a name for themselves in the next generation (including Haydon, Wilkie, Etty, Mulready, Linnell, Landseer, and Leslie), he had only infrequent patronage. Wilkie's friendship with Haydon, who was acutely sensitive to the lack of state patronage for history painters since his aspirations were wholly in that line, would have completed his education in the difficulties of such a career. Wilkie would also have been well aware of the enormous success of one artist in particular, Benjamin West, who, almost from his arrival in London in 1763 had monopolized royal patronage and effectively made a viable career as a history painter impossible for anyone else.

In many different ways, West's career must have been an important example for Wilkie and other artists of his generation. First gaining fame painting neoclassical history pictures such as *Agrippina Landing at Brundisium with the Ashes of Germanicus* (fig. 15), for which he was very much beholden to the works of Gavin Hamilton whom he had met in Rome, West

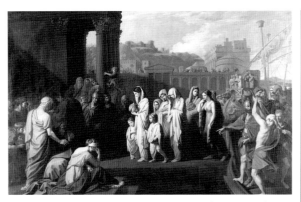

Fig. 15 Benjamin West, *Agrippina Landing at Brundisium with the Ashes of Germanicus*, 1766, Philadelphia Museum of Art

had quickly adapted himself to the growing taste for subjects from British history of various periods. Although West continued to paint classical subjects throughout his career, his most original and influential work was in this national vein. Showing remarkable sensitivity to the shifting taste of his times, and courage in the face of strong advice not to do so (from both George III and Sir Joshua Reynolds), in 1779 he painted an event of recent history, *The Death of General Wolfe* in contemporary dress. Along with its precedent-shattering role regarding the use of costume, *The Death of General Wolfe* was, of course, a model for artists of the next generation through its combination of such modernity with the dignity of traditional history painting. The frieze composition, the poses borrowed from the Old Masters or ancient art (Wolfe's pose recalling the lamentation over the dead Christ), and the convincing if not truly accurate representation of the event (by the inclusion, for instance, of several portraits of living men), set a new standard for modern history paintings. Indeed, although he was not one of the first to paint subjects from British

history, by the end of his life West had painted more works depicting the history of Britain than subjects drawn from antiquity, and in the eighteenth century was particularly important as a painter of Medieval subjects. Among them, in the late 1770s, West had also painted a series of works on the apocryphal story of Alfred the Great, and at least two of these paintings were engraved and so probably known to Wilkie.[10]

West was quite aware of the importance of engravings as income-producers, and Wilkie certainly followed in his footsteps in this regard. The engraving made by Woollett after *The Death of General Wolfe* was one of the most commercially successful engravings in history, gaining West not only world fame but also a great deal of money. Boydell, who published it and most of West's popular compositions, including *Penn's Treaty with the Indians* and the *Death of Lord Nelson*, chose the medium of line engraving which permitted much larger editions to be printed than did mezzotint. Equally alert to commercial implications, Wilkie was quick to choose the line engraving medium for the prints that he arranged to have made after his own works. He supervised their production quite closely and was very concerned that the engravings be able to convey the detail of his paintings faithfully. Both West and Wilkie painted works as speculative ventures with a saleable engraving as the prime goal.[11]

Although one cannot consider Wilkie to be a disciple of West in the normal sense, he became personally acquainted with West almost immediately upon his arrival in London in 1805 and would have had frequent contacts with him through the Royal Academy, where Wilkie became an associate member in 1807 and a full member in 1811, and where West was President until his death in 1820. In a

letter written from London in July 1805, Wilkie gives his impression of the Royal Academy exhibition of that year, noting the dominant role of the portrait painters and remarking that West's *Thetis Bringing Armour to Achilles* was the only "great historical picture" on view. Later he tells of his astonishment upon being taken to meet West at his house and seeing many of his works "which for grandeur of design, clearness of colouring and correct outline beat any modern pictures I have yet seen / his figures have no doubt a flatness about them but with all his faults we have not a painter who can draw like him."[12] Conversely, we also know that West was among Wilkie's early admirers, and by the year of Wilkie's election as an associate member, West regarded him as superior to the great Flemish seventeenth-century master of genre painting, David Teniers, to whom Wilkie was frequently compared, because his facial expressions were more emotionally convincing.[13] West had himself ventured into the realm of genre painting in the 1790's, and seems to have been attracted to humble subjects such as Wheatley and Morland painted, but, as Von Erffa and Staley have shown, he was not to be lured from the "narrow path of history painting" by the popularity and lucrative potential of genre. "By the 1790s, such paintings were seen as belonging to an English tradition stemming from Hogarth, and after war broke out with revolutionary France in 1793 their celebration of native English ways took on a pronounced patriotic appeal."[14] West's adjustment to this trend, as we have seen, was to develop British historical subjects. Wilkie, however, was to exploit the national, patriotic appeal of genre to the fullest, as both a British subject and as a Scot, for the growing interest in British history was closely paralleled by the Scottish cultural reawakening of the late eighteenth and early nineteenth centuries, which was to reach its popular culmination in literature and in the visual arts in the novels of Walter Scott and the paintings of David Wilkie.

THE GREAT POPULARITY of Wilkie's pictures gave rise to imitators and followers of his style, among them Edward Bird, who entered a painting entitled *Good News* at the Royal Academy exhibition of 1809. As Haydon recorded this episode, Wilkie had prepared a small work, *Grandmother's Cap*, for the exhibition. Haydon, feeling it was too slight an effort, advised him against showing it, but Wilkie did not listen. Benjamin West, evidently sharing Haydon's opinion, then approached Sir George Beaumont to urge Wilkie to withdraw it. Haydon now advised the contrary—feeling this would be a loss of face for Wilkie—but Wilkie once again ignored Haydon's advice and withdrew. As one whose own approach was to never retreat, Haydon felt Wilkie had made himself look weak and had given those jealous of his early success the opportunity to rally round Bird's inferior work: " . . . and there was immediately a hue and cry that Wilkie had so completely felt his incapacity to contend with Bird that he had taken his picture away!" As Haydon recorded: "Wilkie felt the indignity" and the episode apparently triggered one of his early bouts of depression.[15] However, there was also a good side to this story, for the Prince Regent, after buying Bird's work, asked Wilkie to paint him a picture as a companion to it (Wilkie eventually produced *Blind Man's Buff*; for the engraving see cat. no. 91), thus beginning the artist's long and favored relationship with the future King George IV.

Although the harm to Wilkie's career was only momentary, it is clear that he was now becoming more conscious of the extent and

character of his reputation. During the second decade of the century he and West increasingly attracted the most attention from the Royal Academy reviewers, Wilkie for genre and West for history painting.[16] In 1810, one reviewer published his rather amusing "dream" of the Royal Academy banquet of 1810, which included toasts and a song and dance by West and Copley with this doggerel verse:

Let David paint for hungry fame
And Wilkie subjects funny,
Let Turner sit and study storms
But *we* will paint for money.[17]

Wilkie was soon to show signs that he resented being categorized by the critics as merely a painter of comic scenes. After showing two more minor works at the Royal Academy in 1811, the following year Wilkie organized his own one-man exhibition, an idea he had apparently been contemplating since 1808 upon the encouragement of friends, notably Sir George Beaumont. As Cunningham tells us: "He now retouched some of his early pictures, finished those which were in progress, and even conceived others entirely new, that his exhibition might have novelty as well as variety to recommend it." Proceeding carefully, anxious to make a proper impression, he wrote to Sir George: "I have engaged a very handsome room in Pall Mall, nearly opposite the British Gallery, which, from its size and entrance, is particularly adapted to my purpose, and, from its situation, as highly respectable as any in London." With the encouragement of Sir George and others, Wilkie was seemingly confident of consolidating his reputation, and perhaps hoping to extend it. He now chose to show his *Alfred Reprimanded by the Neatherd's Wife* for the first time since it was painted, as

well as *Grandmother's Cap*, the picture withdrawn from the Royal Academy exhibition in 1809. He also clearly hoped to make some money. Yet there was more than financial risk, for, as Cunningham relates, "there were not wanting men who prophesied the failure of all collections which were not made up of high history, and who hinted that Wilkie's friends had been patronizing a style destructive to epic art. . . . " Writing to his sister Helen, Wilkie confessed that the exhibition "is giving great offence to some of my brethren of the Royal Academy which I am doing all that I can to pacify, although I cannot entirely remove their dissatisfaction."[18] To appease them, Wilkie presented his diploma picture and prepared two sketches for their exhibition, including a sketch of *Blind Man's Buff*, from the painting he was then completing for the Prince Regent. The unfinished painting itself he requested of the Prince Regent through West, and was granted permission to show it in his own exhibition.[19]

When the exhibition opened in May of 1812, as Raimbach informs us, many important patrons attended but only a few Royal Academy members. The *Alfred* was evidently not a favorite, and Raimbach's comments probably reflect the consensus opinion that the figure of the King was "generally considered not sufficiently dignified, either for the illustrious monarch himself, or for the purely historical character of the subject."[20] The most popular works were the genre paintings and, although the critics were not harsh, as Cunningham related, there were comments about the limits of Wilkie's work from those critics such as Hazlitt who favored history painting.[21] Although we know Wilkie was pleased by the reception of his exhibition[22] (despite the fact that he seems to have lost money), the response to *Alfred* must have justified for him

his early decision to hold it back from public view.

HAYDON AND WILKIE were quite close at this time, and in 1814 the two artists traveled together to France during the short-lived peace of Napoleon's exile. Although Haydon makes fun of Wilkie's bad French and his visits to the Parisian printsellers to hawk the engravings of his pictures, he also relates Wilkie's genuine rapture at the things they saw. The seeds of Wilkie's future fascination with Roman Catholic ritual and the dramatic light effects of the Dutch masters can be seen in Haydon's brief account of their visit to Rouen cathedral: "As we walked along we saw many in side-chapels totally abstracted in devotion. This absorption, in conjunction with their richly coloured dresses, darkly illumined by the religious light of the magnificent windows, filled our minds with grand sensations."[23] In Wilkie's own words: "This was altogether to us a scene that I shall never forget, and which I think no person could see without being inspired with veneration for the Roman Catholic religion."[24] At the Louvre and at other collections they visited, the Flemish and Dutch works attracted Wilkie especially, and he was in awe of Rubens's cycle of paintings on the life of Marie de Medici, particularly the scenes depicting her embarkation and coronation. Visiting Jacques-Louis David with Haydon a bit later, Wilkie was quick to note David's use of Rubens' *Coronation* for his *Coronation of Josephine*, characterizing the latter as nothing more than an imitation.[25] Haydon gives us a sense of Wilkie's growing interest in Napoleon in his recounting of their visit to the painter Gérard. They admired many of his portraits but none more than that of Napoleon, which Wilkie said made all the other heads in the room look like

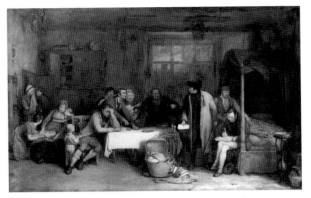

Fig. 16 Wilkie, *Distraining for Rent*, 1815, National Gallery of Scotland

children.[26] Although prints after Wilkie's works would later become extremely popular in France,[27] his first attempts to sell impressions on this visit met with little success. One printseller who declined said of the *Village Politicians* that "he did not think it historical enough for the Parisian market."[28]

Wilkie's first painting for the Royal Academy exhibition after his return to England, *Distraining for Rent* (fig. 16), marked a new seriousness in his work. Depicting the misfortunes of a poor family whose possessions are being seized for failure to pay rent, it had a mixed reception. Haydon relates, "beautiful as the picture was acknowledged to be, the aristocracy evidently thought it an attack on their rights. Sir George [Beaumont] was very sore on the private day, and said Wilkie should have shown why the landlord had distrained; he might be a dissipated tenant."[29] Some critics echoed this view, and wished Wilkie had introduced some incident to relieve the painful feelings conveyed. That Wilkie was consciously trying to show a greater range of ability is confirmed by Raimbach: "During the uncertainty as to its sale, and when Wilkie expected the picture

would remain on his hands, he still expressed satisfaction at having made the experiment, and thereby proved that he was not to be estimated merely as a painter of *comic* scenes, a designation under which the public seemed disposed to consider him, but which he felt, with the modest and becoming confidence that was inherent in his nature, was doing him less than justice."[30] His faithful patron and critic, Sir George Beaumont, when writing to Wilkie at the time he was preparing his 1812 exhibition in Pall Mall, had indirectly challenged Wilkie to attempt more: "Deep pathos, although I think you are quite equal to it, you do not appear to aim at: satire and broad humour are not perhaps congenial to your feelings; what remains then is the amenity of humble life; dashed with a proper proportion of comic pleasantry."[31] Although this shows a nice perception of Wilkie's tendency to avoid the melodramatic, as in his *Alfred*, it also shows that Wilkie, in *Distraining for Rent*, was proving to Sir George and himself that he could deal with "deep pathos."

His experiments were to continue with other ventures into new territory. At the 1817 Royal Academy exhibition he showed *Sheepwashing*, his only full essay in landscape painting; and at the British Institution the following year he exhibited his *Bathsheba*, a rare example of a Biblical subject in Wilkie's work. A small oil, called a study by Cunningham, it was obviously not intended as a major effort in a new field. Wilkie was nevertheless vehemently chastised for attempting something out of his line: " . . . it is an attempt of an eminent artist, to make an excursion from his own proper territory assigned to him by nature, to share a more dignified sceptre over our tastes and feelings, with the masters of refined sentiment and beauty . . . this picture possesses nothing . . .

that in the most distant degree reminds us of the higher class to which it aspires."[32]

WILKIE'S MAJOR breakthrough into a "higher class" of art was ultimately to be achieved through what was, to begin with, a straightforward genre subject rather than an essay such as *Bathsheba*. In 1816 Wilkie had received a commission from the Duke of Wellington for a genre painting which, in another artist's hands, would not have amounted to much but in Wilkie's would become the single greatest success of his career and a classic conflation of genre and history painting: *The Chelsea Pensioners Reading the Waterloo Despatch* (cat. no. 23). Wellington's great victory over Napoleon at Waterloo in 1815, depicted not as a battle scene but as a scene of public rejoicing at home, is the subject. In this painting "the tradition of heroic commemoration, aristocratic in its premises, gives way to a busy genre scene full of domestic interest, a celebration of patriotism at home, of peace and plenty and private joys."[33]

However, when commissioned by the Duke, it was to be no more than a simple genre picture. In a letter to Haydon shortly afterward, Wilkie wrote that "the Duke . . . said that the subject should be a parcel of old soldiers assembled together on their seats at the door of a public-house chewing tobacco and talking over their old stories. He thought they might be in any uniform and that it should be some public-house in the King's Road, Chelsea. I said this would be a most beautiful picture, and that it only wanted some story or a principal incident to connect the figures together: he said perhaps playing skittles would do, or any other game, when I proposed that one might be reading a newspaper aloud to the rest, and that in making a sketch of it many other incidents

would occur. In this he perfectly agreed."[34] Wilkie's idea to use such a device as a focal point was not a new one; he had skillfully employed it much earlier in the *Village Politicians*, his first great public success, exhibited at the Royal Academy in 1806 (for the engraving see cat. no. 90). He now began to develop the composition over a period of several years, during which he completed two other important commissions: *The Penny Wedding* (cat. no. 18) for the Prince Regent, and the *Reading of the Will* for the King of Bavaria. As was his customary method, Wilkie went through numerous drawings and sketches, all the while consulting with the Duke and with other patrons and friends before actually starting the final painting in 1820. During this time the painting took on a quasi-panoramic character and other features which we can trace back to Wilkie's *Pitlessie Fair* of 1804−5 (cat. no. 4), also a composition of many figures in an outdoor setting, in which portraits of real people in an actual place lend truthfulness to the invented scene.

Precisely when Wilkie decided to give the *Chelsea Pensioners* its celebratory and commemorative character is not clear. However, Wilkie's respect and admiration for the Duke of Wellington, and his gratitude at receiving this commission, must be part of the answer as to why he chose to do so. To quote from his 1816 letter to Haydon once again: "With respect to the commission, I felt in the highest degree proud of it. The subject has most probably originated with himself, and Lord Lynedoch has merely recommended me to be employed, but his taking the trouble to come and talk to me himself about it shows a respect for our art that others as well as myself may be delighted to see in such a man. The subject he has chosen seems to reflect on him, from its reference to the good old English companions of his victories; and to me it is a gratification to find that even my peaceful style of Art should be felt necessary as a recreation to a Wellington."[35] Wilkie's 1816 visit to Holland and Belgium, in part expressly to see the field of Waterloo, would only have strengthened his resolve to do full justice to this commission and the man who gave it to him. We know, also, that the Duke himself did not propose any reference to his victory. In 1822, looking back over his years of labor on the picture, Wilkie wrote: "In justice to him as well as to myself, it is but right to state, that the introduction of the Gazette [reporting the victory at Waterloo] was a subsequent idea of my own to unite the interest, and give importance to the business of the picture."[36] If the historical importance that Wilkie gave to the picture can, in part, be seen as his desire to do honor to the man who had honored him with the commission, it can also be seen as part of a new desire to make history come alive through the lives of ordinary people. In a much broader sense, Wilkie had already done this in his *Penny Wedding* (cat. no. 18), painted for the Prince Regent as a companion —arguably a pendant—to *Blind Man's Buff*. Although the *Penny Wedding* lacks the specific historical character of the *Chelsea Pensioners*, it does recreate the heyday of a fast dying social tradition in Wilkie's native Scotland. This is attested to by Wilkie's own commentary in the catalogue of the Royal Academy exhibition of 1819 and in the published reviews of the picture (see Miles, cat. no. 18, under *Comments*). We also know that Wilkie, by this time, had become an admirer of the historical novels of Walter Scott. Publishing his first novel, *Waverly*, anonymously in 1814, Scott went on to write twenty-seven more by his death in 1832. In these works, readers could

enter into the lives of both the great and the ordinary people as they were caught up in the great changes of history. We know that Wilkie met Scott in 1809 and was an admirer of his early narrative poems and the subsequent novels for their ability to bring the historical past to life.[37] Scott greatly admired Wilkie as well, and felt a kinship between Wilkie's art and his own (see Miles, cat. no. 26, under Comments).

Wilkie's parallel ability to relate history through the lives of ordinary people finds pictorial expression in the Chelsea Pensioners. As has recently and most cogently been observed: "The immediacy of the battle, of the great historical event is . . . distanced and mitigated, by the extraordinary indirection in the choice of subject. We are given, not an apotheosis, but a human celebration; not the battle and the victory, but the news and the peace; not the heroes of the day . . . but the private soldiers of another day."[38] Genre and history are here united as private and communal life are given a specific location in history. Anonymous soldiers, through the accuracy of their uniforms and the identifications supplied by Wilkie, become representatives of all the Anglo-French wars of the previous six decades, culminating in the great victory of Waterloo.[39]

THE UNPRECEDENTED popularity of the Chelsea Pensioners gained for Wilkie greater respect on the part of the critics. Whereas earlier he was considered as a mere comic painter, this estimation was now rejected: "Teniers was a painter of humour, Wilkie is a painter of truth. . . . We do not remember a piece of drollery—a touch to make one laugh in any of his pictures. He is as little of a comic painter as Fuseli himself."[40] With the death of

West in 1820, and the success of the Chelsea Pensioners, Wilkie was clearly the most prestigious British painter whose reputation was not based on portraiture. It is doubly ironic, then, that at the moment of his greatest success on a new, higher level, Wilkie should receive a royal preferment that would divert him from the original path he had taken and push him in a new direction. With the death in 1823 of Sir Henry Raeburn, the King's Limner for Scotland, it was not surprising that Wilkie would be named to succeed him by his friend and patron, George IV. Thus began Wilkie's official career as a portraitist and history painter. The King, of course, only wished to honor Wilkie and would not have understood the great burden he was placing on him. A skilled portraitist on a small scale, he would now be required to paint grand full-length portraits for which he had no experience, the early Alfred and the Chelsea Pensioners being his largest works to date. In addition to his new duties painting state portraits (for more on this, see the essay in this catalogue by Miles), Wilkie also received his first royal commission for a painting of a contemporary historical subject. To be sure, although it became a state commission, the Entrance of George IV at Holyrood House had its origins in Wilkie's trip to Edinburgh in 1822, prior to his appointment as King's Limner for Scotland. Wilkie went north that year to observe the historic state visit of George IV to Scotland, the first by a British monarch since the union of England and Scotland in 1707. Most of the festivities in Edinburgh were planned, indeed stage-managed by Walter Scott, who laid stress on Scotland's history and the union.[41] As colorful and grand as all of these events were, Wilkie was unable to settle happily on any of them until after his appointment as King's Limner. His difficulty would seem to

have been in depicting a real event rather than one of his own invention, such as the *Chelsea Pensioners*. Of the King's visit to Scotland he had written: "It presented in reality scenes of the greatest excitement; but to redress these upon canvas seems the difficulty."[42] But with his appointment of Wilkie, the King appears to have forced the decision by fixing on the entrance into Holyrood as his choice of a subject commemorating his visit. Wilkie now prepared a sketch to show the King, quite likely the sketch exhibited here (cat. no. 32), and it was approved. However, the composition proved difficult to develop. While he had great latitude with the *Chelsea Pensioners*, Wilkie was now constrained by the facts of the event and the obligation to incorporate many portraits, including the King's, into the picture. Although it would probably be an exaggeration to say that the King had a major hand in the composition, as was later said, it is true that he did dictate the alteration of his own pose from Wilkie's original conception. Initially drawn in a more ingratiating position, as Millar aptly describes it, bending to receive the keys to Holyrood House from the kneeling Duke of Hamilton, the King preferred a look "more martial and imposing," although the new pose's effect was stiff and detached.[43] This worked against a logical and graceful interrelationship of the figures, which had been a hallmark of all Wilkie's paintings, culminating in the *Chelsea Pensioners*. Compositional inspiration is apparent from Rubens's *Coronation of Marie de Medici*, which he saw in Paris years earlier. Less apparent, perhaps, is the inspiration of Benjamin West's early history picture, *Agrippina Landing at Brundisium with the Ashes of Germanicus*, with which it shares a frieze-like composition flanked by repoussoir groups at the right and left, and a child clinging to a column for a better view in

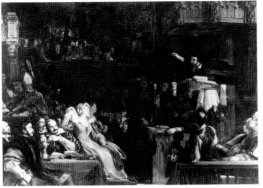

Fig. 17 Wilkie, *The Preaching of Knox Before the Lords of the Congregation*, 1832, Tate Gallery

the left background.

At the same time that Wilkie was painting the *Entrance of George IV at Holyrood House*, he was also beginning to prepare another, very different history painting, the *Preaching of Knox Before the Lords of the Congregation 10th June 1559* (see fig. 17 and cat. no. 96). The unusual subject was of Wilkie's own choosing, according to his biographer Cunningham. It was during his stay in Scotland in 1822 to see the King's visit that Wilkie began to research this subject from Scottish history. The atmosphere of the royal visit, with so many reminders of Scotland's past, would certainly have aided Wilkie, as would his contacts with Walter Scott, with whom he was able to discuss his idea. The painting represents the famous Presbyterian reformer delivering the historic sermon which finally turned the tide against the Catholic government. Wilkie visited the places where Knox had preached and actually found the pulpit Knox had used. This desire to be as historically accurate as possible was not an end in itself, not a matter of archaeology, but a way to better comprehend the past and bring it alive. Where he had thought George IV's

reception at Holyrood to have been arranged with insufficient regard to the importance of it, and worked to rearrange the scene to greater effect, in the *Preaching of Knox* he was completely free to use his imagination. Neither the basic facts nor the portrait requirements of the *Entrance* had to be contended with. Neither was there the King to answer to, for when Wilkie, hoping for a commission, showed his sketch of Knox preaching to George IV, the King declined and said he preferred a humorous subject. However, Wilkie soon found another patron in Lord Liverpool.

A LONG ILLNESS would prevent Wilkie from completing either the *Entrance* or the *Preaching of Knox* for many years, but with these two compositions and the *Chelsea Pensioners*, he had set several different courses for himself as a history painter. The *Chelsea Pensioners*, of course, is unique in its combination of genre and history, for the anonymity of its characters and the specificity of what it commemorates. However, it is the ancestor of other works in which Wilkie was to deal with important national events or issues under the guise of genre, notably his future works on Spanish and Irish themes. The *Entrance of George IV at Holyrood House*, reflecting Wilkie's problems with it, was to have the fewest progeny. In fact, he would complete only one other work in this vein of official, royal history near the close of his career, for Queen Victoria. By far the richest vein he would mine in the future was that begun in the *Preaching of Knox*, reflecting the greater freedom of invention such subjects allowed him. It would divide into several subsidiary veins that demonstrate Wilkie's strong roots in genre painting, his interest in the past, and his growing fascination with the Old Masters, now focused on the Renaissance and

Baroque masters of history painting rather than the Dutch and Flemish masters of genre who inspired his early career.

But for a time Wilkie was unable to pursue any of these paths. A series of family tragedies, perhaps exacerbated by the greater pressures of his career, brought on a prolonged illness, now assumed to have been a nervous breakdown (for more on this see the essay by Batchelor in this catalogue). At the end of 1824 both his mother and his brother James died, followed closely by the sudden death of his sister Helen's fiancé, all within the space of two months. Then in 1825 came the news that his brother John, who had been stationed in India for many years, had also died, leaving his wife and children in need. At the same time, of course, Wilkie's career had reached a new, much more public stage with the success of the *Chelsea Pensioners* and his appointment as King's Limner for Scotland. In any case, in part because of these events and in part due to his own evidently weak constitution, Wilkie became seriously ill for a long period, making work impossible. The solution seemed to lie in travel, and he finally left for Europe in July 1825.

Whereas his first trip to Europe with Haydon in 1814 was a short one, as were his return visits of 1816 and 1821, he was now to spend three years abroad. At first he did not paint at all, devoting himself to studying the Old Masters. Eventually, however, he was moved to take up his brush again, and painted three pictures of popular religious devotion while in Rome. The increased painterliness of such works as the *Penny Wedding* and the *Chelsea Pensioners*, remarked upon unfavorably by a few critics when they were exhibited, now became much more pronounced. *The Pifferari* and *Cardinals, Priests and Roman Citizens Washing the*

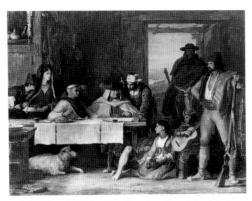

Fig. 18 Wilkie, *The Spanish Posada*, 1827, Her Majesty Queen Elizabeth II

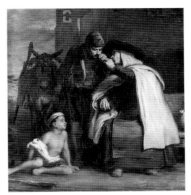

Fig. 19 Wilkie, *The Guerilla's Departure*, 1827, Her Majesty Queen Elizabeth II

Pilgrims' Feet (cat. nos. 27 and 28) of 1827 have a breadth of handling far beyond Wilkie's early paintings. They also reflect his continuing fascination with the Roman Catholic church, its ritual, and the devotion of the people, which had begun on his earlier visit to Rouen in 1814. Small in scale and essentially genre pictures in character, they nevertheless show a reverence for the depth of faith they observe and achieve a certain poetry.

Wilkie did not attempt more ambitious paintings until his arrival in Spain late in 1827, when the recent war of independence against the French caught his imagination. This was no doubt enhanced by the direct role Britain played in driving out the French and by the Duke of Wellington's personal leadership in the Peninsular Campaign. Wilkie's Spanish pictures, with one exception, are a conflation of genre and history in the tradition of the *Chelsea Pensioners*, but with important differences. Wilkie himself referred to the four pictures as "a series illustrative of the late war."[44] Yet they are, except for *The Defense of Saragossa* (cat. no. 30), quite unspecific and do not illustrate a particular historical moment, as does the

Chelsea Pensioners. The *Spanish Posada*, also called *The Guerilla Council of War* (fig. 18) and the pair entitled *A Guerilla's Departure* and *A Guerilla's Return* share this general historical character. In the *Spanish Posada* we see a great variety of Spaniards, from all walks of life, including a Dominican monk, a Jesuit, and a Valencian patriot plotting their country's defense, soldiers from Balboa and Castile, a student of Salamanca and, in tribute to Velasquez and Murillo, a dwarf minstrel and a young goatherd and his sister, among others. They are positioned around a table in the fashion of many of Wilkie's early genre works, such as the *Village Politicians* (cat. no. 90) or *Distraining for Rent* (fig. 16). There is, however, no obvious story or overtly dramatic action. The drama, as would be the case in so many of Wilkie's later works, is largely internal. The faces, gestures, and poses of the figures reflect their thoughts and psychological relationships. *A Guerilla's Departure* (fig. 19) shows a young soldier about to depart for the war, who is lighting his cigar from that of his Carmelite confessor. It shows that same darkness of tone and conspiratorial mood we observe in the

Spanish Posada, and the beggar boy seated on the ground is yet another tribute to Murillo.

In decided contrast to these works is the *Defence of Saragossa*. It is one of Wilkie's purest history paintings, directly representing a famous, quasi-legendary episode in the Spanish defense of Saragossa. It shows the heroine Augustina, celebrated as the "Maid of Saragossa" by Byron, at the moment when she bravely took up the place of her slain husband at the battery (for Wilkie's full description, see Miles, cat. no. 30). Once again Wilkie has populated the painting with a variety of people representing the breadth of Spanish resistance. Although most of the figures are intended to represent historical personages, it should be noted that only one appears to be a real portrait rather than a creation of Wilkie's imagination. The introduction of the figure of Don Juan Palafox who is placing the gun, was, we know, the suggestion of Wilkie's friend Prince Dolgoruki who actually brought Palafox to Wilkie's house in Madrid for this purpose. Writing to Dolgoruki from London in 1828, Wilkie reported the great interest this portrait added to his picture. "The name of Palafox is as familiar here as that of Wallace or William Tell, and appears to give an historical importance to the whole series."[45] Clearly Wilkie's primary intention in this series was to create works that show us a nation at a crisis in its history. Although more direct than the *Chelsea Pensioners*, the emphasis is still on the effect of war on ordinary people in the "Maid of Saragossa" and not on military heroes. The inclusion of Palafox was essentially a happy incident and it is telling that Wilkie placed him not in his military uniform but as "a Volunteer dressed in dishabille well suited to the chief figures of the picture."[46]

WHEN WILKIE RETURNED to London in the summer of 1828 he was naturally anxious about the state of his reputation after three years away and wondered what the response to his new pictures would be. His poor health had pushed him to change his style dramatically to one even broader, darker and more painterly than his Italian pictures, far different from his tightly detailed (and laborious) early manner. His Italian and Spanish subjects were also a major break from the native Scottish or English subjects that had made his reputation. But he had little to worry about thanks to the timely patronage of George IV who not only purchased two of the Italian pictures, but also agreed to purchase the entire series of Spanish paintings sight unseen and as yet unfinished. Wilkie definitely wanted to keep the paintings together despite offers for individual works, until he knew if the King or "some great personage" (presumably the Duke of Wellington) would take the entire group. When the King did so, he gave Wilkie major recognition at a time when it was crucial to his career, giving him the courage and support to persevere in his new style and, as he himself said, in this "higher walk" of art. The barbs of the critics, many of whom were unhappy with these changes, were thus somewhat blunted when the works were exhibited at the Royal Academy in 1829. One wrote: "We have no longer his best subjects, the domestic scenes of English cottages, but Spanish posadas and Italian convents . . . His Defence of Saragossa, too, is a spirited painting. Meritorious, however as are these paintings, we confess we sigh for the domestic scenes of England."[47] The critic of *John Bull*, appropriate to the name of his journal, felt such foreign subjects, however good, should be painted by foreign artists.[48] In general, although the change was noted, and

sometimes lamented, the new works themselves were praised.

His new works sold, Wilkie was now ready to take up once again the two paintings he had left in London unfinished in 1825, the *Entrance of George IV at Holyrood House* and the *Preaching of Knox Before the Lords of the Congregation* (cat. nos. 32 and 96, fig. 17). Haydon, who called on Wilkie while he was completing the *Entrance of George IV*, was disturbed to see Wilkie finishing, in his broad new style, a picture which had been begun "when detail and finish were all in all to him"; he characterized the mixture as like oil and water.[49] Although the critics did not fault Wilkie on this point, at the Royal Academy exhibition of 1830 the majority were not pleased with the picture (fig. 20). The forced attitude and awkward pose of the King and other figures did not escape notice, and the painting was found lacking in historical character by those critics who preferred to see Wilkie paint in his own true line of domestic subjects. Probably the most damning review appeared in *The Court Journal*: "It has singularly and grievously disappointed us. Anything like historical qualities it is entirely without; skill in composition we have not been able to discover in it; and, as to general pictorial effect, our impressions from it are meagre, mean, and altogether unsatisfactory."[50] More than one critic publicly lamented the King's appointment of Wilkie as Painter in Ordinary to succeed Sir Thomas Lawrence who had recently died, feeling this latest honor would only push him further away from his true talents as a painter of genre.

Lawrence's death also left vacant the presidency of the Royal Academy and many felt Wilkie was the proper choice for this post. However, once again it was a portraitist, Martin Archer Shee, called "the most impotent

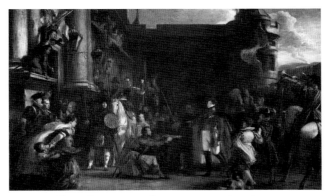

Fig. 20 Wilkie, *The Entrance of George IV at Holyrood House*, 1830, Her Majesty Queen Elizabeth II

painter in the solar system" by Haydon, who was overwhelmingly elected. George IV's appointment of Wilkie as Painter in Ordinary just before the Royal Academy election, if it was intended, as some thought, to aid Wilkie's election as President, clearly did not have the desired effect. However, it did assure that Wilkie would be further burdened with official portrait responsibilities. Wilkie's own comments at the time express relief at Shee's election and gratitude for the honor bestowed by George IV, but there is a curiously impersonal and detached tone when he writes of this new post: "with His Majesty's appointment to an office held in succession by Ramsay, by Reynolds and by Lawrence even the highest ambition may be satisfied."[51] However much he appreciated the honor, it became obvious that Wilkie's own ambition was not really satisfied by portraiture or official pictures such as the *Entrance of George IV at Holyrood*.

On the death of George IV in 1830, only a short time later, Wilkie was bereft: "I have lost the greatest friend I have ever met with, and while impressed with the belief that His gracious generosity has done much more for me

than I deserved, I feel it as an object of ambition as well as of gratitude to vindicate by future labours the good opinion of such a sovereign."[52] Wilkie sought this vindication in historical subjects that gave freer rein to his imagination, such as the *Preaching of Knox*, which we have seen was begun, like the *Entrance of George IV*, prior to Wilkie's long sojourn in Europe. The subject was an unusual choice, and Wilkie's basic conception, which seems to have been worked out prior to his trip, was to show the incendiary preacher at the peak of his fervor, while the congregation is a study of self-control. But what may at first seem to be a relatively passive audience is, on a closer reading of the faces, a mass of conflicting emotions, reflecting the various reactions to Knox's words. The wildly gesticulating figure of Knox is probably the most overtly dramatic figure in all of Wilkie's work. Yet he is quickly taken in, for he is essentially a one-dimensional character, albeit with a striking silhouette, while the congregation rewards repeated and close examination. What could easily have been a very unbalanced and uninteresting subject became one of great interest through Wilkie's ability to convey a wide range of emotion in the faces of the congregation, a talent he had amply displayed in his multi-figure genre paintings and in the *Chelsea Pensioners*. In the *Preaching of Knox* this is especially well drawn in the contrasting expressions of the Catholic bishops opposite Knox, and those of the Protestant Lords of the congregation below them in the foreground.[53]

During his years abroad, Wilkie had obviously been giving thought to the character of Knox and to the status of history painting in Britain. From the evidence of a letter written to his fellow Scot, the painter William Allan, from Geneva in 1827, we can see Wilkie's understanding of the limits of British history painting: "The Italian painter seems inspired by an aim beyond the painter of other countries. He is in every thing more general and abstract —perhaps as a Catholic he has advantages over us as he paints to adorn the altar, and his picture is held equally sacred while we are too apt to paint for an exhibition with which our pictures are to be criticized, dispersed and perhaps forgotten. For the present I am in a place somewhat different, namely Presbyterian Geneva and you may well imagine that where Calvin preached and where Knox came for instruction, where there are neither Altarpieces nor Altar, there can be little refuge for the art of Raphael and Michael Angelo. The artists here are like their people essentially the same as those in our own country, they speak French but they feel and they paint like the English."[54]

Lord Liverpool, who had originally commissioned the painting, had died in 1828. After Wilkie's return to England, the commission was taken over by Sir Robert Peel, his friend and patron, for whom the artist had procured several fine Old Master paintings in Europe.[55] When the *Preaching of Knox* was finally exhibited at the Royal Academy in 1832, the critics were much more favorable than two years before, and they welcomed Wilkie's return to a native subject after his Italian and Spanish pictures. While some still had trouble accepting Wilkie as a history painter, others felt that he had truly attained that status with this work, and, indeed, had created one of the modern masterpieces of the English school.[56]

THE SUCCESSFUL EXHIBITION of the *Preaching of Knox* was the beginning of a new phase in Wilkie's career. From this time until his death nine years later, historical subjects would figure prominently among both

the works he exhibited and those he planned. The variety of subjects was broad, reflecting Wilkie's love of novelty and growing fascination with the near and distant past. All but one would be his own invention and would demonstrate the strength of his roots in genre painting, which gave many of these works a special character as history paintings.

1832 was also a year in which Scotland suffered a major loss in the death of Walter Scott. Early in 1833 Wilkie, at the Duke of Wellington's request, was summoned to Hatfield to assist the Marchioness of Salisbury in arranging scenes for a series of tableaux drawn from Scott's novels. As Francis Russell has pointed out, a number of Wilkie's sketches for these *tableaux-vivants* are arranged around centrally placed tables, a compositional device he had used frequently in the past and would find useful in the future. Among Wilkie's later history paintings, his *Columbus in the Convent of La Rabida* (cat. no. 36) uses this quite prominently. Taken from the *Life of Columbus* by the American writer Washington Irving, whom Wilkie had known in Spain, the scene depicted shows Christopher Columbus explaining the project of his intended voyage to discover the New World. He is relating his theories to a Franciscan friar whom he has met by lucky chance in his travels, for this man was to be the means by which Columbus would gain the attention and eventual support of the Spanish king and queen. The choice of this episode in Columbus's life was made while Wilkie was in Spain working on his series of paintings on the war of independence. In fact, the *Columbus* shares the compositional device of the table, as well as the heavily cowled figure of the friar, with the *Spanish Posada* (fig. 18). Once again Wilkie has chosen a significant but overtly undramatic moment to depict. When it

was exhibited at the Royal Academy in 1835, the critic of *Fraser's Magazine* particularly remarked on the sense of reality Wilkie has given the scene, and his avoidance of all excess: "There is an air of veracity so forcibly impressed upon the whole, that the artist appears to have drawn from actual observation rather than from his own ideas. There is a quiet, unaffected simplicity, that is truly captivating; no aiming at effect, no theatrical display, no mere filling-ups, none of that exuberance that is frequently poured forth in order to catch attention."[57] The drama is internal, residing in the faces and gestures of the characters included. Besides the friar, there is the physician Garcia Fernandez leaning on the table at the left, the sea captain Pinzon (who would later desert Columbus) behind them, and Columbus's young son Diego standing in the right foreground, holding the bread and water provided by the friars. *Leigh Hunt's London Journal* provided an apt description of the expressions: "The lurking approbation in the face of the accomplished physician, and the incipient comprehension of the friar, are excellent. The tried and unconscious look of the young boy is a happy contrast to the absorbing interest of the older people. Columbus is a fine, dignified, and intellectual man, — benign but powerful; we would only object that he appears rather to be deliberating than explaining." The figure of Pinzon, a late addition by Wilkie, was the only false note to this critic: "And why Pinzon's future treachery should have induced Mr. Wilkie to make him so very like Retsch's Mephistopheles in the contract scene, we cannot imagine. He might have had a treachery lurking among the lines of his physiognomy, without exhibiting it so melodramatically and superfluously, handling his telescope as a stage-pirate would his weapon."[58]

It is surely a testimony to Wilkie's restraint with the other figures that the treatment of Pinzon should seem at all extreme. The very choice of this episode in Columbus's life, before all his triumphs and failures, is indicative of Wilkie's effort to make such historical figures seem human, as Irving, partly under Scott's influence, had also done.

As Wilkie's ambition as a history painter grew, so too did the size of his paintings. Where his early historical works had stayed close to the Poussin-size proportions of West's smaller history pictures, his later works now began to grow larger. For the Royal Academy exhibition of 1836, Wilkie entered one of his largest and probably his most daringly simple history paintings, *Pope Pius the Seventh refusing to sign the Concordat, presented to him by Napoleon*, hereafter referred to as *Napoleon and the Pope* (fig. 21). Wilkie drew his inspiration for this scene directly from Walter Scott and a lengthy quotation from Scott's *Life of Napoleon* accompanied the picture when exhibited. Once more, in the tradition of humanized history popularized by Scott, Wilkie has chosen a private moment, not a public event. The moment depicted is when Napoleon, after holding the Pope captive for four years, induced him to sign the concordat of 1813. Their meeting, which took place at Fontainebleau Palace, is depicted by Wilkie as a moment of dramatic confrontation between two men. There are no other characters to divide our interest. Although we know that Napoleon held the upper hand, we are presented with a battle of minds, and the outcome is not yet decided. Wilkie, as in his painting of Columbus, was not creating an image of triumph or defeat, as a more conventional history painter might have done. Rather, he was placing his emphasis on the personality and character of these adversaries, both of

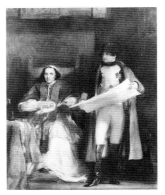

Fig. 21 Wilkie, *Napoleon and the Pope*, 1836, National Gallery of Ireland, Dublin

whom reflect a consciousness of the other's power. *Napoleon and the Pope* is also another example of the great pull that Napoleonic history exerted on Wilkie's imagination over many years, beginning with the *Chelsea Pensioners* and continuing through his series in the Spanish war of independence. This emphasis had its hazards, however, and portraiture was once again a stumbling block for him. The fame and relative contemporaneity of the two figures depicted made comparison with other known portraits inevitable, and the critics were mixed in their reviews, finding particular fault with the character or originality of Wilkie's portraits.[59]

NEW THEMES AND SUBJECTS were also of interest to Wilkie, who had early learned to value the appeal of novelty for the public. He traveled in 1835 to Ireland where he found the people of the western counties fired his inspiration by their Mediterranean appearance and primitive style of living. He planned a series of paintings, all of them ostensibly genre subjects, but focusing on national character, somewhat in the tradition

of the *Penny Wedding*. As Cunningham relates: "At the time of his visit to Ireland he was in search of higher subjects than those which excite mirth only. But of the convulsed condition of Ireland, one half of her talent wasted in idle controversy, the half of her fine energies exhausted in religious rancour, and oppressed by those who should befriend her, he desired to evoke a series of national pictures, of a moral as well as characteristic kind, in which people might see her as a mirror. In this spirit he executed his picture of the *Peep-O'-Day-Boy* and *The Still among the Mountains*; and in the like train of moral thought he imagined several others, in which are sketched the devout feelings, unmingled with rancour or controversy, but calm and holy, of the ancient religion of the land."[60] The first of them, *The Peep-O'-Day Boy's Cabin, in the West of Ireland* (cat. no. 39), has a particularly historical character. Shortly after returning from Ireland in late 1835, Wilkie wrote to Robert Vernon for whom the picture was painted, and told him of his plans to finish an Irish subject for the 1836 Royal Academy exhibition (in addition to *Napoleon and the Pope*). He called this picture *The Sleeping Whiteboy*, not the title under which he would exhibit it.[61] The Whiteboys were an outlawed rural society in Ireland, active in the late eighteenth and early nineteenth centuries, who staged night raids to redress grievances against landlords. The Peep-of-Day Boys were a secret society of Irish Protestants active in the late eighteenth century, who were formed to protect the Protestant peasantry, and gained their name by raiding Catholic villages at dawn (for a more complete description, see Miles, cat. no. 39). Perhaps it was Wilkie's strong interest in religious issues, and especially in the Catholic Church, which turned him toward the latter subject. In any case, a critical

point was made by Wilkie in his letter to Vernon, which would apply equally well to either subject: "I find people interested in this as a subject of expression and [as] connected with public events. This suggests that it should be painted larger than a merely domestic subject. . . . "[62] In Wilkie's mind the picture was important and so would be painted on the same scale as his *Columbus*, not on the small scale appropriate to a genre work such as the *Penny Wedding*. While it shares the anonymity of its characters with Wilkie's genre works and with the *Chelsea Pensioners*, it does not share the specific historical nature of the latter. There is no great historical event recorded here, only the unsettled and dangerous conditions of recent times in Ireland. In this sense, of all Wilkie's history paintings, the *Peep-O'-Day Boy's Cabin* is most heavily weighted toward genre. Perhaps more than anything it was the pictorial effect that Wilkie was most concerned with here, as described in his letter to Vernon: "a young Irishman asleep on the floor of his Cabin, his wife seated at his head watching him, while behind her is a girl just entered the door whispering to her some tidings of alarm, the apartment filled with the untidy furniture —the implements of husbandry and fishing, characteristic of their simple mode of life."[63] The critics responded favorably to the painting primarily on this purely pictorial level and as a return to "his best style"—in so many words— a genre picture.[64]

It was also in 1836 that Wilkie penned some extended "Remarks on Painting," according to Cunningham, who published them posthumously in his biography of Wilkie. In these remarks, Wilkie is realistic in his assessment of the taste for art in Britain, which he feels is of a domestic rather than a historical character. While believing that artists must respond to the

wants and tastes of the people, he poses the question: "In what way can those wants and tastes be rendered available in the higher of the efforts of the sculptor and painter?" His answer is primarily to be seen in his own works. Although he was ever a realist, Wilkie clearly felt the British school was capable of greater heights. His own goal was to paint history pictures which met the ideal of accessibility he had observed in some of the Old Masters. One recalls especially Wilkie's awe at the depth and breadth of admiration among all levels of society in Seville for the works of Murillo. Rembrandt was another shining beacon for him, an example of how individual genius can spring up and develop quite independently of the climate for art: "without state favour or ecclesiastical encouragement, and amidst scenes considered uncongenial and domestic manners unfavourable to her studies, she selects the uncouth but mighty Rembrandt as the disciple of her choice." It was particularly the ability of Rembrandt to bridge the gap between high and low subjects that he admired and which he must have seen as a model for his own work. Wilkie described him as "a painter of wondrous brilliancy, where all else is subdued, —adding lustre by the poetry of his touch to the mystery of darkness and obscurity, —giving splendour to poverty, sublimity of expression to the most homely countenance, majestic motion to the most abject form."[65]

For the Royal Academy exhibition of 1837 Wilkie completed two very different history paintings, *Mary Queen of Scots Escaping from Loch Leven Castle* (fig. 22) and *The Empress Josephine and the Fortune-Teller* (fig. 23). While the former painting, lost since the 1920s, is a return to subjects of Scottish history and a popular heroine of eighteenth century history painting, *The Empress Josephine and the Fortune-*

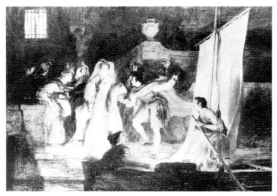

Fig. 22 Wilkie, *Mary Queen of Scots Escaping from Loch Leven Castle*, 1837, location unknown

Teller presents an original conception reflecting Wilkie's continuing fascination with Napoleonic history. As Roy Strong has shown, the cult of the Queen of Scots began with Gavin Hamilton's *Mary Queen of Scots resigning her Crown*, shown at the Royal Academy in 1776. Of the many events of her life that were depicted from that time until the late nineteenth century, her escape from Loch Leven Castle was among the less popular. The more emotionally charged or violent episodes, which never attracted Wilkie, were more common —subjects such as the murder of David Rizzio, or of the tearful queen being admonished by John Knox. Wilkie was again directly inspired by Walter Scott, whose novel *The Abbot* provided the text for the beautiful nocturnal scene in which the Queen makes good her escape. Here again we see Wilkie choosing an episode in which he could experiment with the Rembrandtesque night effects he admired so much. But *Josephine and the Fortune-Teller* is a very different work in which Wilkie is once again exploring the gap between history and genre. The subject was a novel one, probably taken from the memoirs of the Empress Josephine

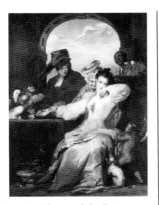

Fig. 23 Wilkie, *The Empress Josephine and the Fortune Teller*, 1837, National Gallery of Scotland

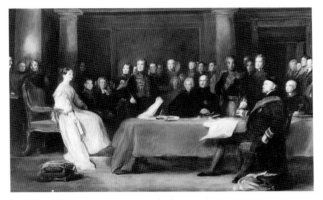

Fig. 24 Wilkie, *The First Council of Queen Victoria*, 1837–38, Her Majesty Queen Elizabeth II

published a few years earlier. It represents an event that took place in Josephine's native West Indies during her youth when an old fortune-teller predicted that one day she would be Queen of France. Wilkie has created a complex composition of many figures, suggesting the atmosphere of a public place, in which the young woman is having her fortune read. Wilkie's rather affected conception of Josephine, which may owe something to his admiration for Correggio in the soft curves of her features, caused more than one critic to object, finding her too arch, too much the silly coquette to be believable.[66] Believability, a sense of reality, must have been his intent, but even his attention to creating a West Indies setting, by the inclusion of the black servant and naked boy, and exotic plants, was ridiculed.[67] Style and detail seem to have overwhelmed meaning.

T HE YEAR 1837 marked another important event for Wilkie's future. For this was the year that Queen Victoria ascended the throne upon the death of William IV, who had knighted Wilkie in the year before.

The young Queen reappointed Wilkie as Painter in Ordinary, the post he had held since 1830, and he set out to paint an official state portrait, as the Lord Chamberlain instructed. However, the Queen had heard of a sketch Wilkie had made of her first Council, and commanded a painting of it, telling him whom to put in it. Wilkie's idea for the picture, with the Queen seated nearly in profile, and slightly elevated, at the end of a long table, was an admirably simple one and pleased everyone (fig. 24). However, it soon became apparent that he was to encounter many of the same problems he had met with in painting the *Entrance of George IV at Holyrood House* some years earlier. As in that instance, the direct involvement of the monarch coupled with the necessity of including many portraits gave Wilkie little freedom. In a letter to Collins of November 1837, Wilkie wrote: "This will be a picture of considerable plague in adjusting the persons; but as every one seems keen about the subject, I shall proceed, though I am putting other things at a stand."[68] Thirty-two portraits, in addition to the Queen's, were to be included and, according to Cunningham, there was

considerable jostling and intriguing as to position in the painting and a flattering likeness. As if this were not enough the Queen expected the painting to be ready for the next Royal Academy exhibition in early 1838. Thus, Wilkie was forced to rush and the painting was compromised. The Queen, worst of all, was not pleased with many of the likenesses and her negative attitude to the picture was to color her future relations with Wilkie. Thus, although he retained his official positions, Wilkie's many years of favor at court had come to a close. No sequence of events could have demonstrated better Wilkie's reasons for avoiding such official subjects, especially those involving many portraits. The critic of the *Monthly Chronicle* summed it up all too accurately: "When a painter takes for his subject a fact of universal or national interest and embodies it on his canvas, we are bound to consider it as an historical picture, 'ce que nous voyous aujourd'hui, sera de l'Histoire un jour.' Wilkie's picture of Queen Victoria presiding at her first Privy Council is, therefore, an historical picture, but it is not historically, nor even poetically treated; it is a mere group of portraits. The artist has had to paint a real and a recent scene, fresh in the recollection of those present, on no doubt has had extraordinary difficulties to contend with, not only in the monotonous costume, schooled attitudes, and conventional deportment of modern existence, but by the suggestions of individual *amour propre* — We make these allowances, still the picture does not please us."[69]

That Wilkie could paint successful portraits cannot be denied, but the circumstances had to be right for him to succeed. One of the most interesting commissions of Wilkie's entire career in this regard was that he received in 1834 from Lady Baird which resulted in the remarkable *Sir David Baird Discovering the Body of Sultaun Tippoo Saib* (cat. no. 42). When commissioned by Lady Baird, the widow of the hero it represents, the painting was already destined to have its dual nature as portrait and history painting in one, commemorating Sir David's discovery of Tippoo Saib's body after having captured Seringapatam on May 4, 1799. Tippoo was the last independent sultan of Mysore and his defeat marked the final consolidation of British rule in India. The then Major-General Baird had led the successful assault and his widow wished to have Wilkie memorialize her husband and the personal triumph represented by his victory. Baird had been imprisoned at Seringapatam for four years by Hyder Ally, the father of Tippoo Saib, and the dungeon grating seen below Baird's feet in Wilkie's painting was meant as a specific reference to that fact.

Although it was commissioned as a domestic memorial and was not intended for a public place, Lady Baird was particularly anxious that the painting lay stress on her husband's personal story, so as not to give any offense to the other military officers who took part in the great victory. Among them, standing next to Baird in the picture, was the future Duke of Wellington, then Colonel Wellesley, for example. Given the artist she had selected, it was inevitable that the painting would be publicly exhibited. Moreover, and to Wilkie's great pleasure, Lady Baird had given him a free hand beyond the stipulations described, and he clearly saw the commission as of great importance. Indeed, the painting would become Wilkie's largest single work and was certainly much more than a portrait to him. He gave extraordinary attention not only to the various Indian and British costumes and accoutrements, but also to the figures themselves, espe-

cially the Indian figures, for whom he used many models. These figures, particularly Tippoo Saib and those around him, although seen in a very subdued light compared to the figure of Baird, are, of course, central to the personal story of the picture. Wilkie left a short memorandum on the importance of the juxtaposition of Baird and Tippoo Saib for the painting: "In considering the taking of Seringapatam a subject for art, one of its greatest recommendations I conceive to be, the bringing the leaders of each side in the moment of victory, to the same spot."[70] The victor gains stature by the impressiveness of the vanquished, and the painting gains a broader meaning as a national as well as a personal triumph.

Critical reaction to the Baird picture was mixed, and, on the whole, unfavorable. Much of the criticism was aimed at the central figure of Baird which seemed awkward and unconvincing, and much of the praise was for the sultan and the group of figures around him. Whereas Wilkie had employed models for the figure of Tippoo and those around him, and had total freedom to conceive them as he wished, it was quite different for Baird's figure. For this posthumous likeness he was dependent on old portraits, principally one by Raeburn, and a bust by the sculptor Lawrence MacDonald. The Raeburn portrait, as Wilkie described in a letter to Lady Baird, "with the hat on the head, and the eyes looking down, would be almost exactly what is wanted"[71] and although he later worried about bringing the hat lower down on the head, Wilkie was evidently reluctant to tamper too much with Raeburn's image which had been painted from the life. His legitimate concern to preserve a good likeness got in the way of a more natural conception and certainly led to the awkwardness of the

pose. Haydon, on a visit to Wilkie's studio in July 1838, was quick to note this problem: "He has put Baird with his head the wrong way for ease, just like his George IV."[72] The parallel to the *Entrance of George IV at Holyrood House* was apt, for although the causes of Wilkie's problems were different in that instance, the stiff effect was the same, with neither figure relating naturally to the others around him. The most sarcastic critic wrote of Wilkie: "He is very kind in the catalogue to tell us what Sir David Baird is doing in his great picture, for we should not have found it out; never was a figure less like a hero, insignificant, in the middle of the picture. Yet in this picture, so deficient as a whole, are beautiful parts, especially in grouping."[73] It is certainly the beautiful grouping of the figures, among other virtues, that prompted another critic to write: "As a work of art, its merits will principally be found in the group which surrounds the body of the sultan."[74] The unstable look of Baird's hat caught the attention of the critic of *The Spectator*, who perhaps best summed up the picture's reception: "[it] might be mistaken for the portrait of one of the old Volunteers flourishing his sword with the air of a victorious hero, his helmet adorned with an extra plume of feathers, stuck on the top of his head to make him look taller; it only wants a figure of fame blowing a regimental trumpet to complete the resemblance. The half-stripped corpse of Tippoo examined by his followers is finely painted, and there are other redeeming points of executive skill; but as a whole it is a failure."[75] One should say a brilliant failure, for the beauty of certain parts is the equal of anything Wilkie painted, even if all the parts do not add up to a beautiful whole.

Wilkie's last major project for a history painting, prior to his fateful journey to the Near East in 1840, was *John Knox Dispensing the*

Sacrament at Calder House (cat. no. 43). Intended as a companion to his earlier *Preaching of Knox* of 1831, it was not seriously contemplated until the engraving for the earlier Knox picture was successfully published. Thus, although the idea for a second Knox subject began earlier (for more on this see Miles, cat. no. 43), it was evidently the lucrative potential of a companion engraving that finally prompted Wilkie to begin the painting. As with the *Preaching of Knox*, he visited Scotland to research the specific site of the event, Calder House in Midlothian. There, it was believed, the first communion according to the Calvinist rite was given in Scotland. That Wilkie used certain elements of Leonardo's *Last Supper* seems clear. He had been enamored of that painting at least from his first visit to Italy and one can readily understand why. Few works in the history of art show as rich and complex an interrelationship of figures with such limited means. Wilkie, in his "Remarks on Art," had written of it: "—the expression of fidelity which seems breathed by all around, given with that relief and reality that the most uninformed may imagine all the interchange of thought, made by sign or whisper or open avowal, and see in imagination the memorable event which follows, and of which this parting scene was to remain a type and memorial."[76] From his early genre pictures, through the history and genre works of his later career, Wilkie had frequently used the table as a compositional focus. Now, at the end of his career, he was, in effect, painting a Protestant Last Supper. And, as in so many of his earlier works, Wilkie was seeking to create an interplay that was largely internal with a limited amount of action or movement. However, the painting never proceeded beyond the sketch stage, for Wilkie left England on an extended trip to the Near East before he could put in more than a few figures on the final panel (fig. 44).

AS TO WHY Wilkie decided to undertake such a long journey at this time, Cunningham gives three principal reasons: "We may say with certainty that he went with enlarging notions of his art; that he was not encumbered with royal commissions, and hoped amendment to his health by a visit to a land endeared to his heart by a thousand associations, all of them devout."[77] Wilkie had, of course, long been attracted to religious subjects, but, except for a few small oils, such as his early *Bathsheba*, had never painted a Biblical subject. We may only speculate that his recent labors on *John Knox Dispensing the Sacrament at Calder House* had given him the impetus to be more ambitious. Moreover, as we have seen, he strongly believed in researching the sites of his subjects if at all possible. However, this was going very far, and Cunningham's reference to his lack of royal commissions may best explain Wilkie's desire to remove himself from London for a time, perhaps with thoughts of a triumphant return as when he came back from Spain in 1828. His health was always precarious, and a voyage to warmer climes would have held promise of renewed strength. But the Queen's dissatisfaction with Wilkie's *First Council* and her state portrait, one of his most unhappy productions, was probably the most powerful motivation for an extended trip, this plus the lure of new subjects to paint. Wilkie was always in search of novelty, particularly so because of the financial importance that the sale of reproductive prints after his works had for him.

From his first passage into Ottoman territory, Wilkie was fascinated by the appearance of the people, their splendid costumes above all.

Indeed, some of the most beautiful drawings of his career were those portrait and figure studies in native costume that he drew on this journey. But it was the powerful Biblical associations of this region which seemed to occupy his mind and his letters most of all. Wilkie, in a letter to Peel from Jerusalem, explained his goal in traveling to the Holy Land: "It is as fancy or belief that the art of our time and of our British people may reap some benefit, that has induced me to undertake this journey. It is to see, to inquire, and to judge, not whether I can, but whether those who are younger, or with far higher attainments and powers, may not in future be required, in the advance and spread of our knowledge, to refer at once to the localities of Scripture events, when the great work is to be essayed of representing Scripture history."[78] Wilkie's characteristic modesty and formality notwithstanding, we can sense a need to justify himself and can see that he was feeling his age. But we can also see from his drawings and sketches that he was full of ideas and enthusiasm for future works. He remarked frequently on the enormous advantage to be gained in depicting Scripture history by actually seeing the Holy Land, which the great masters of the past never had. Although he sketched such exotic contemporary vignettes as *The Turkish Letter Writer* (cat. no. 45), his mind was moving in more ambitious directions as well. He made a sketch of *The Tartar Messenger narrating the News of the Victory of St. Jean d'Acre* (Sir James Hunter-Blair), a subject of contemporary history which is, in a sense, a Near Eastern *Chelsea Pensioners*.[79] And he made many sketches of holy places, the supposed ruins of Pontius Pilate's palace, the tomb of the Holy Sepulchre, the Mount of Olives, and studies of Jews at prayer.[80] He made a sketch of the Nativity at Bethlehem, a subject which seems to have been on his mind from long before his journey, and also sketched *The Supper at Emmaus* (location unknown), which again returns to the table as a compositional focal point, a compositional idea fresh in his mind from his recent work on *John Knox Dispensing the Sacrament.*

What Wilkie would have made of his many sketches and studies for Biblical pictures, had he lived to return to London, would be impossible to say. But certainly his gifts for telling a story and the freedom to invent that such subjects offered, would have been in his favor. As with many of Rembrandt's Biblical works, which Wilkie deeply admired, he would have had a particular ability to humanize the humbler subjects, with his natural preference for the private or quiet moment that we have seen in both his genre and history paintings. But this opportunity was not to be his, for he died on the return voyage to England in June 1841.

Notes

1. See especially: Lindsay Errington, *Works in Progress/ Sir David Wilkie: Drawings Into Paintings* (1975) and Lindsay Errington, *Tribute to Wilkie* (1985). Also: Bridget J. Elliott, "The Scottish Reformation and English Reform: David Wilkie's *Preaching of Knox* at the Royal Academy Exhibition of 1832," *Art History* (September 1984) 7:3 and Roberta J. M. Olson, "Representations of Pope Pius VIII: The First Risorgimento Hero," *Art Bulletin* (March 1986), 67:1.
2. John Burnet, *Practical Essays on Various Branches of the Fine Arts* (1848), 106.
3. Benjamin Robert Haydon, *Autobiography and Journals*, ed. Malcolm Elwin (1950), 33.
4. For an extensive discussion of Davison and the series, see H.A.D. Miles, cat. no. 6 under comments.
5. For more on the "cult of Alfred" see: Roy Strong, *The Victorian Painter and British History* (1978).

6. Allan Cunningham, *Life of Sir David Wilkie* (1843), 1:122–23.

7. Cunningham, 1:123–24.

8. For the essential text of this letter see H.A.D. Miles, cat. no. 6, under comments.

9. *The National Register* (May 1, 1808), 1:286.

10. These two subjects were *King Alfred Sharing his Last Loaf with the Pilgrims*, 1777–8, and *William de Albanac Presenting Three Daughters (Naked) to Alfred, the Third King of Mercia*, 1778. For more on West see: Helmut von Erffa and Allen Staley, *Paintings of Benjamin West* (1986), 68, 94; and Ann Uhry Abrams, *The Valiant Hero/Benjamin West and Grand Style History Painting* (1985), 67–68.

11. For more on West's prints see von Erffa and Staley, 60–63 and the essay in this catalogue by Arthur S. Marks.

12. National Library of Scotland, Ms. 9835, f. 9, Wilkie to Thomas Macdonald, dated 15 July 1805.

13. Nicholas B. Wainwright, "Conversations with Benjamin West," in *The Pennsylvania Magazine of History and Biography*, 102:1, Jan. 1978, 110. As quoted in Dorinda Evans, *Benjamin West and His American Students* (1980), 178–79.

14. Von Erffa and Staley, 113.

15. Haydon, 128. For more of the Bird affair see also: Arthur S. Marks, "Rivalry at the Royal Academy: Wilkie, Turner, and Bird," *Studies in Romanticism*, Fall 1981. For more on Wilkie's mental health see the essay by Batchelor in this catalogue.

16. Evans, 179.

17. William T. Whitley, *Art in England/1800–1820* (1928), 169.

18. Cunningham, 1:340–42.

19. Cunningham, 1:344–50.

20. Abraham Raimbach, *Memoirs and Recollections* (1843), 157.

21. Cunningham, 1:351.

22. Haydon, 154.

23. Haydon, 205–206.

24. Cunningham 1:392.

25. Cunningham, 1:400,410.

26. Haydon, 224.

27. For the popularity of Wilkie's prints in France see Marcia Pointon, "From 'Blind Man's Buff' to 'Le Colin Maillard': Wilkie and his French Audience," *The Oxford Art Journal* (1984) 7:15–25.

28. Cunningham, 1:415.

29. Haydon, 254.

30. Raimbach, 163–64.

31. Cunningham, 1:343.

32. *The Examiner* (1818), 107–108.

33. Meisel, *Realizations* (1985), 162.

34. Haydon, 288.

35. Haydon, 290.

36. Cunningham, 2:73.

37. Wilkie wrote to his friend, Perry Nursey (cat. no. 63) in 1818: "The Highlands have lately become a subject of great interest here in the south from the works of that great unknown the author of Waverly. Another work by the same author is now one which gives a most lively picture of what the Highlands were about a century ago. I mean Rob Roy. This is a work of great genius." Letter from Wilkie to Nursey, Kensington dated 30 January 1818, British Library 29,991 Add. f.14. Scott's authorship of the Waverly novels was not officially revealed until 1827, and in 1818 Wilkie was probably not aware of it.

38. Meisel, 162.

39. Meisel, 163. Wilkie identified each veteran in the commentary of the Royal Academy exhibition brochure. They are also identified in Burnet's engraved key to the picture (cat. no. 93).

40. *New Monthly Magazine* (June 1, 1822), 6:258.

41. For a complete discussion of all these events see: Gerald Finley, *Turner and George the Fourth in Edinburgh 1822* (1981).

42. British Library 29,991 Add.f.36, Letter from Wilkie to Nursey, dated 20 November 1822.

43. Oliver Millar, *Later Georgian Pictures* (1969), 142.

44. National Library of Scotland, Ms. 3812, f.28, Letter from Wilkie to Andrew Wilson dated September 1828.

45. Beinecke Library, letter from Sir David Wilkie to Prince Dolgoruki, dated 27 September 1828.

46. Beinecke Library, Letter from Sir David Wilkie to Prince Dolgoruki, dated 20 April 1829.

47. *New Monthly Magazine* (1829), 27:252–53.

48. *John Bull* (May 18, 1829), 9:157.

49. Haydon, 453, entry for 30 July 1829.

50. *The Court Journal* (1830), 297.

51. National Library of Scotland, Ms. 5680, f.1, Wilkie to Sir Robert Liston, 8 February, 1830.

52. National Library of Scotland, Ms. 5680, f.15, Wilkie to Sir Robert Liston, 19 July, 1830.

53. For a complete description of the historical figures, see Cunningham, 3:55–59.

54. National Library of Scotland, Ms. 6294, f.69, Wilkie to William Allan, 4 August, 1827.

55. Although Liverpool had been a staunch opponent of the Catholic emancipation bill and Peel the leader who finally pushed it through Parliament in 1829, the painting should not be read as a political or religious statement on Wilkie's part. Essentially he was conservative but apolitical, infuriatingly so to friends like Haydon whose whole life was a polemic. Moreover, Wilkie was quite tolerant and open minded about religion, which his extensive travels only reinforced and which his paintings clearly demonstrate. For a different view on this point, see Elliott (1984).

56. See especially: *Fraser's Magazine* (July 1832) 5:717–18; *New Monthly Magazine & Literary Journal* (1 June, 1832), 36:255; *Examiner* (3 June, 1832), 357.

57. *Fraser's Magazine* (July 1835), 12:50–51; for more on this painting see Miles (1969).

58. *Leigh Hunt's London Journal* (1835), 2:167.

59. *The Literary Gazette and Journal of Belles Lettres* (1836), 298 and *New Monthly Magazine* (June 1836), 47:225.

60. Cunningham, 3:488.

61. National Library of Scotland, Ms. 10995, f.29, Wilkie to Robert Vernon dated 15 October 1835.

62. Ibid.

63. Ibid.

64. *Literary Gazette and Journal of Belles Lettres* (1836), 298 and *Blackwood's Magazine* (October, 1836), 40:550.

65. Cunningham, 3:140.

66. *The Athenaeum* (1837), 330 and *Blackwood's Edinburgh Magazine* (September, 1837). 42:336–37.

67. *The Spectator* (1837), 10:475.

68. Cunningham, 3:229.

69. *Monthly Chronicle* (1838), 1:349.

70. Cunningham, 3:266.

71. Cunningham, 3:96–97.

72. Haydon, 555.

73. *Blackwood's Edinburgh Magazine* (Sept. 1839), 47:311.

74. *Literary Gazette and Journal of the Belles Lettres* (1839), 298.

75. *The Spectator* (1839), 12:447.

76. Cunningham, 3:190.

77. Cunningham, 3:285.

78. Cunningham, 3:415.

79. For a full discussion of this painting, see: K. Bendiner, "Wilkie in Turkey, 'The Tartar Messenger narrating the News of the Victory of St. Jean d'Acre'," *Art Bulletin* (1981), 63:267.

80. Cunningham, 3:399, 410–11.

Wilkie as a Portraitist:
Observations on "A National Misfortune"

H. A. D. Miles

THAT SIR DAVID WILKIE was ever attracted to portrait painting by the lucrative considerations which divert so much talent into that channel, we do not for a moment suspect. That caprice should have led him to batten on that field we hold to be a national misfortune."[1] The words were written anonymously (by the 1st Earl of Ellesmere) in 1838. They express bluntly a view of Wilkie's activity in portraiture that was quite common during the last decade or so of his life. Because of this, Ellesmere's words deserve some consideration—not so much to test the justice of his critical evaluation, but rather to outline the story of how Wilkie got into the situation that laid him open to so unsympathetic a judgment.

When Wilkie first began to paint, the temptation toward portrait painting must have been strong. He had shown early a mimic gift. In Edinburgh, where he was from 1799 to 1805, more than half the twenty-one painters known to have been active there at the time were portraitists of one sort or another—suggesting that there was a market. The art was dominated by Raeburn, who lived pretty comfortably on the proceeds. There can be little doubt that

Wilkie, so notably endowed with determination, and born into a family that could not afford to eat meat, could have sustained himself with no great difficulty on a slice filched from Raeburn's side of beef. The relatively dependable rewards of portraiture would also have done much to justify his decision to become a painter in the eyes of parents who were, on that account, apprehensive about his future.

Wilkie took the more ambitious and more hazardous course—that of exerting himself in the direction that he felt to be congenial to his inclinations and most suited to his abilities.[2] His inventive, immature energy went into that formidable compendium, *Pitlessie Fair* (cat. no. 4). The portraits he painted in Fife up to 1805 (e.g., cat. no. 2) may be looked upon as no more than the necessary economic substructure to that picture. Later the same year he took it to London where it was the cornerstone of his success.

His first exhibited picture—at the Royal Academy in 1806—was *The Village Politicians* (for the engraving, see cat. no. 90). Fuseli called it "a dangerous work," and it was in truth subversive of habitual values in painting. Crowds came to see it, and one of the high

nobility bought it. Wilkie achieved fame on the instant, yet he was not deceived by fame, nor did it then bring him more than pitiable reward. At twenty-one he was conscious that he was only half trained and that he had borrowed pounds in his pocket.

In London, as was said at the time, there were "generally speaking, only three kinds of employment which present[ed] themselves to the young student in painting . . . that of *penciling* for the manufacturer . . . that of *designing* for the press . . . [while] the third, the most general . . . and the most profitable and acceptable, is *portrait painting* . . . "[3] Wilkie made two inconsequential designs for the press in 1806—illustrations to stories by Leigh Hunt (for more on this, see the essay by Marks in this catalogue)—but it was again to portraiture that he turned, perforce: "I have been reduced at times to the lowest extremity and the only support I had was from painting a few portraits of some of my friends. But that was a branch of the art in which I perhaps luckily failed, for the want of success in it made me apply to another branch in which I have already established a reputation that will live for ages."[4]

It was the devil of penury who continued to drive him to paint portraits in his early London years, among them the *Marchioness of Lansdowne with Her Page* (cat. no. 10) and *Thomas Neave and His Family* (fig. 25). The first brought him into a world of Peacockian eccentricity at Southampton Castle with which he could barely cope; in the two years that it took to complete the second, Wilkie was harassed by the exigencies of his sitters, and owned to "not much liking this kind of employment."[5]

To a young man in Wilkie's situation the painting of a portrait held more than the promise of payment for the occasion; the social

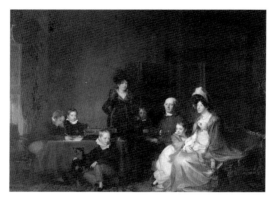

Fig. 25 · Wilkie, *Thomas Neave and His Family*, 1808–1810, Private Collection

encounter itself between painter and sitter brought hope of something no less necessary to his future—access to a circle of potential patrons. Yet patronage had its price, as was observed with some bitterness by writers of the time. Reasons for feeling that employment in portrait painting was perhaps "the most painful and trying to a man of pride and sensibility" were given on Opie's behalf by his widow: "To have high lights taken for white spots, and dark effective shadows for the dirty appearance of a snuff-taker; to witness discontent in the standers-by because the painting does not exhibit the sweet smile of the sitter, though it is certain a smile on canvas looks like the grin of idiocy; while a laughing eye . . . as unavoidably assumes the disgusting resemblance of progressive intoxication."[6] It was of the companions of the sitter, the "standers-by," that a later writer observed: "The greatest perplexities to which a portrait painter is exposed spring, not so much from those with whom he is principally concerned, as from a crowd of monitors, at once indifferent and suspicious, who make it a duty to call upon the portraits of their acquaintance, and cast sentence upon them

before suspension."[7]

In early life Wilkie was uncertain of himself in society. Moreover, he was on the one hand a congenital worrier and, on the other, ever anxious to please. He would have been almost helpless in the face of social and critical tyrannies such as those described. Furthermore, he was throughout his life doubtful of his ability to take a good likeness, and in one particular it was reported that he "complained that his lady sitters seldom rose with praises on their lips at the versions he made of their beauty, and used to observe, with a smile, that Lawrence excelled all by studying to please in the wide dominions of flattery."[8]

Nevertheless, the exigencies of portraiture remained with him. The portrait painter John Jackson reported in 1809 that "some of the people who have ordered pictures from him think themselves neglected by his attention to the portraits he is painting."[9] One of the people referred to must have been no less a patron than Thomas Hope, and his action stung Wilkie to remark: "I think very little consideration might have shown him that I could not have begun to paint portraits voluntarily. Indeed, my principal object in undertaking them was to be enabled, with the money they brought, to do justice to my other works."[10]

There is no clearer statement of Wilkie's position, and when the need for ready money was not overwhelming he could decline a commission for a group portrait from as distinguished a sitter as the Duke of Buccleuch. He did this in 1817, on the grounds that to paint such a thing would be "going out of my line entirely."[11] It was perhaps about this time that Wilkie cried out to a friend: "I *cannot* hurry. Portrait painting is odious. I *cannot* paint portraits, otherwise I might be a richer man."[12]

It may be noticed, incidentally, that from the time of his arrival in London until 1829 Wilkie made no evident attempt to draw attention to himself as a portraitist through the exhibitions at the Royal Academy and the British Institution. Of the four seeming exceptions, including the portrait of the Duke of York (cat. no. 24), each depended so closely upon his personal relationships with those who had instigated the portraits,[13] and each was so clearly of a private nature as make remote any suspicion that, as portraits, the paintings were exhibited with an eye to advertisement in that line.

Several reasons can be suggested as to how Wilkie managed to avoid the subservience to portraiture of which so many British painters complained. Before all else he had, as already noted, a very clear idea of where his originality lay, coupled with a single-minded and persevering loyalty to his gifts. He had been encouraged in this by the acclamation of that originality given almost immediately after his arrival in London. It was sustained by a sufficiency of commissions in his chosen line, and also, in a number of instances, by the personal attentions of his patrons — men wise enough not to divert the talents they recognized in him toward the commonplace activity of portraiture. There is, nevertheless, an important and characteristically businesslike reason why Wilkie was able to sidestep nearly all save the most necessary calls to portraiture during his earlier life. Perhaps mindful of Hogarth especially, and following the cautious advice of Sir George Beaumont, Wilkie set in train the systematic engraving of his more important pictures. This began as early as 1807. As well as broadening his public reputation, the engravings did for him what portraiture could also be made to do; the profits from them helped to stabilize the margins of his life.

To revert to the sentences quoted at the beginning of these observations, enough has been said to justify Ellesmere's willingness to believe that in earlier life Wilkie was not "attracted to portrait painting." We shall next see that insofar as Wilkie took to portraiture in later life, it was not primarily for "lucrative considerations." Where Ellesmere was, however, both mistaken and unjust was in writing the second of his sentences, containing the charge that "caprice" led Wilkie into an acceptance of portrait painting and the wounding expression of regret that the result was a "national misfortune."

It is the charge of "caprice" that calls for comment—taking Ellesmere's meaning to have been that Wilkie took to portraiture on a whim, and with disregard for the consequences. What overtook Wilkie, if caprice at all, was a caprice of fate. In this rather different light we will follow a series of events that did indeed produce in him misfortune, personal and—here it is possible to agree with Ellesmere—artistic. These events were to reach their pitch of irony in Wilkie's appointment as Painter in Ordinary to the King, a luckless honor that befell him in 1830.

Wilkie's induction to formal portrait painting may be said to have begun, obscurely, when the Prince Regent commissioned *Blind Man's Buff*, probably late in 1811. The Prince, later George IV, continued to show a particular regard for Wilkie—possibly more than for any other living painter—and he came to add nine more pictures by him to the Royal Collection.

The Prince was crowned in 1820. In 1822 he made his in every sense extraordinary visit to the capital of his northern kingdom. The occasion gave Wilkie a subject in modern history—*The Entrance of George IV at Holyrood House* (cat. no. 32 is a sketch version of this)

—which was particularly affecting to his undivided patriotisms as a Scot and as a Briton. Although the picture went into the Royal Collection, it is by no means clear for whom, or even precisely why it was first painted. The picture will have a further place in the sequence of events that concerns us; all that needs to be said here is that it was not—as might be assumed—in consequence of his knowledge of this picture that in 1823 the King appointed Wilkie as his Limner for Scotland, in succession to Raeburn who had died earlier in the year. The choice seems to have been made on the suggestion of one of Wilkie's more recent patrons, Robert Peel. Wilkie wrote to a friend: "I am now a placeman, with all the odium as well as credit of holding a post under the Crown . . . and being in regard to Scotland a non-resident, I feel desirous to make such application of my art that . . . I may not be subject to the additional charge of being a sinecurist."[14] From the same letter it is clear that he intended to respond to the honor by giving "new force" to his plan for a history picture celebrating the royal visit to Scotland. By implication, his immediate thought was to turn to royal purpose the talents that were recognized as his own; there is no evidence that he saw his appointment as an avenue toward a reputation in portraiture.

The following year Wilkie expressed himself sensible of an honor of a different kind, one by which again he was asked to assume the mantle of Raeburn, but this time unequivocally as a portraitist. An invitation came from Cupar, the county town of Fife—close to the place of Wilkie's birth, and for him a locus of strong sentimental ties. It was to paint the portrait of the Lord-Lieutenant of the county, the Earl of Kellie (cat. no. 29). Never before had he painted a formal portrait of this kind, and at

first he hesitated to accept the task. Lord Leven, the heir of one of his first local patrons, was persuasive. Besides, Wilkie knew that if he painted the portrait it would be hung in the County Hall with Raeburn's handsome portrait of the previous Lord-Lieutenant, the Earl of Hopetoun.[15] It may be readily supposed that foreknowledge of this juxtaposition would have impressed Wilkie with the feeling that in his native Fife he was held to be Raeburn's peer. To one so conscious of his own roots, as well as of Raeburn's fame, this was flattery enough. He may even have sensed that to be thus hung beside Raeburn would seal a kind of post-humous union with a much-esteemed man who had come to be his friend.

While painting this portrait Wilkie revealed an important, practical reason for having undertaken it. "I wish," he wrote, "to have the practice in painting large, in case I should have anything to paint for the King in the same way."[16] He was referring at last to the proba-bility of being asked to paint an official portrait of the King—an expectation arising naturally from his appointment as the King's Limner. His only experience of royal portraiture hitherto had been the small, informal portrait of the King's brother, the Duke of York—exhibited in 1823 and already referred to. The *Duke of York*, painted for a private patron, is twenty-three inches high; the *Earl of Kellie*, an official portrait on an official scale, is ninety-five inches high. The statistics give ground to Wilkie's feeling that his experience as a portrait painter was not yet adequate to the duties proper to his new position as a placeman.

At this point Wilkie's incipient career as a portraitist, indeed as a painter of almost anything else, was broken by the major crisis in a lifetime of susceptibility to bouts of nervous illness brought on by anxiety. Drained of his powers of mental concentration and manual control, he sought relief abroad in 1825. (Concerning Wilkie's psychological make-up, see the essay by Batchelor in this catalogue.)

One of the compounded anxieties that had beset him at the time lay in the difficulty of resolving the *Entrance of George IV at Holyrood*, the picture he had begun to compose in 1822. By reason of its subject it had come to acquire significance in regard to his office under the Crown, and the particular source of his trouble lay in finding the right attitude for the figure of the King.

In 1828 Wilkie returned to England and to the still-unfinished picture. The following year he was given sittings at Windsor, and humiliated—before courtiers—to find himself unsuccessful in catching the King's likeness.[17] Yet it was from the figure of the King in the *Entrance of George IV at Holyrood* that fate took a further turn toward the establishment of Wilkie as a portraitist of royalty—once more in the shadow of Raeburn.

George IV had been quite ridiculously pleased with his appearance in Edinburgh in Highland dress, wearing also what Wilkie described at the time as "a kind of flesh-coloured pantaloons underneath." It seems that in 1823 the King had intended to have himself painted by Raeburn in this guise, doubtless visualizing the effect from a knowl-edge of the portraits of Highlanders exhibited by Raeburn at the Royal Academy. In 1829, when Wilkie was at Windsor, on the occasion just referred to, he was asked what he "was doing about the large [portrait of the King] in the Highland dress."[18] By implication this must have been a portrait he had been expected to paint at an earlier date, one that had devolved upon him as King's Limner, and presumably a piece of business left undone by Raeburn.

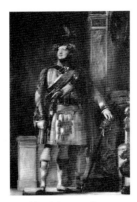

Fig. 26 Wilkie, *George IV*, 1829, Her Majesty Queen Elizabeth II

Wilkie wrote of the consequent life-size portrait (fig. 26): " . . . having tried it on the Earl of Kellie . . . I have made [this] the most glazed and deepest-toned picture I have ever tried, or seen tried in these times. It is . . . a trial of Rembrandt all over—the dress, the accoutrements and gold throne, a dark background, no white, except on the hose and flesh, telling as principal lights. . . . The low perspective is thought new and successful."[19] When the portrait was exhibited at the Academy in 1830 it was noticed that its richness threw the pictures near it out of countenance—the tendency at the time being to paint, portraits especially, at a generally higher tonal pitch. As a picture it was received well enough, but as a portrait less so. Not for the first time with Wilkie's portraits, nor for the last, were doubts cast upon the likeness. This particular work produced, incidentally, one of the most dismissive remarks ever made about one of his portraits: it was described as "a powerful representation of Lady Charlotte Bury, dressed for Norval." The portrait was destined for Holyrood House, in Edinburgh, where it still is.[20]

In January 1830, the year in which this, Wilkie's first official royal portrait, was to be exhibited, Sir Thomas Lawrence died. For Wilkie this was to be the final caprice of fate. Lawrence had been both President of the Royal Academy and Painter in Ordinary to the King —offices by custom held conjointly. The question of who should succeed Lawrence produced much politicking. As it seemed to some, the King favored Wilkie as the next President of the Academy, and because of that the Academicians rejected the notion. They put forward instead the name of Martin Archer Shee—a socially ingratiating, secondary portraitist. A compromise was reached by which the portraitist became the President, while the man generally acknowleged to be the better painter—still, essentially, a non-portraitist —was appointed to the office that made him the official portrait painter to the King. In this final act of regard the King had, too kindly, charged Wilkie with a burden of office that he was never to find strength enough to carry with ease.

Five months after Wilkie's appointment, George IV died. There is horror and pathos in a description of Wilkie's ordeal as he painted a last portrait of the King in Garter robes—a portrait that was not completed. For Wilkie it was one of a man to whom he was attached by more than formal appointment and a shared taste for Dutch pictures. He was also grateful for the personal solicitude the King had shown in 1828 when Wilkie had much need of encouragement in recovering self-esteem and a reputation disrupted by enforced absence abroad. The picture of the two men together for the last time is Maria Edgeworth's:

Wilkie . . . had the honour of making a portrait of his late Majesty a little while before his death.

He told [J. G.] Lockhart it was the most difficult and melancholy business, for there the man was, wasting away day after day; and . . . though he was well enough to look at when dressed up in robes and hung about with orders and ribbons, and set up to be seen across the room, yet, when Wilkie was to go close and get the light upon him . . . it was, he says, "parfaitly frightful." . . . And then it took three hours to get him into those clothes! — lace up all the bulgings and excresencies! . . . and what do you think his last coat cost? A silk coat, it was charged by Stultz — six hundred pounds. . . . Here he [Stultz] was at Windsor, he and two of his men for three weeks or more . . . to try this coat on every succeeding day and cut it and coax it . . . upon the old dying dandy, and an alteration and fresh seaming at every sitting for the picture.[21]

Such was the chain of events that led Wilkie into prominence as a portraitist from 1830 onward. From being a painter of royalty it followed that he was also inevitably — though still reluctantly — to become a painter of persons of rank and fashion. At the time of the opening of the exhibition at the Royal Academy in 1830, Wilkie wrote: "I find it [his portrait of George IV] would lead me at once to full practice in portrait-painting, but my answer is, that I mean to confine myself in these to what is required by the office I held from his Majesty."[22] With that duty in mind he moved into a larger house in order to match the practicalities of painting full-lengths,[23] but his resolve notwithstanding he painted during the latter part of his life almost as many portraits of private sitters as of the sovereigns and royal family. There is not space enough here to discuss Wilkie's later portraits of private sitters. In connection with most of them the charge of "caprice" still seems gratuitous, although the veiled suggestion that they were undertaken for "lucrative considerations" may sometimes be allowed. Yet the diversion of energy from the field of his manifest originality — the basis of complaint against him — was not dishonorable. Account must be taken of Wilkie's need for extra income toward the support of the children of two brothers, a responsibility made heavy by the reverse to his own fortune through the failure of the print-publisher Hurst, Robinson & Co. in 1826.

AN ACCOUNT of Wilkie's further career as a portraitist must be limited for the present to his work as Painter in Ordinary — the pivot of his diversion — and to the fruits of office and duty that brought unhappiness to himself and disappointment to many — even most — of his contemporaries. That downward course may be described quite briefly.

When George IV died, Wilkie's appointment was confirmed by his successor, William IV. The new King was scarcely more attractive as the subject for a portrait than was his predecessor; nor was there here a community of feeling between painter and sitter, as there had been with George IV. Wilkie's prime surviving portrait of the new King (1831–32; fig. 27) was exhibited at the Academy in 1832. Public reception of it was mostly favorable, and Wilkie was moderately satisfied with the likeness.

Under William, Wilkie had Queen Adelaide as a second subject. He exhibited at the Academy in 1834 a portrait of her in coronation robes, which, as to likeness, had satisfied the court at Brighton although Wilkie himself remained uncertain (see fig. 28). When Shee came to paint the Queen in 1836, he was to find her a difficult sitter, who insisted that she should not be flattered: "Oh! Sir Martin,"

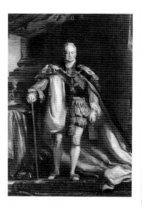

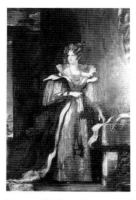

Fig. 27 Wilkie, *William IV*, 1831–32, Her Majesty Queen Elizabeth II

Fig. 28 Wilkie, *Queen Adelaide in Coronation Robes*, 1834, Oxford Examination Rooms

she said carelessly, "I pity you, indeed, for having such a subject."[24] It may be suspected that she had given the same instruction to Wilkie and that he had taken her at her word. She was not endowed with beauty, and it was perhaps not a matter of accident that this, Wilkie's first portrait of Adelaide, did not pass into the Royal Collection after its exhibition. William's concern in 1836 was to have from Shee "a most agreeable likeness" of his wife. That concern probably reflected his estimate of Wilkie's earlier portrait, and it may also explain why this vanished as early as 1838.

Queen Victoria succeeded in 1837. It was unfortunate for Wilkie that his last royal patron should have been a rather vain and spoiled young person, almost a girl to an aging bachelor, and one whose taste in pictures was not far from that of the newly emerging women's magazines. Wilkie was once again confirmed in his office of Painter in Ordinary, but at the same time the Queen appointed George Hayter and the miniaturist A. E. Chalon as her Portrait Painters. Thus for the first time Wilkie had rivals within the royal household—a situation that must have been

galling in proportion to the manifestly paltry artistic stature of each.

Wilkie's first public response to the new reign was to paint an episode in contemporary history that he knew to be a subject of public curiosity. His picture, the *First Council of Queen Victoria* was analogous to the *Entrance of George IV at Holyrood* in that sense, as well as in being a historicized portrait group—incidentally of the same size. The *First Council* (1837–38; fig. 24) was exhibited at the Academy in 1838. The Queen thought that "though a fine picture [it] contains very few good likenesses."[25] What she thought of her own likeness is not known, but Lady Salisbury commented: "it certainly requires all the prestige of royalty to cheat one into the belief of her being pretty—tho' I am sure at that moment, she appeared beautiful in the eyes of half the spectators."[26] At the Academy the picture was received as much for its anecdotal as for its pictorial qualities.

Wilkie's essential duty as Painter in Ordinary was, however, not to paint anecdotes in the life of the Queen, but to make state images of her for such purposes as the furnishing of official buildings at home and of embassies abroad. It

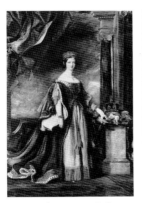

Fig. 29 Wilkie, *Queen Victoria in Parliamentary Robes*, 1838–39, Lady Lever Art Gallery, Port Sunlight

was with this formal business in mind that he had presented himself to her shortly after her accession. It was the Queen who deflected his workaday intention toward a picture of her first Council, and only with evident reluctance did she allow Wilkie a few skimped sittings for a portrait of herself in Parliamentary robes (1838–39; Port Sunlight; fig. 29). He was so flustered by her behavior toward him that it is hardly surprising that the result was unsatisfactory. Critical opinion had usually been hostile to Wilkie's later portraits, and when this one appeared at the Academy in 1840 it did nothing to redress the balance. "Such a Queen! Kneller, Hudson, Ramsay would have disclaimed it!" Haydon had already written.[27] The portrait was intended for a foreign embassy, but it was found to be "so atrocious" that the Queen "cannot send it as a present abroad."[28] After it was paid for—at less than would be expected—it was quietly withdrawn. The Queen's preferred portrait of herself was by Hayter.

Wilkie's career as Painter in Ordinary was one of misfortune and defeat in a calling to which he knew he was unfitted, and made

worse for him by knowing that others knew it, too. He went to the Near East in 1840. There was more than one reason for this journey, but the timing of his departure may well have had some connection with what he probably realized to be his irredeemable loss of esteem at court. The *Times* later nearly allowed itself to say so outright.[29] Looking back on that last journey, from which he never returned, there is sadness in his punctilious requests for extension of leave from court as first war, and then the plague, hindered the course of his travels.

It would not be a fair account of Wilkie as a portraitist that left the matter on this despondent note. In counter-assertion to Ellesmere it must be said that Wilkie painted some half-dozen of the most remarkable British portraits of the 1820s and 1830s. The portrait of the Earl of Kellie, crucial in this discussion, is one of them. Even among the royal portraits there are moments of splendor (see cat. no. 34), but his other good portraits were mostly private (e.g., cat. no. 40). Wilkie's portraits have not been studied as a whole and they deserve to be. He painted more of them than is commonly known: more than 150 are recorded. Furthermore, in his "Remarks of Art" he wrote an illuminating section on the problems of portraiture.[30]

Notes

1. Anon. [Francis Egerton, 1st Earl of Ellesmere], in *Quarterly Review* 62 (1838): 143.
2. Paraphrased from Wilkie's words, in Cunningham, *The Life of Sir David Wilkie* (1843), 1:133.
3. T. F. Dibdin, in *Director* 1 (1807): 12–13.
4. Cunningham, 1:111; the quotation is altered here to conform with the wording of the original letter. The first of the "few portraits of . . . friends" was that of William Stodart, piano-maker to the royal family (1805; private collection).
5. Joseph Farington, *Diary*, ed. K. Cave (1982), 9:3452 (9 May 1809).

6. John Opie, *Lectures on Painting* (1809), 43.

7. Anon. [Richard Ayton?], in *London Magazine* 6 (1822): 323.

8. Cunningham, 1:219. Wilkie's feelings on portraiture in 1821 are reported by Haydon in his *Diary*, ed. W. B. Pope (1960), 2:320, 339.

9. John Constable, *Further Documents and Correspondence*, ed. L. Parris, C. Shields, and I. Fleming-Williams (1975), 223.

10. Cunningham, 1:270.

11. Cunningham, 1:482.

12. Katherine Thomson, *Recollections of Literary Characters* (1854), 2:165.

13. The exhibited portraits before 1829 were *Portrait of a Gamekeeper* (R.A., 1811), for Sir George Beaumont (cat. no. 13); *Portrait, from Recollection, of a Young Lady, Deceased* (R.A., 1813), almost certainly for Lord Mulgrave (lost); *A Finished Sketch of Walter Scott, Esq., and His Family* (R.A., 1818), painted for the purpose of engraving, with Scott's blessing (Edinburgh, Scottish National Portrait Gallery; fig. 40); *H.R.H. the Duke of York* (R.A., 1823), for Sir Willoughby Gordon (London, National Portrait Gallery). The *Earl of Kellie* was exhibited in 1829, and its significance is discussed below.

14. "Wilkie's Letters to Perry Nursey," in *Academy* 14 (1878): 346.

15. H. Miles, "Raeburn's Portrait of the 4th Earl of Hopetoun," *Scottish Art Review* 14, no. 2 (1973): 30–36; no. 3 (1974): 28.

16. Cunningham, 2:125. For an unconfirmed suggestion that Wilkie may have regarded the painting of informal portraits, at least, as an exercise in making "studies from nature the size of life," see John Burnet, *The Progress of a Painter* (1854), 2:1.

17. B. R. Haydon, *Diary*, ed. W. B. Pope (1960), 2:491.

18. Cunningham, 3:10.

19. Cunningham, 3:42, 43.

20. The better-known version at Apsley House, London, is in fact a copy by "Mr. Simpson" (presumably John Simpson), touched over by Wilkie.

21. Maria Edgeworth, *Letters from England*, ed. C. Colvin (1971), 462–63.

22. Cunningham, 3:40.

23. Abraham Raimbach, *Memoirs and Recollections*, ed. M. T. S. Raimbach (1843), 178–79. Cf.

24. M. A. Shee, *Life of Sir Martin Archer Shee* (1860), 2:92, 305.

25. Oliver Millar, *Later Georgian Pictures in the Collection of Her Majesty the Queen* (1969), vol. 1, under 1188.

26. Carola Oman, *The Gascoyne Heiress* (1968), 249.

27. Haydon, 4:258.

28. Alexander Allardyce, ed., *Letters from and to Charles Kirkpatrick Sharpe, Esq.* (1888), 2:525.

29. Obituary of Wilkie, in the *Times*, 15 June 1841, 5. Cf. *Gentleman's Magazine*, n.s., 16 (1841): 99; Cunningham, 3:284.

30. Cunningham, 3:163–79.

This essay is based on a paper given in April 1981 at the conference, "Aspects of Portraiture," held in the University of Edinburgh to celebrate the centenary of the Watson-Gordon Chair of Fine Art.

Editorial note. Because of the publication deadline, editorial changes in the text written by H. A. D. Miles for this catalogue were not approved by the author.

"The True Spirit of Observation": Wilkie as a Draftsman

David Blayney Brown

IN MARCH 1807, when Wilkie had just finished *The Blind Fiddler* (cat. no. 5) for him, Sir George Beaumont wrote of the painter to his friend William Wordsworth, concluding: "The great fault of the English school is a deficiency of drawing & I hope his assiduity will shame our artists into attention."[1]

Beaumont's words were perhaps even more nicely chosen than he knew. "Assiduity" could not have described Wilkie's practice better, for while he always remained a dedicated and prolific draftsman whose art depended absolutely on his drawings, he was not a natural or a compulsive one. Just as his creative genius was fitful, constantly in need of fresh stimulus from the Old Masters, literature, history, travel, or everyday experience, so the act of drawing never sprang from a facile or fecund imagination. We should not be misled by the number, and in many cases the apparent spontaneity, of Wilkie's drawings. Even when they appear the happiest of *jeux d'esprit*, they belong to a long and arduous intellectual process; and far from expressing certainty of purpose, they were often mere spurs to a flagging inspiration, thus being discarded almost as soon as they were put to paper.

Delacroix, observing that most of Wilkie's drawings were "sketches and rough drafts," and "beyond all praise," added regretfully that "like all painters, in all ages and in all countries, he regularly spoils his best work."[2] Yet much has survived. After giving away several hundred sheets during his lifetime, Wilkie still had over 2,000 drawings in his possession at his death, and they have since been prized precisely because their relative significance of purpose has no effect on their beauty. The "assiduity" Beaumont noticed so early in his career turned Wilkie into a draftsman to rank with the Old Masters, outstanding in any company and still unique in the British school.

Whether or not it was true, as Géricault would claim on his visit to London in 1821, that British artists "complain that their drawing is inferior, and envy the French School as the more accomplished,"[3] it is certain that no British artist has produced drawings quite like Wilkie's, or with his exact intentions. Apart from the rarity of British figure drawings, it will be apparent that Wilkie's fit perfectly into the pantheon of "master drawings"—from the Carracci through Rubens and Rembrandt to Ingres, with whom he would have whole-

heartedly agreed that "drawing is the integrity of art." His mastery of line, of the plastic form of the human figure as well as its particular expressions, his no-less enthusiastic curiosity about tonal effect and chiaroscuro, even his abiding preference for ink, pencil, or chalks, are European rather than British, realms apart from the characteristic national preoccupations with watercolor landscape or drawn portraiture.

Again, Wilkie's intensely practical and intelligent attitude to his drawings—almost all of which are preparatory studies for pictures and scarcely ever independent works, however great their beauty—belongs to an academic tradition that has never taken deep root in England. Indeed, one might reflect that Reynolds, in many ways the most academically sophisticated of British painters, was an inept and occasional draftsman, and remark the paradox that whereas Reynolds's greatness was all in his pictures, the grandeur and resonance of Wilkie's drawings can sometimes seem at variance with the low-life or picaresque character of much of his finished work. It might even appear that we are dealing with two distinct artistic personalities in the draftsman and the painter. Yet just as the drawings gave birth to the pictures, so their intrinsic nobility and elegance presage his later development as a painter of more elevated subjects. Drawing was the dynamic of Wilkie's art.

Cunningham and others relate that Wilkie was fond of drawing even as a small boy, sketching his classmates at school at Pitlessie; and it was there that he made the drawing of a scene from one of this favorite works of Scottish literature, Allan Ramsay's pastoral drama *The Gentle Shepherd* (see cat. no. 25). Unusual in being an attempt at a finished watercolor, and understandably gauche, it is nevertheless already an example of Wilkie's interest in his

Fig. 30 Wilkie, *Dancing Faun*, 1799, National Gallery of Scotland

native vernacular tradition, and proof of the influence of the Scottish artist David Allan, whose illustrations to Burns and Ramsay were widely admired; Wilkie himself was to own the 1788 edition of *The Gentle Shepherd* with Allan's plates.

Allan had been master of the Trustees' Academy in Edinburgh, but it was John Graham who instructed Wilkie on his admission there in 1799. The purpose of the school was chiefly to train designers for Scottish industry and thus it had no life class, but as best he could Allan had based his teaching on the Royal Academy in London, and his students were able to copy antique casts, a discipline for which Wilkie's aptitude was already evident in his admission drawing, after a cast of a dancing faun, now in the National Gallery of Scotland (fig. 30). To these classical examples—whose influence culminated in the *Diana and Callisto* with which Wilkie won a prize before leaving the Academy (cat. no. 1)—were added the experience of prints after Ostade, Rembrandt, and Teniers that Wilkie saw in Edinburgh. Allan himself did not encourage copying from prints and drawings,

but Wilkie's continuing interest in familiar and interesting characters, and his developing habit of observing his own features and expressions in a mirror, acted as counters to any more derivative practices. The balance of interests that was to underlie his work for most of his life was already being formed in these early years.

Wilkie's first picture, *Pitlessie Fair* (cat. no. 4), depended heavily on drawings, but in none of the ways that the later paintings were to do. Indeed, it was probably through the very haphazardness of his approach to *Pitlessie* and other early works that he learned the lessons he was to follow so scrupulously in the future. *Pitlessie* is a busy picture, but far from resolving its general effect in rough compositional sketches at the very beginning, as he almost always did later, he seems to have begun at several levels at once, sketching the village for the background, the vague jumble of figures in front of part of it exhibited here (see cat. no. 48), and capturing interesting local characters on the flyleaves of his Bible while he sat in church. In the end the composition was surprisingly successful, but it lacks the focus, the masterly control over related incidents, that came later through a more carefully organized approach to preparatory drawings. The much more concentrated study for *The Village Politicians* (cat. nos. 49 and 90), though scarcely more refined in handling than the sketch of the *Pitlessie* group, already marks a change, a recognition of the need for a rough working design of his composition and an arrangement of its principal figures. Coincidentally, an early sketch for the *Politicians* had appeared on the reverse of the *Pitlessie* drawing, and from such tentative memoranda as these Wilkie worked up to a drawing in which most of the essentials of his design were evolved.

Wilkie's studies in London from 1805 did much to clarify his early objectives. His boyhood observaton of natural expression, for example, now gained support from the lectures on anatomy given by Charles Bell, himself an Edinburgh man. These were presumably very similar to Bell's *Essay on the Anatomy of Expression in Painting*, published in 1806 with his own illustrations. Shocked by the bad drawing and ignorance of anatomy of the artists of the day, Bell began the same year to lecture to painters. His students drew both from skeletons and from the life, and far from restricting them to the ideal stasis of antique statues or the posed model, Bell addressed them to the body in motion, conditioned by passion and feeling. The interplay of action and emotion in *The Village Politicians* painted that year was surely a response to this, and it can hardly be an accident that an academy study of a straining figure appears on the verso of the exhibited drawing for the picture. Certainly Bell's teaching had lent a new dimension to Wilkie's drawing—the study of the motivation behind appearance that he himself had described as "the true spirit of observation."

His fellow student, B. R. Haydon, recalled Wilkie's skill at drawing expressions, especially in a study of "Terror with the hands up." But he was not uncritical: "Though Wilkie drew at the Academy with spirit, it was in a style of smartness, so full of what are called spirited touches that it could not be recommended for imitation to students. This style belonged to him and originated with him."[4] Wilkie's very early drawings are so rare that Haydon's comments can only be appreciated with the benefit of hindsight, but it is clear that Wilkie's graphic style was always distinctive, reaching beyond academic conventions. Nor, at first, was it particularly elegant. His first significant drawings are, as is to be expected of a narrative

artist, above all searches for subject and focus. Unlike many from later in his career they are little concerned with light and shade, or tonal effect, and in the sketches for *Pitlessie* and the *Politicians* these considerations are absent altogether while he struggles only with a mesh of lines, looking for shape and design.

By 1809, he had moved on. The beautiful little study of *Lady Beaumont's Maid on the Staircase at Coleorton Hall*, half concealed in shadow, which he drew that year when a guest of the Beaumonts along with Haydon (see cat. no. 50), is a very early example of his long-standing interest in the dramatic effects of chiaroscuro, and of a tendency, frequently seen in later drawings, to define figures against dark washed backgrounds. Beaumont, an admirer and collector of Rembrandt, had been encouraging his guests to draw candlelight effects, and though the model had been posed largely for the benefit of Haydon, who was planning a large picture of Macbeth for his host, Wilkie was too canny and cautious to miss the opportunity to study a motif that could perhaps be used later in another context. Moreover, in its deliberate Rembrandtism, the drawing exemplifies the studious approach by which Wilkie strove to refine his graphic style. If he was mainly concerned with lighting effects here, he was soon to practice control of line by copying Holbein—a replica of Holbein's drawing of the Duchess of Suffolk (Royal Collection) is in the National Gallery of Scotland—and contour and shading by studying Rubens—his copy of that master's portrait drawing of Isabella Brandt (British Museum) is in a private collection (fig. 31). From Rubens above all he learned the mastery of tonally contrasted chalks—the classical "trois crayons" of red, black, and white—which is so beautifully expressed in sheets like the *Woman Tiring Her Hair* (cat. no. 61).

Fig. 31 Wilkie after Rubens, *Isabella Brandt*, Private Collection, U.K.

Through copies of the masters Wilkie studied the art of drawing for its own sake, and one is reminded of Ingres's copying a Holbein portrait just before his death and explaining simply, "I am learning."

THE GREAT MAJORITY of Wilkie's drawings, however, were made in connection with his own pictures. His most prolific period as a draftsman falls roughly between his arrival in London in 1805 and his departure for the Continent in 1825. For the paintings that established and consolidated his reputation during those twenty years, he made vast numbers of drawings, ranging from the most rudimentary scribbles to highly elaborate studies. Although it is impossible, and invidious, to attempt to establish a chronology between the drawings within each stage of Wilkie's working process—except of course in cases where letters and other sources throw light on the matter—the phases in the development of a picture were roughly as follows. As we know from Wilkie's own descriptions and those of his engraver John Burnet, it became his custom first to try out an idea in numerous

tiny sketches, usually in pen, on any piece of paper that lay to hand, whether an envelope or the back of a bill, then to concentrate on certain details for which he would make independent studies on a larger scale and with more finish, and later to combine these into a more carefully worked-out composition; then more finished drawings would be made—for example, that for *Blind Man's Buff* (cat. no. 51)—from which Wilkie would paint the oil sketches he referred to when painting the final picture. During the course of the work, Wilkie would use both live models and lay figures, sometimes arranging the latter in a shadow box to observe the play of light and shade.

Naturally, Wilkie did not formulate this series of procedures at once, and certainly not immediately after *Pitlessie Fair*. It is true that the drawing for *The Village Politicians* (cat. no. 49) would fit perfectly into it, but Wilkie was still working rather haphazardly as late as 1808, apparently producing, as recorded in his journal, an oil sketch for *The Cut Finger* before he began drawings for it, and it was perhaps his difficulties with *The Village Festival*, a picture finished in 1811 (cat. no. 12), that did most to prompt him to a more methodical use of preparatory drawings. The "want of general compactness and singleness of effect" noticed by at least one critic[5] could well be ascribed to a failure to resolve the composition at a sufficiently early stage. Wilkie now confronted this problem directly, and for *Blind Man's Buff* completed the following year (fig. 5 and cat. no. 91) he made many more compositional studies. Mainly in pen, Wilkie's preferred medium for his earliest explorations of a theme, they display not only a new fluency and facility of handling, but also a search for a more sophisticated and tightly integrated composition. Rather than the friezelike horizontality of

Pitlessie and *The Village Festival*, Wilkie was now investigating possibilities of tension and movement in and out of the pictorial space.

By the time Wilkie made his finished drawings for *Blind Man's Buff*—in addition to the exhibited example another, very similar, is in the Castle Museum, Nottingham—he had worked out the structure of the picture, with its interlocking patterns of figures, fairly precisely. But even then he was not entirely satisfied, for the Edinburgh sheet has an insert bearing a variant design for the left half, equally carefully drawn in the tight, almost etched style that Wilkie had recently evolved for some of his finished working drawings. Perhaps because he was now paying so much attention to compositional problems, Wilkie had not at first followed his usual habit of drawing figures from life for this picture. However, adverse criticism compelled him to return to live models, and drawing from these was to be a vital element in the preparation of his most elaborate pictures of the following years, such as *The Penny Wedding* of 1818 and *Chelsea Pensioners* of 1822 (cat. nos. 18 and 23).

As is manifest from both pictures, Wilkie's art had come increasingly to focus on single incidents rather than combinations of episodes, and it was inevitable that he should attend as much to individual characters as to the composition itself. These two interests dominate his drawings for *Chelsea Pensioners*, a crucial picture marking his transition from an anecdotal approach to one determined by a solitary and significant event. At least eighty drawings, in every medium and degree of finish, survive for this highly important composition. They record Wilkie's imaginative progress from the original idea suggested by the Duke of Wellington in 1816, of a simple genre scene of old soldiers reminiscing outside an inn, to a dramatic

subject of modern history centered on the reading of the Waterloo dispatch; and they mirror his struggles to achieve a balance of interest between the numerous subordinate figures within the picture, without distracting attention from the main feature. The very basis of Wilkie's anecdotal style had been the combination of figures who, whether individually or in groups, had struck his fancy. Now, however, the intrinsic interest of minor characters was no longer the point, and Wilkie's recognition of this may be seen particularly clearly in his gradual modification of a group of figures originally planned for the right foreground. Numerous ink drawings, including the one exhibited here (see cat. no. 57), present the prominent figure of a woman looking almost to the front and tiring her hair, but, sensitive to the changing needs of his picture, Wilkie altered her pose to a profile, which is less assertive and serves to lead the eye in to the dispatch-reader at the center of the composition.

Disinclined to waste a good idea, however, Wilkie used the original pose of the woman for another picture, *The Cottage Toilet* of 1824 (fig. 13), and it was presumably in connection with this later work that he made the magnificent large drawing (cat. no. 61) that is one of his finest studies of a single figure. Full of life and imbued with a lazy sensuality that is extremely rare in his work, it was surely drawn afresh from a model. The combination of red, black, and white chalks is consciously Rubensian, whereas some of the sketches for *Chelsea Pensioners*, in their staccato handling of the pen and dark washed backgrounds, had been further exercises in the manner of Rembrandt. The refined finish of the *Woman Tiring Her Hair*, along with the lack of tonal relationship between the heavily washed and contrasted sketches for *Chelsea Pensioners* and the bright outdoor effect of the painting itself, is perhaps already symptomatic of a change in Wilkie's attitude to his drawings. Although they were still essentially working materials, their more developed techniques might suggest that Wilkie was now conceding them a certain independent status; and his later habit of signing and inscribing some of the more finished examples was further recognition of this.

Wilkie never took greater pains than he did with *Chelsea Pensioners*. Besides dozens of compositional sketches, he made drawings of London's Kings Road where the scene was to be set, measuring the ground to ensure correct proportion, and drew numerous figures both from life and, as he told Perry Nursey, from specially constructed colored clay models. The Duke of Wellington's whims together with his own changing ambitions for the picture kept Wilkie at work on it for six years, and meanwhile he was beset by requests for works of lightweight genre and busy preparing designs for other important pictures, notably his two royal commissions, *The Penny Wedding* for George IV and *The Reading of the Will* (Bayerische Staatsgemäldesammlungen, Munich), for the King of Bavaria. But as *Chelsea Pensioners* itself had shown, Wilkie was bored by such popular subjects and was reserving some of his overstretched energies to work toward a historical picture, *The Preaching of Knox Before the Lords of Congregation*, in which he hoped to interest George IV. The king was not to be tempted, but the royal visit to Scotland in 1822 provided Wilkie with material for another major work of modern history over which he was to toil for almost eight years.

The subject eventually chosen, *The Entrance of George IV at Holyrood House* (fig. 20 and cat. no. 32), gave Wilkie many problems, which, as usual, are mirrored in the drawings. Already

yearning for a new and grander style, and eager to pursue the transition from anecdote to history, he was conscious of the high public profile that attached to his theme. In fact he had been disappointed by what he had seen in Edinburgh; the sketches he made there during the royal visit were evidently uninspired, and Sir Robert Peel, to whom he showed them on his return to London, "did not think them capable of making a picture."[6] After brooding for a year or so Wilkie resumed work, but the composition continued to trouble him, its ultimate solution—if indeed it can be regarded as a success—coming mainly from an injection of baroque rhetoric derived from Rubens, whose Marie de' Medicis cycle he had admired in Paris in 1814.

One delaying factor was the need to obtain convincing portraits of a number of important protagonists—chiefly, of course, of the king himself—and portrait and pose studies feature prominently among Wilkie's drawings for the picture. The studies of the Dukes of Hamilton (cat. no. 59) and Argyll (Royal Collection) were made at an early stage; the splendid portrait of the Earl of Morton (cat. no. 60), another example of Wilkie's superlative handling of chalks, this time combined with wash, dates from a special visit to Scotland to make drawings in 1824; and Wilkie apparently still needed sittings for some of the figures as late as 1829. The more fundamental problem posed by The Entrance, however, was the same Wilkie had confronted over Chelsea Pensioners; how, as he put it to Beaumont, "to acquire what the great masters succeeded so well in, namely, that power by which the chief objects and even the minute finishing of parts, tell over everything that is meant to be subordinate in their pictures".[7]

This was not only a question of design. The solution could not come from composition drawings alone, and lay as much in painterly devices, chiefly, perhaps, in the management of light and shade. Yet in the use of chiaroscuro, and the preference for dark backgrounds to throw significant figures into relief, Wilkie was following the same path on paper and in paint. The Earl of Morton is set against somber and bold hatching in black chalk, and it is striking how, in other drawings, Wilkie subdues a confusion of line by a vigorous application of wash. The importance of tonal values in coordinating a composition was now fully apparent to him, and considered as an integral element even in very early sketches for pictures.

Thus at least the tenebrist aspect of Wilkie's later style was already evident before his extended period on the Continent from 1825 to 1828; and indeed it should be regarded less as a response to external stimulus than as a logical stage in an established pattern of development. In other respects, however, his working methods changed dramatically, and the impact fell as heavily on his drawings as on his paintings, for it was apparent that his almost obsessively elaborate preparations for pictures, often drawn out over a period of years, had been a prime cause of his breakdown. When he began painting seriously again, in Spain in 1827, he adopted a far more economical attitude toward drawing, both to spare labor and to anticipate the spontaneity he now sought in paint. The guerilla subjects painted while abroad were founded directly on broad and spirited drawings of the entire compositions or their main features, usually in chalks and watercolors; examples of these are the studies for The Defence of Saragossa (cat. no. 65) and The Spanish Mother, the latter not being used for a picture until Wilkie was back in London, when he transferred the subject from a military

to a domestic context (see cat. no. 35). These attractive drawings do not seem to have been based on trial-and-error pen sketches of the sort Wilkie had formerly made in such profusion; nor is he known to have drawn independent figure studies for the pictures.

MUCH OF THE FRESHNESS and directness of Wilkie's Continental drawings—and indeed those he made in Ireland in 1835 and on his final journey to the Holy Land—sprang from the inspiration of unfamiliar people and events, an invaluable tonic after years of working essentially the same vein. Back in England Wilkie reverted somewhat to his former practices: for another Spanish subject painted in London, *Columbus in the Convent of La Rabida* (cat. no. 35), he once again made large studies of individual figures and parts as well as of the whole design. Other pictures of the 1830s follow this trend, but in both drawings and paintings Wilkie generally managed to maintain his accelerated pace, brooding and revising less than in the past and expressing his ideas more confidently. His drawings of this decade are striking for their breadth of handling and often large scale, and the combination of chalks and watercolor that he had come to favor more and more gives them a new integrity and individuality as works of art.

Wilkie now preferred to solve his compositional problems at a very early stage, and then to move on to large and quite finished studies of specific parts of a picture which would be fitted together to construct it almost like a jigsaw puzzle—a process that can be followed particularly closely in the numerous drawings for one of the most important pictures of the decade, *Sir David Baird Discovering the Body of Sultaun Tippoo Saib* (cat. nos. 42, 76–81). Early pen or

Fig. 32 Wilkie, Composition Study (Sir David Baird placed to right), Ashmolean Museum, Oxford

pen-and-wash sketches for the composition seem at first to show Wilkie subject to some of his old uncertainties and constant revisions, but their vigor is perhaps indicative of a more sustained impetus. Wilkie characterized his approach to his patron Lady Baird in 1834: "The drawings I am proceeding with, trying changes and rearrangements in the details of the group, or, what is more the case, trying to give form and shape to what in the first sketch was vague and confused." Many of the changes essayed in the sketches were designed to emphasize the heroic role of Baird himself— "the moving principle of all that surrounds him"—and Wilkie tried him on both the right and the left of the composition (figs. 32 and 33) and in a variety of poses before deciding on the elevated stance with one arm raised to indicate the order for the removal of Tippoo's body.

As the picture was to be a night-piece, Wilkie constructed a model to create the play of shadow, and his sketches for it are among his most Rembrandtesque in their nervous penmanship and somberly washed backgrounds. They usually focus on the principal figures and

Fig. 33 Wilkie, Composition Study (Sir David Baird placed to left), Ashmolean Museum, Oxford

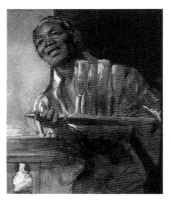

Fig. 34 Wilkie, *A Negro with a Tray of Glasses*, 1836, Duke of Buccleuch and Queensberry

generalize or obscure the background—another example of Wilkie's mature use of chiaroscuro to concentrate a composition. Other elements of the picture were worked up later from more detailed studies, for as Wilkie wrote in 1837, "the interest of the subject I find grows as I proceed. The subordinate figures and the background I generally leave till the principal figures are painted in."[8]

Wilkie's highly finished studies for *Baird* are among the most magnificant of all his drawings. Comprising studies of figures and heads, and also of costume and accoutrements including Tippoo's armor, they are usually in chalks and watercolors, and often exceptionally large, serving almost as cartoons for the picture. No such finished colored drawing of the complete composition survives, however, and to observe the relationship between studies of the whole and the parts one must turn to such drawings as those for *The Empress Josephine and the Fortune-Teller* of 1836 (cat. no. 83) and the projected *Burial of the Scottish Regalia*, for which two colored composition drawings exist (see cat. no. 72 for that exhibited) as well as a large study for three of its principal figures (see cat.

no. 73).

Though it is clear enough that the drawings of entire subjects were made to solve compositional problems, to refer to while sketching the design on canvas or panel, or to show to prospective patrons, the figure studies had a more specific function. Besides providing such ingredients as likenesses or costume details, their role was chiefly to capture expressions and gestures that would convey appropriate reactions to the situation in the picture. The drawings for the soldiers surrounding Baird (cat. no. 77), of the Indian supporting Tippoo's body (cat. no. 81), of the Negro servant attending Josephine (fig. 34), of the girl in the *First Ear-ring* (cat. no. 70), of the sleeping Peep-o'-Day Boy (cat. no. 69), of the family in *Grace Before Meat* (cat. no. 84), and of the Highland boatman for *The Escape of Mary Queen of Scots* (cat. no. 74) express this function beautifully, displaying a wide range of emotional and physical responses. Wilkie went to considerable trouble to find suitable models, or even to employ himself, to act out the dramas needed for his pictures; and it is easy to see from the acutely sensitive observation of

such details as eyes and hands, that most of these drawings were made from life.

But just as Wilkie had largely ceased to paint everyday life, so he was not simply drawing what was there. Except when he traveled abroad, he was rarely simply a recorder. Rather, his intelligence controlled and selected what he saw, and his lifelong study of human nature lent truth to what in the hands of many other artists would have seemed theatrical contrivance. His people appear real even when their situations are not because by the time he committed them to paint, he had ensured that everything they did had a purpose. "Meaning was the first thing he demanded," said Cunningham, adding the anecdote that, if reliable, perhaps best expresses Wilkie's approach to the figure, and the function of drawing in his art:

"What is this?" he said one day to a student. "It is a man, sir." "Yes, I see it is a man, yet I seldom see a man utterly idle with hands or with head; now your man is doing nothing with his hands; what is he doing with his head?" "He is thinking, sir, what he will do with his hands." "Now, young man," said the other, with a grave smile, "your answer is naught: you have made this man because you can draw well; but you should never draw any thing with the hope of others finding out a meaning for it. If you had really thought of some work for the man's hands, or some sentiment to be expressed by his head, you would have made a far finer figure, because there would have been meaning in every limb."[9]

PURPOSEFUL as Wilkie's drawings usually are, it would be wrong to suggest that he never drew for pleasure or outside the immediate context of his pictures. His dedication to his art, especially to his commissioned work, left him little time, but even before his serious breakdown in mid-career, he had several times been brought near to exhaustion. On these occasions he had sought relief less in complete rest than in a change of work, and to holidays and visits to friends can be ascribed various drawings whose subjects lie beyond his usual concerns. While convalescing at Joanna Baillie's house in Hampstead in 1810, he probably made some attractive studies of trees and plants that are now in the British Museum, and his delightful if slightly naïve views of his native Cults (cat. no. 55) and of *Edinburgh at Night* (British Museum) were almost certainly both drawn on a working holiday in Scotland in 1817—the year, incidentally, that he painted his only exhibited landscape in oil, *Sheepwashing* (National Gallery of Scotland), based on sketches made in Wiltshire two summers before.

Wilkie made several more landscape studies on his final journey to the Holy Land, but the subject was never of consuming interest to him. Portraits on the other hand, while being escapes from picture-making, contributed to his study of human expression and character—and it may have been his preeminent concern with these aspects that left his likenesses sometimes questionable. Spells away from his studio again provided a spur. The two drawings of his friend Haydon—images of youthful genius taking itself rather seriously and brought down to earth by sleep (cat. nos. 52 and 53)—derive from a holiday in Brighton in 1815; and Beaumont, noticing that Wilkie seemed happier doing something rather than nothing during his recuperation at Coleorton after a serious illness in 1810, set him to draw interesting local characters. This was of course a practice that went back to Wilkie's youthful drawings of the people of Cults and Pitlessie, and was followed throughout his life as the

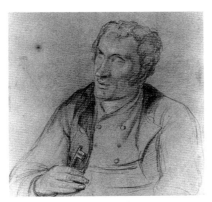

Fig. 35 Wilkie, *Blind Alick of Stirling*, 1817, Ashmolean Museum, Oxford

opportunity arose. A sketch of *"Blind Alick" of Stirling* (Ashmolean Museum, fig. 35), drawn in 1817, is an example of Wilkie's collecting of personalities; others were made on his travels in Ireland, Italy, and Spain, and many of the drawings made in Constantinople and the Holy Land are the magnificent culmination of this aspect of his work.

Wilkie's finished or commissioned portrait drawings are in a different class. Although often intimate works, they can reach elaborate degrees of finish. The portrait of Helen Wilkie (cat. no. 67), drawn with studied elegance in chalks and watercolor, is among his most highly wrought works on paper, while that of his friend and patron Sir William Knighton (cat. no. 82) was judged fit for exhibition at the Academy in 1837. The precision of line and the subtly modulated shading and hatching of the backgrounds of some of these drawings suggest analogies with printmaking—particularly lithography or soft ground etching; and indeed the portrait of the elderly Duchess of Buccleuch (cat. no. 56) was made for the painter-etcher Andrew Geddes, possibly for reproduction in a print. Such drawings are

further to be distinguished from studies like *The Earl of Morton* or *Perry Nursey* (cat. nos. 62 and 64), which, although also often considerably finished, were made in connection with pictures.

As a draftsman Wilkie was more a collector of people than of events or places. Such chance happenings as struck his fancy as potential pictures tended to be found abroad more often than at home. Lord Mahon recalled Wilkie sketching "at Toledo a little passing scene—a muleteer lighting his cigar from that of a monk," which was later incorporated into *The Guerilla's Departure* of 1829 (Royal Collection; fig. 19);[10] and *The Turkish Letter Writer* of 1841 (Aberdeen Art Gallery) preserved—with certain variations—another immediately memorable image, spotted when Wilkie was walking in Tophanna early in his stay in Constantinople, and caught in the oil sketch at Aberdeen and the drawing at Oxford (cat. nos. 45 and 86). The drawings, however, are sufficiently large or developed, in a combination of chalks, water and body colors, as to have been certainly made back at Wilkie's hotel rather than on the spot. It is clear that Wilkie relied heavily on his memory and shared little of the current enthusiasm for *plein air* sketching, and some of his compositional sketches for historical or imaginary subjects, the products often of painful feats of imagination in the studio, have a greater feeling of spontaneity than his drawings of real events or people.

At heart Wilkie was little interested in the immediate present. The Scots vernacular of his roots had soon turned to nostalgia, and it is certain that he could never have become a celebrant of modern life in the sense that the impressionists were to be, or even the British artists like W. P. Frith or Richard Redgrave who looked to his example. It is true that *Chelsea*

Pensioners, more than any other British picture of its age, made their work possible, but omnibuses, railway stations, and other soon-to-be characteristic scenes on the contemporary stage hardly claimed Wilkie's pencil, and the vivid sketch of a crowded stagecoach (cat. no. 63) stands out as exceptional. Indeed, his eye was alert for specific figures or details that could contribute to the more universal situations of his art—like the old man in the eating house where he used to dine with Haydon, who became the newspaper reader in *The Village Politicians*, or the musician in Oxford Street who was immortalized as *The Blind Fiddler*.

More than any of his followers, Wilkie used style to transcend time and subject. The shadowed tones of paintings like *The Penny Wedding* (cat. no. 18) emphasize the traditional nature—indeed the antiquity—of the subject, whereas in *The Blind Fiddler* they deepen the pathos; and in the drawings Wilkie's heightened feelings found their most immediate expression, endowing their subjects with a heiratic grandeur far beyond their intrinsic content. Thus the study for the girl drawing water in *Sancho Panza in the Days of His Youth* has a *gravitas* that rises above the Cervantes story, and even Wilkie's own interpretation of it in the finished picture (see cat. nos. 66 and 37). The masterly handling of broken line and subtle modulation of the shadows are in Wilkie's broadest style, while the Correggiesque source of the pose demonstrates his awareness of artistic tradition, seldom absent from his mind after his Continental travels. Moreover, he was now consciously imitating Old Master drawings in style and format, for example, in the studies for *The Scottish Regalia* (cat. nos. 72 and 73) where the composition, figure types, and juxtaposition of sharp penmanship with flickering washes add up to some of his most brilliant

tributes to Rembrandt.

AS WILKIE'S TECHNIQUES matured, his drawings grew in size and splendor. Although he was sometimes surprised at how much others esteemed them —putting aside at modest prices for the younger Knighton in 1837, the ones his father "seemed to wish for"—even he allowed them more importance.[11] He signed or inscribed many of the later ones, perhaps not always at the time of execution but later for gifts to friends; and to the 1830s belong a certain number of drawings that can be characterized as presentation pieces, among them the *Female Nude*, another Rubensian exercise in chalks, and the watercolor of *The Penitent Magdalen* (cat. nos. 54 and 85). Against this background it is tempting to see Wilkie's large and elaborate Eastern drawings as independent works complete in themselves. This, however, would be misleading, for it takes no account of his original intentions in going to the Holy Land, or of his tendency, now stronger than ever, to deepen the resonance of meaning in his art. The Bible was his "guide book," as it would be General Gordon's, and William Collins remembered his eagerness to draw a mother and her child at Bethlehem, for a Holy Family.[12] His acknowledged purpose had been to gather documentation for religious subjects, which, though intended to be more faithful than hitherto to the historical realities of the Holy Land, would have brought him still closer to the Old Masters. Like many of their predecessors, Wilkie's Oriental drawings were working materials, not final statements.

The majority of them are large figure studies. They are hybrid works, partly portraits, for the subjects are usually clearly identified whatever their social status, partly costume studies for

future reference, and partly genre pieces in that the figures are often in some characteristic action such as praying, dictating to a letter writer, or summoning a hookah. The need to preserve new colors and costumes accurately resulted in substantial modifications to Wilkie's style. As in Italy and Spain fifteen years earlier, he was so inspired by what he saw as to work straight away on a large scale and with some degree of finish, abandoning small experimental sketches and—save for a scattering of oil sketches of Gospel subjects—deferring the planning of pictures until his return to England. Yet there was a difference. In Constantinople and Jerusalem the subjects he was drawing were not in themselves quite what he planned to paint, and nor were Titian, Correggio and Velázquez at hand to help transmute reality into art. The vivid realism and immediacy of technique in the Eastern drawings arose precisely because they were almost always viewed independently of pictorial projects.

Wilkie's color is exceptionally brilliant in these drawings, but it is often applied only in parts, to illuminate passages of pure chalk. The manner is suddenly very modern, recalling the colored drawings of Wilkie's friend David Roberts, whose own work in the Holy Land had certainly impressed him, of J. F. Lewis who followed him to the Orient, and even the later drawings of Samuel Palmer. Rich reds and bright pinks, and bold heightenings of white body color, are laid freely over the chalk, often on a buff paper that sets them off perfectly. Joseph Nash, who lithographed the best of Wilkie's Eastern drawings after the artist's death, claimed that Wilkie disliked this paper, declaring himself "worthy of white at least";[13] but Wilkie had already used it in England and must have been aware how effective it was as a foil for his colors.

The oil sketch and drawing of *The Turkish Letter Writer* (cat. nos. 45 and 86) are distinctive, if not unique, among the Eastern subjects in being adapted for a genre picture, and it can hardly be an accident that they re-enter the shadowy world of Rembrandt, and are also the most overtly sentimental. They are exercises in picture-making in a way that the other drawings made on the final tour are not. Whether Wilkie would have later exploited others for pictures as he did his Spanish drawings—anticipating thereby the more popular Orientalism of Lewis and a host of lesser artists later in the century—must remain in question. The oil sketches left unfinished at his death were mostly for biblical or historical subjects, and the arrangement and tonality of *The Letter Writer* promise no great change in the style of his work. Distinctive as they are, the Eastern drawings do not imply quite the new departure that they might at first appear to be; nor do they suggest a commitment to drawing as an independent art. Intensely curious, Wilkie was also profoundly conservative, and it was fitting that he should end his days accumulating—with an eye never more sympathetic or acute—the visual biography of peoples who "recall, by their appearance a period of antiquity in every way removed from the present time."[14]

Notes
1. Beaumont to Wordsworth, 15 March 1807, Dove Cottage Trust, 23.
2. Delacroix to Charles Soulier, 6 June 1825, in *Selected Letters, 1813–1863*, selected and translated by J. Stewart (1971), 123.
3. Géricault to Horace Vernet, 1 May 1821, in L. Eitner, *Géricault* (1983), 218.
4. Haydon, *Autobiography*, ed. T. Taylor (1853), 1:43.
5. Victoria and Albert Museum Library, London, newspaper cuttings, 86.0.2.

6. Cunningham 2:96.
7. Wilkie to Beaumont, 14 February 1823, in Cunningham 2:99.
8. Wilkie to Lady Baird, 18 June 1827, in Cunningham 3:223.
9. Cunningham 3:493.
10. Cunningham 3:521.
11. Wilkie to Sir W. W. Knighton, 13 April 1837, Glasgow, Mitchell Library, 308895.
12. Cunningham 3:393.
13. Nash, *Wilkie's Sketches in Turkey, Syria and Egypt, 1840 and 1841*, 1843.
14. Wilkie to Sir Robert Peel, 18 March 1841, in Cunningham 3:414–19, and more correctly, in Errington, exh. cat. N.G.S. 1985, 87.

Wilkie and the Reproductive Print

Arthur S. Marks

REGARDLESS OF the role his talents might have played—and unquestionably it was considerable—a major asset in the development of David Wilkie's enormous success was surely his remarkable sense of the relationship between the artist and society at large. Quite early in his career, soon after his arrival in London in May 1805 from his native Scotland, he seems to have already possessed an acute sensitivity to the realities of his professional situation. Feeling his way about, he was able to recognize and subsequently to pursue the sorts of subjects that would be well and widely received. Even if he was not always successful in pursuing his ambitions with regard to the disposal of his paintings, he was seemingly determined to control to whom and how they would be sold. Indeed, with particular regard for the distribution of his images, he was among the first to recognize the enormous commercial benefits offered by the reproductive print. Not only did this medium have the potential for the widespread dissemination of his work, but given the practical and often expedient streak that seems to have characterized his career, especially for his production prior to 1825, it also promised the possibility of an elevated income.

Even if tempered at times by an ambivalence encouraged by the purported nobility of his calling, financial considerations always were a major motivation for Wilkie's plans and actions. Possessed of a reasonably astute awareness of his opportunities, he was able to recognize and pursue the various rewards that a suitable combination of the right subject with a means of multiple reproduction could offer. And these rewards he promptly realized could be considerable.

Following his emigration south, Wilkie's reputation was quickly established and his fame was soon widespread. His name was recognized throughout Britain, and eventually on the Continent and in the United States as well. Unquestionably, besides gossip and conversation or journalism and other literary appearances, the device that served this elevation and distribution was the print. In accounting for this phenomenon, it might be claimed that his success was in large part of an entirely new sort, for his audience was to be differently defined. Unlike most of his ambitious and academically oriented predecessors, Wilkie was prepared to reach out into the population. Rather than reacting to a restricted

constituency, he sought to attract ever broader elements to an appreciation of his work. To speak of the popularity of Reynolds, West, or Barry, for example, is to speak largely of artists whose clientele was generally socially limited to a long established elite. Their paintings, whether portraits or, more to their own liking, historical compositions, could be seen briefly at the Royal Academy or some other annual exhibition, assuming that one was willing and able to pay an entrance fee; or they could be viewed in a grand home or some other purportedly public institution, assuming that the viewer had access to such facilities. Furthermore, with regard to portraiture, the social homogeneity that joined the wealthy sitters to their audience at the same time denied recognition and self-significance to the largest share of the population. Similarly, the considerable knowledge necessary for under-standing most history pieces also denied broad access. Of course there was the rare exception, notably William Woollett's 1776 print after West's *Death of Wolfe*, which in its wide distri-bution and commercial success demonstrated the potential that existed when such publica-tions reached an expanded audience.

When we speak of the public for art prior to 1800, to use a convenient date, we are speaking at its broadest of a body made up largely of royalty and nobility, landed gentry, the clergy, and other professional individuals. Not only did they tend to be united by social and economic commonalities, but they also were constituted within certain geographical limita-tions, being centered on London and the satellite country estates that extended out from the capital. Little access to art was available in provincial cities and centers. What Wilkie was to achieve was the creation of the sorts of images that by subject could transcend these social lines, that would possess a broad accessi-bility of meaning and at the same time by reproduction could achieve a broad distribution. Assuming that these conditions could be satisfied, profitability it was believed would follow. Wilkie was to play a crucial role in recognizing, encouraging, and exploiting the rising middle-class art market.

In the course of Wilkie's early years in London, that is from 1805 to 1825 when he left England for a three-year stay on the Continent, the social structure of the nation was undergoing significant transformation and growth. Whatever the reason, whether it was the Industrial or the Agricultural Revolution, or any of the myriad other causes, there was a new and heightened social mobility with increasing pressures toward democritization and enfranchisement. By 1814, according to Colquhoun writing in that year, the vast part of a rapidly expanding population fell within what he identified as the fourth through the sixth classes and incorporated such categories of labor as "Teachers of Youth of the superior order, respectable Freeholders, Ship Owners, Merchants and Manufacturers of the second class, Warehousemen and respectable Shop-keepers, Artists, respectable Builders, . . . Inn-keepers, Publicans, and Persons engaged in miscellaneous occupations or living on moderate incomes with their families . . . Working Mechanics, Artisans, Handicrafts." Obviously, these were not the sorts of persons to whom in most cases paintings were financially available. Besides, even if they could afford such embellishments, and some occasionally were able to, it also might be suggested that as a medium painting was not accessible to them, it still being allied to other strata, that is, to Colquhoun's first through third classes, the upper reaches of society. It was the reproductive

print that would have been a more accessible medium for these newly prospering and rising individuals. Not only were prints more affordable, but of equal importance these social groups historically were more accustomed to the graphic media. Inexpensive prints, often crudely executed, had long been available to them in the form of penny prints, broadsides, crude caricatures, or some other variation.

In his search for suitable subjects, in the quest for the sorts of images that would possess a broad appeal, Wilkie was remarkably successful. It is useful to recall here some "Remarks on Painting" that he wrote in 1836 or just previously. They are self-serving; they even seem to have been composed in an attempt to justify certain marked changes that took place in his work following his return to England in 1828 after a long sojourn abroad. Certainly, one is aware that they incorporate a retrospective glance and are a fully conscious attempt to react to his earlier popular achievements. If anything, in reading through these "Remarks," there is a striking, underlying sense of commercialism present, but this is not projected negatively. Rather, it appears as a gloss of cleverness, as a confirmation of Wilkie's remarkable sensitivity and astuteness.

The text quickly acknowledges that in Britain patronage is not dependent on traditional sources of support, namely the church and the state. But even if this lack of encouragement is to be lamented, for Wilkie, unlike many of his mournful predecessors, there would be no perverse or obsessive struggle against such deficiencies. Instead, new means of support must be discovered and cultivated. He emphasizes the artist's rising reliance on a new source of patronage, the private sector. What becomes the "important question" for him is "What are the tastes and wants of those people in whose

land we live and in what way can those wants and tastes be rendered available in the higher efforts of the sculptors and painters?" In his opinion, artists are obliged to "obey public feeling as the truest index of the wants of the people." The artist should get "to know the taste of the public," and "what will best please the public is . . . the most valuable of all knowledge and the most useful to him whose skill and fancy call it into exercise."

Such an outright commercial approach as he outlined in the "Remarks," and which he seems to have followed from his beginnings in London, required the ability to determine what sort of art would secure a broad appeal. By what process appropriate subjects were to be discerned or divined Wilkie does not say, but he was fortunate enough to be able to identify and exploit them. They were, he recalled, of a "domestic rather than an historical character," and reminiscent of Dutch and early eighteenth-century French painting, they were adapted "to man's private abode and domestic residence, rather than to the abbey or the public hall."

Unlike his immediate predecessors, those who followed the dictates of the higher callings in the history of art, he preferred, to use a disparaging phrase from Reynolds, to employ his "genius on low and confined subjects." Yet unlike the works of the Dutch and Flemish little masters whom he admired, or those of his near contemporaries such as George Morland and Francis Wheatley, his were usually emboldened with a new seriousness of purpose. Rather than emphasizing the romantic or erotic or the fatuous and frivolous, Wilkie instilled his compositions with a didactic note. Although they were of a domestic character, he drew upon the tenets of history painting in an effort to endow the pictures with an emphasis on virtues and values. Instead of being represen-

tative of the aristocracy or some other social elite as had been the case in the past, these qualities reflected the interests of a broader mass, the new middle class.

Before considering the reproductive prints made after his paintings, it should be observed that Wilkie's initial contact with engraving his works came from the world of book publishing. During his early months in London when searching for sources for financial support that would enable him to continue his training at the Royal Academy, he seized upon several opportunities for employment. Some of these involvements were of a shady nature, such as making copies, actually little less than forgeries, after Netherlandish masters, but he also was involved in preparing two small canvases for *Classic Tales*, an anthology of stories edited by Leigh Hunt. Anthologies like Hunt's proliferated during the early decades of the nineteenth century, their primary purpose being to offer a variety of literature for an increasingly literate public. Often they would be ornamented with engravings, and for this project Hunt employed several artists besides Wilkie, including Thomas Uwins and Arthur William Devis. Issued monthly, *Classic Tales* was made available in the form of inexpensive individual fascicules. If books because of their price still remained something of a luxury for most people, this fractionalized means of distribution did allow for a considerable reduction in price and thus could attract an expanded audience. Wilkie's plates done for stories by Goldsmith (fig. 36) and Voltaire, and engraved by Anker Smith, appeared in January and March 1807. Although at best a diversion done within the confines of what was regarded as a minor art—book illustration—his involvement in this project would have introduced him to the commercial dimensions of the printing

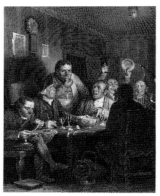

Fig. 36 Anker Smith after Wilkie, *The Clubbist*, for Leigh Hunt's *Classic Tales*, 1807

process as well as to the potential for distribution and the necessity for affordability, all being factors that would have also motivated Hunt.

WILKIE'S RISE to prominence as a painter followed upon and was rapidly sustained by his first London exhibition appearances. Initially there was *The Village Politicians* shown at the Royal Academy in 1806, with *The Blind Fiddler* placed there the following year. In 1808 he exhibited *The Card Players*, and in 1809 *The Rent Day* and *The Cut Finger*. Presumably it was the critical and popular acclaim that greeted these works which encouraged him to turn to the reproductive print, though of equal if not greater importance would have been the pressures exerted by both engravers and publishers who always were looking for opportunities of the sort that his works seemingly offered. The first of the paintings to be engraved was another painting of 1809, one that had not been on public display, *The Jew's Harp* (see fig. 37), it having passed directly into the collection of Francis Freeling, an early admirer. Possibly the decision

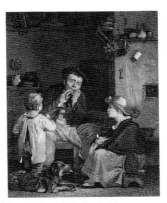

Fig. 37 John Burnet after Wilkie, *The Jew's Harp*, 1809, engraving

to proceed with *The Jew's Harp*, a small picture, with only three figures and thus easily and quickly executed, was an attempt to capitalize on Wilkie's early fame by offering an image that had not been publicly available. Just as likely it may have resulted from difficulties in securing the loan of any of the other works for an extended period. Often a year and a half to two years were required for an engraving to be made of the extensively figured compositions. Sir George Beaumont, for example, the owner of *The Blind Fiddler*, who had assumed the role of mentor early in Wilkie's career, certainly was not especially sympathetic to the apparently demeaning qualities of the reproductive media and also may have been discouraging in this effort. On the other hand, as Wilkie quickly realized, there was money to be made from prints, and money, as his diaries and other comments constantly indicate, was ever a strong motivating force for his actions.

The engraver of *The Jew's Harp* was John Burnet, a fellow Scot and a friend, someone who had studied alongside Wilkie when both attended the Trustees' Academy in Edinburgh. When Burnet followed Wilkie south in 1806, it was at Wilkie's rooms that he first called. In London, like many other engravers, he found work in the burgeoning book trade, executing illustrations. At the same time, as he recalled in some autobiographical notes, he sought some "larger form upon which to employ my graver," that is something of a sufficient size and impact that would make his reputation. The result was an arrangement for a plate after *The Jew's Harp*, with impressions to be the same size as the painting, thus suggesting that the print would be a surrogate for the painting and could serve as a suitable ornament in a residential situation. It is also worth observing that for this first effort a painting was chosen which seems devoid of any overt didacticism. Unlike *The Rent Day*, for example, with its emphasis on economic rectitude, *The Jew's Harp* was a straightforward and uncomplicated genre scene.

Executed with some haste in order to take advantage of Wilkie's rising star, the engraving was published the same year, 1809. It must have been successful, for it encouraged the pair to attempt another venture. Their next print was to be after Wilkie's most acclaimed painting up to this time, the widely admired *Blind Fiddler* (see cat. no. 5), a complex work in which morality and industry did emerge as essential concerns. For whatever reason, this effort was regarded as less successful artistically. Burnet must have dawdled with the plate, and in 1811 when Wilkie was presented with proofs he was not at all satisfied with what he saw. He made several suggestions for improvements, as did Beaumont, who passed on the recommendations to a friend.

As Burnet recalled, even after the required adjustments had been made, Wilkie was still dissatisfied with the engraver's work. He found it "cold," and consequently chose to withdraw

from the arrangement, receiving fifty pounds for his share, the others being held equally by Burnet and the publisher, Boydell. Yet despite his own misgivings the print was sufficiently successful, following its publication on 1 October 1811, to encourage Burnet to approach his friend with yet another proposal, this time that he engrave *The Village Politicians*. Not only would such an edition have benefited from the publicity that surrounded Wilkie's recent election as a full member of the Royal Academy, an election coming at the precocious age of twenty-six, but in addition it would have served as a suitable pendant to the recent *Blind Fiddler*. The hoped-for agreement was not forthcoming, not only because, as Burnet suggested, Wilkie was dissatisfied with his work, but because it already had been promised to another engraver, Samuel W. Reynolds (of whom more later). At this time, too, Wilkie was entirely rethinking his attitude toward patronage and his economic status as an artist.

Initially, his support had been of the traditional kind, with patronage coming from the nobility and gentry, often tinged by a sort of well-intentioned paternalism. Of this group of patrons, which included the Earls of Mansfield and Mulgrave and the brewer Samuel Whitbread II, the most notable figure was Sir George Beaumont, Bart., who early recognized Wilkie's formidable talent, purchased *The Blind Fiddler*, and brought his work to the attention of others. Beaumont also constantly offered him advice, whether solicited or not, at times in an overbearing, even proprietary manner, especially when it pertained to his own commissions. Constantly emphasizing the higher callings of art, Beaumont feared, as the diarist Joseph Farington recorded, that Wilkie's "greatest danger is that he might become fond of money." As early as 1808, when approached about the possibility of making some sort of financial arrangement for a print after *The Blind Fiddler*, Beaumont had informed his protégé that "I dread your engaging yourself in a traffic of any kind. It is necessary you should preserve that liberality of mind I know you possess, inviolate, or you will not give the talents Heaven has blessed you with all the fair play necessary to bring them to perfection." A man of limited means, Beaumont also feared that Wilkie might soon entirely outprice him. In the end, perhaps in an attempt to mollify his protégé, he relented and lent the picture, but he must have faced considerable pressure from Wilkie, who came to realize not only that his paintings were not bringing him their full worth, but that considerable profits could be made from the sale of reproductive prints.

Wilkie's attitude toward patronage was marked by ambivalence. Unquestionably he was pleased and disarmed by the flattery that accompanied the traditional sorts of support whereby paintings were promised to various individuals often before their completion, or entirely in advance of the conception or execution, with the price being determined at the same time. With his rapid success he was quick to realize that such premature commitments were depriving him of adequate rewards and denying him his true worth. Increasingly he was determined to avoid making any such future agreements. Rather, making the most of his popularity, he sought to take advantage of the numerous patrons who began calling at his painting rooms in the hopes of obtaining a picture. In late 1807 he had begun work on a tavern scene, *The Card Players* (see cat. no. 9), with the intention, as he stated, of "not declaring it to be for any particular person but when finished will see who is disposed to offer most for it." At other times he adopted similar

strategies and once even contemplated placing a painting at auction as a device for determining his proper commercial value.

Regardless of his ambitions, with *The Card Players* as with other works, circumstances often led him to compromise his stance, notably when he was approached by a well-positioned patron. In the case of *The Card Players*, he garnered royal patronage: William Frederick, Duke of Gloucester, made a commitment of 50 guineas for the painting. The sum was far less than Wilkie had imagined would be adequate, but in the face of such distinction he believed there was little he could do. In the end the Duke did agree to triple that price, though not without gaining the painter's contempt for undervaluing his work by such a considerable sum. Such discrepancies and the pain they brought were to be a constant problem. Wilkie yearned for the honor and flattery that accompanied these opportunities, for this sort of patronage linked him with past masters. At the same time, he resented the requisite subservience and yearned to break out of this system of support. In part he was to look to the reproductive print as a means of accomplishing this.

Samuel Whitbread, besides being an extraordinarily wealthy brewer, also had been active as a prominent Whig politician. A distinguished philanthropist, he had great concern for the nation's poor, which may have encouraged a sympathy for Wilkie's paintings and their portrayal of an earnest and industrious peasantry. Wilkie was first brought to his attention in 1807 by the landscapist Humphrey Repton, and was invited several times to Southill Park, Whitbread's Bedfordshire estate. In 1809 Whitbread obtained Wilkie's small Academy piece of that year, *The Cut Finger* (see cat. no. 11). Among the people Wilkie would

have met at Southill Park was Samuel W. Reynolds, an engraver and occasional painter who had been a well-supported member of Whitbread's household since the turn of the century. During one of Wilkie's occasional visits, arrangements must have been made for Reynolds to engrave the plate for *The Village Politicians*. However, by April 1812, Wilkie had begun negotiations to purchase Reynolds's already commenced plate and the accompanying copyright, with the intention of reborrowing the painting, which had passed into the Earl of Mansfield's collection, and entering into some new arrangement with another engraver. Beaumont had urged that he use some "masterly hand." Discussions with Burnet came to naught, for no satisfactory financial accommodations could be agreed upon. Wilkie offered an even division of the profits with no additional sum offered for the labor on the plate and Burnet wanted more. Instead a partnership was arranged with another engraver, Abraham Raimbach, who, like Burnet, had been primarily occupied until this time as an illustrator and was seeking, as he put it, "an opportunity of trying my hand upon a larger scale than I had been accustomed to, and thereby obtaining at least a chance of escape from the thraldom of devoting the labours of a whole life to the end, as it would seem, of their being shut up in a book."

Under their arrangement the pair would serve as their own publishers, and to cover Raimbach's investment of time, he would receive a three-fourths share. Proceeding apace Wilkie bought back the copyright and plate from Reynolds for 140 guineas, a sum that seems to provide a good indication of the lucrative market that existed for prints after his painting, for three years earlier he had only received 50 guineas for the painting itself.

However, such an arrangement had its hazards, the partners soon learned to their dismay. Whatever the quality of the plate might be, sales were slow, because having been cut out of the profits, the commercial dealers, most of whom also served as publishers, were "opposed to any enterprise," according to Raimbach, "originating out of the pale of their own (as they considered by right) exclusive domain."

It is likely that Wilkie's decision not to proceed with Reynolds's effort had come about because of a basic dissatisfaction with the latter's method of engraving; from his point of view, the mezzotint process that Reynolds used was entirely unsuitable for the transcription of his paintings. The early years of the nineteenth century saw a heightened interest in the recreation of light effects in printmaking, in the reproduction of chiaroscuro with an emphasis on its dramatic and emotional impact. Aquatints and especially mezzotints with their textured finishes were admired because they could recreate broad handling and strong contrasts. Together with another innovation, stippling, these methods offered an added advantage, rapidity of preparation. Speed, it was realized, was an important element in trying to take full advantage of any publicity generated by the appearance of paintings on public exhibition.

Wilkie had no great liking for mezzotints. Rather he preferred the older, even *retardataire* method of line engraving. The mezzotint process tended to deemphasize the legibility of details, and it was the discrimination of such fine points in the composition, a discrimination permitted by the line technique, that the critics and public recognized as being essential to the understanding of his pictures and their carefully phrased narrative structure. As his friend the history painter Benjamin

Robert Haydon, an artist whose ambitions were almost diametrically opposite to his own, observed somewhat bitterly—for he saw Wilkie's success as coming at the expense of his own—Wilkie's audience consisted of those who found their satisfaction in "cocking their nose close to the Picture, and let its intellectual qualities be what they may, condemn or praise in proportion to its mechanical excellence . . . even in my friend's picture. What do they admire in it? The character of the mind? No, the dutch part, the touching, the knives, the pewterplates, and tin saucepans—this is all they comprehend—this is what they look for, and this is what they see." Of necessity, to succeed, such meticulous qualities, such virtuosity, would have to be preserved in the print.

Similarly, and even though Haydon does not single out such features, stress also would have been given to the legibility of physiognomy and gesture. Unlike many of his predecessors in English genre painting, notably George Morland whose work commonly appeared in the stipple manner, Wilkie imposed a heightened seriousness on his subjects. In large part this was achieved not just by changing the nature of the anecdotal situations he adapted or invented, but also by humanizing his figures. Rather than treating them as boors or lowlifes or as vacuous swains and milkmaids, as had been common previously, he seemed to draw his characters from the immediacy of life. He elevated them by respecting and emphasizing their individuality and their expressive reactions. The reading of human nature was another of the details to which he was committed and which he realized of necessity would need to be carefully carried over by his engravers. Often he prepared additional drawings, enlargements of details, notably of hands

in their various positions, for their benefit and guidance. He recognized that the laborious attention he required could only be respected and retained in line work.

In the pursuit of such strict and limiting demands, marked for example by his difficulties with Burnet over *The Blind Fiddler*, Wilkie would seem to have forced professional compromises on his engravers. For their part the engravers would have sought some form of accommodation from him. To their minds they existed in an artistic limbo. They were in a continuous and strenuous search for status, for some acknowledgment that their calling did not just involve a process of slavish imitation, of simple straightforward and unimaginative reproduction, but that it maintained an autonomy and legitimacy and incorporated serious aesthetic decisions. The question of their status had been debated continuously in the Royal Academy almost from its beginnings and remained unresolved. At best, engravers were offered Associate rank, but professionally they were not deemed sufficiently worthy of election to full Academician. Whatever arguments were put forward on their behalf were ill received. It was claimed that conceptually theirs was an entirely different process, involving independent judgments, and therefore strictly speaking was not just a mere act of translation. Instead it was an act of transformation and conversion into an entirely different sort of art. To assert and confirm this presumed autonomy, the reproductive engravers developed various tactics, notably that of issuing proofs.

Such proofs were not necessarily touched or progress proofs, though Wilkie's collaboration with his engravers often involved the handling of such specialized sheets. Rather, they involved the publication of the various plates prior to the introduction of any or all of the inscriptions, legends, or coats of arms, which were generally inserted in the wide lower margin. These proofs were early pulls, and when copper plates were used for printing, such first impressions had an enhanced value. The quality of the cuts in soft metals like copper did not endure, but broke down and deteriorated with repeated use. Consequently, proofs offered a crispness and freshness that would soon vanish. Also, by omitting the textual elements, early proofs seemed to maintain the notion of the print as an independent art work. Limited in number, possessed of these presumed special qualities, and with an elevated cost fostered by their rarity, proofs became a pursuit of the connoisseur. They emphasized the particularity and pecularity of the engraver's contribution, for the addition of the various texts made the sheet somewhat mundane, emphasizing its repetitious commercial nature and endowing it with an ordinariness. When extended editions were required of a successful reproduction, it generally involved the engraver's recutting of the plate in an attempt to revive a sense of detail and finish.

The introduction of steel-faced plates during the second decade of the century changed many of these procedures. With their hardened surfaces larger editions with no noticeable variance in quality became possible. A burgeoning market could now be satisfied. Indeed, it was this expanding demand that encouraged the development of the new technology. Yet despite these changes, or better, in the face of them, the engravers still had to struggle to assert their individuality and to maintain some sort of specialized market for proofs, the aspect of the printing process that had traditionally emphasized their own contribution. An ironic result was not a limitation

in the issuance of proofs, but rather their proliferation. The larger the potential edition, the greater was the pressure to create and maintain uniqueness and relative scarcity in some form or another.

Both of Burnet's prints would have been from copper. Raimbach's early plates very likely also were from copper, but presumably he eventually shifted to steel facings, a technology in which he is said to have been a pioneer. In all cases, in attempts to capitalize on the painter's popularity, proofs would have been taken. It was even possible that these proofs could come back to haunt the artist's reputation. The initial unlettered pulls of Burnet's *Blind Fiddler* engraving had been taken prematurely, before the submission and application of Wilkie's corrections and of course well before his selling out his share. These sheets he had believed were destroyed, but to his dismay, when his reputation was sufficient to take advantage of heightened prices, they reappeared as rarities, never having been pulped.

Raimbach's search for an appropriate personal expression also involved the issuance of etched proofs. Frequently in the line process the plate was etched first in order to block out the larger areas tonally. The meticulous line work then followed. This procedure permitted an accelerated preparation. Prior to the introduction of engraving, proofs could be taken of the etched surface. These first impressions would have been the part of the print that in execution came closest to being the printmaker's personal contribution. It was their highly individual character, their sense of immediacy, that made them desirable and gave them an enhanced validity. They offered a suitable parallel to the interest that Wilkie was fostering for his oil sketches, for both were appreciated by discerning collectors as initial statements,

being, it was thought, as close as one could come to the original conception and execution. Like the oil sketches, these proofs also could draw a premium price because of their relative rarity.

The actual number of etched proofs published for each print is difficult to determine, and it is even harder to know when Raimbach introduced this particular format. We know from his memoirs that in the instance of *The Village Politicians* there were 250 proofs as well as an additional twenty-four "before the insertion of the coat of arms and the alteration of the etched letters of the title." The proofs of the former group were available at four guineas, and the ordinary impressions sold at half that price. Initially sales were slow, especially since the latter price was thought high for a print meant to have widespread distribution; but in time they began to be appreciated, and proofs were known to change hands at three times the original cost.

IN 1812 A SERIES of incidents pressed Wilkie to reassert his claims to fame. In 1810 a serious challenge had been made to his reputation by Edward Bird of Bristol, another genre painter (for more on this, see Marks 1982). A repercussion of that rivalry was that in 1811 Wilkie showed nothing at the Royal Academy. The following year, despite his election as a full Academician, he was still smarting over his previous treatment by his colleagues during the Bird business and presented only smaller, relatively insignificant efforts. Furthermore, his tribulations during this whole affair had brought on a somewhat incapacitating illness. Consequently he feared that his name had become less familiar. He supposed that a means of returning to prominence would be a one-person show. To that end he rented some

rooms in Pall Mall and obtained the loan of twenty-nine of his pictures, including ten oil sketches. He also displayed two long-awaited compositions that were still in his hands, *Blind Man's Buff* and *The Village Festival* (see fig. 5 and cat. no. 12).

Wilkie had not suffered a dimunition of admiration: the show was well received and encouraged him to have more works engraved. He wrote to Samuel Whitbread to obtain the loan of *The Cut Finger*, though he did not require it immediately, for—as he informed his patron—Raimbach already was occupied. Wilkie wrote, "It may be some years before the work can be begun, yet it will afford me much gratification to have the Picture when required for the above mentioned purpose as I am now applying to all the possessors of my paintings to grant me the same indulgence." Referring assuredly to the response to his private exhibition, and the potential it offered, he then continued, "I have been applied to, by some of the most eminent Engravers in this country to permit them to Engrave from my Pictures, and as of course I shall have some interest in such works, and considering what is still more important to me my reputation, it is my intention, to employ men of the finest abilities, and also to devote much of my own time, to the progressive advances of the subjects." It was at this time that he had negotiated the purchase of the copyright for *The Village Politicians* and also made arrangements to secure *The Rent Day*, then in the Mulgrave collection. All the work was to be done by Raimbach, and all the prints were to be published in a venture jointly entered into by the engraver and the artist.

Recognizing the difficulties raised by their acting as their own publishers and the limited access this arrangement offered to an audience, Wilkie assumed an aggressive role in selling the prints. For English print sellers the Continent had long been an important outlet, especially France, but during the course of the French Revolution and subsequently the Napoleonic campaigns, distribution there had been almost entirely cut off. In May 1814, during Napoleon's exile on Elba, Wilkie and Haydon took advantage of the peace and traveled to Paris. Like many other artists who took advantage of what was to be only a brief respite from war, Haydon went to see the assembled treasures that Napoleon had systematically looted during his various campaigns across Europe. Disparagingly and falsely, Haydon would later claim that his traveling companion's "principal object" while there was "to open a connection for the sale of his prints." Since it was anticipated that the war was now permanently at an end, Wilkie did expend a good part of his energy visiting various print dealers, but as his diaries indicate he also spent much time in the galleries, though undoubtedly the pictures upon which he focused his attention, notably works by Netherlandish masters, were those for which Haydon had little sympathy. He also carried with him several letters of introduction to the various shops, written in his behalf by Raimbach, who recalled that "his method of proceeding was to sally out in the morning with a roll of the prints under his arm, and call at the shops of the different dealers, submitting his merchandise to their inspection." He carried with him several impressions of the recently completed *Village Politicians*, one of which was eventually entered into the Salon exhibition where it won the engraver a gold medal. The wholesale prices requested of the dealers were sixty francs for proofs and thirty for the standard trade edition, while the recommended retail prices represented an increase of

twenty and ten francs respectively. Wilkie's reception was not especially good, though he did find one dealer, Delpech, who took a proof and two other impressions. By Raimbach's account their failure came about because "the subject was utterly unsuited to the refined and classical taste of the French nation and was evidently only calculated for the Low Countries."

In his search for expanding opportunities, Wilkie also took advantage of his family. On several occasions, he apparently forwarded impressions after various prints to his brother John, who was then on army service in India, where they must have held some appeal as reminders of home for officers serving in distant parts. He also maintained his interest in possibilities on the Continent, but had been chastened somewhat by his previous experience. With his next print, *The Rent Day*, Wilkie again traveled abroad, only this time, perhaps recognizing the relative unsuitability of his type of work for the French, he avoided France and went directly to Holland and Belgium, those lands where his style was rooted and where it was hoped he would receive a better reception. Accompanied by Raimbach, who had actually urged this journey on him, Wilkie departed in September 1816, following Napoleon's final defeat. Like many other tourists, besides tending to their own business, the pair also made the obligatory pilgrimage to the battlefield of Waterloo. They carried proofs of *The Rent Day*, for publication did not occur till the next year. In Antwerp they met little success, but fared somewhat better with the Brussels dealers. Subsequently, following Raimbach's early departure, Wilkie traveled alone to Holland. At Amsterdam, he discovered that one of the dealers he called upon already stocked impressions after several of his other paintings, having obtained them from the publisher Boydell, with whom he preferred to do business. Nevertheless, Wilkie did convince him to subscribe for several sheets from the forthcoming edition.

During these years Wilkie was involved again in book illustrations, though under entirely different circumstances. Now, unlike his earlier effort, his contributions were not made out of necessity, but were the result of gentle pressure and prodding from friends for personal projects. The earliest was done for the auctioneer and poet Peter Coxe, an early admirer of his work who also had befriended him. For Coxe's epic poem, *The Social Day*, small paintings were solicited from a good many of his friends, including, besides Wilkie, John Constable and James Ward. Wilkie's submission was *The Broken China Jar*, an illustration to a mock ghost story. Initially scheduled for publication in 1814, and then announced for 1822, the volume did not appear until 1823. The delay was due largely to the engraver, Charles Warren, who dawdled with the plate, for which he was being paid 50 guineas. Originally scheduled for completion in twelve months, the plate took him, in the end, five years to execute.

Another book illustration was for Samuel Dobree, a distinguished bibliophile and a collector of modern masters—he had purchased Wilkie's *Letter of Introduction* (see fig. 10), an 1814 Academy exhibit. In January 1818 he applied to Wilkie for illustrations to his *Book of Death*, a compilation of the deaths of more than 200 notable persons drawn from Chamber's *Encyclopedia*. Since what was required was work in a historical vein, the painter sought to beg off and instead recommended Thomas Stothard as a more suitable artist. Dobree's application to Stothard as well as to several other possible illustrators was

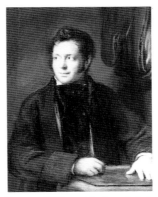

Fig. 38 Abraham Raimbach after Wilkie, *The Death of Sir Philip Sidney* for Samuel Dobree's *Book of Death*, 1819

Fig. 39 Wilkie, *Abraham Raimbach*, 1818, National Portrait Gallery, London

futile, and finally he was able to convince Wilkie to assist him. Two small paintings were prepared, *The Death of Sir Philip Sidney* and *The Death of the Chevalier Bayard*, though only the former, engraved by Raimbach, was used for the volume, which appeared in 1819 (see fig. 38).

The joint agreements between Wilkie and Raimbach in which the latter served as engraver and the two functioned as their own publisher continued through Wilkie's departure for Europe in 1825. Their ongoing relationship was recorded in Wilkie's small portrait depicting Raimbach at work, executed in 1818 (fig. 39). Included in these new agreements were prints after two paintings, *Blind Man's Buff*, issued in 1823, and *The Errand Boy*, published 1 September 1825, several weeks after Wilkie's removal for the Continent (see fig. 5; cat. nos. 91 and 19). Of the two, *Blind Man's Buff* was the more important, not only because it is the more complex work, but because it was in the collection of the former Prince Regent, who by the time of publication already had been on the nation's throne for nearly two years as King George IV.

Blind Man's Buff represented something of a shift in the painter's oeuvre, for it lacked the tenor of seriousness that generally attended his more ambitious works of a larger scale, *The Rent Day*, for example, or *The Blind Fiddler*. Active in its presentation, the scene is in some respects frivolous, showing a fun-filled game tinged with an erotic content. While children cavort with an apparent innocence, their elders romp in a somewhat friskier and more amorous manner. Derived largely from the frequent representation of this theme by French rococo artists, the painting must have been conceived from the beginning with the Prince in mind as the patron. The future monarch, widely recognized for his decidedly French decorative tastes, had commissioned a painting with the choice of subject being entirely Wilkie's own. There is little reason to doubt that Wilkie would not have gone out of his way to specifically satisfy such a prestigious patron. The effort certainly was appreciated, and for *Blind Man's Buff* he received the handsome sum of 500 guineas. Then followed the difficulty of obtaining the picture's loan so that Raimbach might proceed

with the plate, often a difficulty when a picture was prized by its owner. Finally in August 1818, the Prince made it available for three years. By the time of publication, the edition could be enhanced by the presence of the monarch's arms in the dedication.

The various prints published by Wilkie and Raimbach had mixed receptions. *The Village Politicians* and *The Rent Day* were unquestionable successes. By the time of Wilkie's death in 1841, Raimbach recalled that *The Rent Day* had sold between four and five thousand impressions and *Village Politicians* sales were not far behind. The continued popularity of both was sufficient that at times he had to rework the plates to maintain the desired legibility. The smaller *Cut Finger*, he observed, had "indifferent" sales. *The Errand Boy* was done as a companion to *The Cut Finger*, with the same measurements, in the hope that as a pair they would do better. This did not occur; he described its reception as "dull," noting that it "may be considered as not having paid its own very moderate expenses." The shortcoming of both, perhaps, was their small scale, their unimposing size, which kept them more in the realm of illustrations than pictures and consequently made them less suitable for household display.

Blind Man's Buff, a substantial work in size, "obtained a fair measure of success," but even here they miscalculated by pulling an excessive number of proofs for this edition. Wilkie had noticed that proofs of *The Village Politicians* and *The Rent Day* had appreciated on the market, having doubled in price. Seeking to take advantage of this appreciation they decided to print 500 proof sheets of *Blind Man's Buff*, with the hope that collectors would take full advantage of their offer. It was, as he said, "a capital error," and their flood of proofs never

Fig. 40 Wilkie, *The Abbotsford Family* (Walter Scott and His Family), 1817, Scottish National Portrait Gallery

resulted in any real financial advantage.

Other efforts that Raimbach and Wilkie planned jointly came to nothing; one even brought the painter despair. In the autumn of 1817, Wilkie had visited Walter Scott at Melrose, his home at Berwick on Tweed. Having met him some years previously in London, he knew Scott to be a poet and antiquarian. Like everyone else he did not yet know him to be the author of the *Waverly* novels, though Wilkie's presence in Scotland at this time had been encouraged by the remarkable success of these books. While at Melrose he did a curious oil sketch of the writer, surrounded by his family and some friends (see fig. 40). Rather than portraying them heroically, he depicted them in domestic guise, seated outdoors. No finished painting after this exercise seems to have been intended. Rather, it appears that in conjunction with Raimbach, an engraving would be prepared after the sketch. Scott and his family were pleased with the portrait and encouraged Wilkie to proceed. The following year he included the sketch in the Royal Academy

show. "From its effect there," he wrote Scott, "I shall be able to estimate what its success may be as an engraving." To his surprise and dismay it was received in entirely vituperative language, being called "vulgar" and "conceited." Having tested the waters and found them unreceptive, Wilkie abandoned the project, and the painting was not reproduced until 1828, when it was engraved by H. Worthington. It appeared in two gift annuals, *The Bijou* and *The Cameo*, with an accompanying lengthy description by Scott.

Doubtless the least successful of Raimbach's plates after Wilkie was for an enterprise he entered into by himself, having been forewarned of its probable failure by Wilkie. *Distraining for Rent*, shown at the Academy in 1816, was a work that violated what would seem to have been the painter's own formula for success. The picture dealt directly with some of the more regretful repercussions of the Peace of 1815. If his earlier paintings generally dealt with lower-class subjects, *Distraining for Rent* (fig. 16) touched upon the domestic lives of the agricultural middle class, the very sort of people to whom Wilkie had been appealing in the sale of his prints. Farmers had prospered greatly during the prolonged Napoleonic wars, but following the cessation of hostilities, when demand for their produce suddenly dropped and their debts became due, many found themselves about to be "distrained," evicted from their homes for nonpayment. On exhibition, the painting met considerable criticism for its unpleasant subject, which offended conservative critics and angered the landed aristocracy with its implications of injustice. One of his few pictures that did not go to the Academy with a buyer already committed, it also failed to find a purchaser subsequently. Fortunately for Wilkie, Sir George Beaumont

and the Marquess of Stafford intervened and arranged that it be bought for 600 guineas by the British Institution, where it was shown the following year. Again it failed to find public approbation, and the Institution's directors arranged that it be consigned to some nonpublic location for storage. They also refused an approach that an engraving be made. In 1822, at the height of their success, Raimbach again proposed an engraving, but Wilkie, recalling the previous fate of the picture and holding little hope for the print, refused to participate in any joint enterprise. Although forewarned, Raimbach persisted on his own and purchased the painting from the British Institution at its original price. Etched proofs were pulled in 1824, but the line work must have required great attention, for the print did not appear until 1828 (cat. no. 92). Even then, despite the tempering of time, it was poorly received. However, Raimbach eventually was able to recoup his investment and then some, for he sold the painting to a private collector for 200 guineas in excess of what he himself had paid.

TOWARD 1820 interest in Wilkie's work was peaking. As the painter informed a friend in April 1817, following publication of *The Rent Day*, 450 impressions had been sold in the first six days. Reflecting his search for a broader audience, he also observed that he anticipated that distribution would be widespread: "I suspect that the great sale will be in the country and particularly in the agricultural districts." But as fast as he might have wished to make his prints available, difficulties always presented themselves. Engraved work in the line technique was demanding and steel plates when introduced were more diffcult to cut, requiring still further time. Furthermore, there

always was the difficulty of securing the loan of paintings for prolonged periods, depriving their owners of a prized and admired possession. In an apparent effort to accelerate production, Wilkie once again turned for assistance to John Burnet.

Unlike the prints done in partnership with Raimbach, those that would now be done with Burnet were not entirely private efforts. Instead they were issued in conjunction with an established commercial publisher, Hurst, Robinson and Company. Having succeeded in establishing a reputation as one whose reproductive prints usually sold admirably, Wilkie was now in a stronger position to negotiate suitable financial arrangements. Burnet's first plate, *Rabbit on the Wall*, after an 1818 painting, appeared in 1821, and in 1823 he completed *The Letter of Introduction*, after the painting of 1815 (fig. 10), which records an autobiographical incident that occurred following Wilkie's initial arrival in London. Burnet's most important projects were *The Reading of the Will* (fig. 41), after the painting completed in 1820 on a special commission from the King of Bavaria, and *Chelsea Pensioners*. For *The Reading of the Will*, it had been required that Burnet spend several months in Munich, for the King had refused permission for the painting to leave Germany and a drawing that had been forwarded to assist Burnet provided inadequate guidance.

Given its scale and the number of figures involved, *Chelsea Pensioners* was Wilkie's most ambitious composition to date. Commissioned in 1816 by the future Duke of Wellington to celebrate his victory at Waterloo of 1815, it was also unusual for Wilkie in being set out of doors. At the Royal Academy exhibition of 1822 it was the outstanding success. So great was the press of the admiring crowds that a

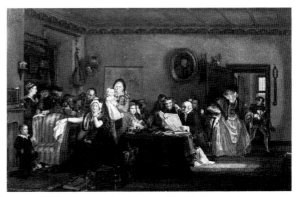

Fig. 41 John Burnet after Wilkie, *The Reading of the Will*, engraving

special guard rail was erected for protection. From Wellington he received 1,200 guineas and the copyright for the print (the engraving to be done by Burnet), which he sold to Hurst, Robinson and Company for 1,100 guineas. A startling sum, it serves to indicate the sort of profits it was anticipated the publisher would reap. Also to be given to the artist as part of the agreement was a special presentation proof, which, Burnet claimed, must have made Wilkie's total remuneration from the publisher nearly equivalent to the price of the picture. The only problem was securing the painting's loan for the engraver's work, for it was anticipated that *Chelsea Pensioners* would be required for three to four years. Negotiations did not begin for seven years, not until Wilkie had returned from abroad.

Following the severe breakdown of his health, Wilkie traveled to the Continent in June 1825. On his departure, he also left several other engravings in preparation. There was a private arrangement with Charles G. Lewis for a plate after a drawing of a Chelsea pensioner in the guise of Smollett's Commodore Trunnion. With Hurst, Robinson,

prints were in preparation by Francis Engleheart after *The Refusal*, an 1814 painting based on Burns's poem "Duncan Gray" (see cat. no. 15), and by Edward Smith after *Guess My Name* or *The Unexpected Visitor* shown at the Academy in 1821. The publisher also arranged that *Alfred Reprimanded by the Neatherd's Wife*, one of Wilkie's earliest essays in a historical vein, painted in 1806, be engraved by James Mitchell, but that was an arrangement of their own and did not involve Wilkie at all. The anticipated income from these various publications as well as that from the several prints already issued by Hurst, Robinson, had become crucial to the painter's livelihood, especially now that he was traveling. Although on occasion he did remain in one place for several months at a time, it is also evident that his production of paintings was not as great as it had been at home, being hampered by his health, his travels, and a general indecision about how to proceed in his work. Furthermore, being abroad he did not have immediate access to his usual sympathetic body of patrons. As a result, it was the credits to his account being accumulated from print sales at home that would provide the income crucial for his maintenance. This state of affairs did not endure for long.

The Great Panic of 1826, a financial collapse, coming shortly after his departure, took as part of its toll Hurst, Robinson and Company. With their failure went not only the good fortune of Wilkie, but that of numerous others, including Sir Thomas Lawrence and Walter Scott. Needless to say, when he learned of Hurst, Robinson's bankruptcy by post he was highly distraught, for as he wrote his brother, he was dependent "on them not only for my money, but for my support, to see whether time might improve my health." The news had come

as a shock. Only recently the firm had appealed to him for an additional 250 impressions of *The Letter of Introduction* and *Rabbit on the Wall,* and he had been in the process of arranging for Burnet to review the condition of those plates which had reverted to his possession prior to permitting any additional printing. Suddenly and entirely unexpectedly this whole business had come to naught and he found himself in a financial morass. His distance from London would only have exaggerated his reaction. He was not entirely ruined, but certainly he was very badly affected. For a brief time he was cheered when he heard that Hurst, Robinson was attempting a reorganization, though he did deem it appropriate to halt the progress of Smith and Engleheart with their reproductive plates until the publisher's affairs were straightened out. But in the end, these efforts failed as well and he submitted his claim against the bankruptcy for £1,730—11—0, with little hope that he would receive more than five shillings on the pound.

Eventually Smith and Engleheart resumed their work, but Wilkie had to seek other publishers for their plates. Also, though proofs were being forwarded to him for touching, it was difficult for him while abroad to follow through on any corrections and he made arrangements that such friends as Andrew Geddes, Raimbach, and Daniel Maclise might look them over and make sensitive adjustments. For example, at one point Wilkie was distressed to learn that Smith had introduced several passages of stippling into *Guess My Name* and he sought to have them removed, with the preferred line work inserted in their place. Negotiations with Colnaghi to issue this print were unsuccessful, although the company did attempt to purchase the copyright of the still unexecuted *Chelsea Pensioners,* previously with

Hurst, Robinson and Company, but which had since reverted to the artist's possession.

Duncan Gray was finally published under his own auspices, appearing 1 February 1828, well before his return to England. To judge from the instructions issued by post to his brother Thomas in London, who was handling the bulk of his domestic affairs during his absence, and who would have seen the print through publication, besides proofs of an unspecified number selling for a guinea and a half each, there were to be 600 ordinary impressions at a guinea apiece. Another account, however, implies that the latter were available for seven shillings and six pence each, a lesser price that would have encouraged still further dissemination. Following his arrival in England in the summer of 1828, *Guess My Name* was completed and appeared on 1 January 1829, under the auspices of Moon, Boys, and Graves, which had bought out the remains of Hurst, Robinson and Company. In some form of partnership, Moon, Boys, and Graves was to be responsible for the publication of the bulk of his reproductive plates through the end of his life and even a bit beyond.

Besides his involvement with the trade it should also be noted that occasionally Wilkie tried his own hand at printmaking. What he produced were not commercially viable reproductions of his own paintings, as James Barry or George Stubbs had sometimes attempted before him. Rather, at various times before his departure in 1825 he produced a number of plates in which he apparently sought to test his abilities and talents within the discrete and established tradition of the painter-etcher. There were several recent precedents for these exercises. Among Scots there was the example of Alexander Runciman and the amateur John Clerk of Eldin. More accessible personally was

the stimulation provided by a close friend of Wilkie's, the portrait painter Andrew Geddes, several of whose prints predate Wilkie's efforts. However, none of these possible predecessors seems to have been especially interested in doing genre subjects, although a possible forerunner could have been another painter he admired, Julius Ceasar Ibbetson, who did make some etchings of picturesque rural figures. His truest antecedents were the various Dutch and Flemish delineators of domestic life who also had occasionally turned to etching, most notably Rembrandt. There seems little reason to doubt that at a time when he was being regularly compared as a painter with Ostade or Teniers or even Rembrandt, he would have sought to reinforce links with that distinguished pedigree through the print media.

The earliest of these prints probably date to 1813 and seem at best tentative experiments. They exhibit a haphazardness in their preparation, being done on convenient bits of metal rather than on carefully designated plates. A character study of a man and a small interior actually are on opposite sides of the same plate, while a third scene, portraying a woman inside reading a letter to another just outside a window, is etched on the reverse side of Wilkie's calling card. *The Bagpiper*, a sketch with several fragmentary heads, seems related to studies for the 1813 painting of that subject. The earliest firmly dated prints are inscribed 1814, and seem related to observations he had made during his second trip to France, notably that of a woman at prayer in a church interior. Having been raised within the austere environment of Scottish Presbyterians, Wilkie was enthralled by the elaborate rituals of Catholicism that he encountered on the Continent. In the future several such themes were to appear in paintings, and this print may be cited

as a harbinger of that fascination. The remaining plates can be related to paintings, a fragment of *The Reading of the Will* dated 1819, for example, or fresh compositions, such as *The Sedan Chair* or *The Lost Receipt*, the latter being the only example also entirely in dry point, Wilkie's preference being for etching or etching combined with dry point.

In 1824 Wilkie published a selection of these prints. Included in the volume were seven plates on four sheets in an edition of unknown size. Omitted were the very early efforts, but included was the largest of his plates, *Benvenuto Cellini Offering His Censer for the Arrival of Pope Paul III* (7 by 5½ in.), inscribed 1824. This illustration of Renaissance patronage may have been related to an early idea for a painting, though he did not complete a painting of this subject until 1840, when it was shown at the Royal Academy. Following this publication, Wilkie seems to have lost interest in printmaking. There is a unique, undated lithograph, *Kissing the Child*, but it seems to have led nowhere. Obviously his extended absence abroad provided a critical interruption in his work as an etcher, and following his return, he had less interest in the genre subjects that had been the focus of his own printmaking efforts.

With his return, he quickly recognized the necessity of producing a series of reproductive prints not only as a means of recouping some of his losses, but to improve his future prospects. If his reputation was to succeed and be maintained, his name must be kept constantly before the public, and the wide distribution of reproductive prints remained the best device for achieving this publicity. Almost immediately he arranged for the loan of *Chelsea Pensioners* so that Burnet might proceed with the plate. He anticipated that the plate would require three

to four years, but found that the Duke only would lend the painting "at periods at which it will not be inconvenient to him to part with it. On the day he will require it he must have it again." The print was published in 1831. At Sir Walter Scott's personal request he also made four small paintings for an illustrated edition of the *Waverly* novels, which were issued from 1830 to 1834. There also were several appeals for contributions to the various gift Annuals that were just beginning their rise to popularity and that, thanks to the advantages of steel engraving, could be produced in almost limitless editions. *The Dorty Bairn*, engraved by James Miller after an 1818 painting, was included in *The Amulet*, issued in time for Christmas 1829, and the following year, *The Spanish Girl*, a painting resulting from his recent stay in Spain, appeared in *The Forget-Me-Not*. Engravings after several of his works would also appear in the Finden brothers' *Royal Gallery of British Art*, issued serially from 1838 through the late 1840s.

DURING THESE SAME later years of his career, Wilkie's painting underwent a profound transformation. His handling broadened. No longer was there the emphasis on detail that previously had been so essential to an understanding of his anecdotes and narratives, for the very nature of his work was being transformed. His designation as successor to Henry Raeburn as Limner to the King for Scotland had come as early as 1823, and in 1830 his longtime patron, George IV, had him designated principal painter to the King, a position he held under the succeeding monarchs, William IV, who knighted him in 1836, and Victoria, although she never had any great fondness for his sense of her appearance. He took all these offices very seriously. This is

not to imply that he entirely forsook the portrayal of domestic life, only that it assumed a lesser importance for him and consequently made a rarer appearance. Portraits, generally of an official nature, became his preoccupation. It was with some regret that a German visitor, Gustav Waagen, observed in 1835, "Wilkie is unhappily so overwhelmed with portraits, that he has hardly a moment for his good, natural, humorous subjects."

He also devoted himself to history pieces, the subjects primarily taken from Scottish history or emphasizing Scottish heroes. Included were *The Preaching of Knox* (1832), *Knox Dispensing the Sacrament* (1839), *Mary Queen of Scots Escaping from Loch Leven Castle* (1837), and the gigantic *Sir David Baird Discovering the Body of Sultaun Tippoo Saib* (1838) (see figs. 17 and 22; cat. nos. 43 and 42). Many of these were engraved, including *Knox Preaching* (cat. no. 96), published in 1838, the work by George Doo on a plate 28 by 22 inches, which made it, as Wilkie noted, "about the largest ever done in line manner."

Yet the majority of paintings that continued to be translated into reproductive prints, with publication continuing well into the decade following Wilkie's death, were after his popular scenes of domestic life painted before 1825. If his current paintings were directed to a restricted audience, it was these earlier pieces that would maintain his public reputation. Included were *The Penny Wedding* (cat. no. 18), published in 1832 after an 1819 companion to *Blind Man's Buff* that also had entered the Royal Collection, and *The School*, which appeared in 1845. The former had been engraved by James Stewart, another Scot, trained in Edinburgh under Robert Scott, the same master who earlier had taught Burnet. On obtaining the picture on loan in December

1828, Wilkie noted the King's generosity "so handsomely, evinced to me on my first landing, to restore me to *better times*." *The School,* engraved by Burnet after an unfinished painting, doubtless involved a good bit of invention on the engraver's part. In his remaining years, Wilkie even began to permit several prints to be executed in mezzotint, *The Maid [Defence] of Saragossa,* for example, a heroic scene painted while in Spain which was derived from an incident during the Peninsula War. Issued in 1837, the work was engraved by Samuel Cousins, a former pupil of S. W. Reynolds. Although he had earlier rejected this technique, Wilkie now found it suitable for his new style, with its broadness of handling and emphatic tonal qualities. Furthermore it permitted a speed of execution that was highly desirable. Indeed, Wilkie now was so satisfied with the mezzotint process that he even recommended it to others.

There are several testimonials to the value of reproductive prints in dispersing and maintaining Wilkie's fame through the first half of the nineteenth century. For example, at the posthumous auction of Wilkie's artistic property at Christie's in May 1842, six plates and the remaining stock of prints for each achieved a total price of £970—4—0. Individually the different lots reflected their previous sales records, with *The Village Politicians* the favorite, selling for £367—10—0, while at the opposite end of the scale the failed *Errand Boy* brought only £50—8—0. Further indications of their circulation comes from the evidence, admittedly fragmentary, of the sizes of the different editions, not to speak of the publication of hitherto unengraved works, following the artist's death in 1841. A particular culmination of this enthusiasm was *The Wilkie Gallery*, a folio compilation of seventy illustrations after his

work, many after previously unpublished paintings or drawings, and the remainder in new versions, engraved by George or William Greatbach. Issued serially between 1848 and 1850, they were accompanied by the artist's biography and, for some of the pictures, descriptive texts. For enthusiasts there also appeared two handsome volumes of lithographs by J. Nash after Wilkie's recent sketches in the Middle East.

Wilkie's fame also extended well beyond the borders of Britain. Raimbach said that "his celebrity might truly be termed European," but even this description is inadequate, for his reputation was more worldwide. As has been noted, there were painting commissions from Germany, but he also found patrons as far afield as Riga, Latvia, and New Orleans. As for his prints it will be recalled that he personally sought out dealers and encouraged sales in France, Belgium, and the Netherlands. While abroad again from 1825 to 1828 he did the same in Italy and Spain. There also were the impressions he had forwarded to his brother John in India.

Further testimony on the international level comes from the numerous pirated prints, copies of the original editions. Forgeries and unauthorized imitations flooded the market. Not only do these variants confirm Wilkie's success in creating a market, but they seem to demonstrate a lack of success in exploiting it fully. Somehow the official productions—whether in volume, cost, or general circulation—could never properly satisfy demands. In the early 1820s, in an otherwise undatable letter, Wilkie informed Raimbach that Hurst, Robinson was prepared to "go to law" in pursuing unauthorized versions of *The Blind Fiddler* and *The Rent Day*. Besides copies being made at home there was a proliferation of fakes on the Continent.

Wilkie's reputation had been slow to grow in France, but by 1817, when a friend, the painter C. R. Leslie, visited Paris, he found it to be "very high." As a local informed him, with reference to Benjamin West, then still President of the Royal Academy, "I like your Vilkie, but I don't like your Vest." An undesired repercussion of this rise in reputation was the proliferation of French prints of varying quality, often in aquatint, since speed in bringing them to market would have been a prime consideration. In 1818–20 J. P. M. Jazet published a suite of three, *The Blind Fiddler*, *The Village Politicians*, and *The Cut Finger*. Three years later he produced *Blind Man's Buff* and *The Rent Day*. Others followed by additional publishers such as the Bettanier brothers and Edmé Bovinet, who in 1826 issued *The Village Politicians*, *Blind Man's Buff*, *The Rent Day*, and *The Reading of the Will*. Unquestionably *Blind Man's Buff* was the great favorite and had the largest circulation. Being a popular French subject it found a sympathetic audience. Besides Raimbach's original, it is known to have gone through at least eight other editions. Some acknowledge Wilkie and Raimbach in the legend, while others give the illusion of being entirely original conceptions. Indeed, in some there are changes in details, notably in the costumes, which although minor in character are nevertheless sufficent to transform the scene from an English subject into a French one.

There was a similar distribution of genuine prints and copies in Germany, the latter notably by Theodor Janssen of Düsseldorf. Unlike in France, where Wilkie's works seem to have had little impact on the local artists, in Germany he was to be widely imitated. His paintings could have been known by some at first hand, the result of a trip to England or, in the case of *The Reading of the Will*, to Munich,

but there can be little doubt that it was the reproductive prints that had the greatest importance in disseminating Wilkie's images. Inspired by his example, numerous painters, notably Johann Peter Hasenclever, Joseph Danhauser, and Ferdinand Georg Waldmüller, took up such themes as *The Reading of the Will*—obviously because of its convenience—*Distraining for Rent*, *The Village Politicians*, and *The Blind Fiddler*.

Finally there is America, another place where prints would have been dispatched almost from the beginning. Of the excessive number of proofs of Raimbach's 1814 edition of *The Village Politicians*, for example, the engraver was to recall, "we sent a large quantity on a venture to America and never received any tidings of them more." However, the United States was to prove receptive to this sort of image, which was regarded as being especially suitable for a democracy. As early as 1813, John Lewis Krimmel was showing his painted copy of *The Blind Fiddler*, done after the 1811 Burnet engraving at the Pennsylvania Academy of Fine Arts (fig. 42). The next year he produced his picture of *The Cut Finger* and in 1817 that of *The Jew's Harp*. For these copies he was quickly dubbed "the American Wilkie." The catalogues of the Academy show that such copies after Wilkie, generally by minor artists, were also popular during the 1830s and 1840s.

Before and just after the Civil War numerous other painters treated themes similar to Wilkie's, having no doubt been stimulated by his works. It is difficult to determine just how closely Wilkie was followed in untraced works such as Christian Mayr's *Blind Fiddler*, exhibited at the Pennsylvania Academy in 1837 and 1847, George W. A. Jenkins's 1842 treatment of the same image, and John Gadsby Chapman's 1837 *Blind Musician*. Certainly, a

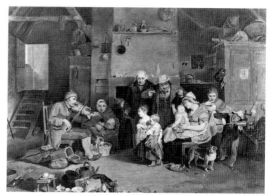

Fig. 42 John Lewis Krimmel after Wilkie, *The Blind Fiddler*, 1812, Berry-Hill Galleries, New York

direct indebtedness can be seen in Eastman Johnson's 1866 *Fiddling His Way* and in Mayr's *Kitchen Ball at White Sulphur Springs*, (fig. 43) of 1845, which bears comparison with *The Penny Wedding*. Another painter whose compositions were frequently derived from Wilkie and who often was compared to him was Francis Williams Edmonds, whose *First Aid*, for example, derives from *The Cut Finger*. But Wilkie's importance for American painters went well beyond providing specific subjects for imitation. Rather, he might be recognized as providing an overall stimulus for the American genre painters; William Sidney Mount and George Caleb Bingham, perhaps the finest painters in this manner before 1850, seem to have used Wilkie's work as a lexicon, drawing upon it regulary for ideas and motifs. As a result, Mount also was to be publicly dubbed "the American Wilkie."

By mid-century Wilkie's reputation was undergoing major changes. In France and Germany he seems to have gone into decline. Perhaps the failure of the movement toward democracy in those lands marked by the collapse of the Revolutions of 1848 led to his

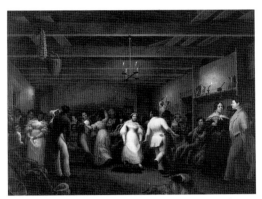

Fig. 43 Christian Mayr, *Kitchen Ball at White Sulphur Springs*, 1838, North Carolina Museum of Art, Raleigh

falling popularity. In America, it was the Civil War that led to his eclipse. Wilkie's work and that which followed upon it represented a stable agricultural existence, almost idyllic in character, but that cataclysmic event transformed the land, and subsequently the portrayal of the nation's domestic life seems to have lost favor. In Britain, however, he remained a favorite, being admired by members of the pre-Raphaelite group and holding his importance for the vast number of Victorian genre painters.

Sources
Besides the standard biographical materials, notably Alan Cunningham's *Life of Sir David Wilkie* (London, 1843), the following sources have been used in the preparation of this essay:

Alexander, David, and Richard T. Godfrey. *Painters and Engraving: The Reproductive Print from Hogarth to Wilkie*. Exhibition Catalogue, Yale Center for British Art. New Haven, 1980.

Altick, Richard. *The English Common Reader*. Chicago, 1957.

Burnet, John, "Autobiography," *The Art Journal* 12 (1850): 275–77.

Clark, Henry N. B. "The Impact of Seventeenth-Century Dutch and Flemish Genre Painting on American Genre Painting, 1800–1850." Ph.D. diss., University of Delaware, 1982.

Deuchar, Stephen. *Paintings, Politics and Porter: Samuel Whitbread II and British Art*. Exhibition catalogue, Museum of London. London, 1984.

Dodgson, Campbell. *The Etchings of Sir David Wilkie and Andrew Geddes*. London, 1936.

Godfrey, Richard T. *Printmaking in Britain*. New York, 1978.

Harrison, J. F. C. *The Common People of Great Britain*. Bloomington, 1985.

Hoover, Catherine. "The Influence of David Wilkie's Prints on the Genre Paintings of William Sidney Mount. *The American Art Journal* 13 (Summer 1981): 4–33.

Hunnisett, Basil, *Steel-engraved Book Illustration in England*. London, 1980.

Keyes, Donald D. "Aspects of the Development of Genre Painting in the Hudson River Area Before 1852." Ph.D. diss., New York University, 1973.

Immel, Ute. *Die Deutsche Genremalerei im Neunzehnten Jahrhundert*. Heidelberg, 1967.

Pointon, Marcia, "From 'Blind Man's Buff' to 'Le Colin Maillard': Wilkie and His French Audience." *The Oxford Art Journal* 7 (1984): 15–25.

Raimbach, Abraham. *Memoirs and Recollections*. Edited by M. T. S. Raimbach. London, 1843

Raimbach, Abraham, and David Wilkie. Correspondence. Manuscript Collection, The Huntington Library, San Marino, California.

Rix, Brenda D., *Pictures for the Parlour: The English Reproductive Print from 1775 to 1900*. Exhibition catalogue, Art Gallery of Toronto. Toronto, 1983.

Sir David Wilkie's Psychiatric State

Sir Ivor Batchelor

RECENTLY a prominent historian of nineteenth-century British art referred to Sir David Wilkie's life-history as being "clearly deeply neurotic."[1] There is no case history to which we can turn, and contemporary witnesses are not explicit, but a scrutiny of the literature allows us to say, as clearly but in contradiction, that there is little or no evidence of a psychiatric nature that could support this assertion of neuroticism. Wilkie's mental instability was of another sort. The facts appear to be as follows.

Family History

There was a family history of psychiatric illness. Wilkie's father appears to have had two attacks of what was probably depression: one in his twenties, when he "fell sick of the worst of all diseases—hope deferred";[2] the other fifteen years later when he was cured of an illness, "brought on by study and anxiety," that threatened his life.[3]

Personality

Wilkie was a rather typical, canny Lowland Scot. Initially slow, diffident, and awkward, he grew up to be sociable and widely popular. The modesty, mildness, kindness, and gentleness of his disposition were often remarked upon. It could be said that he had some obsessional traits in his attention to detail, conscientiousness, and punctuality, and in his prudent, cautious, and deliberate ways. He was no doubt very conventional, fearful of offending, and always mindful of the proprieties. Benjamin Robert Haydon attacked his timidity and self-interest, and described him as "a slave to the great and the World."[4] Sir Walter Scott, like many others who knew Wilkie, appreciated "the virtuous simplicity of his character."[5] He seems at times to have been hypochondriacal. He did not marry.

This is not the picture of an intense neuroticism, of a personality riven by mental conflicts.

Psychiatric Illness

Wilkie suffered at least four episodes of psychiatric illness.

At age twenty-one (1806), he had "a long period of doubt and depression";[6] but it is uncertain how disabling this was and if it constituted an illness.

At age twenty-two (1807), he had a "fever brought on through excitements by sea and

land,"[7] which lasted for about four months, until October. This "fever" was probably a depressive illness.

At age twenty-four (1809), he had a further attack, which was briefer, lasting apparently less than one month (July).[8] It had no obvious precipitant. A "cloud . . . hung about him"; he had "doubts and fears"; he couldn't paint.

At age twenty-five (1810), he had an unequivocal attack of depression, precipitated by the Council of the Royal Academy advising that he withdraw a painting submitted for the Annual Exhibition and thus avoid a challenge by his fellow artist Bird (who had submitted two paintings of the same type) to Wilkie's reputation as the leading painter of genre.[9] Again he felt unable to work. He "could neither think nor paint for a quarter of an hour at a time without experiencing a giddiness of the head." He wrote home "despondingly": port wine failed to "restore either his looks or his spirits." Again he referred to his illness as a "fever." In December 1810 Sir George Beaumont wrote to him, "Endeavour to keep up your spirits; remember that is a main point in a nervous case, as I am confident yours is." This attack of depression lasted about five months (April-September).

Wilkie's major depressive breakdown occurred when he was aged forty (1825).[10] It was precipitated by a "combination of disasters": The deaths of his mother, two of his brothers, and his sister's fiancé (in Wilkie's house) all occurred within a year, and a third brother became financially embarrassed. His depression began in February 1825, and it lasted for at least ten months. His mind was "harassed by depressing events"; he felt dull and low in spirits, complained of persistent mental fatigue and of dizziness, and could not concentrate his mind for more than half an hour. His friend the

engraver Abraham Raimbach diagnosed Wilkie's illness as "nervous disorder."[11] Wilkie himself recognized that the malady was in his head and described it as a "state of nervous debility"; but his doctors variously and confusingly prescribed travel (abroad), rest, abstinence, a vegetable diet, and the application of leeches to his feet. By December 1825 he had spontaneously considerably improved, and had begun to draw again. But for many months after he had visibly and apparently clinically recovered, he continued to complain of a "want of energy for continued thought" and considered himself still an invalid. He had obviously lost confidence in himself and had become somewhat hypochondriacal. He was painting consistently, if cautiously, by October 1826.

In February-March 1828 (aged forty-three), in Madrid and still complaining of his "malady," Wilkie may have had an episode or swing of excitement.[12] He adopted a "larger" and "bolder" style and reported that "pictures are growing up under my hands with even greater rapidity than they used to do . . . the quantity of work I have got through all seem surprised at . . . with me no starved surface now—no dread of oil—no perplexity for fear of change."[13] Blaney Brown remarks that "Wilkie's new simplicity of method did not last for long."[14] If it was a hypomanic reaction, it was a mild one.

The Sequelae of Illness
Wilkie had no further serious psychiatric illness before his death at age fifty-six (1841); but his state of health was not robust. He continued to complain, at least intermittently, of easy fatigability. Haydon referred to "his unhappy debility of constitution." On 27 June 1828 Haydon found that Wilkie was "thinner, and seemed more nervous than ever. . . . He looks

radically shaken."[15] Two days later he found him better. Haydon, an excitable witness, also thought that marriage was Wilkie's "only chance of recovery."[16] On 12 April 1829 Haydon "Called on Wilkie, Found him again ill and shattered and ill. He will never be able to finish another Picture properly."[17] But in April-May Wilkie sent eight pictures to the Royal Academy's exhibition, and later in that April he was painting the King. In November Haydon reported that Wilkie "has recovered. His illness was principally owing to a disappointment in a matrimonial connection."[18] In July 1831 "Wilkie called after an absence of one year and a half. He was old, shaken, cold, nervous, and mean looking."[19] But in April 1832 he was looking, again according to Haydon, "remarkably well."[20]

This apparently marked variability in Wilkie's emotional state and appearance suggests that he may have experienced depressive moods or longer depressive troughs, short of a breakdown into frank illness.

Diagnosis
The evidence cited above is sufficient to justify the conclusion that Wilkie suffered from a phasic psychiatric illness, manifest in recurrent attacks of depression (and possibly also in a mild attack of hypomania or morbid excitement). Some of the attacks of depression were precipitated by external events and consequent emotional stress; others were not: they lasted for weeks or months. Between these attacks Wilkie was mainly mentally well, busily creative and active socially. On his last visit abroad (1840, at Constantinople) he reported that his health was "excellent." These facts, taken with the family history and his own traits of personality indicate a diagnosis of manic-depressive psychosis. The illness was intermittent and psychotic, not neurotic.

The Effects of Manic-depressive Illness on Artistic Production
Many artists expressing themselves in painting or writing have suffered from this type of psychiatric illness; and it appears that it, or the underlying predisposition, may sometimes be the seed-bed of their creativity. The illness may declare itself in attacks of depression or of mania (morbid excitement or elation), or of both. Depression usually seriously impairs productivity. The painter feels acutely the loss of motivation and concentration; every action is an effort and a burden to him; he is slowed down; he thinks with difficulty; and very often he cannot paint at all. If he does take up his brushes, his lack of inspiration may be evident, his subject matter gloomy or morbid, his drawing wooden, his colors dull or dark. It is an emotional swing in the direction opposite to depression, toward elation, in its early stages or if it remains mild, that commonly releases and propels creativity. At such a time the individual feels buoyantly well and will deny that he is ill in any way. But if the reaction of elation becomes acute, a state of mania, conduct becomes so disordered that artistic production is impossible. With these clinical phenomena in mind, knowing the dates of the artist's illnesses and their type, and allowing for subtleties, complexities, and individual variations in the connection, art historians may with some confidence relate the quantity and quality of an artist's work to his mental state.

Notes
1. M. Pointon, *Burlington Magazine* 77 (1985): 733.
2. A. Cunningham, *The Life of Sir David Wilkie* (1843), 1:5.
3. Cunningham, 1:8.
4. B. R. Haydon, *The Diary of Benjamin Robert Haydon*, ed. W. B. Pope (1963), 5:57.
5. Sir Walter Scott, *The Letters of Sir Walter Scott, 1825–1826*, ed. H. J. C. Grierson (1935), 215.

6. Cunningham, 1:111.
7. Cunningham, 1:149f.
8. Cunningham, 1:239f.
9. Cunningham, 1:305f.
10. Cunningham, 2:140ff.
11. A. Raimbach, *Memoirs and Recollections of the Late Abraham Raimbach*, ed. M. T. S. Raimbach, (1843), 172.
12. Cunningham, 2:506f.
13. Cunningham, 2:524.
14. D. B. Brown, *Sir David Wilkie, Drawings and Sketches in the Ashmolean Museum* (1985), 18.
15. Haydon, 3:285f.
16. Haydon, 3:301.
17. Haydon, 3:353.
18. Haydon, 3:405.
19. Haydon, 3:527.
20. Haydon, 3:606.

Catalogue of Paintings

1. Diana and Callisto

Canvas; 22¾ × 28½ in. (57.8 × 72.4 cm.)
Lent by The Chrysler Museum, Norfolk, Virginia.

History and Provenance
Painted in 1803/4. After the death of his father in 1813, the picture was sent to Wilkie in London with other effects from the manse at Cults. Wilkie Sale, 30 April 1842, bought by Coles, £48—6—0; (Philip Eberle, 1881?); Walter P. Chrysler Jr. and given by him to the Museum in 1971.

Literature
Burnet (1848), 106–7; Cunningham, 1:44.

Formation
Painted in competition for a prize given at the Trustees' Academy in Edinburgh for a historical composition in oils. Cunningham wrote: "In the year 1803, as Thomas MacDonald tells me, who was in the Trustees' Academy with Wilkie, the subject selected for the ten guinea premium was that of Calisto in the bath of Diana: this was won by Sir David." The subject may indeed have been set in 1803, but the result of the competition was almost certainly that recorded in the Trustees' minutes for 29 February 1804 (ERH: NG.1.1.31, p. 305). John Clerk, later Lord Eldin, an advocate and a collector (see cat. no. 23, under Versions), was the examiner: "The highest premium which Mr. Clerk proposes should be £9 to David Wilkie for the Historical picture." (On the same occasion, John Burnet, who will reappear later as one of Wilkie's engravers and biographers, won the third prize of £1 for his drawings after plaster casts.)

Comments
The Trustees' Academy in Edinburgh was opened in 1760, under the administration of the Board of Trustees for Fisheries, Manufactures, and Improvements in Scotland. Its concern was to improve the level of design in manufactured goods, principally textiles. Wilkie was a pupil at the Academy from 1799 to 1804. In his time the Master was John Graham (1754 or 1755–1817), an obscure painter of history and portraits who nevertheless elevated the purpose of the Academy and laid the foundations for the development of Scottish painting in the nineteenth century. An important innovation on his part was the introduction of exercises in the art of painting itself (rather than simply of drawing, as at the Royal Academy in London); the prizes were part of Graham's endeavor to encourage this. Wilkie always held him in affectionate regard. For more on this see Miles 1975–77.

John Burnet wrote of the picture as one in which Wilkie's "close observation of nature was apparent, however inappropriate to the higher walks of art: . . . [in this example, Callisto] was made to blush with so deep a colour in the ear and the upper part of the neck as gave Graham an opportunity . . . for descanting on the difficulty of introducing the peculiarities of familiar life into the higher branches of the art." Wilkie was soon to face the problem of reconciling natural observation with the abstract convention of history painting (see cat. no. 6).

This is one of two surviving examples, and the last in date, of the seven paintings of literary subjects known to have been painted by Wilkie while at the Trustees' Academy. All were presumably small by the normal standards of history painting at the time. They were: *Coila Crowning the Bard* (1802; from Burns's "Vision"), *Sir William Tells Patie's Fortune* (1802–3; from Allan Ramsay's *Gentle Shepherd*), *Patie Disbelieves Sir William's Prophecy* (1803?; from the same; private collection), *Norval and the Hermit* (1803; from John Home's *Douglas*), *Ceres in Search of Proserpine* (1803;

from Ovid's *Metamorphoses*), and *Lady Macduff Defending Her Son* (2d prize, 1803; from Shakespeare's *Macbeth*).

Drawing
Edinburgh, National Gallery of Scotland.

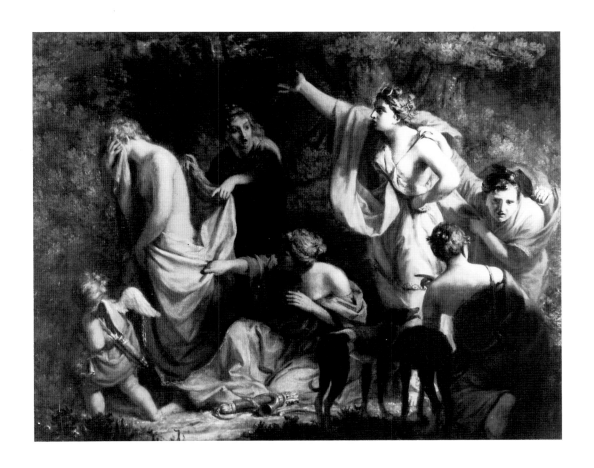

1. Diana and Callisto

2. William Bethune-Morison with His Wife and Daughter

Canvas; 49½ × 40½ in. (125.7 × 102.9 cm.)
Signed, and dated 1804.
Lent by the National Gallery of Scotland.

History and Provenance
Painted in 1804, it remained with the sitters' descendants until bought by the Gallery in 1985.

Exhibition
Edinburgh 1981; Edinburgh and London 1986.

Comments
William Chalmers of Pitmeddan (1744–1807) married Margaret Bethune (otherwise "Beaton") in 1782, and assumed her name. She was the heiress to Blebo, an estate some three miles east of Cupar, Fife, which passed to him at her death. On his second marriage, to Isobel Morison of Naughton (1760–1850), who is shown with him in the portrait, he assumed the additional name of Morison. By this second marriage he had his only child, Isabella (1795–1818). Chalmers, as William Bethune of Blebo, was Principal Clerk of Chancery. Although this was a sinecure obtained by purchase, it seems probable that he was a lawyer, perhaps practicing in Cupar.

Isabella appears in another group portrait by Wilkie, of the same size, and dated 1805 (private collection). It represents her with her grandfather, James Morison of Naughton, and a dog called Sailor. In both these portraits Isabella embodies the union and the hopes of the families of Bethune and Morison.

As well as these two group portraits (and possibly a third), Wilkie painted about this time thirteen recorded portraits in oil of single sitters other than members of his family; nearly all the portraits have survived into this century. He seems to have begun in 1803 with a few portrait miniatures—in effect small finished drawings. The oils appear to belong to the months between the latter part of 1804, when Wilkie left the Trustees' Academy, and May 1805, when he left Scotland for London. The portraits may be interpreted without cynicism as potboilers cheerfully undertaken, and doubtless salted by the flattery to his youthful abilities that the commissions implied. Yet there are also suggestions that a number of these early portraits may have been commissioned with the specific intention of encouraging and supporting the talent of a young man native to the district of Cupar, the son of a man respected there. Indicative of this is the observation that nearly all the portraits are of local landowners and professional men, some of them related to each other. What Wilkie got for a portrait at this time is suggested by the £5 mentioned in the case of one and the £10 in the case of another.

This group portrait is not simply remarkable as a display of ambition in a youth of about nineteen; it also distinguishes itself from among Wilkie's other still accessible early portraits as being perhaps the least obviously indebted to the example of Raeburn. The group painted in 1805 of Isabella and her grandfather, as a natural point of comparison, is in its openness of composition and handling related unhesitatingly to Raeburn. In this earlier work, on the other hand, the three figures are brought together, even compressed, into a firm physical and emotional unity—a unity reinforced by control of abstract color. Groups of this condensed character are more common in French than in British portraiture of the later eighteenth century, but it is unlikely that Wilkie had seen such portraits in the original. Parallels, perhaps not entirely fanciful, might be found also in the grouping of figures in sixteenth-century Italian prints of religious and allegorical subjects.

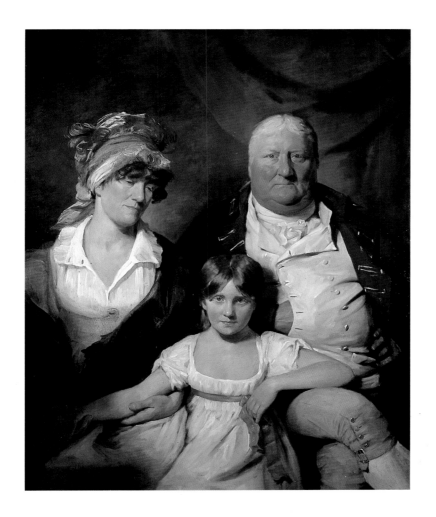

2. William Bethune-Morison with His Wife and Daughter

3. Self Portrait

Canvas; 20¼ × 24 in. (74.3 × 61 cm.)
Lent by the Scottish National Portrait Gallery.

History and Provenance
Painted in 1804/6. Said to have been given by Wilkie to Sir William Knighton (see cat. no. 31), who acquired it not long before 6 July 1833. He died in 1836 and the portrait was inherited by his son, Sir W. W. Knighton; his sale, 23 May 1885, bought by Agnew, £115—10—0, and sold to Robert Rankin, 1885; his sale, 14 May 1898, bought in and presented to the Gallery by his brother, John Rankin, the same year.

Exhibitions
Edinburgh and London 1958; Edinburgh 1985.

Comments
Of the six surviving self-portraits, this is the most important; for another of them see catalogue number 44. Apart from these, it was a matter of contemporary remark that in his early career Wilkie made use of his own features in other compositions. People who had known him as a young man identified his likeness in *The Village Politicians* (private collection), *Alfred Reprimanded by the Neatherd's Wife* (cat. no. 6), and in *The Blind Fiddler* (cat. no. 5). A drawing of Wilkie made by Haydon in 1807 (reproduced in Haydon 1876, 1:252) offers visual evidence of the rude energy with which Wilkie could impress his features, and which is recognizably reflected in those pictures. This early testimony makes it possible to detect Wilkie's grimacings in other early compositions—kaleidoscopically in *Pitlessie Fair* (cat. no. 4). After such pictures as *The Village Politicians* and *The Blind Fiddler* had made a lion of him, Wilkie became in turn a subject for other painters, mainly friends.

The dating of this portrait depends primarily on a drawing for the hands. This is on the back of the sheet on which Wilkie drew the buildings in the background of *Pitlessie Fair*, a picture that dates from 1804. Also on the back of the sheet is a group of figures at a table, which has the appearance of being an adumbration of *The Village Politicians* of 1806. The portrait is usually accepted as having been painted in 1804, when indeed it may have been prefigured. Nevertheless, on grounds of style, the year 1805 seems a more likely date for its beginning; it was possibly completed in London, even in 1806.

Drawing
Edinburgh, National Gallery of Scotland.

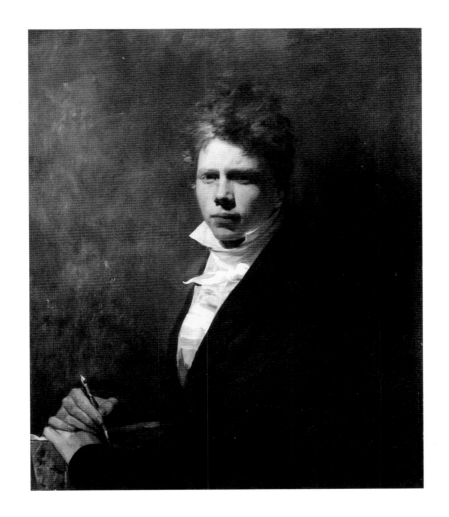

3. Self Portrait

4. Pitlessie Fair

Canvas; 23 × 42 in. (58.5 × 106.7 cm.)
Signed, and dated 1804.
Lent by the National Gallery of Scotland.

History and Provenance
Possibly planned late in 1803 or early in 1804. Painted 1804–5 as a commission, it appears, from Thomas Kinnear of Kinloch—to whom it was sent by Wilkie's father in about August 1805. By 5 January 1806 Kinnear had lent the picture to Wilkie in London, and it was not returned until late that year or early in 1807. There is a hint that, while the picture was in London, Wilkie may have given it "the benefit of his increasing skill." Kinnear died in 1809, and the picture passed to his son Charles, and in turn to Charles's younger son, also Charles (who died in 1894). The picture was bought by the National Gallery of Scotland from his widow in 1921.

Exhibitions
Wilkie's Exhibition 1812; Edinburgh, Royal Institution, 1821; Edinburgh and London 1958; Edinburgh 1975; Edinburgh 1985; Edinburgh and London 1986.

Literature
Burnet 1848, 108; Cunningham, 1:55–65, 67, 92, 102, 110, 133–34, 342, 3:501; Farington, 7:2724–25.

Formation
In August 1804 Wilkie wrote from Cults to Thomas Macdonald in Edinburgh, a fellow student from the Trustees' Academy: "I have now fairly begun to The Country Fair." On December 24 Wilkie wrote again to Macdonald: "I have not got the Fair finished yet, but it is pretty well on, and people of all ranks come to see it." The picture was finished, if not entirely to Wilkie's satisfaction, by May 1805, when he left Fife for London.

Comments
The fair was that which took place annually at Pitlessie on the second Tuesday in May. Wilkie described the topography of the picture in a drawing in the National Gallery of Scotland; only a little of what is shown in the picture survives (Andrews 1966; Megaw 1966).

Wilkie was reluctant to acknowledge the identity of the scene, feeling that it might cause offense to the protagonists. In the catalogue of his exhibition in 1812, the picture was called simply "The Country Fair," and Wilkie went no further than to add that "most of the figures in are portraits of the inhabitants of a small village in Scotland." Cunningham called the picture "the portrait of a village and its people," and claimed to be able to vouch for the identity of "all the persons in the drama." He refers generally to "farmers and rustics," and to "district worthies" and "magnates of Strath-Eden" (Pitlessie is on the river Eden); more particularly he mentions Wilkie's father, grandfather (James Lister, farmer and miller at Pitlessie), sister (Helen), sister-in-law (an inexplicable reference), Wilkie himself, and an old soldier and mendicant from the Borders, Andrew Gammell (Walter Scott's "Edie Ochiltree").

But Cunningham specifically identifies only the first of these individuals—Wilkie's father, "standing conversing with a publican." His father may thus be the man wearing a stock, and with a stick under his arm, to the right of the group of three men who stand in the middle distance in front of the two small trees to the right of center. Henrietta Keddie (Tytler 1873, 109) recalled that her mother, who had been at school with Wilkie at Cupar, had said that "a group in the fore-ground consisted of Wilkie's grandfather giving a fairing to his grand-daughter, Helen," but the group is not identifiable in the picture. Wilkie almost certainly painted himself as the boy silhouetted against the byre to the right. Other young faces wanting in gravity—conspicuously that of the youth amazed at the recruiting sergeant left of

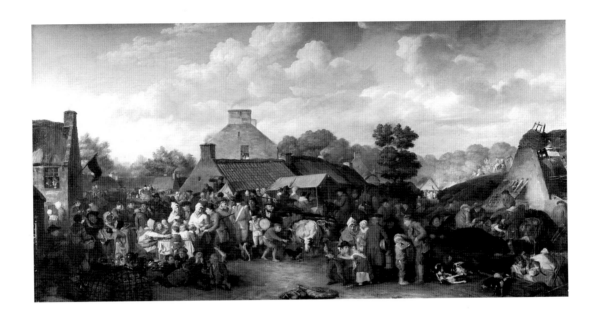

4. Pitlessie Fair

center—are also likely to be reflections of himself. In Edinburgh Wilkie had made use of the looking glass, and "his countenance . . . served as a model for the representation of the . . . passions." (For a note on this mode of self-portraiture, see cat. no. 3, under Comments.)

Some of the likenesses of older people were said by contemporaries to have been taken while his father ministered in the church at Cults. The heads Wilkie drew in the Bible in which he inscribed his name in November 1799 (National Library of Scotland) show signs of having been made in church, and in type they correspond to those in the picture. There is a close resemblance between the drawing of the old man on the inside of the front cover of the Bible and the dark, apparently seated figure looking out of the picture in the group in the foreground to the right of center.

In August 1804 Wilkie continued his letter to Macdonald quoted above (under Formation): "I have the advantage of our herd-boy and some children who live about the place as standers; and I now see how superior painting from nature is to any thing that our imagination, assisted by our memory, can conceive." This contrasts with Wilkie's hesitancy between the claims of nature and imagination as manifest in the painting of *Diana and Callisto* (cat. no. 1). Again he wrote on October 23, a . . . present of two lay-figures which belonged to his brother, the painter [David Martin (1737–1797), a Fife-born portrait painter who had practiced in Edinburgh], each of them measuring about three feet in height. . . . One is male and the other a female; and I have got some clothes made for them in a low style. . . . I am coming much quicker on with the Fair since I got these figures." Wilkie continued to use inanimate models (see cat.

nos. 5, 6, 23, 42).

Despite the way in which Wilkie's human panorama is huddled rather uncomfortably in front of its topographical backcloth, there are evident affinities between his scheme of composition and that of village scenes of horizontal form by such seventeenth-century painters as Teniers, Adriaen van Ostade, and Droochsloot. The connection with Teniers in particular was made early, but there is no evidence that Wilkie had seen a painting by Teniers before he went to London. Indeed, after seeing this picture in the exhibition of 1812, Haydon annotated his copy of the catalogue: "Painted at 19 years of age had never seen a picture by Teniers." The color in the picture does not suggest direct contact with the work of Teniers; its harshness, and its abrupt transitions perhaps betray the example of his master, John Graham (see cat. no. 1). Wilkie's knowledge of Ostade—also implied by the picture—was at this time almost certainly derived from prints alone, and the same may well have been true of Teniers. Prints by and after these and other painters of the sort were certainly to be found in Edinburgh. So far as the treatment of the landscape element is concerned, a connection with Ibbetson has been suggested (Irwin 1975). In 1800 Ibbetson had been in and around Edinburgh under the wing of Lady Balcarres—younger members of whose family took a neighborly interest in the Wilkies at Cults—and Cunningham reports that Wilkie eagerly absorbed Ibbetson's published recipe for oil painting.

There were native archetypes for the theme of a country gathering, notably in the work of David Allan, to whom Wilkie owed much at this time (see cat. no. 47), as well as in the work of Allan's pupil Alexander Carse (d. circa 1838). John Burnet, Wilkie's fellow at the

Trustees' Academy in Edinburgh, implied that Wilkie had an early interest in Carse, whose watercolor of the fair at Oldhamstocks, dated 1796 (National Gallery of Scotland; fig. 3), provides a close antecedent to Wilkie's picture. (For a recent, perceptive account of the picture, see Errington 1985.)

It is evident that much ambition went into the making of this picture, and there can be little doubt that at the time he left for London Wilkie saw in it the most substantial realization of his natural talent. That it should have been sent after him to London may have been in order to improve it, but it is as likely that it was because he saw its usefulness at this juncture as a show piece and a prospectus.

Wilkie wrote to Kinnear "in the latter end of the autumn" 1806: "When I first came to London I found the picture I had painted for you of less use to me than I expected. It lay beside me for months without being seen by any body; it was, however, at last accidentally shown to the Countess of Mansfield, in consequence on which Lord Mansfield commissioned [The Village Politicians] . . . , after which the Pitlessie Fair was also seen by a great number of people, and Lady Elizabeth Whitbread desired it to be sent to her house. I have now got it back again. It has, upon the whole been admired; but more on account of its being painted in Scotland, than for any intrinsic merit it has in itself."

The picture had been in London before 5 January 1806. On that day Wilkie wrote to his father: "The Countess of Mansfield happening to see the Pitlessie Market at [the Stodarts'] house one day, desired that it might be sent home with her to show some gentlemen: the consequence was, that I was sent for the next day [with the picture, it is to be presumed]." William Stodart (active 1795–d. 1824) has a

place in the history of the development of the modern piano, and styled himself "Maker to their Majesties and the Royal Princesses." His wife, Janet, was the sister of Mathew Wilkie of Bonnington, a cadet branch of the artist's family. Wilkie's meeting with the Stodarts, probably not long after his arrival in London in May 1805, was seen by Lockhart as "the turning point in his fortunes." Before 6 September 1805 Wilkie had painted portraits of Stodart (private collection), of his son (?) Matthew, and of Matthew's wife.

Joseph Farington and Sir George Beaumont saw the picture in Wilkie's studio on 19 April 1806. On June 5, Wilkie wrote to his father after a recent visit from "that mirror of patriotism," Samuel Whitbread: "I called on Mr. Whitbread the other day, and took the Fair along with me to show to Mrs. Whitbread. She asked me to let it remain with her, and entreated me not to send it back to Scotland. Mr. Whitbread has engaged me to paint a picture for him [cat. no. 11]. Tell the people of Pitlessie that they have more honour conferred upon them now than they even had before." In the last sentence Wilkie alludes to the honor done previously to the inhabitants of Pitlessie when "people of all ranks" came to see his picture of them in December 1804—an honor subsequently exceeded due to the grandness of those who were viewing the picture now that it was in the capital city of the kingdom.

The ownership of the picture was uncertain while this was going on. That it had not been paid for, and that even its price had not been fixed, is clear from a letter Wilkie wrote to his father in April 1806: "You know I was obliged to borrow twenty pounds; but that, I expect, will be nearly paid for by the price of the Pitlessie Fair." A decision had been made on the matter of ownership by August 30, when

David Wilkie the elder wrote to his son: "I commend your resolution of sending the Pitlessie Market to Mr. Kinnear, as it was always designed for him, and I do not suppose he will hesitate to allow you £30 for it, yet I cannot be certain of this" (NLS: in Acc. 7972). Not long afterward the whole matter must have been settled, because Wilkie's father reported in February 1807: "Mr. Lister of Auchtermuchty came in, and told us he had been at Kinloch, and had seen the picture of Pitlessie Market, which was . . . much esteemed by Mr. and Mrs. Kinnear." Cunningham gave the price as £25.

Thomas Kinnear (c. 1773–1809), who first owned the picture, lived at Kinloch, near Collessie, about five miles northwest of Cults. His younger brother was Charles Kinnear of Kinnear (d. 1811). They were the sons of a locally notable agriculturalist.

As well as the present picture, Thomas had two small, very Ostade-like village interiors by Wilkie, which in 1840 were said to have been "presented to him in testimony of the kindness . . . [Wilkie] had . . . received in his youth at Kinloch." These, probably painted in 1802–3, disappeared after 1920 (they are reproduced in Gower 1902). One of them, *The Village Card Players*, foreshadows the picture of the same subject exhibited in 1808 (cat. no. 9).

That Wilkie was indeed appreciative of that early recognition may be seen from a further passage in his previously cited letter to Thomas Kinnear in the autumn of 1806. It began: "I have no doubt but you would rejoice to hear of the unexpected encouragement that has so happily attended me [from being able to show off the picture], particularly as you yourself were the chief promoter of my exertions in that branch of the art which was so congenial with my inclinations, and which [unlike portraiture]

is probably most suited to my abilities." The goodwill of Thomas Kinnear was continued by his son, Charles, who lent the picture to the two exhibitions in Wilkie's lifetime already mentioned (and to two more later). Wilkie stayed at Kinloch in 1824.

Early in 1812 Wilkie was preparing his one-man exhibition. He wrote to Beaumont about it on March 10: "*The Country Fair* we have also thought worth while to have among the number, and I have already given directions to have it sent up by sea on purpose. I saw it when I was last in Scotland [in the autumn of 1811]; and, although it is no doubt very badly painted, it has more subject and more entertainment in it than any three pictures I have since painted." Wilkie's reference to the picture having "more subject" than others becomes clearer in the light of a reviewer's remark at the time of the 1812 exhibition that the picture was "so fertile in incident, that it contains the ground-work of several of [Wilkie's] afterpieces." Burnet, later, was more specific: "Many of the incidents . . . were afterwards worked up into separate works, such as his 'Blind Fiddler' [cat. no. 5], 'Jew's Harp' [Liverpool], &c. [e.g., *The Village Recruit* (private collection)]."

Drawings
Edinburgh, National Gallery of Scotland and National Library of Scotland; London, British Museum.

5. The Blind Fiddler

Wood; 22¾ × 31¼ in. (57.8 × 79.4 cm.)
Signed, and dated 1806.
Lent by the Tate Gallery.

History and Provenance
Commissioned by Sir George Beaumont in early April 1806 and completed in early August that year. Sent by Wilkie to Beaumont at his mother's house in Dunmow, Essex, in February 1807, but the picture was returned to Wilkie in London for exhibition in May. Thereafter it presumably went back to Beaumont's London house in Grosvenor Square. By 17 June 1808 it was among the pictures selected by William Seguier to be sent to Beaumont's new house at Coleorton, Leicestershire. However, it seems to have stayed in London, and in April 1809 it was on loan to Lord Mulgrave. Beaumont lent the picture back to Wilkie in 1810–11 for the purpose of having it engraved, and again in 1812 for exhibition. It is possible that afterward it was kept by Wilkie; it was not among the pictures listed at Coleorton in 1818, and Wilkie certainly had it in January 1823. One of the sixteen paintings given by Beaumont to the National Gallery in 1826. Transferred to the Tate Gallery in 1919.

Exhibitions
Royal Academy 1807; Wilkie's Exhibition 1812; British Institution 1825; Edinburgh and London 1958; Edinburgh 1985; Edinburgh and London 1986.

Literature
Burnet 1848, 105, 108; Burnet 1854, 20–21, 29–31; Burnet 1860, 237; Cunningham, 1:67, 95–96, 131, 143–44, 145, 146, 249, 332, 3:512; Farington, 7:2716, 8:2898, 3009, 3040, 3164, 9:3297, 3431; Haydon 1926, 1:54–55; Haydon 1960–63, 3:135, 142–43; Raimbach, 155–6.

Formation
Farington wrote in his diary for 12 April 1806: "Beaumont called, quite enthusiastic about Wilkie . . . who [he said] . . . has painted several pictures . . . superior to [George] Morland . . . and almost equal to Teniers in execution and superior to him in variety of character. Not being known, he has almost starved . . . from want of means of subsistence.

Lord Mulgrave has bought a picture from him [*Sunday Morning* (missing since 1914)] and has ordered another [*Rent Day* (private collection)] and Sir George has ordered one." Wilkie himself wrote on April 15 that Mulgrave and Beaumont had visited his lodgings, attracted there by *The Village Politicians* (private collection), and that each had ordered a picture. According to Cunningham, the introduction was effected by the portrait painter John Jackson, who was Mulgrave's protégé and Wilkie's contemporary.

Versions
The present picture may have been based on an earlier, probably smaller, version of the subject (missing since 1846). This had been bought, perhaps late in 1805, for five guineas from a frame maker at Charing Cross by a countryman of Wilkie's, Daniel Stuart. He was a successful newspaper proprietor; Wordsworth and Coleridge were among his contributors. Of the four early—and inconsistent—accounts of this transaction, the most circumstantial, which conceivably was by Stuart himself, was published in 1841 (*Gentleman's Magazine* [1841]: 35). Its concluding sentences deserve quotation here, even though they fail in absolute veracity: "In the spring of 1807 . . . at dinner with Mr. Stuart, Mr. Wordsworth the poet mentioned a new artist of . . . singular merit . . . and described Wilkie's picture . . . at the Royal Academy [i.e., the present picture]. . . . Mr. Stuart's curiosity thus excited, he attended the opening . . . of the exhibition. . . . On examining Mr. Wilkie's picture, Mr. Stuart had no doubt it was by the same hand [as the picture he possessed], and . . . he went straight to Mr. Wilkie . . . in Upper Norton Street, whom he found painting the same subject over again. . . . He proposed that

Wilkie should paint a picture for him, but he declined, saying that he was deeply engaged to paint for Lord Mulgrave, and that at present . . . his design was to paint for fame, not for money. He added that the picture Mr. Stuart possessed was one of his latest productions." There is no further trace of the second version seen by Stuart.

What was described as "a mere idea of the picture" was exhibited at the British Institution in 1842 as a sketch of 1806. It is possibly the small canvas in the National Gallery of Scotland.

Comments

Although the subject of the picture has formal counterparts in seventeenth-century Dutch and Flemish painting, it is nevertheless an invention of Wilkie's, and it has no source in literature or in an established event. John Burnet, Wilkie's early friend, who was also the engraver of the picture, saw it as a development of the motif of the blind fiddler in the left middle distance in *Pitlessie Fair* (cat. no. 4).

Burnet also provides the most interesting of the early expositions of the content of the picture in his autobiograpical novel of 1854, *The Progress of a Painter*. There, Wilkie is made to explain the picture in the presence of a fictitious Lady Crumbie: "'The subject . . . is a Blind Fiddler, who, we suppose, is come into a cottage for shelter from the snow or rain, as I have endeavoured to indicate by the boy who leads him, warming his hands by the fire; his fiddle-case, stick, and bundle, are laid beside him, not only to give him consequence as the principal figure, but to convey the idea of his passing from village to village . . . ; next to him is his wife, who . . . sells her laces, garters, trinkets, and other matters represented in the basket on the ground.' 'Oh! Mr. Wilkie,

she is an ill-far'd creature,' exclaimed Lady Crumbie. . . . 'Well, you see, I made her no bonny on purpose; for no angel would marry a blind beggar; and you ken the misery of Job was heightened by having a bad woman for his wife. The next figure is the boy who leads him, warming himself by the fire—as cold and hunger are often companions—and the auld grandfather, standing wi' his back to the ingle, is reflecting on the miseries of mankind, like another melancholy Jaques. I have endeavoured to vary the different ages of the group, from infancy to age [cf. Jacques in *As You Like It*, II, 7] . . . the child on its mother's lap is pleased with the father snapping his fingers to the fiddler's music.' 'And, dear me, there is their son imitating the poor blind man with the bellows for a fiddle.' 'Yes, my lady, I have considered him an imitating genius in embryo; that drawing over his head, wafered on the *amory* door, is a specimen of his pictorial propensity; it is a figure representing the Pretender, with his highland claymore.'"

Elsewhere, Burnet wrote that the expressions of the heads of the figures in action are Wilkie's own, following from his practice of drawing from himself in a looking glass. The relationship made between the auto-reflective figure of the boy aping the fiddler and the drawing stuck on the amory, or press, under-lines Wilkie's personal presence in the picture. Not only did he amuse himself in his early London years by playing the fiddle, but Cunningham tells us that the drawing was "said to be a copy from one of the artist's Pitlessie school attempts." The connection is extended by Katherine Thomson (Thomson 1854, 2:166–67), who remembered asking Wilkie's mother whether he had shown an early talent for drawing: "'Aweel,' said she, 'I mind he was ae scrawling and scratching . . . and he had an

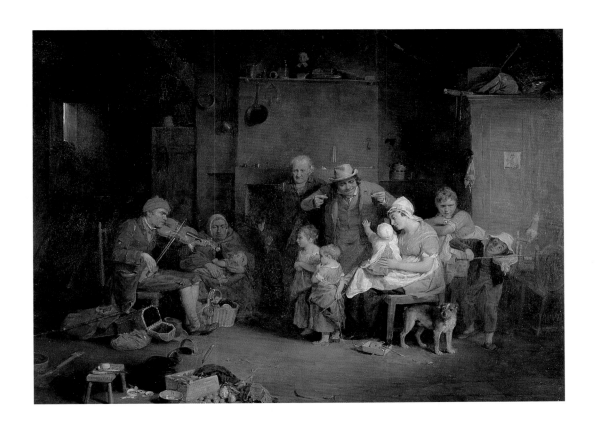

5. The Blind Fiddler

idle fashion o' making likenesses and caricatoores like of all the folk as came. And there was an auld blind mon, Willie, the fiddler . . . that used to come wi' his noise . . . and Davie was ae taking o' this puir bodie into the hoose . . . and I used to cry shame on the lad for encouraging such lazy vagabonds. . . . Aweel, they told me . . . that Davie had painted a grand pictur; and he wrote me to go to Edinburgh to see it [presumably the engraving exhibited in Edinburgh in 1812]; and I went, and sure eno' there was puir old Willie, the very like o' him.'" On the testimony of Abraham Raimbach, however, the fiddler in the picture was "faithfully studied from a mendicant well-known in London, where his most usual station was in Oxford Street." According to Burnet, Wilkie, when painting the fiddler, made use of "a small lay figure, for the purpose of copying the drapery, and light and shade [see cat. no. 4, under Comments]."

The model for the mother was named by Haydon as Lizzie, a "young woman of masculine understanding, not regularly beautiful," who lodged above some mutual friends and was one of their circle. Raimbach, who came to know Wilkie later than this, asserted further that in this picture, as in *The Village Politicians*, there are portraits of Wilkie's early companions: George Callander, a painter; Thomas Macdonald, an engraver and print seller; and one Stewart (the miniaturist Anthony Stewart?). In Burnet's fiction, Wilkie is made to say that in the figure of the grandfather he introduced, at Beaumont's request, "a portrait of Sir George's gamekeeper"; in 1826 Haydon claimed that he had painted from the same model, presumably in London. Although circumstances in 1806 make it seem unlikely that Wilkie would have had access to the gamekeeper he was to paint in 1810 (cat. no. 13), some resemblance may

nevertheless be found between the head of the grandfather and that in the portrait of Beaumont's gamekeeper—allowing for the change of expression. (The notion that the features of the boy aping the fiddler were those of Hartley Coleridge may be dismissed.)

The setting of the scene is that of a shoemaker's cottage, if Cunningham is to be believed; he offers no evidence for it. The father's apron is not the sort usually worn by a cobbler. On the other hand, cobblers were said to be musically inclined (Errington 1985, 33). An alternative claim, made in 1844 (*Art-Union* 1844, 19–20) on the inadequate evidence of the vegetables in the foreground, was that the interior is that of a market gardener's cottage. Cunningham also drew attention to the "stiff formal head of a parson" on the mantelshelf as "designed perhaps to intimate that this merry cobbler was inclined to Methodism." This should be weighed against the words of Sydney Smith: "The Methodists hate pleasure and amusements; no theatre, no cards, no dancing . . . no blind fiddlers."

Reverting to the painter's own presence in the picture, Andrew Wilson, the landscape painter (quoted by Cunningham), recalled being told by Wilkie that "one day [John] Bannister the actor called, and was shown in while [Wilkie] was sitting on a low seat, dressed as a woman, with a looking-glass before him." He was evidently caught as he was giving thought to the figure of the fiddler's wife. Writing of Wilkie's practice of drawing from himself, Burnet observed: "This mode of study enabled him to give correctly those muscles of the face that indicate mixed expression. A head of this character we see in the girl leaning on the back of the chair . . . ; she chides the boy for mocking the blind man . . . [and] at the same time cannot refrain from smiling at

his drollery. This head . . . is the strongest likeness we possess of Wilkie when a young man [cf. cat. no. 3]."

Wilkie's observation of "those muscles of the face that indicate mixed expression" had recently been given scientific form by (Sir) Charles Bell, an Edinburgh surgeon with a strong artistic intelligence. Bell, like Wilkie, had come to London in 1805. In February 1806, about two months before the present picture was begun, he lectured on anatomy "merely for the use of painters," and Wilkie went to hear him. (Later, Bell referred to Wilkie as his pupil.) The lectures are not likely to have been substantially different from Bell's *Essay on the Anatomy of Expression in Painting*, published in the same year. Its burden is that "expression is to passion what language is to thought." We have seen that Beaumont's first enthusiasm for Wilkie's pictures was grounded in a recognition of the "variety of character" in them, which made Wilkie superior in this respect to the painter he was most immediately compared to, Teniers. Wilkie's capacity to delineate not just fixed expressions, but also changes and interrelations of feeling, was indeed the essence of his originality. In Burnet's fiction this capacity is said to extend even to the depiction of the dog in *The Blind Fiddler*.

Wilkie's first exhibited picture, *The Village Politicians*, had caused a sensation in 1806; "there was a daily crush to see it" at the Royal Academy—whose receipts from admissions rose correspondingly. It was reported that when the present picture was exhibited in 1807, at the opening of the Academy's doors on the first day, "about 300 persons were assembled and a rush was made at entering, like those which take place at the theatres."

This was public notoriety, but there is no room here for a discussion of its causes. The picture inspired a sonnet by a good minor poet, William Bowles; it also brought a letter of tribute from the novelist John Galt, who recognized a community of intention between Wilkie's picture and his own writing (Gordon 1972, 10–11; see also cat. no. 18, under Comments).

Wordsworth, whom Wilkie had met on 7 May 1806, probably for the first time, was to see the picture after November 10 when he wrote to Beaumont: "I long to see Wilkie's picture; from Lady Beaumont's account it seems to have surpassed your utmost expectations. . . . No doubt you will read him my Orpheus of Oxford Street, which I think he will like" (Wordsworth 1969, 95). Wordsworth was referring to his poem "The Power of Music," probably conceived in London in April 1806. It is a ramshackle work about the effect on the passersby of a blind fiddler in Oxford Street—possibly the very man identified by Raimbach as Wilkie's model. Wordsworth was at the exhibition in 1807, and has already been reported as having drawn Wilkie's picture to the attention of Daniel Stuart. However, Farington quoted Constable as saying on December 12 that Wilkie was "offended with Wordsworth who . . . gave him to understand that when he could not think of subjects as well as paint them, he would come to him." Wordsworth's condescension must have been annoying to a painter who was jealous of his capacity to invent his own subjects. The gulf between him and Wordsworth was further evident in 1809 when Wilkie wrote that after reading the Preface to *Lyrical Ballads* he "could not be brought at all to coincide with the fundamental principles of [Wordsworth's] system, or to admire the elegant pieces which are pointed out as examples of his style."

Wordsworth and Wilkie almost certainly met

through Beaumont, who was a patron of both. Among Wilkie's early patrons he was the most important, not because of the number of pictures that he bought—he had only two, this one and the *Portrait of a Gamekeeper* (cat. no. 13)—but because of the steadfastness of his always kindly, if self-indulgent, tutorage of the young artist. The relationship was especially valuable to Wilkie in his earlier years in London, and it was to continue until Beaumont's death in 1827.

Nevertheless, Beaumont's feelings about the picture appear to have been mixed. We have seen that it was among the pictures selected from Beaumont's collection by William Seguier to go to Coleorton. But there is no evidence to suggest that it ever left London, and Jackson saw it on loan to Lord Mulgrave, as reported on 3 April 1809 by Farington—who was further informed that "Sir George had sent [the picture] to Lord M's saying he knew not where to hang it, it being so ill coloured. Lord M. then shewed Jackson some letters written to him by Sir George in which he went to the utmost length of expression in praise of the picture, and that it would be a perpetual companion to him. . . . Lord M. remarked on the contradiction. . . . Haydon is now Sir George's Hero . . . Wilkie is on the decline in favor." (William Wilberforce had remarked that "Sir George must have a Hero.")

Again, in July 1811, when the time came for Wilkie to return the picture to Beaumont after it had been engraved, Beaumont suggested that Wilkie should keep it by him: "it will be gratifying to . . . your . . . admirers to see it with you, and . . . not disadvantageous to yourself occasionally to refer to the simplicity of your first feelings." As it happened, the picture had already been sent back to Grosvenor Square. On 12 January 1823, however, Wilkie

wrote to Beaumont: "The Blind Fiddler is in perfect safety and now and then seen with interest by my visitors" (PML: in MA 1581).

Beaumont's feelings about color may have been the source of his seeming aversion to the picture. It can scarcely have been finished before he wrote to Wilkie, perhaps late in 1806: "Some peculiar colour is always striving to get the better of an artist. . . . I have endeavoured to detect something in you of this kind, that I might mention it as a warning. . . . I think I perceive a tendency to . . . a metallic appearance in some parts of the drapery of the woman with the child, particularly about the apron and the head-dress of the child. Round the blind man, also, there is a sort of slaty smoothness . . . [which] appears in his stockings and various parts of his dress."

There was much gossip at the time over how much Beaumont was to or should pay for the picture (50 guineas in the event). In March 1810 Haydon told a version, moistened with crocodile's tears, of this chapter of misunderstandings, exclaiming in the course of it: "Oh Sir George . . . did you not say Wilkie did not colour quite the thing, that [the picture] was slaty, that you hung it out in your passage because it looked so bad by your other pictures." The epithet "slaty" thus twice applied is echoed in Cunningham's remark that in some of Wilkie's early works, "even in the Blind Fiddler," there is a "grey leaden hue" resulting from his reading of J. C. Ibbetson's *An Accidence, or Gamut, of Painting in Oil* of 1803 (for Wilkie and Ibbetson, see also cat. no. 4). When Farington saw the picture on 7 November 1806 he noted that "the colour of the ground was rather too grey."

In the end, the picture was among those given by Beaumont in 1826 to the newly founded National Gallery, and he wrote to

Wilkie, if merely to please, that he "had the great pleasure to assist in hanging [it]. . . . The Blind Fiddler shines amongst [the other pictures] like a jewel and is the admiration of everybody." It was Wilkie's second picture to enter the Gallery (the first had been cat. no. 12), and he was then still the only living painter to be represented there.

Burnet wrote: "The silvery tone of Teniers was pressed upon [Wilkie's] attention by the critics, and while he was engaged upon the picture, a small silvery-toned picture by Teniers [perhaps a kitchen interior with an old woman frying pancakes], a present from Sir George Beaumont, stood by his side. This certainly influenced its hue of colour, and lowered its effect at the exhibition [at the Royal Academy]; and contributing to this deteriorating quality, was a warm picture by Turner of a blacksmith's shop hanging near it." Cunningham, no friend of the Academic establishment, gave a fuller account of the matter, not without a character-istic turn of innuendo: "The fame of Wilkie . . . was not heard, it is said, without a leaven of bad feeling on the part of some of those members whose genius ought to have raised them above such meanness. . . . We know . . . that in arranging the pictures on the walls . . . an envious academician can make one fine picture injure the effect of another, by a startling opposition of colour. . . . When the doors of the Exhibition were opened in 1807 . . . the public were not slow in observing The Blind Fiddler, with its staid and modest colour, was flung into eclipse by the unprecedented splendour of a neighbouring picture, hung for that purpose beside it, as some averred, and painted into its overpowering brightness, as others more bitterly said, in the varnishing time which belongs to academicians . . . [before] the Exhibition opens." The

"neighbouring picture" was Turner's *Country Blacksmith* (Tate Gallery); his other exhibit that year was the *Sun Rising Through Vapour* (National Gallery).

Cunningham's son, Peter, writing about Turner, made a point of substantiating the story. After naming Turner's two pictures, he continued: "A modest picture . . . injured by being hung between the two fires was 'The Blind Fiddler'. . . . On the varnishing day . . . Turner, it is said . . . blew the bellows of his art on his blacksmith's forge,' 'to put the Scotchman's nose out of joint. . . . ' The story is told in Allan Cunningham's 'Life of Wilkie', and condemned as an untruth by the reviewer [J.G.Lockhart] of the Life in the 'Quarterly Review' [1843, 413–15]. But there is no doubt about the truth of the story; and that Wilkie remembered the circumstance with some acerbity—though he never resented it openly —I can undertake to say."

Turner's biographers seem agreed that he almost certainly painted his otherwise unchar-acteristic *Country Blacksmith* in a spirit of rivalry toward Wilkie, and there is also evidence to suggest that Turner's picture was indeed brought to a finish in its frame. Turner had a certain jealous ruthlessness, and a reminder of his sensitivity to competition in fame—even when competition came from outside his acknowledged superiority as a landscapist—is provided by Farington. He recorded that when Beaumont asked the price of the *Country Blacksmith*: "Turner answered that he understood Wilkie was to have 100 guineas [the sum had indeed been mentioned] for his Blind Fiddler and he should not rate his picture at a less price."

To all this it should be added that the published complaints against Turner were made after Wilkie's death (the elder Cunningham's

was the only one made in Turner's lifetime), and there seems to be only one reference to the affair among sources more immediately contemporary to it. Cunningham's animus toward the Academy, and his son's loyalty to him, might make both suspect as witnesses; yet they are balanced by Burnet, and the essential truth of the story seems confirmed by a relatively casual remark by the painter William Collins. Writing to his friend Wilkie in 1827, he described the *Country Blacksmith* as "your old enemy." Even before the exhibition, Farington reported that Beaumont had hoped that Wilkie's picture "would not be hung . . . near any 'Boiled Lobsters': i.e. glaring pictures," while at the exhibition Wilkie himself felt that it "wants richness of colour in some respects." For more on this incident, see Marks 1981.

If at this time Wilkie was in disfavor with certain academicians, Turner among them, it may have been largely the fault of Beaumont's tactlessly excessive expressions of enthusiasm for him. Beaumont virtually admitted it.

Engravings

1. By John Burnet, published by Josiah Boydell and dedicated by him to Sir George Beaumont; 41 × 55.2 cm. On 3 March 1807, Wilkie wrote to Beaumont: "When I last saw you [probably not since mid-November last] I requested your permission to have a print engraved from the picture, and since that time I have had several applications, and some considerable offers made me for the privilege of publishing it, by people of respectability. I find it will be utterly impossible to get it done in the stroke engraving from the length of time it will take, and that, if it is to be done in the chalk manner . . . it would require the picture to be much longer in the hands of the engraver. . . . I request . . . that you will . . . advise me how to act." It was not until 18 April 1810 that Beaumont "agreed that Burnet . . . is to have the picture." Burnet wrote of it as "executed . . . in the manner of Cornelius Vischer. It exhibits more graving than etching." Burnet was dedicated to

the "purity" of line-engraving, and in Wilkie he found "a great advocate of the superiority of that method." He made his first print after Wilkie in 1809, and six more after this one.

Wilkie was to have 50 guineas from Boydell, but there are clear signs that the arrangements were not carried out, and Burnet wrote that Wilkie "thought so coldly of the first state of the plate, that he sold his third share for fifty pounds." The etching was complete by 1 May 1811, and the engraving not long before July 8. The published prices were Prints £2—2—0 and Proofs £4—4—0. There was trouble over the unauthorized sale of first proofs ("before putting the cross-hatchings on the boy's hat"). An impression of the print was exhibited in Edinburgh in 1812, and Wilkie saw one at a print seller's in Amsterdam in 1816.

2. By Charles Marr, published on 15 April 1836 by Hodgson & Graves, in Allan Cunningham, *Cabinet Gallery of Pictures* (1836), vol. 1, frontispiece; 10.7 × 14.5 cm. Since by 1836 the picture had entered the National Gallery, "a pretty point of law" was raised among interested publishers over the question of copyright. Wilkie seems to have taken no part in the dispute.

3. By C. W. Sharpe; 16.1 × 22.2 cm. In the *Wilkie Gallery* (1848–50). A number of lesser prints were made from the picture.

Copies

Because the picture was in the National Gallery, as well as engraved, it was much copied in the last century. Copies were in circulation in Wilkie's lifetime, the earliest in 1816. Some copies were by named artists; some belonged to people of interest. There were copies by American painters. One by Alexander Rider, exhibited at the Pennsylvania Academy in 1825, was presumably after Burnet's print—likewise that by William Hall, exhibited at the Artists' Fund Society in Philadelphia in 1837. A copy by John L. Krimmel is in the New York art market (see fig. 42).

6. Alfred Reprimanded by the Neatherd's Wife

Canvas; 43 × 61 in. (109.2 × 154.9 cm.)
Signed, and dated 1806.
Lent by M. C. C. Armitage.

History and Provenance
Painted in 1806–7 for Alexander Davison; his sale, 28 June 1823, bought by Hurst, Robinson & Co., £525, and with their successors, Hodgson & Graves, in 1839; sold by them to Joseph Marshland; his sale, 6 June 1840, bought by Nieuwenhuys, £451—10—0; Sir Thomas Baring by 1842; his sale, 2 June 1848, bought by Ryan, £430—10—0; John Naylor by 1854, who had paid £787—10—0 for it; James Patrick; his sale, 9 May 1870, bought in by Ray at £756; anonymous sale, 17 June 1871, bought by Gray, £367—10—0; W. J. Armitage by 1878 and thence by descent.

Exhibitions
Wilkie's Exhibition 1812; British Institution 1842; Edinburgh and London 1958.

Literature
Cunningham, 1:123–24, 125–26, 127, 137, 159.

Formation
Commissioned by Alexander Davison for 150 guineas before Wilkie left London for the country on 16 August 1806. The composition may have been laid in already by that date. Whether or not this was so, Wilkie had certainly proposed the subject to Davison by then, and discussed the difficulty of realizing it with Sir George Beaumont (see Comments, below).

Wilkie was back soon after October 9, and by November 20 he had proceeded with the picture far enough for Beaumont to be able to observe: "With the old woman, and especially the man, I am perfectly satisfied, but Alfred . . . is rather insipid—I mean only as to his countenance. . . . I rather object at present to the expression of the girl who is taking up the cakes, as a little too ludicrous [i.e., frivolous]." Wilkie intended to have the picture finished by the end of December, as he

had "many other pressing engagements on hand," but not until 7 February 1807 did he announce: "I have finished the Alfred, and delivered it to Mr. Davison at the appointed time, and I have since had the happiness to hear that it gives him satisfaction."

Version
A small version of the picture (private collection) was made by Wilkie as one of a series of reductions from his own works, painted during his convalescence in the winter of 1810–11 for Lord Mulgrave (see cat. no. 8, under Comments). Wilkie initialed and dated it 1806, presumably doing so in allusion to the date of the original. (This is one of a number of instances that impose caution in accepting literally the dates on some of Wilkie's paintings and drawings.)

Comments
In response to Davison's invitation to "contribute in forming a grand collection of pictures illustrative of our national history," Wilkie wrote: "I beg to propose as the subject of the picture 'Alfred disguised in the Neatherd's cottage; reproached by the Neatherd's wife for allowing the cakes to burn which she had committed to his care.' I conceive this simple circumstance—though apparently trifling—may be made interesting from its relation to one . . . who may be regarded as the founder of our monarchy and adored constitution."

When the picture was exhibited in 1812, Wilkie acknowledged, incompletely, the source of the subject as from David Hume's *History of England* (1762; chap. 2)—a common quarry for history painters at the time. By Cunningham's account, "Wilkie read and studied, and referred to authorities till he filled his mind with the subject," and it may be guessed that

he looked at the illustrated editions of Hume published in the 1790s, as well as at other illustrated histories of England. None, however, seems to have contained a usable exemplar for the treatment of this rustic episode in the life of "the best of kings."

In the matter of the archaeology of costume, Wilkie is not likely to have found much help in published sources because, at the time, they were notably lacking in illustrations of Saxon peasants. Appropriate illustrations came later, and so allowed a critic of Mitchell's engraving (see Engravings, below) to write in 1828: "Who could ever look at the neatherd's wife in that old village granddam dress, and fancy her the wife of a Saxon churl . . . ? Nor is there a piece of real Saxon furniture about the hut" (*Gentleman's Magazine* [1828]:547). In effect, Wilkie had made no advance on Wheatley's picture of the same subject, and from the same literary source, which was painted for Robert Bowyer's Historic Gallery and engraved in 1795.

On a more subtle point, Wilkie wrote on 9 October 1806 to Beaumont, with whom he had evidently been discussing his choice of subject: "I am perfectly sensible of the difficulties I have to encounter in representing the king in the habit of a peasant, for it has been observed that painters even of eminence have had more assistance from the outward display of rich robes and jewels in giving dignity to their characters, than from any intrinsic greatness they had in themselves. From which I am fully aware that it will not be an easy matter to give majesty and rank where these symbols of greatness are wanting. I also agree with you, on the other hand, that every appearance of vulgarity should be avoided in the peasants themselves, as the principal object in an historical composition is to lead the mind

back to the time in which the transaction happened, and the mind being always ready to associate elevated ideas with antiquity, the illusion must be instantly destroyed, and the purpose of the picture entirely defeated, if the vulgar familiarity of the circumstances instantly puts us in mind of what passes every day under our eyes. It will however be necessary for me in the present instance to contrast the cottagers as much with Alfred as may prevent him from being mistaken for one of the family."

In these considerations Wilkie was taking his cue from sixteenth-century ideas on the role of dress in painting that were still partly current through Reynolds's *Discourses*. Wilkie had already met a comparable pictorial dilemma while still at the Trustees' Academy (see cat. no. 1, under Comments). The success of his solution to the central problem here was questioned when the picture was seen in the sale room in 1823: "The figure of Alfred is well painted; but there is nothing in it which would lead the spectator to suppose that he was a remarkable man. We should, indeed, imagine that Wilkie would find it difficult to paint a hero" (*Gentleman's Magazine* [1823]:65).

According to Cunningham, "the picture was regarded as a noble effort; yet so fearful was Wilkie of 'critical dissection' [as a result of entering the field of history painting in London], that though satisfied with it himself, he withheld it from public exhibition [at the Royal Academy] till other works and increasing fame had rendered him less timorous." (Abraham Raimbach, one of Wilkie's engravers and a friend, thought that "the picture had never been a favourite" with Wilkie.)

In his account of the making of the picture, Cunningham said that Wilkie "considered and reconsidered the story; drew the figures singly, then grouped them; and, not content with

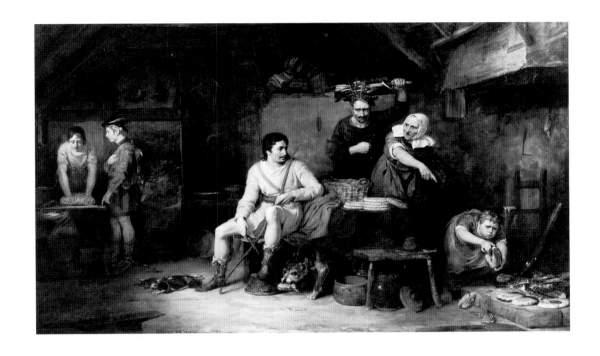

6. **Alfred Reprimanded by the Neatherd's Wife**

calling in the living model for each, to secure the truth of the posture, he modelled the whole in clay, that he might ascertain the light and shade of the composition." This is the earliest attested example of Wilkie's use of small clay models, for which see also cat. no. 23.

At the time of the 1812 exhibition it was observed that "in the lad talking to a girl in the background . . . is Mr. Wilkie's own portrait," an observation repeated in 1828 and confirmed by Raimbach. For this form of self-portraiture, see cat. no. 3.

Alexander Davison (1750–1829), who commissioned the picture, began his career as a merchant in Canada. There too he began his friendship with Nelson, whose prize-agent he became after the Battle of the Nile. In 1795 he was contractor for army clothing and, on a commission basis, government agent for barrack stores. He entertained splendidly at his house in St. James's Square. In 1806 he was found guilty of taking the government's commission on stores supplied by himself. Wilkie visited him in prison in 1809, as did a "deputation from the Loyal Britons Volunteer Corps . . . to assure him . . . of their unceasing attachment to him as their Colonel."

On 9 August 1806, Farington was informed that Davison had ordered eight pictures of subjects from the history of England: "After each picture is finished he will pay . . . for it, and will then take the opinion of acknowledged judges to determine its merit. If it be approved he will place it in his picture room [his dining room], if not he will send it to an auction." The choice of subject was the artist's. In 1807 this part of Davison's collection consisted of works by Copley, West, Northcote, Smirke, Tresham, Devis, and Westall; Wilkie was twenty years the junior of the last and youngest of these.

At this time, Davison was seen as at one with Sir John Leicester, Sir Thomas Barnard, Charles Hoare, Thomas Liston Parker, and the following who were, or who were soon to become, patrons of Wilkie: the Marquis of Stafford, Samuel Whitbread (see cat. no. 11), the Earl of Mulgrave (see cat. no. 8), Sir Francis Baring, Lord De Dunstanville, and Sir George Beaumont (see cat. no. 5). Each, in his own manner, was collecting "with the noble purpose of encouraging contemporary merit" among British painters. The patriotic tenor of the subjects of Davison's collection of history pictures was, however, closer in this respect to the earlier collections of John Boydell and Thomas Macklin, and yet closer to that of Robert Bowyer. His collection, like Davison's, centered on Hume's *History of England*.

Drawings
Cambridge, Fitzwilliam Museum; Princeton, N.J., The Art Museum, Princeton University.

Engravings
1. By James Mitchell, published by Messrs. Boys & Graves, on 1 September 1828, and dedicated by them to the Duke of Wellington; 36.6 × 54.9 cm. The picture had been bought by Boys & Graves's predecessors in the print-publishing business, Hurst, Robinson & Co., of whom Wilkie wrote in 1826, the year of their bankruptcy, that "even in their dealings with me they were not satisfied, but must buy my picture of Alfred, to engrave themselves." Mitchell was employed by them, and at work by 7 January 1826, but he may not have finished at the time of the bankruptcy, for on 13 August 1827 Wilkie expressed no objection to John Burnet "touching upon the plate." The published prices were: prints £2—2—0, French proofs £4—4—0, India proofs £5—5—0, proofs before letters £7—7—0. This engraving was presumably the basis of a copy of Wilkie's composition by J. Hall, exhibited at the Artists' Fund Society in Philadelphia in 1840, and of a copy painted by Thomas Sully in 1854.

2. By G. A. Periam; 14.7 × 22.6 cm. In the *Wilkie Gallery* (1848–50).
3. By Normand, fils, Paris (in outline only), date unknown.

7. The Rev. David Wilkie and His Wife

Wood; 12 × 8½ in. (30.5 × 21.6 cm.)
Lent by Dr. Joan MacKinnon.

History and Provenance
Painted in 1807, and in Wilkie's possession in 1823. On his death the portrait passed to his sister, Helen, later Mrs. Hunter; she died in 1857 and the portrait went probably directly to her nephew, the Rev. David Wilkie, who certainly had it in 1902. Anonymous sale, 15 April 1929, bought by Wace, £18—18—0; J. Ramsay Macdonald by 1931; he died in 1937 and the portrait passed to his son, Malcolm Macdonald, and thence by descent.

Exhibitions
Wilkie's Exhibition 1812; British Institution 1842.

Literature
Cunningham, 1:68 (chronologically misplaced), 3:524.

Formation
Wilkie's first return from London to his parents at Cults was on 1 June 1807. Illness seems to have prevented him from painting before about the beginning of August. The portrait was probably complete, or nearly so, when he left Cults not long after October 8.

Version
A second, slightly smaller version of the portrait was painted by Wilkie in London in November 1813, apparently within a week. As a portrait of his father it is therefore posthumous. He sent it to his brother, Lieutenant (later Captain) John Wilkie, in India, and it remained in the family until it was bought by the National Gallery of Scotland in 1958. In this later version, the composition is made to seem more spacious; the furnishings are less austere (because they are probably based on things Wilkie had in London); and Mrs. Wilkie's shawl is more showy than in the earlier version.

Comments
The Rev. David Wilkie (1738–1812) was the heir to John Wilkie, tenant of Rathobyres (about eight miles west of Edinburgh). He seems to have first matriculated in 1757 at the University of Edinburgh, where he studied Latin, Greek, and philosophy but did not graduate. He matriculated at the University of St. Andrews in 1769. Partly through the good offices of a distant cousin, the Rev. Dr. William Wilkie, author of the *Epigoniad* and the late Professor of Natural Philosophy at St. Andrews, he was presented to the charge of Cults. He was ordained there in 1774.

As a preacher he was "sensible." It was further observed that he had "a rapid delivery and spoke thick," and that as a man he was "universally esteemed for his genuine piety and rectitude of conduct." In 1794 he published a *Theory of Interest . . . Applied to Annuities*—a work reputedly used by the younger Pitt. A year before the publication, Mr. Wilkie recovered from "a complaint . . . which, brought on by study and anxiety, threatened his life."

Two years after his ordination, Mr. Wilkie married his first wife. He was reduced to a widower within a few months, and this was again his state a year and a few months after his second marriage. In 1781, when he was forty-three, he married Isabella, aged nineteen, the daughter of James Lister and Rachel Mackie. James Lister was the farmer and miller at Pitlessie Mill, about a mile from the church of Cults—of which he was an elder. His daughter bore the six children of the manse: John (1782–1824), James (1784–1824), David (the artist), Thomas (1787–1865), Rachel (born 1791, died within six weeks), and Helen (1793–1870).

As a father, Mr. Wilkie seems to have been remotely affectionate; he was also protectively

7. The Rev. David Wilkie and His Wife

fussy over the insecurity that might follow from his son's determination to pursue his gifts as a painter. From his father Wilkie may have inherited the strong self-command and lack of impulsiveness that were, at moments, injurious to his health—even to his art. Wilkie's relationship with his mother, on the other hand, was evidently close and openly loving. It was continued after Mr. Wilkie's death in 1813 when she and Helen joined Wilkie in London. There, without losing her gentle rusticity, his mother created the comfortable sociability of the household, which Helen sustained after Mrs. Wilkie died in 1824.

The objects on the table are a Bible and two communion cups (of pewter?). It may be supposed that it is Saturday night and that Mr. and Mrs. Wilkie sit in contemplation of the signification of the instruments of his ministry —although the mother's glance suggests that she has been distracted by her son. Her glance serves to link the affairs of the world to Mr. Wilkie's separation in thought: "He for God only, she for God in him," to borrow words from Milton.

An analogy has been shown between this otherwise novel composition, with its affecting sense of submissive piety, and a late eighteenth-century etching by an Edinburgh artist, David Deuchar (1742–1808). The latter was a pastiche based on an earlier etching by the younger Jacob de Gheyn, but bearing the name of Adriaen van Ostade, the seventeenth-century Dutch painter and etcher. For this, see Marks 1974.

The portrait was lent by Wilkie to the sculptor Sir Francis Chantrey as an aid to the making of his portrait relief on the memorial tablet to Wilkie's parents in the church at Cults, which is dated 1833.

8. Rent Day: Sketch

Canvas; 10½ × 15½ in. (26.6 × 39.3 cm.)
Initialed, and dated 1807
Lent from a private collection

History and Provenance
Possibly painted late in 1806, and almost certainly by February 1807. Bought from Wilkie by Lord Mulgrave for 15 guineas (ten per cent of the price of the finished picture). His sale 12 May 1832, bought by Smith, £64—1—0; Narcisse Revil, Paris (d. 1844); his sale, Paris, 28 February 1845; John Clow sale, Liverpool, 21 April 1852, £157—10—0; with T. Agnew & Son, Liverpool, [the present sketch should not be confused henceforth with "The Rent Day: Original sketch for the celebrated picture," sold 19 July 1890 on the death of the 2nd Marquess of Normanby (and 3rd Earl of Mulgrave), a work of questionable authenticity its provenance notwithstanding]; anonymous sale 23 December 1953, bought by Nicholson, £68—5—0; anonymous sale, Torquay, 16 April 1980, bought by T. Agnew & Son, London, and with them in 1981.

Exhibition
Wilkie's Exhibition 1812.

Literature
Cunningham, 1:324.

Formation
Traditionally this has been called—and possibly it is—a sketch for the finished picture of *The Rent Day* (private collection), which is over twice this size. But see further under Comments, below.

Comments
The finished picture was ordered by Lord Mulgrave in April 1806, but probably not much worked upon before the end of the year. Although signed and dated 1807, the picture was not delivered and varnished until May 1808. It was exhibited at the Royal Academy in 1809, and engraved by Abraham Raimbach in 1817.

If the present picture is a sketch for the larger one exhibited in 1809, it was probably made at an advanced stage in the planning, even of the laying-in, of the final composition—which it seems to reflect as much as to foreshadow. All the essential ingredients of the picture are present here, namely the disposition of the figures (with their specific physiognomies), the furnishings, and the lighting (for establishing the distribution of which a sketch was possibly made). The differences lie chiefly in the development of pictorial space and of descriptive detail.

On 24 March 1807, Farington reported Mulgrave's after-dinner talk: "He described a picture which Wilkie is now painting for him . . . and said it would surpass . . . the 'Blind Fiddler' [cat. no. 5]. . . . He said he believed Wilkie would go beyond Teniers, Ostade, and all who had preceded him, as he not only gave exquisitely the ordinary expressions of the human countenance but those of thought and abstraction."

According to Cunningham, the subject was of Wilkie's choice. There is no evidence as to how he arrived at it. Cunningham suggests that if Wilkie had not already known about "griping landlords," he might have learned from the description of a rent day in Burns's poem of "The Twa Dogs"—of which one was "whalpit some place far abroad" (as to all intents and purposes the animal on the hearth-rug might have been), while the other was "a ploughman's collie" (hunched expectantly by the diners at the right). But the poem, if it provided a happy embellishment, is most unlikely to have been the whole source of the invention.

When the finished picture was exhibited in 1809 it gave rise to a number of conjectural translations of its story into prose. Nevertheless it is a later account of its anecdotal content

that deserves repetition because written by John Burnet, who knew Wilkie when the picture was being painted. In his autobiographical novel of 1854 (see cat. no. 5, under Comments), Burnet purports to describe a visit to Wilkie while *The Rent Day* was in progress: "Wilkie produced his study [presumably not in fact the present sketch because this already shows the dogs] . . . and began an explanation of the picture. 'I have laid the scene in the steward's room, where the tenants are assembled to pay their rents. The steward, seated at the table, is listening to a farmer who is paying, and calling his attention to some disputed point. His clerk is represented casting up the account. The next tenant stands at the table, with his rent ready in a bag, waiting his turn with patience. The female, seated next to this figure, you may imagine a widow, with a child in her arms, and her little girl on the ground. This group I intend shall receive the principal mass of light, as the dresses of the women and children are better adapted for that purpose; besides it draws the attention of the spectator to a pleasing part of the composition. The two figures behind, one holding the other by the button, to express if possible the detainer wishes assistance of a loan. The two seated, I have endeavoured to give expression and variety of character to, by one of them having a "sair barking host [cough]," as we say in Scotland, and the other having his rent quite safe in his pocket. The figure behind them, I mean as the nobleman's servant drawing a well-corked bottle of wine to regale the tenants, who are dining in a recess . . . to which they have retired after paying their rent. The whole of course will be enriched with accessories appropriate to the scene, such as the landlord's fat French pug-dog, sleeping . . . before the fire, and the farmer's collie, watching at the dinner table.

The great thing . . . is to introduce as much variety of character and expression as possible.'" The anecdote is certainly richer than any in Wilkie's work so far.

Cunningham, in his reading of the subject, refers to the tenants as seeming "to be of a class who are drooping under the double pressure of 'racked rents,' and an exacting landlord." That there is any pointed political intention behind the subject must be questioned however. There is no evidence that Wilkie was thinking in socially critical terms, and if at all it was apparently with acceptancy. After the publication of the engraving in 1817, he wrote: "I expect that the great sale [for the print] will be in the country, and particularly in the agricultural districts." He could have added that he already had a few subscribers in Kent and Suffolk, half of them clergymen. (It should not be imagined that prints were priced within the means of the tenant class here represented.) Again, Sir George Beaumont was "highly pleased with the print," and Lord Mulgrave showed it to "several of the Cabinet Ministers who were all greatly pleased"—none are likely to have been so had they seen the print as subversive, and Mulgrave least of all since it would seem that his sister and daughter were the models for two of the figures.

A commonsensible view of the subject and its treatment was given by a reviewer in 1809: "Far be it from us to attribute any of those extravagant sentiments of content and happiness, which romantic people [including Wordsworth?] fancy must belong to the hard-labouring countryman: Crabbe's poems have wiped away every notion of that description, which in our youth we might have imbibed [from the writings of Goldsmith especially, or from pictures by Morland?]." There were Netherlandish precedents for the subject, as in

8. Rent Day: Sketch

the work of Pieter Bruegel the Younger.

The Rent Day was to become the loosely related subject of a play of the same title by Douglas Jerrold. It opened in Drury Lane in January 1832 and was famed for the beginning and the end of its second act, which consisted of tableaux-vivants representing in "fac-simile" Wilkie's *Rent Day* and his *Distraining for Rent* of 1815 (National Gallery of Scotland). The play, and its living images from Wilkie, were a considerable success in 1832, the year of the Reform Act, but even then their haphazard political implications were not Wilkie's.

Henry Phipps (1755–1831), Baron Mulgrave in 1792, went into the army and was promoted to lieutenant-general in 1801 and general in 1809. A member of Parliament since 1789, he was in the cabinet in Pitt's last years, maintaining his seat until 1820. Appointed First Lord of the Admiralty in 1807, he resigned in 1810 and became Master of the Ordnance. He was created 1st Earl of Mulgrave in 1812.

Mulgrave, "good-nature itself," and Sir George Beaumont (see cat. no. 5, under Comments) were introduced to Wilkie in April 1806 by Mulgrave's protégé and Wilkie's contemporary, John Jackson, the portrait painter. Mulgrave there and then bought a small picture, *Sunday Morning* (lost), and ordered another which emerged as *The Rent Day*. He was also to extend to Wilkie (as to Jackson and Haydon) much personal kindness.

The Rent Day was Mulgrave's only major work by Wilkie, but he told Farington on 24 March 1807 that he had "made an agreement with Wilkie to have all his studies and sketches for whatever pictures he may hereafter paint, and will furnish a room with them at Mulgrave Castle [in Yorkshire] to preserve them, and will endeavour to educate his son [Constantine Henry, then aged ten] to possess a proper taste for them." The arrangement was, as recorded by Farington on 28 March 1808, that Mulgrave would pay Wilkie "at the rate of 10 per cent for all the small studies, on the prices he [Wilkie] may put upon the finished pictures." In 1809 Mulgrave asked Wilkie for a self-portrait to be added to the collection, but it was not painted. For no clear reason the relationship seems to have died out after 1812.

There were fourteen paintings by Wilkie in the sale after Mulgrave's death. They were the two finished paintings already mentioned, while the rest were called sketches. (The two paintings and four of the sketches were bought back for the family.) That all the sketches were truly so in the sense of being studies or working models for paintings, as implied by the agreement between Mulgrave and Wilkie in 1807, is doubtful. Six of them (including this one) are recorded by Cunningham as having been painted during Wilkie's convalescence in the winter of 1810. Cunningham added that "some of these approached in merit the original pictures; they had all their careful freedom of touch and vigour of character and colour, and their inimitable stamp of original thought." In short, and if Cunningham is to be believed, at least six of Mulgrave's sketches, so called, were in fact reductions after finished pictures, presented in the guise of sketches. Surviving examples of such reductions bear the dates of their originals, rather than that of 1810 (see cat. no. 6, under Version).

However, not all of Mulgrave's sketches can have been of this late date. Nearly a year earlier, Wilkie had noted in his diary for 3 December 1809: "Had an interview with Lord Mulgrave at the Admiralty; and helped [William] Seguier to arrange the pictures and sketches I had painted." So far as the present sketch is concerned, its authenticity as a sketch

in the usual sense of the word—that is, as being antecedent to the finished picture—may be supposed on the ground that while Mulgrave could well have had an interest in possessing a sketch for his finished picture of *The Rent Day*, it is not likely that he would have been satisfied with something that was merely a reduction after it. For other pictures belonging to Mulgrave that were probably true sketches, see cat. nos. 5 and 9, under Versions.

Another military man to collect Wilkie generously, and also in miniature, was Sir Willoughby Gordon (see cat. no. 32).

9. The Card Players

Wood; 21 × 29½ in. (53.3 × 74.9 cm.)
Lent by The Lord Denham.

History and Provenance
Painted in 1807–8 and bought in 1808 by the Duke of Gloucester, who died in 1834; it seems that in 1839 the Duchess placed the picture with [W. C.?] Bryant, and that in March that year he sold it to Charles Bredel for £500. Bredel died in 1851, and the picture passed to his daughter, Miss Bredel, who still had it in 1872; John Walter, 1882; on his death in 1894 the picture passed to his son, A. F. Walter; his sale, 20 June 1913, bought by Agnew, £504; the Countess of Carysfort 1913, and by descent to Miss L. G. Boothby Heathcote, who had the picture in 1940; Lord Denham by 1951.

Exhibitions
Royal Academy 1808; Wilkie's Exhibition 1812; British Institution 1842.

Literature
Cunningham, 1:146–47, 167–69, 179; Farington, 8:3151, 3164, 9:3206, 3232, 3248, 10:3615, 11:4116.

Formation
A friend of Wilkie's, the painter Andrew Wilson, recalled: "The Blind Fiddler [cat. no. 5] excited great admiration in the exhibition [at the Royal Academy in May 1807]. . . . and [Wilkie's] great youth and his extraordinary merit induced several eminent persons, lovers and patrons of art, to consider the best means of encouraging [him]. . . . I . . . was present . . . when several noblemen and gentlemen met . . . for the purpose of consulting [Benjamin] West [the President of the Academy] on the subject. One of them . . . observed that perhaps it might not be prudent to give Wilkie too many commissions at once, as he would probably exert himself beyond his strength. . . . The President replied . . . 'Wilkie . . . is already a great artist, therefore do not hesitate in offering him commissions and all the encouragement in your power. . . . ' One of those persons (Sir Francis Bourgeois [R.A.], I

think) agreed to speak in his favour to the Duke of Gloucester, who had at that time given commissions to several artists. For his Royal Highness he painted The Card Players."

Wilkie left London for Scotland in mid-May 1807, and did not return until after October 8. By November 29, according to Farington, Sir George Beaumont "had seen a picture begun of Card Players for the Duke of Gloucester, the coat of one figure rather slaty." Constable told Farington on December 12 that it was "most admirably executed as far as is done."

On 24 January 1808, Farington noted: "Bourgeois has sent a frame for the Card Players now painting," and on March 1, having met Wilkie, he referred to the picture as "lately finished." When they met again, on March 28, Wilkie said "it took him four months to paint the picture . . . [and that he had] carried it to the Duke about a fortnight since." The picture was at the Royal Academy for the opening of the exhibition on 2 May 1808, and afterward removed on June 20. The next day Sir Francis Bourgeois took Wilkie and the picture to the Duke in his carriage, and Wilkie was given 100 guineas on top of the 50 guineas he had already been paid. For the question of the price, see under Comments below.

Versions
On 28 March 1808 Farington recorded Wilkie's difficulties over the price for the present picture, and continued thus: "Wilkie said he communicated these particulars to Lord Mulgrave . . . [who] having engaged Wilkie to let him [have] the small studies of all the pictures he may paint, he told Wilkie that he reckoned the value of the 'Card Players' at 200 guineas and [that since] he meant to pay him at the rate of 10 per cent for all the small studies, he should pay him 20 guineas for this small

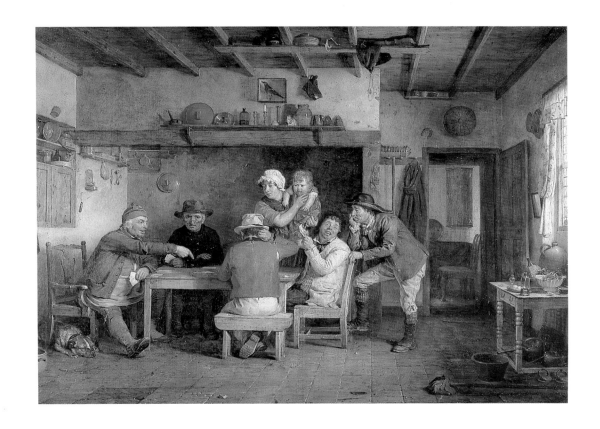

9. The Card Players

study [of *The Cut Finger*], which he did." This small version can be traced with certainty to 1876, and with less certainty to 1977.

In this way Mulgrave began a collection of at least ten (probably twelve) small versions of Wilkie's more important early compositions. In Wilkie's lifetime they were referred to as sketches—as is still generally the case—but it seems clear that not all of them were sketches in the sense of being the "small studies" for pictures that Mulgrave bespoke in 1808. Some were almost certainly reduced versions of his own pictures made by Wilkie during his convalescence in the winter of 1810 (see cat. no. 8, under Comments).

Cunningham knew of a "sketch, with variations, of this picture . . . in the possession of Mr. [Henry] Howard, R.A. A black man is introduced as a looker-on of the game, and adds much to the merit of the work." Wilkie was painting a black man into *The Village Festival* (cat. no. 12) on 30 September 1809 and perhaps used the same model. Howard died in 1847 and there is no further trace of this small variant.

Comments

Constable, having seen the picture in Wilkie's studio, told Farington that Wilkie had said that "when he has made a sketch for a picture and settled his design, he then walks about looking for a person proper to be a model for completing each character in his picture, and he paints everything from the life. He said he sometimes walks about for a week before he can meet with the character of head &c. that will suit him."

The figure seated at the far side of the table was seen in 1838 as an exciseman, and the man leaning with his elbow on the back of the chair to the right as a maltster (*Literary Gazette* 1838, 732); the man at the end of the table, to the left, was called a butcher in 1842 (*Athenaeum* 1842, 566).

In Cunningham's view, "Scotland is stamped less legibly on this than on any other of Wilkie's preceding pictures. It is, in both animate and inanimate things, essentially English, and belongs more to London than to the provinces." England is certainly indicated by the form and furnishing of the window. But Cunningham was undecided as to whether the interior was that of a small inn (the usual contemporary assumption) or of a cottage. The latter seems more likely, unless we are to take it that a contemporary English inn was as decently suffused with the spirit of Goldsmith as this. If it should be an inn, it is both far from a Scotch houff (compare *The Village Politicians* of 1806) and from its counterpart in a seventeenth-century Dutch or Flemish picture.

According to Cunningham, the subject of the picture "is believed to have been suggested" by the Duke of Gloucester, but this seems unlikely. As a subject it had been rudely adumbrated by Wilkie in a lost picture of about 1802–3 (reproduced in Gower 1902, f. p. 10).

From what has been seen of the early history of the picture (under Formation, above), the sequence of events would lead not unnaturally to an assumption that Wilkie painted it for the Duke of Gloucester. Yet after he had begun work on it, Wilkie was reported to Farington as having said: "The Card Players he shall finish, not declaring it to be for any particular person, but when [it is] finished [he] will see who is disposed to offer most for it." The notion of letting a finished picture go to the person who made the best offer for it, rather than painting on commission at a fixed price, was in Wilkie's case born of his unhappy experience over the payment for *The Village Politicians* made by the

Earl of Mansfield in 1806. This had been a matter of notoriety at the time. That incident and the confusion that arose over the price of the present picture are of interest because each in its way raises questions as to how a young painter, especially, should calculate the price of a picture, and how he should interpret an informal understanding on the part of a patron. An answer must take into account the inherent value to a young painter of the patronage of the great; conversely, there is the question of behavior proper in a patron.

To confine the story to that of the present picture, Farington is again the principal source. On 24 January 1808 he wrote: "Wilkie I met today. The Duke of Gloucester, through Bourgeois, proposed to give him 50 guineas for a picture to be painted. Bourgeois has sent a frame for the Card Players now painting. The £1.50 [for "50 guineas"] is a trifle compared with the value of this picture. Lord Mulgrave is for Wilkie letting the Duke have it. I recommended to him to paint another for the Duke more suited to his offer." On 1 March, Farington was told by Wilkie that "he had determined to let the Duke . . . have the . . . 'Card Players' which he has lately finished." Farington heard more from Wilkie on March 28: "He said it took him four months to paint the picture. . . . The Duke on seeing the picture and having been informed of the long [time] which Wilkie had been employed upon it was conscious that 50 guineas . . . was too little. He therefore took Bourgeois on one side and expressed this to him, and asked Bourgeois for his opinion, which Bourgeois declined to give. Since that time Bourgeois has called upon Wilkie and informed him that the Duke, sensible that 50 guineas was too little for that picture, was willing to give him 50 guineas for the picture he is now painting, 'The Sick

Woman' [since lost], which, not having so much work in it, would make up for the over work on the other. Wilkie said to me that he felt indignant at such a proposal, which shewed so little sense of what was due for his labours. He declined it. . . . Wilkie said he communicated these particulars to Lord Mulgrave who felt as I did [that the Duke's meanness was contemptible] . . . [and] told Wilkie that . . . he reckoned the value of the 'Card Players' at 200 guineas."

The account given to Farington by Bourgeois in 1810 was that when he and Wilkie called upon the Duke, the latter "took Bourgeois into his closet and said 'The report of this picture is so high, that I cannot possibly take it at the price proposed.' Bourgeois replied that the price had been fixed, and that there was no claim on His Highness. The Duke then said it would be 150 guineas [the price of *The Sick Lady*], which was paid to Wilkie."

An explanation for this confusion given by Cunningham (politically a radical) was that "those noble persons had not been accustomed to pay for any productions of British art save portraits, the offspring of half a dozen sittings." There was doubtless a certain truth in this, but in the present context an oddity in the Duke himself is worth recalling. In making the arrangements for his one-man exhibition in 1812, Wilkie had "hopes of getting the Prince Regent and the Duke of Gloucester to the private view." Gloucester came, although on the day before. As he was leaving, so Farington reported, "he stopped and opened his purse and delivered a note to an attendant to carry to Wilkie, who hesitated to receive it, but the attendant said he had the Duke's command to deliver it to him. Wilkie then took it and, on opening, it proved to be a *one* pound note—an extraordinary specimen of the

Duke's mode of thinking."

As for Wilkie's own feelings about the payment he received for the picture, at the time of its exhibition in 1808, he wrote that the Duke "has behaved to me in the most handsome and liberal manner." Nevertheless, the experience once again caused Wilkie to say, on Farington's report, "that henceforth he would not paint any picture on commission," and "that the picture he shall next execute, having made a sketch for it, he will finish, and then leave it open for sale" — the very way of disposing of this picture he had decided upon in December 1807.

This was Wilkie's first picture for a member of the royal family; the Prince Regent's commission of *Blind Man's Buff* (Royal Collection), and the beginning of that decisive association, came (seemingly) in 1810.

William Frederick, 2d Duke of Gloucester (1776–1834), left no mark either as a patron of artists or as a collector. His interest in the latter direction seems to have centered on prints illustrative of British history. He was to be met, however, around the time of the events described, in the circle of the art establishment that included Sir Francis Bourgeois (1756–1811), who was his link with Wilkie.

Bourgeois is forgotten as a painter, but is well remembered as the owner of a collection of Old Masters bequeathed to him, and now enshrined (with his mortal remains) in the Dulwich College Picture Gallery in London. The relationship between Bourgeois and Wilkie was no deeper than emerges in the story of this picture. Charles Bredel, the other owner of the picture in Wilkie's lifetime, was a merchant and a collector of some significance.

Engravings

1. By C. G. Lewis, published by Hodgson & Graves, on 1 Aug. 1838; mezzotint, 41.8 × 56.4 cm. The prices were: prints £1 — 11 — 6; proofs £3 — 3 — 0; proofs before letters £5 — 5 — 0.

 A Memorandum of Agreement between the publishers and the engraver had been drawn up on 6 July 1837 "as to engraving a Plate after a Drawing of the 'Card Players' by W.[illiam] Derby from a Picture by Sir David Wilkie." Lewis was to get £200 for a plate in mezzotint with etching, to be completed by 20 Sept. 1838, and 1,000 good impressions were to be taken from the plate, which was to be left in good working condition. There is no sign of involvement by Wilkie, and the part played by the Duchess of Gloucester — the owner at the time — is not known. Wilkie anyway favored line engraving for the reproduction of his pictures, a laborious and costly process that was even then being displaced by the relatively rapid method of mezzotint engraving.

 William Derby (1786–1847) was a miniature painter who did much copying for engravers. His son, A. T. Derby, exhibited a copy of the picture, almost certainly from the engraving or his father's drawing, at the Artists' Fund Society in Philadelphia in 1840. It was from the engraving that the Canadian painter Cornelius Krieghoff must have made the copy of the picture now in the Art Gallery of Ontario, Toronto.

2. By W. Greatbach; 15.5 × 22 cm. In the *Wilkie Gallery* (1848–50).

10. Maria, Marchioness of Lansdowne and Her Page

Wood; 12⅝ × 9⅞ in. (32 × 25 cm.)
Lent by the National Gallery of Ireland.

History and Provenance
Painted in 1808–9 for the Marquess of Lansdowne; in his widow's sale, 12 July 1833. The further history of the portrait is not known until it was presented by the Misses Entwissle to the Gallery in about 1958.

Exhibition
Wilkie's Exhibition 1812.

Literature
Cunningham, 1:174, 192–96, 198, 219, 221–25, 270.

Formation
Commissioned in May 1808. Wilkie was invited by the Lansdownes to Southampton Castle, where he arrived on September 1 and began the portrait the next day. When Wilkie returned to London on September 15, the picture seems to have been essentially complete —sufficiently so for Haydon to be able to say on 20 September that "some parts of it were infinitely superior to any thing [Wilkie] had hitherto done." Any further work was almost certainly set aside in favor of *The Sick Lady* (also for the Lansdownes; lost), *The Jew's Harp* (Liverpool), the *Neave Family* portrait (private collection), and the *Cut Finger* (cat. no. 11).

When Wilkie delivered *The Sick Lady* to the Lansdownes on 14 January 1809 the portrait was still not ready. He repainted the hand holding the cup and went over the dwarf's dress before taking the portrait to Berkeley Square on February 2. For the two works he received a week later a check that included the 50 guineas he had asked for the portrait.

Comments
Maria Isabella, the widow of a Mr. Duke Gifford who had assumed the rank of baronet, married John Henry, 2nd Marquess of Lansdowne (1765–1809), in 1805. At the time she was described by Lady Bessborough as "a Vulgar Irish woman near fifty and larger than Mrs. Fitzherbert . . . she has lived with him publickly . . . for some years past." Under his wife's influence, as gossip had it, Lord Lansdowne sold the contents of Bowood, the principal family house, and left it to decay. With a town house in Berkeley Square, they spent their summers in a castellated mansion he "built with brick . . . covered with white composition, . . . in the High Street" of Southampton. It was said to be difficult to find its entrance since the base of the building was "entirely blocked up with small houses belonging to the poorer inhabitants."

A visitor to "the strange House . . . and . . . its stranger Mistress" saw Lady Lansdowne "with her three daughters [the Miss Giffords] following her, wrapt in thin lace veils, blue silk shoes, and bare-headed . . . [as they] brav'd the wind and the . . . muddy streets of Southampton." Another visitor to the town described Lord Lansdowne as "a very tall and thin man, riding on a long lean horse, and . . . following him a very little page, called his dwarf, mounted on a diminutive poney"— perhaps the same page as is in the portrait. After Lansdowne's death his widow became the accepted suitor of a young German seeking to restore his wealth, Prince Puckler-Muskau, but she jilted him in 1815. Southampton Castle was demolished in 1816, and the Dowager Marchioness died in 1833. The 3d Marquess of Lansdowne was later to become a patron of Wilkie.

A fee of £50 was for Wilkie, at this stage in his career, a handsome return for a small portrait. Cunningham said that he painted it for money, and added that it was a faithful likeness—"too faithful, as I have heard."

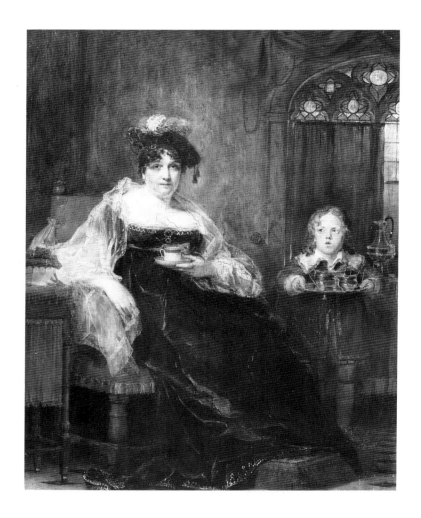

10. **Maria, Marchioness of Lansdowne and Her Page**

11. The Cut Finger

Wood; 13½ × 18⅛ in. (34.3 × 46 cm.)
Lent by S. C. Whitbread, Esq.

History and Provenance
Painted in 1808–9 and bought by Samuel Whitbread
for 50 guineas. The picture has since passed by descent
to the present owner.

Exhibitions
Royal Academy 1809; Wilkie's Exhibition 1812; British
Institution 1842; Museum of London 1984.

Literature
Cunningham, 1:202–5, 207–15, 224–6, 230, 238,
244, 3:525.

Formation
The picture was destined for offer to Samuel
Whitbread. In 1806 Wilkie had agreed to paint
him a picture, of an unspecified subject. It is
not known whether Whitbread later agreed
with Wilkie that he should proceed with this
particular subject as a result of having seen the
sketch (see Versions, below).

In his diary, Wilkie described the devel-
opment of the picture as he worked on it
almost daily from 13 October to 28 December
1808. In Sols Row where he then lodged (he
moved to Great Portland Street during the
painting), he found a model for the head of the
old woman. He had established the head and
hands, and some of the dress, of that central
figure by October 22, as well as some other
heads and hands. He seems to have advanced
the picture next by concentrating on the hands
of the children—the anecdotal focus of the
composition. At the beginning of November he
was working on what seems to have been a
third phase, the clothing of the figures. At this
point he also began to be given advice, some of
which he took. On November 12 Wilkie noted
that Haydon had called and "objected to the
blue apron of the old woman, on account of its

being too cold for that part of the picture." The
next day William Seguier, the picture restorer
who advised the Prince Regent on his
collection, suggested that the boy's hand should
be "lessened" (for the sake of the squeamish?)
and that his pinafore should be altered "from a
strong to a pale yellow"—which it now is.

Wilkie then seems to have left the figures
almost entirely and turned to the background
and accessories. On November 18 John Burnet,
Wilkie's fellow student from Edinburgh and
soon to become his first engraver, urged him "to
make the wall behind the old woman much
whiter." Seguier and Wilkie went to see Henry
Hope's collection, notably of Dutch pictures,
on November 21, and there Wilkie "found
some things which will be of use . . . in my
picture," by which he almost certainly meant
the present one. He continued putting in or
altering the accessories, and sent out "the girl
of the house to buy a fowl, which was plucked
for me to paint from." By December 21 the
picture must have been nearly finished and
there are signs that Wilkie was beginning to
fuss over it.

Wilkie announced the completion of the
picture on 2 February 1809, when Whitbread
invited him to dine and to bring both the
present picture and the portrait of Wilkie's
parents (cat. no. 7) for Mrs. Whitbread to
see—in 1806 she had sent for *Pitlessie Fair* (cat.
no. 4). The inspection evidently produced
thoughts for improvement, for he added details
(one has since disappeared) on February 7 and
9. On February 20 the engraver and painter,
S. W. Reynolds, called to say that his patron,
Whitbread, wanted Wilkie "to make the Boy
with the Cut Finger a little more youthful in
the face." Wilkie delivered the picture on
February 22, and was paid 50 guineas for it.

After the exhibition at the Royal Academy

1809, the picture had to be touched in due to a scratch. Following his one-man exhibition in 1812, Wilkie wrote that he had "altered it in one or two places, I think for the better" (Deuchar 1984, 76).

Versions
Wilkie noted in his diary that on the evening of 27 September 1808 he had "made a slight sketch of a subject I have in contemplation—The Cut Finger." This was almost certainly an oil sketch that he completed, or nearly so, on October 12. While painting the present, finished picture Wilkie wrote on November 7: "I began to alter the effect of the sketch." The sketch has since disappeared. (The supposed sketch in a private collection is no more than a probably posthumous copy of the central group in the present picture.)

A reduction of the composition, initialed and dated 1809, was painted by Wilkie in the winter of 1810 for Lord Mulgrave. It has not been traced since 1953.

Comments
An anonymous and self-evidently unreliable anecdotalist (possibly W. H. Pyne) wrote in 1841 of a visit by Wilkie to Whitbread's country house, at Southill in Bedfordshire: "Mr. Whitbread proposed a subject on which Mr. Wilkie was requested to try his skill. There had been a conversation on our national phrase *pluck* or *bottom*, as generally applied to our common sailors. . . . Wilkie had been been requested to make a design of an incipient hero of this cast, a sturdy urchin of about five years of age, who had been caught by his grandmother . . . carving a tiny ship's boat . . . and has cut his fingers. . . . Whitbread delighted in relating genuine stories of our tars" (*Fraser's Magazine* 1841, 446–47).

Although suspect in its explanation of the subject of the picture, the anecdote may nevertheless contain a little substance. Cunningham soon afterward reverted to something like the same story: "This picture was, when it appeared first, called The Young Navigator by the purchaser . . . who desired to see in its story the maritime glory of England in the dawn; but a boy who cried at the sight of his own blood was not considered a true representative of our conquering tars, and the picture soon took the humbler name which the . . . painter first bestowed upon it." Whatever the event, the picture should not be made to bear political weight, either on Wilkie's side or, more especially, on Whitbread's—if only because, as we have seen, there is no evidence that Whitbread commissioned a picture of this specific subject. So far as is known, he got what he was given.

Samuel Whitbread (1764–1815), the heir to a prosperous London brewery, was well known in his day—and is still remembered—as a Whig member of Parliament with democratic leanings, and notable for his patriotic benevolence. This was manifest, among other ways, through his patronage of contemporary British artists. John Opie's wife, Amelia, wrote as a visitor in 1806: " . . . the longer you inhabit Southill, the more you feel assured that, used as it is here, opulence is a blessing." Whitbread and Wilkie met for the first time in 1806, when Whitbread tried to be helpful in the wake of the success and vexation that attended Wilkie on the exhibition of *The Village Politicians* (private collection). Their last recorded meeting was at Sir George Beaumont's in 1809. The relationship does not seem to have been close, and it may have ended when Wilkie suppressed S. W. Reynolds's mezzotint after the picture (see Engravings, below).

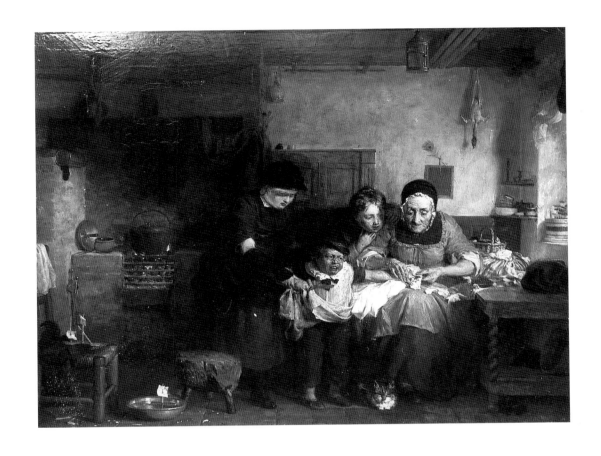

11. **The Cut Finger**

Wilkie disapproved of this technique of reproduction, but his action may have been taken more as a slight on the engraver, and Reynolds was an intimate protégé of Whitbread's. For a good account of Whitbread's patronage, see Deuchar 1984.

Drawings
Edinburgh, National Gallery of Scotland and Royal Scottish Academy; London, British Museum, Courtauld Institute, and Victoria and Albert Museum; private collection.

Engravings
1. An incomplete mezzotint by S. W. Reynolds was bought up and suppressed by Wilkie to make way for Raimbach's engraving.
2. By Abraham Raimbach, published by Raimbach and Wilkie, on 16 January 1819, and dedicated to the owner, W. H. Whitbread; 28.5 × 38.6 cm. Wilkie had applied to Whitbread's father, Samuel, to allow an engraving; this was in 1812, when Wilkie was, as he himself wrote: " . . . applying to all the possessors of my paintings to grant me the same indulgence . . . [and] it is my intention to employ men of the finest abilities, and also to devote much of my own time to the progressive advances of the subjects." Nothing came of this particular campaign for reproducing his pictures. Raimbach did not have the picture to work from until March 1817. He was still engraving in December, and probably later; the printing was not done until December 1818. Raimbach thought the picture a sufficient favorite with the public to "safely warrent the speculation of a print of half the size and half the price of the Rent Day [see cat. no. 8]," but in the end its sale was "but indifferent."
3. By W. Greatbach (probably after Raimbach), 1846; 16.1 × 21.9 cm. Also published in the *Wilkie Gallery* (1848–50).

12. The Village Festival

Canvas; 37 × 50¼ in. (94 × 127.6 cm.)
Signed, and dated 1811.
Lent by the Tate Gallery, London.

History and Provenance
On 1 October 1808, John Julius Angerstein visited Wilkie in the company of Lawrence and commissioned a picture without limitation as to price or time to be taken, or stipulation as to subject. The present picture, which was to become his, was begun on 29 September 1809, "nearly finished" by 28 July 1811, and delivered to Angerstein that October (?). He died in 1823, and in 1824 his collection was bought for the nation as the nucleus of the National Gallery; the picture was transferred to the Tate Gallery in 1919.

Exhibition
Wilkie's Exhibition 1812.

Literature
Cunningham, 1:168, 199–200, 230, 231, 236–38, 256–69, 271, 272, 274–77, 278, 279, 281, 283, 285–86, 287, 291, 293–94, 296, 297–99, 304–5, 324, 332, 333–34, 341–42, 347–48, 3:525; Farington, 9:3465, 11:3874, 4092, 4093; Haydon 1960–63, 1:207, 2:470–71.

Formation
Wilkie noted in his diary that he began a sketch of the subject in August 1808. There it seems to have rested until he took it up again in March 1809 and developed it in its present essentials up to June 20. See further under Versions, below.

Wilkie's diary likewise provides much detail on the progress of the present, finished picture. On the basis of the sketch, work began on 29 September 1809. The process of transferring the ingredients of the sketch to a canvas about three times as large, also of a composition more complicated than he had attempted before, entailed a great deal of reconsideration and readjustment. Most of the subject seems to have been on the canvas by the second week of October, but an evolution of its parts and of their interrelationships continued. At different stages, Wilkie heard comments on the picture from Haydon; the landscape painters Andrew Wilson, Callcott, and Sir George Beaumont; and the art expert William Seguier. He also took technical counsel from works by Ostade and Teniers, and felt chastened by the example of industry set by Thomas Heaphy, a painter of subject pictures in watercolor.

The better part of the three weeks from about mid-October was spent in clarifying the principal group of lurching figures, to the left of center. For that purpose an "old man, Morely," was brought in as the model for the men in the group. Of the dress of the central figure with a hat Wilkie wrote: "I bought the smock frock for thirteen shillings which I so much wanted to work from." He also used female models, including, for the figure of the woman in a cap, Charlotte Fletcher, the sister-in-law of John Jackson, the portrait painter (see cat. no. 5, under Formation).

Wilkie then turned to the seated man in the blue jacket who holds up a bottle; on him he spent much of the ensuing week, not entirely to his satisfaction. The model was John Liston, then recently come to fame as a comic actor. From this figure followed the others at the table, then those behind them, both under the porch and at the window. The black model may have been an American called Wilson, from whom Wilkie's friend Haydon worked a year later. After much labor and revision up until early in January 1810, the principal group and the group at the table with its subsidiary cast were largely settled. Progress was interrupted by three weeks diverted to a particularly exigent task in portraiture, the Neave family group (Private Collection; see fig. 25).

When Wilkie returned to work on this picture again on January 31, it was to tinker for

a fortnight with what he had already done and to advance the so far slightly treated figures on the balcony to the left. In the latter part of February he was engaged on a small picture, the *Wardrobe Ransacked* (also known as *Grandmother's Cap*) (destroyed 1934?), largely intended as a stop-gap submission for the exhibition at the Royal Academy—there being no prospect of having the present picture ready for the occasion.

The fate of the *Wardrobe Ransacked* (which reflected something of the spirit of the principal group in the present picture) is another story; in this context it was a distraction that lasted until mid-May. Yet to Wilkie it may have been a welcome distraction since from early February he had become concerned as to how to realize the largest area of the present picture—that occupied by the buildings, trees, and sky. Perhaps unnerved by the problem, he had consulted Sir George Beaumont, who wrote back on February 9: "I am only afraid, from [your] want of practice in these things, the sky and background may cost you some trouble. How essential [it is] . . . to the effect of the whole . . . to make them . . . a bed for the main part of the picture—to place the lights and shades in such places as will animate without disturbing the whole, is a task more difficult than is generally imagined. . . . My notion is that your sky should be grey, silvery, and tender. . . . I have a small landscape by Teniers, the sky of which is nearly the same colour I should recommend, and . . . I will send it to you." Wilkie acknowledged his "uneasiness" and accepted the offer of the Teniers (see cat. no. 17, under Comments).

On April 29, still in 1810, Wilkie had a visit from Angerstein. With the force of his affirmation of interest in the picture, and the affair of the *Wardrobe Ransacked* by now past,

Wilkie was able to go forward again. From May 11 his attention turned to the furthest figures—those which enliven the gable end of the inn, at the center of the geometry of the picture, and extend the Watteau-like arabesque of human activity threaded through it. (The acknowledged sources for the architecture were a public house at Paddington and "houses at Brompton.")

Wilkie's journal, and doubtless his work on the picture, ended at the time when he fell ill about the middle of June 1810. When health returned he worked again on the picture, and was doing so in February 1811. It was "nearly finished" on July 28. His final effort was directed principally toward the landscape. It was, however, too late to think of sending it to the Royal Academy exhibition that year, as once he had hoped. He was already thinking in the unorthodox direction of holding a one-man exhibition. While that was taking shape in 1812, Wilkie spoke of the present picture as "of much greater consequence to the success of my plan than any other." He was paid 800 guineas—about five times more than any sale had yet brought him.

Versions

Wilkie was indisposed on 3 August 1808 when he wrote in his journal: "to amuse myself, began to make a blot of The Public House Door, the subject I next intend to paint"; and, the following evening: "began to paint again at the sketch I had begun last night." It was probably this sketch to which he returned on 22 March 1809, referring to it on May 13 as a "little sketch."

On May 15 Wilkie went to Paddington "to look for a public house that might do for my picture." The next day he wrote: "Began to paint on my sketch . . . and tried it on an

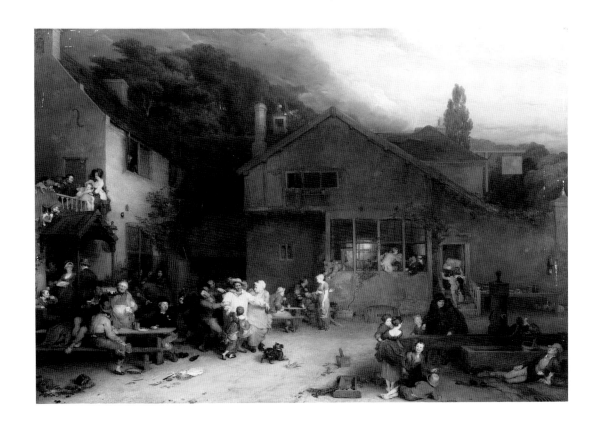

12. The Village Festival

absorbant ground." His remarks suggest that he was now working on a second, more definitive sketch. Work on it continued intermittently until June 20, when it seems to have been more or less complete, and was put aside during two absences from London that summer. The finished picture was begun on September 29, and during the painting of it Wilkie seems to have made alterations to the sketch. This was presumably in order that it should fulfill its practical use as an epitome of his intentions in relation to the finished picture. The sketch, possibly exhibited at the Royal Academy in 1812, was bought by Lord Mulgrave. It was last recorded in New York in 1968.

The differences between this definitive sketch and the finished picture lie less in the general setting and the grouping of the figures, which were well premeditated, than in the furnishing and incidental details. More striking, however, is the distancing effect in the finished picture of a longer and steeper foreground, with a consequent diminution in scale of the figures relative to their setting. Thus in the finished picture, as compared with the sketch, there is a certain loss of focus on the principal group of tipsy figures, which constitutes the pivot of both the composition and the anecdote.

On 5 December 1809, Wilkie made "a sketch on millboard [therefore presumably in oil] of the figure in the blue jacket." The figure is that sitting at the end of the table to the left, wearing a hat and holding up a bottle. This sketch was last recorded in 1888.

A repetition of the principal group, of unusual skill in execution and possibly by Wilkie, is in the Montreal Museum of Art.

Comments
Wilkie's title for the sketch was "The Public House Door," and for the present picture "The Alehouse Door." When this was exhibited in 1812, that is after it had come into Angerstein's possession, it was catalogued as "The Village Holiday." (The now standard title, "The Village Festival," appeared for the first time under Marr's engraving.)

The change of expression in the title from the frank to the shuffling may have been an effect of sensitivity on the subject of drink. If so, the sensitivity is not likely to have been Wilkie's since not only was he frank in the title he gave to the picture, but it was he who chose its subject. As Cunningham observed, "the drama of strong drink he had seen performed from Cults to Canterbury; and he wished besides to measure himself with Teniers and Ostade"—both well known as painters of that drama. While Wilkie was working on the sketch in March 1809, Haydon advised him "not to go on with the picture," and there can be little doubt that, as Cunningham hinted, the objection was one of propriety. Farington reported on May 22 the same year that Wilkie "thinks Lord Mulgrave does not much like the subject of the . . . sketch" (although he later acquired it or another). Later on, Angerstein, who was notable as a philanthropist, may have had feelings on what was then still a serious source of disorder in metropolitan life, and so may have caused the published title of his picture to be made less direct.

Of the same visit to Wilkie in May 1809, Farington wrote: "He shewed me a sketch for a picture, the subject 'A Man taken from his Ale-House Companions by his Wife and Children'. I admired . . . the manner of treating the subject. He shewed me in one corner of the picture a man drunk and laid down, with a few spectators looking at him as an object of disgust, and even, he said, 'His dog

seemed to look ashamed of him.' This he called the moral part of his picture, and he took it from what he happened to see in the street." When the finished picture was exhibited by Wilkie in 1812, his catalogue note read: "In the principal group . . . a man is represented hesitating whether to go home with his wife, or remain with his companions at the public house.

> 'On ae hand drink's deadly poison,
> Bare ilk firm resolve awa';
> On the ither, Jean's condition
> Rave his very heart in twa.' — MACNEIL."

The stanza was taken (surely with hindsight, and not as the initial platform for the picture) from Hector MacNeill's verse tract on the "modern depravity" of drink, "Scotland's Skaith: or the History o' Will and Jean," first published in 1795.

Wilkie had already made allusive use of this poem in explanation of the subject of *The Village Politicians* (private collection) when it was exhibited in 1806. In neither picture does he betray a narrow commitment to the reformative intention of the poem, although both pictures touch on feelings that also belong there. In the earlier picture the equation appears to be between drink and what Wilkie's father called the "political disputes and cabals [that] are still popular in our villages among the lower classes," or what Cunningham more pointedly described as "our clubs of rustic legislators, the spawn of the French revolution." Wilkie seems to comment on the intensity of localized radical feeling in Scotland—and to this extent he does more than simply emulate seventeenth-century Dutch and Flemish models for tavern scenes.

In the present picture, the subject of drink is treated with amiable satisfaction, and the moral tug embodied in the principal group has an air of balletic play reminiscent of Garrick's in the famous picture by Reynolds. Furthermore, in contradistinction to *The Village Politicians*, with its background in Fife and the hortatory pages of Hector MacNeill, the present picture conveys a mood to express which Wilkie might have borrowed words from Boswell, an earlier expatriate Scot, by admitting that at the time he was painting the picture he was "full of English feelings." We are no longer in Fife, but in a London suburb. (The "Village" in the common title, which was never Wilkie's, need not cause us to believe that the setting was truly rural.)

Yet the right-hand corner of the picture is pointedly shadowed, actually and morally. A reviewer in 1812 (almost certainly Robert Hunt, who may have been in touch with Wilkie at the time the picture was begun), after praising the "jauntiness and joviality" of the scene, and a number of its incidental felicities, points to "the odious nature of drunkenness" as "strikingly expressed" in the man lying by the trough. Hunt notes that "in the introduction of this circumstance the painter has taken care that while our imaginations are entertained by the various graces of his pencil . . . our minds should be duly impressed with the immorality of the habit, otherwise so amusingly depicted." Turning, in contrast, to the left-hand corner of the picture, the writer continues: "The group in which the landlord is pouring out a glass of ale to partake with his guests, and in which a negro is suspending his drinking while he observes the fate of the contest to keep possession of the hesitating husband [in the principal group], is a perfect specimen of complacent surrender of mind and body to the social enjoyment of the oft replenished glass" (*Examiner*, [1812]:282). Complacent social enjoyment is surely the true subject of the picture.

Albeit accidentally, this was the first picture by a living artist to enter the National Gallery (it was soon to be joined by cat. no. 5). It stirred an old and continuing debate as to the function of a national gallery. Haydon, an excitable champion of the notion that the Gallery should foster national and living talent, saw this inclusion as a "triumph," while reporting that Wordsworth "seemed angry."

Once in the National Gallery, the picture was open to copying. A number of copies of it in oil and in watercolor are recorded, including some by more or less remembered younger artists: Frederick Goodall, H. P. Riviere, and F. P. Stephanoff.

John Julius Angerstein (1735–1823), an important figure in the history of insurance-brokerage and a merchant, was man of considerable wealth. About 1790 he befriended Lawrence. His collection of "forty-two of the best pictures of the great masters," gathered partly on the portrait painter's advice (including the present picture, as we have seen), was bought for the nation under the Earl of Liverpool's administration in 1824 — again with Lawrence acting in the background. The only other British pictures in the collection were Hogarth's series, *Marriage à la Mode*. Angerstein was one of the original subscribers to the British Institution in 1806 (founded "to encourage and reward the talents of artists of the United Kingdom"), but had no further claim as a patron of living artists. It was said of him: "he is much respected for his good heart and intentions, but is considered deficient in education and very embarassed on all occasions when he is required to express himself. . . . Mr. Angerstein might have been at the head of popularity in the City, but has chosen to associate chiefly at the west end of the town."

Drawings
Edinburgh, National Gallery of Scotland; London, Courtauld Institute and Tate Gallery; private collections.

Engravings
Given the self-evident importance of the picture, as well as its known importance to Wilkie himself, it is surprising that it was not included among the corpus of line engravings after his works that he was so much concerned to establish. The prints after this picture are relatively minor, and Wilkie had no part in them.

The prints are by C. W. Marr, 1823; W. Finden, 1830; P. Lightfoot, 1833; C. G. Lewis (contracted for in 1837 as to be finished in 1838, and perhaps not published); and W. Greatbach, in the *Wilkie Gallery* (1848–50).

13. Portrait of a Gamekeeper

Wood; 10⅛ × 7⅞ in. (25.7 × 20 cm.)
Lent from a private collection.

History and Provenance
Painted in 1810–11 for Sir George Beaumont, who
died in 1827; by descent certainly until 1888, and
probably into the 1940s; anonymous sale, 14 December
1981, as "Attributed to John Faed."

Exhibitions
Royal Academy 1811; Wilkie's Exhibition 1812.

Literature
Cunningham, 1:317, 320, 321, 324, 325–6, 327, 328.
Haydon 1876, 1:259.

Formation
When he acquired *The Blind Fiddler* (cat. no.
5), Beaumont expressed his intention of
ordering a second, unspecified picture from
Wilkie. Evidently this was to be as much as
anything a means by which to give Wilkie more
money without offending him through making
a direct gift. It will be gathered from the
genesis of the present picture that it was almost
certainly unpremeditated on Wilkie's part, and
possibly painted with materials provided on the
spot by Beaumont. As the picture took shape,
Beaumont may well have seen in it the pretext
for liberality that he had been looking for.

While convalescing after a serious break-
down in 1810, Wilkie was invited by Beaumont
to stay with him in the country, at his mother's
house at Dunmow, Essex. Wilkie arrived there
on November 5 or 6, having written to
Beaumont less than a week before leaving
London: "I shall not bring my colours with me,
as it is my object to run wild as much as
possible." Not to paint was to follow both the
medical and the friendly advice he had been
given.

Nevertheless, Wilkie had scarcely been at
Dunmow for a week before his host wrote to

Wordsworth on November 13: "I have recom-
mended to [Wilkie], if he must paint, to take
up subjects that will not require great exertion
of mind . . . such as studies of interesting
heads, to which he has great adroitness in
giving such an interest, that 'more is meant
than meets the eye'. . . . We have found
excellent characters and tomorrow he is to
begin and I am to take care he does not fatigue
himself" (DCT: MS 33). On what must have
been virtually the same day, Wilkie wrote to
Haydon in an undated letter: "I intend to try
some thing on a small panel I have got from a
man who is coming to sit, and although I shall
not bestow much labour on it, I hope to give it
that which will make it a marketable
commodity." This was followed by another
undated letter: "I am getting on pretty briskly
with the little picture I told you of. The subject
of it is a man sitting warming his hands at the
fire, and . . . I expect very soon to get it
finished. My whole care is to be so decided in
every touch I put on as not to require any
alteration . . . afterwards, and you cannot
think how such precaution . . . shortens the
labour." Wilkie was still at Dunmow when he
wrote on December 6: "I am now bringing [the
picture] towards a conclusion and expect to
finish it before coming to London. I paint for
two hours and a half a day [moderate for
Wilkie]" (NLS: MS 3649/46–7). Probably not
long before December 14 he wrote that he had
finished the picture. He left Dunmow on
December 16.

Beaumont wrote to Wilkie on 15 January
1811: "I am so anxious to hear some report of
your health . . . [and] I hope you abstain from
painting, if you find it fatigues you. . . . I hope
you will not think me impatient if I wish to see
my picture. When can you spare it? Is a frame
made?" Wilkie replied on January 26 to say that

next week he would send the picture to Dunmow, with a "flat French frame about four inches broad" made by Benjamin Charpentier. He added: "I have touched on various parts of the picture, and gone over entirely the right sleeve of the coat. There are still, however, a number of amendments I should wish to make before it can be considered a finished picture, but which the present clammy and soft state of its surface prevents me from doing with effect." When the picture arrived, Beaumont wrote back objecting that the frame "covers some of the picture, and has put out some of the *fire*. I would not have a hair's breadth of it lost." (The picture is painted up to the edges of the panel. Pin-holes visible round the sides of the panel suggest that it was at one time built up with strips of wood to ensure that none of the paint surface would be lost to sight, as Beaumont had wished. The frame must have been correspondingly enlarged.)

It was characteristic of Beaumont, the amateur painter, that he should intervene in more than the matter of the frame. On February 10 he wrote to Wilkie: "I have repeatedly considered your picture . . . and the result is a confirmation of my former opinion of its excellence—a very little more would, I think, render it perfect. . . . It appears . . . to me that at the distance required to look at the picture as a whole, there is too great a proportion of tint, nearly resembling the coat, which gives rather a blue-black tendency to the general hue; this, I conceive, might be entirely removed merely by a warm-reflected light from the fire, smartly touching on the crown of the hat, and extending to the brim [advice little heeded, if at all]; this would warm the lower part of the picture, and remove, at the same time, a certain monotony which I think prevails over the group of objects placed there,

and makes a little confusion amongst them when seen at a particular distance. I think, also, the reflected light upon the wall behind the head is rather too cold, but I know the difficulty of that, and am in hopes that the varnish will remove that sufficiently. My last remark is, that the bag [evidently suppressed] and nightcap [hanging upper right] somehow or other do not *tell*; perhaps some other colour might remedy this. . . . If you . . . wish to reconsider the picture, the sooner I send it to you the better, that if you do anything it may have time to harden before the Exhibition [at the Royal Academy]." Wilkie's response on March 4 was more or less acquiescent: "What you have proposed in your letter about showing the nightcap only, and without the bag, will be an improvement; and as I happen to have a nightcap here of the same sort as that you got me at Dunmow, I shall be able to do it without difficulty." The bag referred to was apparently replaced by the pheasant on the chair, the plumage of the bird perhaps introducing the note of warmth Beaumont had looked for through other means.

Before returning the picture to Beaumont when the exhibition at the Royal Academy was over, Wilkie wrote: "I put some touches on the sleeves of the man's coat, which had been a little rubbed." Beaumont paid £100 for the picture.

Comments

The sitter was a "favourite servant" of Beaumont's, but he has not yet been identified.

The picture was exhibited with the title "Portrait of a game-keeper," but, as a portrait of a man of low social station, it is treated as a kind of genre subject by giving the sitter an activity and appurtenances that combine to intimate the nature, even the narrative, of his

13. Portrait of a Gamekeeper

Wood; 10⅛ × 7⅞ in. (25.7 × 20 cm.)
Lent from a private collection.

History and Provenance
Painted in 1810–11 for Sir George Beaumont, who
died in 1827; by descent certainly until 1888, and
probably into the 1940s; anonymous sale, 14 December
1981, as "Attributed to John Faed."

Exhibitions
Royal Academy 1811; Wilkie's Exhibition 1812.

Literature
Cunningham, 1:317, 320, 321, 324, 325–6, 327, 328.
Haydon 1876, 1:259.

Formation
When he acquired *The Blind Fiddler* (cat. no.
5), Beaumont expressed his intention of
ordering a second, unspecified picture from
Wilkie. Evidently this was to be as much as
anything a means by which to give Wilkie more
money without offending him through making
a direct gift. It will be gathered from the
genesis of the present picture that it was almost
certainly unpremeditated on Wilkie's part, and
possibly painted with materials provided on the
spot by Beaumont. As the picture took shape,
Beaumont may well have seen in it the pretext
for liberality that he had been looking for.

While convalescing after a serious break-
down in 1810, Wilkie was invited by Beaumont
to stay with him in the country, at his mother's
house at Dunmow, Essex. Wilkie arrived there
on November 5 or 6, having written to
Beaumont less than a week before leaving
London: "I shall not bring my colours with me,
as it is my object to run wild as much as
possible." Not to paint was to follow both the
medical and the friendly advice he had been
given.

Nevertheless, Wilkie had scarcely been at
Dunmow for a week before his host wrote to

Wordsworth on November 13: "I have recom-
mended to [Wilkie], if he must paint, to take
up subjects that will not require great exertion
of mind . . . such as studies of interesting
heads, to which he has great adroitness in
giving such an interest, that 'more is meant
than meets the eye'. . . . We have found
excellent characters and tomorrow he is to
begin and I am to take care he does not fatigue
himself" (DCT: MS 33). On what must have
been virtually the same day, Wilkie wrote to
Haydon in an undated letter: "I intend to try
some thing on a small panel I have got from a
man who is coming to sit, and although I shall
not bestow much labour on it, I hope to give it
that which will make it a marketable
commodity." This was followed by another
undated letter: "I am getting on pretty briskly
with the little picture I told you of. The subject
of it is a man sitting warming his hands at the
fire, and . . . I expect very soon to get it
finished. My whole care is to be so decided in
every touch I put on as not to require any
alteration . . . afterwards, and you cannot
think how such precaution . . . shortens the
labour." Wilkie was still at Dunmow when he
wrote on December 6: "I am now bringing [the
picture] towards a conclusion and expect to
finish it before coming to London. I paint for
two hours and a half a day [moderate for
Wilkie]" (NLS: MS 3649/46–7). Probably not
long before December 14 he wrote that he had
finished the picture. He left Dunmow on
December 16.

Beaumont wrote to Wilkie on 15 January
1811: "I am so anxious to hear some report of
your health . . . [and] I hope you abstain from
painting, if you find it fatigues you. . . . I hope
you will not think me impatient if I wish to see
my picture. When can you spare it? Is a frame
made?" Wilkie replied on January 26 to say that

next week he would send the picture to Dunmow, with a "flat French frame about four inches broad" made by Benjamin Charpentier. He added: "I have touched on various parts of the picture, and gone over entirely the right sleeve of the coat. There are still, however, a number of amendments I should wish to make before it can be considered a finished picture, but which the present clammy and soft state of its surface prevents me from doing with effect." When the picture arrived, Beaumont wrote back objecting that the frame "covers some of the picture, and has put out some of the *fire*. I would not have a hair's breadth of it lost." (The picture is painted up to the edges of the panel. Pin-holes visible round the sides of the panel suggest that it was at one time built up with strips of wood to ensure that none of the paint surface would be lost to sight, as Beaumont had wished. The frame must have been correspondingly enlarged.)

It was characteristic of Beaumont, the amateur painter, that he should intervene in more than the matter of the frame. On February 10 he wrote to Wilkie: "I have repeatedly considered your picture . . . and the result is a confirmation of my former opinion of its excellence—a very little more would, I think, render it perfect. . . . It appears . . . to me that at the distance required to look at the picture as a whole, there is too great a proportion of tint, nearly resembling the coat, which gives rather a blue-black tendency to the general hue; this, I conceive, might be entirely removed merely by a warm-reflected light from the fire, smartly touching on the crown of the hat, and extending to the brim [advice little heeded, if at all]; this would warm the lower part of the picture, and remove, at the same time, a certain monotony which I think prevails over the group of objects placed there,

and makes a little confusion amongst them when seen at a particular distance. I think, also, the reflected light upon the wall behind the head is rather too cold, but I know the difficulty of that, and am in hopes that the varnish will remove that sufficiently. My last remark is, that the bag [evidently suppressed] and nightcap [hanging upper right] somehow or other do not *tell*; perhaps some other colour might remedy this. . . . If you . . . wish to reconsider the picture, the sooner I send it to you the better, that if you do anything it may have time to harden before the Exhibition [at the Royal Academy]." Wilkie's response on March 4 was more or less acquiescent: "What you have proposed in your letter about showing the nightcap only, and without the bag, will be an improvement; and as I happen to have a nightcap here of the same sort as that you got me at Dunmow, I shall be able to do it without difficulty." The bag referred to was apparently replaced by the pheasant on the chair, the plumage of the bird perhaps introducing the note of warmth Beaumont had looked for through other means.

Before returning the picture to Beaumont when the exhibition at the Royal Academy was over, Wilkie wrote: "I put some touches on the sleeves of the man's coat, which had been a little rubbed." Beaumont paid £100 for the picture.

Comments

The sitter was a "favourite servant" of Beaumont's, but he has not yet been identified.

The picture was exhibited with the title "Portrait of a game-keeper," but, as a portrait of a man of low social station, it is treated as a kind of genre subject by giving the sitter an activity and appurtenances that combine to intimate the nature, even the narrative, of his

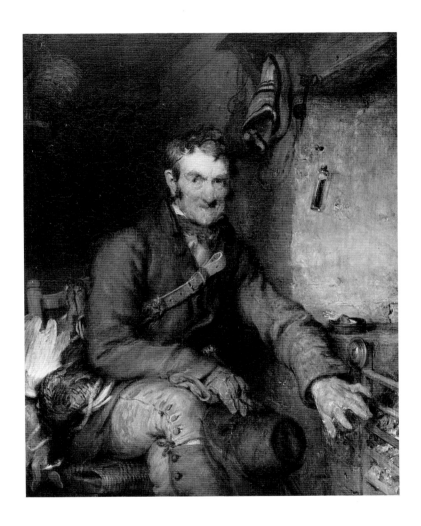

13. **Portrait of a Gamekeeper**

daily round—in other words, something of Beaumont's "more is meant than meets the eye." The gamekeeper has returned to his cottage at the end of a winter's day. (Pheasants are plentiful in November, when the painting was begun.) This form of quasi-portraiture in a manner reflects seventeenth-century precedent from the Low Countries, in images of single figures drawn from comparable social positions.

For a different manner of representing a single "portrait" figure of this sort, see *The Veteran Highlander* (cat. no. 20). This, in contrast to the present picture, shows a man—virtually inactive and so without narrative implications—who seems as if he had been selected and posed as representative of a species. The appurtenances that he has been given are emblematic in nature—attributes of his type rather than, as in the present picture, the accidental belongings of a particular individual.

14. The Soldier's Grave

Wood; 7¾ × 6½ in. (19.7 × 16.5 cm.)
Signed, and dated 1813.
Lent by the Castle Museum and Art Gallery,
Nottingham.

History and Provenance
Dated 1813. (Conceivably "The Interior of a Church; a
sketch" sold on 13 March 1835 from the collection of
H. Gritten.) With the print publisher Richard Hodgson
in 1840; Wynn Ellis, by 1874; his sale, 6 May 1876,
bought by R. G. Millns of Mansfield, £26—5—0; he
died in 1903 (?) and bequeathed the picture to the
Museum, which received it in 1904.

Version
The composition is repeated, with some
differences, in a smaller picture (Victoria and
Albert Museum) that is partly overpainted with
a study for a head in the *Rabbit on the Wall*
(whereabouts uncertain) of 1816.

Comments
An essay in the use of dramatic light after the
fashion of Rembrandt, perhaps made with half
an eye on his *Christ and the Woman Taken in
Adultery* (National Gallery), then belonging to
J. J. Angerstein (for whom see cat. no. 12,
under Comments). The costume is of Wilkie's
time, but neither the event depicted nor the
church in which it is set has been identified.

The picture was engraved as an illustration to
accompany a poem by James Shirley
(1596–1666), titled "Death's Final Conquest,"
in the first volume of an anthology by S. C.
Hall, *The Book of Gems; the Poets and Artists of
Great Britain* (1836). The ingredients of the
picture, which include a military officer, accord
in spirit with some of the lines in the poem:

> The glories of our birth and state
> Are shadows, not substantial things;
> There is no armour against fate;

> Some men with swords may reap the field,
> And plant fresh laurels where they kill;
> But their strong nerves at last must yield:
> . . .

In his preface, Hall wrote: "The Editor . . .
succeeded . . . in obtaining the zealous co-
operation of so many of the Painters, that he
has been enabled to introduce into his volumes
engravings after one hundred Artists [not really
quite so many], whose productions have chiefly
honoured and dignified the age and country
[another exaggeration]." It is not known
whether Wilkie was one of the painters who
gave his cooperation; indeed the picture may
not have been in his hands at the time.
However this may have been, it is impossible for
the present picture to have been painted for
Hall's purpose. The coincidence of feeling
between the picture and the poem must be put
down to Hall's serendipity until more infor-
mation comes to light.

"Shirt Collar" Hall (1800–1889) was a perti-
nacious book maker with a knack for the
meretricious—although the art historian must
be grateful to him as the founder of the *Art
Journal*. He was a leader in the fashion for
Keep-Sakes, in which connection he had
already had, in 1829, a contribution from
Wilkie for an engraving in the *Amulet* of 1830.

Engraving
By William Finden, published by Fisher, Son & Co. in
1836 as under Comments above; 7.5 × 6.1 cm.

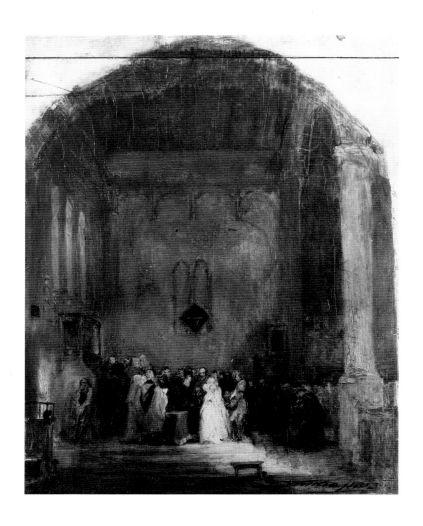

14. The Soldier's Grave

15. Duncan Gray

Wood; 14½ × 12⅝ in. (36.8 × 32 cm.)
Lent by the National Gallery of Scotland.

History and Provenance
Painted for George Thomson of Edinburgh in 1819, and sold by him in or before 1828; Alexander Baring (later 1st Baron Ashburton), by 1833, and by descent to Louisa, Lady Ashburton; her sale at Melchet Court, 26 September 1911; (this or a good copy with the Galerie Charles Brunner, Paris, 1919); with Doig, Wilson, & Wheatley, Edinburgh, and bought from them by the Gallery in 1928.

Exhibitions
Edinburgh, Royal Institution, 1824 (?), Edinburgh 1975; Edinburgh 1985.

Literature
Cunningham, 3:526.

Formation
This is a repetition by Wilkie of a painting of almost twice the size now in the Victoria and Albert Museum. The latter was begun in November 1813, exhibited at the Royal Academy in 1814, and apparently reworked in 1817/18. Wilkie wrote in 1833: "Of the two pictures . . . that belonging to Lord Charles Townshend . . . was the original painted in 1814, the other belonging to Alexander Baring was afterwards painted for Mr. George Thomson, by permission of Lord Charles, with some alterations" (FM: General Series, s.v. Wilkie). The date given to this repetition, 1819, is Cunningham's.

The alterations were made largely in the background by opening a view into rooms behind the standing figure, counterweighted to the right by the addition of a jug and a skein of wool hanging from the ceiling.

Versions
The original picture has already been referred to. A sketch for it, presumably the one Wilkie noted as begun 8 November 1813, is in the National Gallery of Scotland.

Comments
George Thomson, whom Wilkie had met when he entered the Trustees' Academy in 1799, asked Wilkie to paint a picture for him "from Duncan Gray" in 1807. He was referring to the poem of that title by Burns—a tripping song about the worthy Duncan's wooing of Maggie, who looks askance at him and holds him off, deaf to his coaxing; then his desperation touches her and both melt into joyfulness. When the original picture was exhibited for the second time, in 1818, it was accompanied by lines from the first stanza of the song; and when Engleheart's engraving (see below) was published by Wilkie in 1828 it was over lines from the second stanza. Between them they tell the first part of the story, which Wilkie illustrates here. Maggie's parents, encouraging her to better sense, and the peeping sibling, or servant, behind the door are Wilkie's addition to the anecdote.

In the original picture the model for Duncan was named by Wilkie as the painter William Mulready. It was later claimed that Maggie was taken from Wilkie's sister Helen; that the older couple were taken from Mulready's parents; and that for the figure of Duncan the artist was "partly helped from Wilkie's brother" Thomas (see cat. no. 40). It was Cunningham's belief, however, that the two women were taken from Wilkie's mother and sister.

Duncan Gray was also the subject of works by an older contemporary of Wilkie's, Alexander Carse, and by Thomas Stothard (1815)—the latter work being destined for Thomson again. Both works are lost.

George Thomson (1757–1851) was an important collector of old popular music in

Scotland, an activity in which he was helped by Burns (and which in turn provided material used by Beethoven). Wilkie quarreled with him over his use of Ranson's engraving after the present picture (see under Engravings, below): Wilkie had his own plans for publishing the engraving by Engleheart after the original picture. Thomson wrote to Wilkie in November 1822 that he "little expected such a letter as yours of the 13th." For more on Thomson, Burns, and Wilkie, see Errington 1985.

Engravings
1. By T. F. Ranson, published by T. Preston on 1 June 1822, for the proprietor of the painting, George Thomson, Edinburgh; 18.1 × 15.4 cm.
2. By G. Greatbach (seemingly a copy after the above); 18.3 × 15.2 cm. In the *Wilkie Gallery* (1848–50).
 (The original painting of the subject was engraved by F. Engleheart, and published by Wilkie in 1828; 36.8 × 33 cm.)

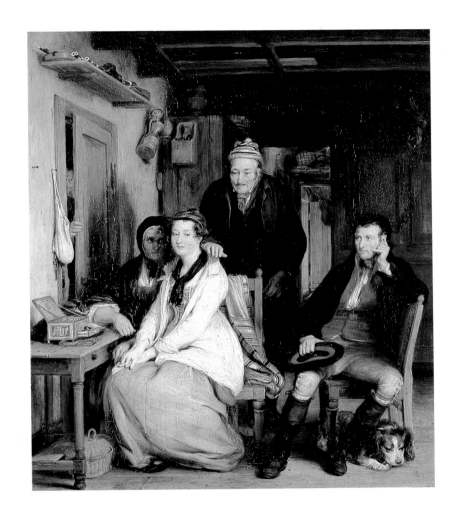

15. Duncan Gray

16. The Pedlar

Wood; 24 × 20 in. (61 × 50.8 cm.)
Signed, and indistinctly dated.
Lent by the Yale Center for British Art, Paul Mellon Fund

History and Provenance
Painted for Mrs. Sophia Baillie, and probably begun in the late summer of 1814. The picture was exhibited in 1842 as having been painted in 1814, but a reviewer read the date on the picture as "1815." Mrs. Baillie still had the picture in 1842; Samuel Barlow, 1872; Sir John Fowler by 1896; his sale, 6 May 1899, bought by Agnew, £903; Lord Joicey; his sale, 4 July 1913, bought by Agnew, £420; Sir Michael B. Nairn, who died 1915; anonymous sale, 20 February 1959, bought by the Fine Art Society and passed to MacNicol, Glasgow; with William Hardie Ltd., Glasgow, 1985, and bought by the Center in 1986.

Exhibitions
British Institution 1817; (borrowed by Wilkie from Mrs. Baillie in August 1828 for exhibition in Birmingham, but if the picture was exhibited it was not catalogued); British Institution 1842; Edinburgh 1985 (ex catalogue).

Literature
Raimbach, 166–67.

Formation
Samuel Dobree bought *The Letter of Introduction* (National Gallery of Scotland; fig. 10) in March 1814, and Dr. Matthew Baillie bought the first version of *Duncan Gray* (see under cat. no. 15) in April. Both pictures were exhibited at the Royal Academy in May that year, and were presumably sent there by Wilkie himself without their owners having yet taken possession of them. Raimbach continues the story: Dobree's picture "proved the most popular, and Mrs. Baillie, wife of the Doctor, wrote to Wilkie, expressing her hopes that it was destined to ornament her drawing-room. Wilkie . . . could only regret that [this] . . . was impossible. . . . After the exhibition, the pictures were sent to their respective proprietors,

and Duncan Gray was received at Dr. Baillie's with avowed satisfaction. But Wilkie was not a man to rest satisfied with such circumstances. He quietly proceeded with another subject of the same size, The Pedlar, which, when completed he sent to Mrs. Baillie, requesting that, if preferred, it should be retained instead of Duncan Gray. This handsome conduct was abundantly acknowledged, and Duncan Gray returned to the painter."

Version
"The Pedlar; the original sketch for the well-known picture" was in the W. B. Tiffin sale, 20 May 1837, but has not been traced since.

Comments
The interior looks southern English and rural; the pedlar may be Scottish or from the north of England, since his wares include bonnets, his own being hung on the back of his chair. (Perhaps he has been to the house before, because yet another bonnet hangs beside the door.)

When Wilkie borrowed the picture back for exhibition in 1828, because it was "less known than . . . others"; he told Mrs. Baillie he liked "its looks and condition" (LRCS: Hunter-Baillie Letters III.2/93b). When, in 1832, he asked for her permission "to get it engraved in the same style with my other works," he was perhaps implicity admitting to a certain fondness for a work that would seem to have been relatively casually produced.

Dr. Matthew Baillie (1761–1823) went to London from Scotland, and is remembered for an important book on morbid anatomy, published in 1795. Four years later he turned to general practice and became physician to the royal family. He was noted for a "total contempt of that science of humbug by which so many of

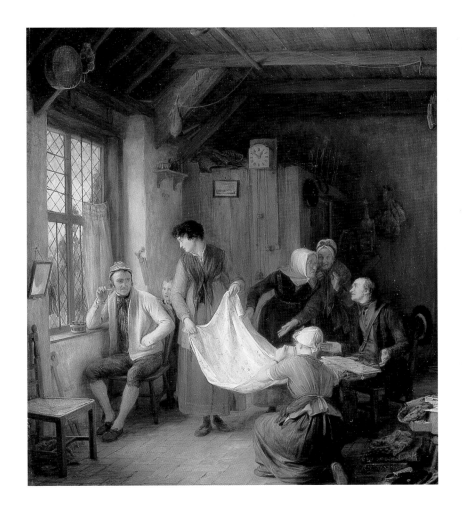

16. **The Pedlar**

his bretheren make fortunes." His wife, Sophia, was a sister of Thomas Denman, later lord chief-justice. Also of their household in Hampstead were Baillie's two sisters, of whom the younger, Joanna, had fame as a dramatist and poet.

The Baillies lived a life of domestic affection and did much kindness to Wilkie. He was first invited among them in 1808. At the onset of his illness in 1810, Dr. Baillie gave advice and the sisters provided him with a homely retreat. According to Cunningham, Wilkie painted this picture for Dr. Baillie, to whom "he attributed, with reason, his restoration to health."

Drawing
London, Royal Academy.

Engravings
1. By James Stewart, published by Moon, Boys, & Graves, 1 January 1833; 37.2 × 31 cm. Stewart was paid £350 for his work, and he resigned the copyright to the publishers. Wilkie's financial share in the print is not known.
2. By G. Greatbach; 20.9 × 17.1 cm. In the *Wilkie Gallery* (1848–50).

17. A Wooded Landscape

Wood; 9¾ × 13⅛ in. (24.9 × 33.3 cm.)
Inscribed with the artist's name.
Lent by the Aberdeen Art Gallery and Museum.

History and Provenance
Probably painted in the summer of 1815, and possibly the same as the sketch of "A Woody road-scene" in the Wilkie sale on 30 April 1842, bought by Tiffin, £4—10—0. The picture is then said to have belonged by inheritance to the second wife (Mary Dalzell?) of Fleet Paymaster Joseph Whittall. After his death in 1908 it passed to Miss F. Whittall and was left by her in 1949 to her nephew, Major J. M. Whittall; sold at auction by his widow on 19 November 1965 and bought by the Gallery.

Formation
Wilkie wrote on 27 May 1816 to Thomas Macdonald, his framemaker at the time: "I send you the picture of the *Sheepwashing* and beg you will . . . send it off [to] . . . John Davis, Esq., Bapton, to be left at Wylye, Wiltshire" (NLS: MS 9835/92). This must refer to a small version of the painting of the same subject (National Gallery of Scotland), which was exhibited at the Royal Academy in 1817. Connected with this in terms of its ingredients and its apparent date (see Miles 1981) is a landscape virtually identical to the present picture, but smaller and with a shepherd in his flock in the foreground (private collection). Both landscapes were almost certainly painted at or very soon after the time Wilkie visited Wiltshire, where he acknowledged having found material for the exhibited picture.

There is no record of when Wilkie was in Wiltshire, but circumstances point to the summer of 1815 and to somewhere near Davis's farm at Bapton as the locality depicted. Bapton is about a mile from Wylye (also mentioned in Wilkie's letter to Macdonald) and, in the other direction, from Fisherton Delamere—where even today it may be seen that the mill provided the setting for the *Sheepwashing*.

Version
A smaller variant with a shepherd and sheep, also with a moon in the patch of sky, is referred to above.

Comment
The *Sheepwashing* was Wilkie's only exhibited landscape, and in December 1816, just before exhibiting it, he owned that "landscape [was] entirely new" to him, adding: "I certainly wish to get practice and to obtain some kind of proficiency in this way; but my ambition is not more than that of enabling myself to paint an out-door scene with facility, and in no respect whatever to depart from my own line."

Discounting as egregious the background to *Pitlessie Fair* (cat. no. 4), as probably he himself would have done at this stage in his career, Wilkie was still not quite right in saying that landscape painting was entirely new to him. His success since 1805 had indeed been founded on paintings of figures in ceiled spaces, but in the autumn of 1808 and the spring of 1809 his sketches for *The Village Festival* (see under cat. no. 12) had imposed the problems of landscape and of outdoor light. It was presumably because of his sense of "uneasiness" over this aspect of his projected composition that he turned to Sir George Beaumont. In August and September 1809, before starting work on the final version of *The Village Festival*, he stayed with Beaumont at Coleorton in Leicestershire. There he painted half a dozen or more landscape sketches (since lost). It is difficult to suppose that he painted them for a purpose other than to "obtain some kind of proficiency in this way," and specifically in anticipation of the challenge he had set himself

with *The Village Festival*. Between 1809 and the Wiltshire landscapes of 1815, Wilkie painted a landscape sketch at Mulgrave Castle in Yorkshire in September 1812 (lost).

Despite the accomplishment and charm of his landscape studies, as exemplified here, Wilkie was true to his word in not developing the art for its own sake. In his finished pictures other than the *Sheepwashing*, landscape is a subsidiary element and anyway not common. Later than the present picture, in 1817, he seems to have painted a few landscapes while in Scotland; also from the same year, and set in a landscape, is his portrait of Walter Scott with his family (Scottish National Portrait Gallery; fig. 40). A landscape is the setting for *Death of the Red Deer* (cat. no. 21) of 1820. Wilkie's last picture with an important landscape element is the *Chelsea Pensioners* (cat. no. 23), completed in 1822. Even while painting this Wilkie said, as reported by Kathleen Thomson to Cunningham (2:53): "Indeed I am awkward and slow at any thing like landscape." He is not known to have painted landscapes after the crisis of 1825, or indeed after the end, in 1824, of his familiarity with Perry Nursey.

Wilkie's friendship with Perry Nursey (1771–1840) had done much to sustain his last interest in making landscape studies. Nursey was at first a surgeon but he married into money. When Wilkie came to know him in 1814—at which time Nursey was also in touch with Constable—he was a gentleman living at Little Bealings, near Woodbridge in Suffolk. There he diligently practiced landscape painting as an amateur. Wilkie first visited the family at "The Grove" in 1816 and joined in Nursey's amusement. He painted several small landscapes in the district between then and 1822 (two are in the Tate Gallery), and one of their expeditions provided the source for the background to cat. no. 19. Nursey's son Robert, who was engaged to Wilkie's sister Helen, committed suicide in Wilkie's London house in 1824, and about the same time Nursey himself sold "The Grove"—apparently in consequence of financial difficulties. There the friendship seems to have ended. Wilkie's letters to Nursey have been preserved, and were in part published in the *Academy* in 1878.

Wilkie's perception of landscape and his practical realization of it were squarely founded on seventeenth-century Flemish models, specifically on Rubens and Teniers—both, incidentally, like himself in seeing landscape as essentially a receptacle for a leading human activity. Wilkie's work hardly betrays an awareness of the seventeenth-century Dutch and French traditions of landscape painting, although he appreciated both. To the eighteenth century, with the exception of Watteau (another translator of the Flemish style), and to British landscape painting, he owed virtually nothing. Happily he was untainted by the mannerisms of his principal mentor in landscape painting, Beaumont.

17. **A Wooded Landscape**

18. The Penny Wedding

Wood; 25⅜ × 37⅝ in. (64.4 × 95.6 cm.)
Signed, and dated 1818.
Lent by Her Majesty Queen Elizabeth II.

Exhibited at Yale only.

History and Provenance
Commissioned on 8 May 1813 by the Prince Regent as a companion to the *Blind Man's Buff* (Royal Collection) of 1812, Wilkie's first commission from the Prince, who had told Wilkie he was "delighted" with it. The composition seems to have been begun in the winter of 1817. It was finished by 14 November 1818 and delivered to Carlton House on 26 January 1819. On 27 September 1823 the picture was sent to the King's Lodge at Windsor for a short time; it was sent there again on 17 June 1824, and was still there in the spring of 1828. Before 19 December 1828, Wilkie was allowed to borrow the picture for engraving and exhibition in Edinburgh (see below). It was returned to him shortly before 20 October 1831 (thus after the King's death), when Wilkie's subsequent concern was to get the picture back to its new owner. It later went to Buckingham Palace, where it has remained.

Exhibitions
Royal Academy 1819; Edinburgh, Royal Institution, 1829; British Institution 1842; Edinburgh and London 1958; Edinburgh 1985; Edinburgh and London 1986.

Literature
Cunningham, 1:281, 379, 2:9–11, 16, 19–20, 524, 3:8–9, 49; Errington 1985, 14–21; Millar 1969, 138.

Formation
The commission had been given in 1813 without stipulation as to the subject of the picture, the time taken on it, or the price. Work on it was apparently in train by 4 December 1817 (NLS: MS 10995/7–8). By March 4 of the following year a frame was being thought of, but work on the picture was to be interrupted by a "bad fever," from which Wilkie was recovering by July 6 (NLS: 3889/135–6). In an undated letter, possibly written that autumn, Wilkie asked W. S. Watson (1796–1874) to help him with the picture, but without specifying how. (Watson had recently come to London from Edinburgh and had entered as a student at the Royal Academy; he later made his career as a portrait painter.) It was not until October 17 that Wilkie was able to write that the picture "is just about finished and I am only waiting the means of getting it introduced at Carlton House [the Prince's residence]" (*Academy* [1878]: 324). It was taken to Kensington Palace on October 29, and Wilkie reported that the Prince "seemed perfectly satisfied." However, it is clear that the picture was even then not entirely finished, for on November 14 Wilkie wrote to Charles Long, the Prince's adviser on artistic matters, to say that the picture was "now finished" and ready to go to Carlton House. Wilkie wrote out a bill for £525, plus £20 for the frame (probably made by Thomas Macdonald), on 28 November 1819; he gave his receipt for the money on 10 February 1820.

Versions
What was catalogued as a "First sketch for the Penny Wedding" was in the sale of the painter C. R. Leslie on 25 April 1860, bought by Flotow, £33—12—0. Leslie had known Wilkie and was not likely to have been deceived as to the nature of his picture.

Also from the collection of a friend of Wilkie's, Sir William Knighton, was "A sketch for the picture in the Royal Gallery"; in his son's sale on 23 May 1885 it was further catalogued as "Signed and dated, 1830." It was bought by Agnew, £147. Assuming the date to have been recorded correctly, this picture must have been a sketch after the finished picture and not "for" it. It is quite likely that Knighton had been helpful when the King agreed to lend the finished picture to Wilkie in 1828, and that this sketch, or souvenir, was Wilkie's recognition of this—the date being that of the

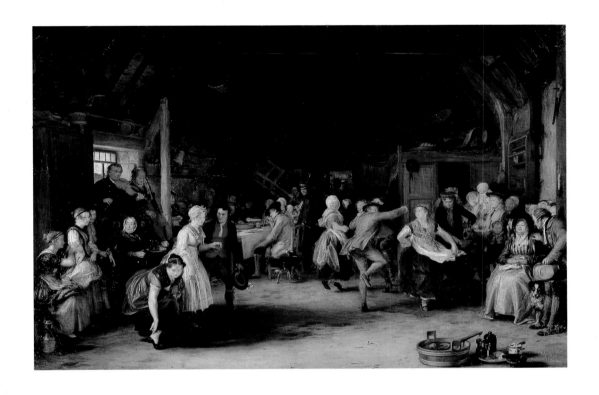

18. **The Penny Wedding**

making of the sketch and of the gift. Alternatively, this may have been indeed a sketch for the finished picture, given to Knighton in 1830, and thus so dated. There are demonstrable instances in which Wilkie made gifts of earlier works and dated them with the year of the gift.

There are later records in the nineteenth century of sketches that may or may not have been the same as the preceding two, but none of them has been identified in this century.

A copy (further particulars not given) was lent by a Mrs. Tawse to the exhibition in the Carlisle Academy of Arts in 1827.

Comments

A penny wedding was explained by Wilkie in the catalogue of the Royal Academy exhibition: "This is a marriage festival, once common in Scotland, at which each of the guests paid a subscription to defray the expenses of the feast, and by the overplus to enable the new-married couple to commence housekeeping." The occasion had been commonly one of animal disorder, and after a traceable history of some two hundred years the practice was discouraged by the Presbyterian church. By the time Wilkie painted the subject it is probable that the custom had virtually died out.

The decency of the occasion as Wilkie presents it, the sensibility with which he treats it, indeed the archaic dress of the figures themselves, suggest that he was looking back to the late eighteenth century with the purifying and approving eye of nostalgia. The eighteenth-century connection is reinforced by his giving the features of Niel Gow to the fiddler silhouetted against the window to the left—an identification made when when the picture was first exhibited. Gow, who died at the age of eighty in 1807, was a celebrated Perthshire fiddler and composer; for some of his tunes the words were written by Burns. Wilkie, in his evident will to record a way of life attached to an age already fast disappearing in the face of Anglicization and economic improvement, was in tune with other Scotsmen of his time: among painters, Alexander Carse, an older and less accomplished contemporary; among writers, most notably Walter Scott and John Galt.

Precedents for a picture of a country wedding were not scarce. It is likely that Wilkie knew the theme as treated in seventeenth-century Dutch and Flemish paintings and prints. Closer in their modulations of feeling to his own management of the subject were works, presumably accessible to him through prints, by late eighteenth-century French painters of genre such as P. A. Wille and J. L. de Marne. Also from the eighteenth century, and closer to home, was the example of his admired David Allan—whose watercolor of 1795 (National Gallery of Scotland; fig. 9), precisely of a penny wedding, he may have known.

The idea of painting a wedding dance was in Wilkie's mind in 1807. It is quite likely that it had been put there by George Thomson (for whom see cat. no. 16, under Comments) at the time when he saw *The Blind Fiddler* (cat. no. 5) in the artist's studio. In June that year Wilkie agreed to paint a picture for Thomson "either from Duncan Gray, or Muirland Willy." In the event he was to get a picture of the former subject (cat. no. 16), but in his reply to Wilkie, Thomson wrote of the latter subject: "It is a merry making . . . and being within doors can receive a more beautiful effect of light and shadow and tone of colour than daylight compositions of figures. I know not whether the following stanza has attracted your notice, the last in Muirland Willy

Sic hirlum dirlum and sic din
Sic laughing, quaffing, and sic fun,
The minstrels they did never blin'
Wi' mickle mirth and glee
And ay they bobbit and ay they beckt
And ay they cross'd and merrylie met,
Fal lal, etc.

The bride and bridegroom, the bride's maid and her sweetheart, and the convivial old folks might be seated in the foreground, and behind them the dancing group and the fiddlers might appear." Thomson's quotation from "Muirland Willie" is itself a polite version of the stanza from the old Scottish song.

Also as a result of seeing *The Blind Fiddler* in 1807, although in his case at the exhibition, John Galt introduced himself to Wilkie by letter (they do not seem to have met). In it, Galt wrote: "Previous to leaving Scotland I often felt myself interested by the peculiarities of conduct, opinion, and notions among the peasantry, and at one time entertained the idea of describing some of them in the colloquial manner of our ancient humorous ballads." With his letter Galt enclosed copies from drafts of two of these verse descriptions. They have since been lost, but in 1832 he said that one of them was his poem "The Penny Wedding," which, when published in 1833 he dedicated to Wilkie. (Galt also described briefly a penny wedding in chapter 48 of his novel of eighteenth-century Scottish life, the *Annals of the Parish*, which he began in 1813 but which Wilkie would not have known then, because it was not published until 1821.)

On 4 March 1810 Wilkie saw a Sir William Erskine, probably the major-general for whom he had declined to paint a portrait the previous year, and noted that he "said he would give me 150 guineas for the picture of The Penny Wedding, which I was to paint for him." Although nothing seems to have come of it, the statement is of interest, not only for the firm definition of the subject, but also because it suggests that a design for such a composition is likely to have been in existence at the time.

Cunningham alluded to more distant literary counterparts in poems by King James VI and by Allan Ramsay.

This was, as we have seen, the second picture by Wilkie to be bought by the Prince Regent (1762–1830)—who again expressed himself pleased with it. The Prince, who was to succeed as King George IV in 1820, was beginning to collect Dutch and Flemish pictures on an important scale about the time he gave his first commissions to Wilkie. His taste in pictures was thus consistent. West, as president of the Royal Academy, seems to have effected the initial communication in 1812, and there were other links between the Prince and Wilkie through some who knew him and to whom the Prince listened on the matter of pictures: Lawrence, his portrait painter; William Seguier, the keeper of his collections; Sir William Knighton, his physician and man of business; and Charles Long, who advised on the decoration of the royal residences. The relationship was formalized in 1823, when the King appointed Wilkie as his Limner for Scotland, and again when he appointed Wilkie to succeed Lawrence as his portrait painter. The King gave Wilkie special encouragement at a particularly difficult moment when, on his return from the Continent in 1828, Wilkie felt that by his long absence from the public eye he had in effect to start upon a new career. By acquiring six pictures painted or designed while Wilkie was abroad (including cat. nos. 27 and 30), the King's patronage gave him the confidence that he most needed.

For more on George IV as a patron and collector, see Millar 1969, xxiii-xxxix, and Millar 1971, 20–32.

Drawings
Cambridge, Fitzwilliam Museum; Edinburgh, National
Gallery of Scotland; Glasgow, University of Glasgow;
London, British Museum, Royal Academy, and Victoria
and Albert Museum; New Haven, Conn., Yale Center
for British Art; Oxford, Ashmolean Museum; Windsor
Castle, Royal Collection; private collections.

Engravings
1. By James Stewart, published by Moon, Boys, &
 Graves, 16 April 1832, and dedicated by them to
 William IV; 41 × 61.2 cm. The picture was sent to
 Stewart in Edinburgh, probably at the end of
 December 1828, and it was sent back in London in
 mid-October 1831. The publishers paid Stewart
 £1,207—10—0 for the engraving, and Wilkie
 £367—10—0 for the copyright. The copy of the
 picture by A. Hoffy, recorded in Philadelphia in
 1848, was presumably made from this engraving.
2. By W. Greatbach; 15 × 22.9 cm. In the *Wilkie
 Gallery* (1848–50).
3. By William Howison? (Recorded but not traced.)

19. **The Errand Boy**

Wood; 14 × 19 in. (35.5 × 48.2 cm.)
Lent by The Lord Glenconnor.

History and Provenance
Painted for Sir John Swinburne in 1818, and kept in his town house in Grosvenor Square; in his sale, 15 June 1861, bought by Agnew & Son, £456—15—0; John Knowles, 1861; in his sale, 7 April 1865, bought by Farrar, £1,102—10—0; C. F. Huth, 1865; in his sale, 6 July 1895, bought by Agnew & Son, £850—10—0; Sir Charles Tennant, 1896, who died in 1906; the picture passed to his son, Sir Edward Tennant, later 1st Baron Glenconnor; thence by descent.

Exhibitions
Royal Academy 1818; British Institution 1842.

Literature
Cunningham, 2:8, 3:525; Raimbach 1843, 122.

Formation
The date, 1818, is given by Cunningham, who also gave the price as 90 guineas. Nothing is known of the circumstances in which the picture was painted.

On 30 December 1818, Wilkie wrote to Perry Nursey (see cat. no. 17, under Comments): "I have just finished the picture of Mr. Edwards's house, the subject of which is Gipsies mending China" (*Academy* 1878, 324). Edwards was a neighbor of Nursey's in Suffolk. Wilkie's picture of *The China Menders* (untraced since 1921) shares the same architectural background as this, with its view through the doorway and of the gable beyond—a background mirrored in a small picture that Wilkie painted at Edwards's house in 1816, and which belonged to Sir Willoughby Gordon (private collection). The present picture may be regarded, in short, as a confected cabinet picture.

Version
A "study" was lent to the exhibition at the British Institution in 1842 by Dr. George Darling. He was an "early admirer" of Wilkie, and advised him on his health. What was probably the same picture was last recorded in 1880.

Comments
Broadly, the motif might be said to be derived from Dutch example, while in the manner of its presentation it is as broadly reminiscent of Morland. However, its legibility, in human terms at least, is entirely of the essence of Wilkie. The specific location of the scene is identified under Formation, above.

Sir John Swinburne (1762–1860), a reformer in politics, was also a notable patron of British artists, and in particular of Wilkie's friend in early life, William Mulready, whom Swinburne took under his wing in 1811. By marriage he was related to another of Wilkie's patrons of this time, Sir Willoughby Gordon (see cat. no. 24). For more on Swinburne, see Pointon 1986.

Engravings
1. By Abraham Raimbach, published by Wilkie and Raimbach, 1 May 1823; 28.2 × 38.3 cm. Intended as a companion to Raimbach's engraving of *The Cut Finger* (cat. no. 11), and to "re-animate" its sale. But, as Raimbach wrote, "in this hope we were entirely disappointed," in part due to the bankruptcy soon afterward of the print sellers, Hurst, Robinson & Co.
2. By Charles Boyer, published by Abraham Raimbach, London, and François Janet, Paris, 1826; 8.3 × 11.3 cm.
3. By J. Mitchell; 17 × 22.8 cm. In the *Wilkie Gallery* (1848–50).

19. **The Errand Boy**

20. The Veteran Highlander

Wood; 14 × 11½ in. (35.6 × 29.2 cm.)
Signed, and dated 1819.
Lent by the Renfrew District Council Museum and Art Gallery, Paisley.

History and Provenance
Painted in 1819 and bought on 21 January 1820 by Richard Payne Knight, who died in 1824. The picture came into the possession of his brother Thomas, and then to Thomas's daughter Charlotte, who married Sir W. E. Rouse Boughton. He died in 1856, and the picture passed to his second son, A. J. Rouse Boughton, who assumed the additional name of Knight in 1857 and died in 1909. His daughter married W. G. Pereth Kincaid Lennox. He died in 1934 and was succeeded by W. M. P. Kincaid Lennox, from whom the picture passed to D. P. H. Lennox. It was with T. Agnew & Son in 1978, and was bought by the Museum in 1979.

Exhibition
British Institution 1820.

Literature
Cunningham, 2:27–28.

Formation
Almost certainly this was a picture made for sale to the first taker. It was probably referred to by Wilkie in a letter of 25 November 1819 to Thomas Macdonald, his framemaker at the time. In it he asked to have a frame prepared for a picture of a size like to this, which he called "the Old Man's Head" (NLS: MS 9994/162). The price with the frame was 35 guineas.

Comments
The title given to the picture when Wilkie exhibited it in 1820 was "A Veteran Highlander, who served at the Battle of Minden." At the battle of Minden in 1759, during the Seven Years' War, a British brigade under Ferdinand of Brunswick routed the larger French army without the support of cavalry,

unaccountably withheld. The only Scottish regiment that fought at Minden was Lowland, The King's Own Scottish Borderers, but this would not invalidate the veteran's claim to have been there. Highlanders took their pay where they might.

In August and September 1817, Wilkie had made an expedition into the Highlands, an object of which was clearly to gather material for pictures. While he went no farther than the southern fringes of the Highlands in Argyllshire, Stirlingshire, and Perthshire—which were by then commonly visited by seekers after the picturesque—his eye was rather more on the inhabitants than on the landscape. In particular he was interested in old customs and places of habitation, and in people whose memories went back into the eighteenth century. For advice on what to see he turned to Walter Scott.

On his return to London, Wilkie wrote on 5 November 1817: "Scotland is . . . remarkable . . . as a volume of history. It is the land of tradition and of poetry. Every district has some scene in it of real or fictitious events, treasured with a sort of religious care in the minds of the inhabitants, and giving a dignity to places that in every other respect would to the man of the world be considered as barren and unprofitable. I have brought home several sketches and studies that I am now trying to turn to use" (BL: Add. MS 29991/10–11).

The present picture may well have resulted from one of these sketches made in 1817—as did The Death of the Red Deer (cat. no. 21). In 1819, old soldiers were anyway in Wilkie's mind as he worked on the Chelsea Pensioners (cat. no. 23). The sitter's leather apron gives him the appearance of a servant, or a tradesman. The medieval capital on the low column behind him invites curiosity, so far unsatisfied, as to

the setting of the subject. But all in all Wilkie's intention was probably no more than to paint a picturesque assemblage centered on a character study illustrative of a type. Wilkie painted only four or five single figures of this sort; the *Gamekeeper* (cat. no. 13) is another.

Richard Payne Knight (1751–1824) was an antiquarian, a collector, and a writer on matters of aesthetic taste. He bequeathed over 1,000 Old Master drawings to the British Museum: his relatively small collection of Old Master paintings was select, and included richly shadowed works by Elsheimer, Rembrandt, and Ruisdael. His patronage of living artists was extended most notably to Richard Westall, whose neoclassical style was evidently sympathetic to Knight's Mediterranean leanings.

Knight was also a founder of the British Institution, which was designed to encourage native painters, and at one of its annual exhibitions he bought the present picture. It was somewhat out of character with his other British pictures, yet in its Rembrandtesque lighting and its relative freedom of handling, newly found in Wilkie, Knight may have sensed an accord with his Old Masters from northern Europe.

For an excellent account of Knight, see Clarke and Penny 1982.

20. The Veteran Highlander

21. **The Death of the Red Deer**

Wood; 9½ × 13½ in. (24.1 × 34.3 cm.)
Signed, and dated 1821.
Lent from the collection of The Duke of Atholl at Blair Castle.

History and Provenance
Presumably painted in 1820. Seemingly bought by Samuel Rogers on behalf of his brother—not named, but perhaps Daniel. In 1842 the picture belonged to a Miss Rogers, who must have been their unmarried sister, Sarah. Samuel Rogers died in 1855 and the picture was included in his sale of 2 May 1856, bought by Bentley, £393—15—0; Thomas Baring 1856–57, who died in 1873; the picture passed to the 2nd Earl of Northbrook, who died in 1929. With P. and D. Colnaghi 1931; anonymous sale, 23 November 1984, bought for the present owner.

Exhibitions
British Institution 1821; British Institution 1842; Edinburgh 1985.

Literature
Cunningham, 1:479–80, 3:478, 481–82.

Formation
The beginning of the composition was described by Wilkie in a letter from Blair Atholl, in Perthshire, on 11 September 1817: "I began to make a sketch in oil of one of the dead deer, with some of the [Duke of Atholl's] gamekeepers about it, who have all got kilts, and are very picturesque characters." The formality of the present picture suggests that it is an elaboration from the sketch, if only by reason of its concentration on the piper (see under Versions, below). Although it is dated 1821, the 1821 exhibition at the British Institution opened on January 29, so it must be assumed that the picture was largely painted in 1820.

It was not a commissioned work, as is indicated in an undated letter, presumably written shortly before 29 May 1821, Samuel Rogers wrote to Wilkie: "Mr. [Thomas] Stothard [the painter, who had worked for Rogers] mentioned to me . . . that he had some conversation with you on . . . your picture of The Death of the Red Deer. My brother . . . will think himself much obliged . . . if you can favor him with it. The price, I think, was thirty five guineas" (NLS: in Acc. 8382). Wilkie accepted the offer on May 29. Rogers's brother is here taken to have been Daniel, who lived in the country and so was perhaps not in position to negotiate in London—unlike his younger brother, Henry.

Versions
A sketch mentioned by Wilkie has been noted above. There is no certain trace of it later. Wilkie also mentioned, in the same letter of 11 September 1817, that he had been struck by the Duke of Atholl's piper and that he had made "a sketch [in oil?] of him in a group." This is also lost. Likewise connected with the subject, and possibly contributing to the present composition, was an oil sketch not recorded until 1886 and 1888, when it was variously titled "Figures with Dead Deer" and "Killing the First Deer." For this see more under Comments, below.

Comments
The context from which the composition derives was described by Wilkie, again in his letter of 11 September 1817. He wrote of his arrival two or three days earlier at Blair Castle with a letter of introduction to the (4th) Duke of Atholl, and continued: "As the Duke was going out to hunt the deer, he gave directions that I should be shown about through the day. . . . In the course of the day I was surprised to find in the slaughter-house a man skinning a red deer of immense size, which the Duke had newly shot, and which had been brought from the hills [here an uncertain recol-

21. **The Death of the Red Deer**

lection of Glen Tilt?] by an old maniac with a bonnet and kilt, who is employed to bring them down on horseback. Next day several horses and a cart were sent to bring others from the forest; and when the old maniac arrived with them, the whole formed the most picturesque scene imaginable." Wilkie then made the sketch already noted.

The letter continues: "Among other objects that here indicate its being a Highland territory, is a piper. This is a famous personage. He has got the complete uniform of his order (a kilt and plaid), [and] is a fine-looking fellow. . . . He plays regularly for half an hour before breakfast and dinner, and walks with stately majesty before the house." Wilkie put this man into the second sketch, also noted above.

Clearly Wilkie, a Lowlander, was much impressed by this glimpse of seigniorial Highland life, to him distinct and foreign, and by this sporting episode in particular. Cunningham makes further, alas mysterious, allusions to it. He writes: " . . . nor has the Atholl deer, which [Wilkie] limned with his pencil as it lay bleeding among the brakes, found its way into any of his compositions"; and again of Wilkie's interest in "two men slaying a wild deer on the braes of Atholl." He had presumably seen drawings by Wilkie of such incidents, but there is also a later suggestion of a related oil sketch (see under Versions, above).

The piper in the present picture was called McGregor. The man with a gun was the Duke's head keeper, Donald McIntyre; his features recur in a picture begun in 1824 by Edwin Landseer, called the *Death of the Stag in Glen Tilt* (Blair Castle). The boy in fancy costume has an air of reality and may well be a portrait (possibly of the Duke's nephew, George Murray, later the 6th Duke of Atholl); the woman behind him may be another member of the family. Perhaps the picture should be looked at as a group portrait in the manner of Wilkie's rustic assemblage of Walter Scott and his family of 1817 (Scottish National Portrait Gallery).

Landseer's picture of the *Death of the Stag in Glen Tilt*, for which he made studies at Blair Atholl in September 1824, and again in 1825 and 1826, was exhibited in 1830. Its central figures are those of the 4th Duke and George Murray. The commission may have been given to him because Wilkie had declined it. This is suggested by a letter from Wilkie of 12 September 1824 to William Scrope, the writer of a valuable book on deerstalking and an amateur landscape painter. Wilkie wrote: "In answer to the request you have made to me from his Grace the Duke of Atholl [I] have to express my extreme regret that circumstances prevent me undertaking the picture in question, however much from my respect for that nobleman, and from the interest of the accompaniments proposed, it would have been my inclination to have painted such a portrait of his Grace. . . . [I] also must decline the invitation to Blair—which I do with the more regret from recollecting some happy days I had the honor to pass there with his Grace and the Duchess upon a former occasion when the sports of the forest in which the Duke was engaged made that sort of impression which, but for other pressing engagements, I should have been but too happy to have had such an opportunity of transcribing upon canvas" (NLS: MS 9836/75–6). The combination of portrait and of interesting "accompaniments"—which could have meant only dead deer and other evidence of the Duke's ruling passion in sport—was to be skillfully realized by Landseer. Yet the germ of what was presumably Scrope's idea may have lain in the present picture. The

preventive "circumstances" Wilkie alludes to were "in collecting materials for a work of a somewhat similar kind for His Majesty"; in other words, his even more ambitious picture incorporating what he called "portraits in action," *The Entrance of George IV into Holyrood* (see cat. no. 32).

22. The Chelsea Pensioners: Sketch

Wood; 11⅜ × 15¾ in. (29 × 40 cm.)
Signed, and dated 1818.
Lent by the Commissioners of the Royal Hospital,
Chelsea.

History and Provenance
Almost certainly painted between 7 March and 18 June
1819. There is no further certain record of the picture
until it reemerged in an anonymous sale on 10 June
1921, bought by Twickenham, £11 — 11 — 0. Presented
to the Royal Hospital by Commander C. W. Phillips in
1956.

Exhibitions
St. Andrews and Aberdeen 1985.

Literature
Cunningham, 2:17–18, 25–26.

Formation
Discussed under cat. no. 23.

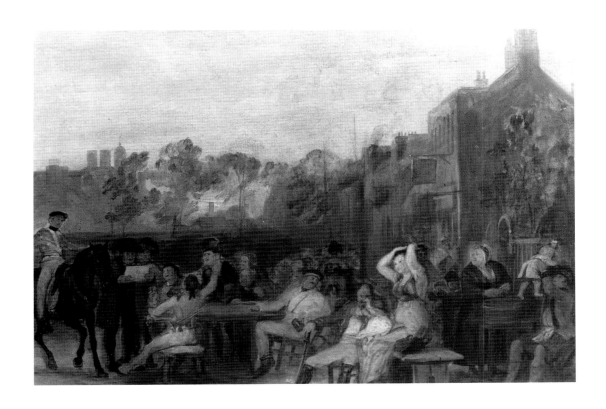

22. **The Chelsea Pensioners: Sketch**

23. Chelsea Pensioners Reading the Waterloo Despatch

Wood; 38¼ × 62¼ in. (97 × 158 cm.)
Signed, and dated 1822.
Lent by the Victoria and Albert Museum, Apsley
House.

History and Provenance
Commissioned by the Duke of Wellington in 1816,
Wilkie began the picture in April 1820 on the basis of
intervening sketches (see under Versions, below). It
seems to have been finished in March 1822, and was
delivered to the Duke at Apsley House on July 22.
There it has since remained, and it was given to the
nation, with Apsley House, by the 7th Duke of
Wellington in 1947.

Exhibitions
Royal Academy 1822; British Institution 1825;
Birmingham, Society of Arts, 1832; Edinburgh, Royal
Scottish Academy, 1837; British Institution 1842; Edin-
burgh and London 1958; Edinburgh 1985.

Literature
Cunningham, 1:170, 453, 459, 2:13, 14, 16–18,
25–26, 29, 45, 48, 49, 50–51, 53–54, 58, 66, 68–69,
72–73, 109–10; Haydon 1926, 1:245–47.

Formation
The Duke of Wellington visited Wilkie's studio
on 17 August 1816 and commissioned a picture
of old soldiers at a public house in Chelsea (on
the subject see more under Comments, below).
When asked how long it would be before it was
ready, Wilkie replied that existing commit-
ments, and "the time it would take to collect
materials, would prevent [him from] being able
to get it done for two years." With this the
Duke was satisfied.

According to Cunningham, Wilkie "was
busied in preparing studies for his Wellington
Picture, and also for The Scotch Wedding [cat.
no. 18]" in 1817. These studies were perhaps
all drawings, since it was not until 26 July 1818
that there is any mention of painting. On that
day Wilkie wrote: "I have not painted much

since coming into Suffolk [to stay with Perry
Nursey; see cat. no. 19], but have now begun
my sketch for the Duke of Wellington's picture,
which I hope to get ready to send to [the Duke
in] Paris by the time I come [back] to town"
(HL: MS 1052). Wilkie was certainly back in
London by mid-August, and two months later,
on October 17, he wrote to his friend Nursey:
"[As] for my sketch of the Chelsea Pensioners, I
am not yet satisfied with it, and am altering it
very much from what it was when at your
house. The Duke has not yet seen it, but I wish
to have it ready to show when he next comes to
England" (Academy 1878, 324). On November
28 Wilkie agreed to let Sir Willoughby Gordon
have the sketch (after he had had the use of it,
presumably) for 60 guineas. It need not be
assumed that it was was finished by then
—indeed it was not until December 23 that
Wilkie announced that the sketch was finished
and ready for submission to the Duke.

On 18 January 1819, Wilkie wrote: "The
sketch . . . I have not yet got his Grace to look
at, and [I] cannot begin [the picture] . . . till
he . . . is satisfied" (PML: MS MA 2797). The
Duke called within the week, but Wilkie was
out. Wilkie left the sketch at Apsley House on
February 27, and went back on March 7 to
hear the Duke's opinion of it. As Wilkie
afterward related, "he wished to have in the
picture more of the soldiers of the present day,
instead of those I had put of half a century ago.
He wished me to make a slight sketch of the
alteration." The alternative sketch was made by
June 18, and both were discussed at Apsley
House on July 12. Charles Long was there, and
the Duke showed him the two sketches, stating,
in Wilkie's words, "what he liked and disliked,
and observing that out of the two a picture
might be made that would do. He preferred the
one with the young figures; but as Mr. Long

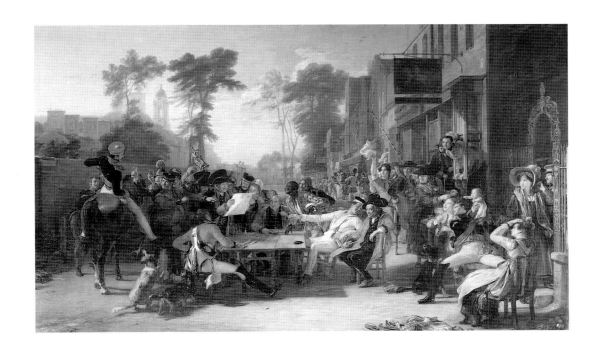

23. **Chelsea Pensioners Reading the Waterloo Despatch**

remonstrated against the old fellows being taken out, the Duke agreed that the man reading should be a pensioner, besides some others in the picture. He wished that the piper might be put in, also the old man with the wooden leg; but he objected to the man with the opthalmia. Mr. Long preferred the composition of the first sketch in the grouping on the right." After hearing these remarks, Wilkie was told that he might proceed to the final picture.

Wilkie then turned to Sir George Beaumont for further advice. Beaumont called when Wilkie was out, but was shown two sketches about which he wrote on 22 November 1819. He was not surprised that the Duke had preferred the first sketch—"Might it not . . . be owing to its being rather more finished?"—for he doubted the Duke's ability to envisage the final effect of a work presented "in embrio," as was the case with the second sketch. Beaumont went on to say that his own preference was for the second sketch, although he added, presumably in relation to his understanding of the Duke's opinion: "I never can reconcile my mind to the loss of that son of Glee who, with his extended arms, not only gives animation to the whole, but seems to me essential to connect the groups and carry the light through the picture" (NLS: MS 9835/128–9). Beaumont's reference to the man at the table to the left, with his back to us and his arm upraised, thus makes it likely that the sketch exhibited here (cat. no. 22), despite the date on it, is, or represents, the second, alternative composition painted between 7 March and 18 June 1819, and seen by the Duke.

In his reply, Wilkie concurred with Beaumont's reading of the function of the figure of the man with his arm upraised, and explained that since the second sketch was made for "the purpose of trying some alterations which . . .

consisted chiefly in having younger men in the picture . . . [I] put in a prominent place that figure which you are pleased to call a 'son of Glee.' This required a considerable change in all the figures at that corner; and although, to my mind, the composition in that part is in itself improved, it has been thought not to make so neat an arrangement when considered in respect to the rest of the picture. The Duke . . . did not give a preference about this point, but Mr. Charles Long . . . gave his opinion in favour of the other [arrangement] . . . though I . . . think . . . that the second was an improvement. . . . I shall have no hesitation in adopting it."

But before embarking on the final picture, Wilkie concentrated on getting out of the way his *Reading the Will* (Munich, Neue Pinakothek), destined for the King of Bavaria. Thus it was not until 20 April 1820 that he "began to line in the perspective of the picture." Yet it must have been something of a false start because, on October 21, Wilkie wrote in his journal: "Engaged for the last fortnight in making a great alteration in . . . my picture . . . ; it consists chiefly in transposing the figures on the left-hand side . . . which were before much more towards the side, nearer the centre; so that the man reading the paper should be more in the eye of the picture." This he elaborated in a letter written a few days later from the country, where he had gone to recover health lost by overwork: "The effect has been to concentrate the interest to one point, and to improve the composition by making it more of a whole." It remains to discover what led to this fundamental upheaval of the composition, which, from Wilkie's account of it, seems to have produced the anecdotal focus that now gives character to the finished picture.

In 1822, when all was done, Wilkie looked

back in his journal on "sixteen months' constant work, besides months of study to collect and arrange." He recalled that the Duke's commission in 1816 had been for a picture then described as of "a number of soldiers of various descriptions seated upon the benches of the door of a public house, with porter and tobacco, talking over their old stories." He went on: "In justice to him as well as to myself, it is but right to state, that the introduction of the Gazette was a subsequent idea of my own to unite the interest, and give importance to the business of the picture." Part of his early difficulty must have been in giving a sense of shape to the subject as it had been at first envisaged by the Duke. At the time of the commission he had been alert to the need for "some story . . . to connect the figures together," and the Duke said "perhaps playing at skittles would do [Wilkie tried the idea in a drawing] . . . when I proposed that one [of the figures] might be [shown] reading a newspaper aloud to the rest, and that in making a sketch of it many other incidents would occur." The motif of the irruption of news, hesitantly introduced in the second design (cat. no. 22)—and possibly adumbrated by a newspaper reading in the first—became the basis of the final change in the form of the design. The original scene may have been one of little more than idle contentment; the new structural and emotive unity was found by stressing the importance of the activity of reading the Gazette that announced the victory at Waterloo.

This significant remanagement of the subject in October 1820 was, however, only a start in what was to be still a long and anxious process of development. Despite interruptions, the picture was, in Cunningham's phrase, "like a spell on Wilkie." On 16 February 1821 he wrote of the composition as having been "altered very much, but . . . now nearly settled." The only description of one such alteration concerns the figure of the woman clutching an infant, half seen to the right of the man reading the Gazette. She was a replacement for a woman shown "fainting away under the influence of . . . sudden affliction; her eyes half-closed and her whole action quietness itself" (*New Monthly Magazine* 5:219). On December 24 Wilkie was able to say: "All the figures . . . are finished or at least painted in. The background is what I next proceed upon, and as every thing is arranged [I] expect to get on without difficulty" (BL: Add. MS. 29991/30–1). A week later he wrote that though he was apprehensive about the painting of the background (see cat. no. 17, under Comments), he did not intend to alter anything, and that he expected to finish the picture in plenty of time for the coming exhibition at the Royal Academy.

By the last days of March 1822 the picture must have been finished. The Duke came to see it, and Wilkie wrote on April 6 that "during the last week I have let in my neighbours . . . of whom 362 have seen it, and my house in consequence has been like a cryed fair" (HL: MS 1073). On May 3, a varnishing day at the Academy, he noted in his journal that he had toned down "some greys that were a little raw," adding: "This is the first picture I have had [at the Academy] that does not appear injured by the exhibition [cf. cat. no. 5, under Comments]."

Versions
As already seen from the above, there is documentary evidence that Wilkie made two preliminary sketches before starting on a larger composition. The first, begun by 26 July 1818 and completed by December 23, was relatively "finished." The figures in it were noticeably

elderly, and they included a man with a wooden leg, and a man with an inflammation of the eye. Possibly there were also a "piper" (meaning the boy playing a fife, i.e., a fifer?), and a Chelsea Pensioner reading a letter or paper. The group of figures to the right of the composition differed from the equivalent group in the second sketch.

The second sketch was made at the Duke's request as an alternative variant of the first, and painted between 7 March and 18 June 1819. It is quite likely to have been cat. no. 22.

Cunningham wrote of other small versions of the picture: "A finished sketch . . . a variation of his great picture . . . was the produce of this period [1823]. It went to John Clerk. . . . A similar sketch with some changes, but the leading figures the same, was bought by Sir Willoughby Gordon. These sketches are little inferior in value to the more elaborate picture. . . . They have, in several respects, more freedom of hand, and . . . more careless vigour of touch. . . . To these may be added as of equal merit, and the produce too of this season, a sketch or finished study of the same picture for James Vine." In 1840 it was said that there were "several very beautifully-finished sketches in existence." Some of these sketches or small reductions can be traced closer to the present time, but the evidence is confusing and it is not possible to equate any of them securely with surviving sketches—cat. no. 22 being a reasonable exception.

Cunningham had already mentioned the sketch for John Clerk, later Lord Eldin, who, when he "desired in 1822 . . . a sketch . . . the artist immediately complied with his wish, and sent him a finished study of . . . rare excellence." In 1830 Wilkie was anxious to buy back this "finished sketch of mine," because the present picture was to be engraved and he was "under an obligation . . . to prevent any of the smaller studies or pictures I made of that subject being engraved." In the event Clerk's sketch went to Sir James Gibson Craig in 1833, and was sold by his son in 1887. A composition of the same arrangement and size was bought by the Yale Center for British Art in 1974, with a provenance from Bishop John Gott who exhibited it at Yarmouth in 1863–64 as a "Sketch for the large picture." It is spuriously signed.

Turning to Sir Willoughby Gordon, it will have been noticed, under Formation above, that he bespoke a sketch on 18 November 1818. It is not known what he got, or when. In 1827 he had in his possession what was then described as "a finished copy in small." His pictures were sold in 1926, on which occasion the sketch was said to be dated 1822. It was perhaps the sketch sold by Alan Spencer on 25 November 1977.

The third sketch mentioned by Cunningham is that painted at the same time for James Vine. It was sold in 1838, and is likely to have been the sketch that Thomas Baring had in 1842, which Waagen described as "spirited and careful." It descended to the 2d Earl of Northbrook.

Comments

Wilkie seems to have had thoughts, at least, of painting Chelsea Pensioners before the Duke visited his studio in 1816. Cunningham would have it that in the winter of 1810 he painted "Chelsea Pensioners indulging themselves at Pension Time," a subject that Cunningham saw as "finally resolved" in the present picture. From the winter of 1810 to the following summer Wilkie was living in Chelsea. Again according to Cunningham, Wilkie agreed to

paint for Sir Willoughby Gordon a pair of pictures showing contrasting aspects of military charity in Chelsea, of which one was to be "An Old Soldier claiming admission as a Pensioner at the Hospital." This was in 1814; so far as is known, nothing came of the commission.

The setting of the present scene, as Katherine Thomson informed Cunningham — she knew Wilkie at the time he was gathering material for the picture — was Jew's Row in Chelsea, once parallel to the present Turk's Row. It has long since gone, but it was, as she described it, "a low Teniers-like row of extremely mean public-houses, lodging-houses, rag-shops, and huckster-shops, on the right hand as you approach Chelsea College [as the Hospital was still sometimes called]. It is the Pall Mall of the Pensioners." On the left of the picture is a more distant view of the north front of the Royal Hospital. It had been opened in 1694 as a home for invalid common soldiers, "Chelsea Pensioners." Wilkie thought the background, "from drawings made upon the spot," to be "almost a correct view of the place itself."

The title of the picture, as first exhibited, was "Chelsea pensioners receiving the London Gazette Extraordinary of Thursday, June 22d, 1815, announcing the Battle of Waterloo!!!" The setting and the identities of some of the figures were detailed by Wilkie in a catalogue note:

"The picture represents . . . pensioners and soldiers in front of the Duke of York public-house, Royal Hospital-row, Chelsea. The light-horseman ["an orderly of the Tenth Hussars"] on the left has just arrived with the Gazettes, and is relating further particulars to his comrades, among whom is a Glengary Highlander who served with General Graham at Barossa [1811].

"The Gazette is in the hands of an old pensioner, a survivor of the Seven Years' War, who was at the taking of Quebec [1759] with General Wolfe, and is now reading aloud to his companions the details of the Victory of Waterloo. Opposite to him is a black, one of the band of the 1st regiment of Foot Guards, who was in France during the Revolution; was present at the death of Louis XVI, and was afterwards servant to General Moreau, in his campaigns in Germany. . . .

"Next to the black, in a foraging dress, is an Irish light-horseman, explaining the news to an old pensioner ["old Doggy"] who was with General Elliot during the bombardment of 21 months and 21 days, at the memorable siege of Gibraltar [1779–83]; and behind the black's head is that of a soldier who served with the old Marquis of Granby. Further to the right is a corporal of the Oxford Blues [Royal Horse Guards], who was at the battle of Vittoria [1813]; and at his feet is a black dog, known to the officers and man, by the name of 'Old Duke,' who followed that regiment all over the Peninsula." It was said in 1841 that the old woman opening oysters, to the right, was a portrait of Wilkie's mother (*Fraser's Magazine* [1841]:451)

Cunningham (2:74–78) gives an amplified enumeration of the principal figures in the picture, and Burnet's key to his engraving after it is in the exhibition (cat. no. 94).

Although the incident portrayed in the picture was of Wilkie's imagination, his description of it insists on the actuality of the place and yet more on the individuality of a number of the protagonists — each of whom, from different parts of the kingdom, carried in him a piece of the military history of a United Kingdom. Some are Pensioners, invalids from the past; others are the younger men whom the

Duke had wished to see represented. These are therefore serving soldiers, but they are witnesses to victory no less than their elders—to the Duke's still recent victories in the Peninsula. In summer the Pensioners received their pay, and "then, accordingly, they are . . . all engaged in a glorious carouse," here interrupted by the messenger.

Yet the overall reality that the picture celebrates, truly a liberation and a turning-point in national history, is that of Waterloo—won by the Duke in the year before the picture was commissioned. It should be observed, however, that there is no evidence for thinking that, when he gave the commission, the Duke expected to see in the picture either a specific reference to the victory or an expression of his numinous presence in the shaping of the national destiny. These were equally of Wilkie's invention. They were also a source of the popular—patriotic—success of the picture. Simply as a picture it made as deep an impression on even that radical dissenter from its political premise, Robert Hunt: "The natu-ralness of the scene is . . . so triumphant, that we doubt whether any subject of its class ever painted, (mortifying as the consequences of the Waterloo Battle are to every hater of the liberticidal system of the Divine Right)—has ever given so pleasing, because so faithful a picture of Nature" (*Examiner*, [1822]:381).

At the exhibition at the Royal Academy the picture was hung, surely with deliberation, between a portrait by Lawrence of Wellington, and a portrait by John Jackson of the Duke of York (on whom see cat. no. 24).

Early in the final stage of arranging this composition, Wilkie announced his intention of returning to the assistance of a device he had used in *Reading the Will*. He wrote on 20 July 1820: "I mean . . . to try . . . a model in clay of the groups of figures which I am to make, and which, by being properly coloured and put in a proper light and shadow, is one of the most powerful helps, next to nature itself, for deter-mining the effect of a picture" (*Academy* 1878, 324). That he did this can be seen in two of his drawings for the picture. Wilkie was well aware of sixteenth- and seventeenth-century precedent for this, and there is a firm suggestion that he had in fact used clay models as early as 1806 (see cat. no. 6, under Comments).

Incidentally on the matter of assistance, Wilkie wrote on 22 December 1819 to Abraham Cooper, the animal painter: "I have not yet begun my Chelsea people—but when I do [I] may probably apply to you for some assistance with the horse" (BL: MS Egerton 2075/21). However, it is not known whether he did so, or whether he got the assistance. In February 1822, Maria Edgeworth was helping Wilkie on the choice of detail by which to give national identity to the figure in undress at the right of the table—he wanted "to make one of the figures . . . an Irishman" (Edgeworth 1971, 347).

What Wilkie got wrong, a matter of mild notoriety at the time, was that it was illegal to eat oysters in June.

Wilkie's bill for the picture was sent to the Duke on 22 July 1822. It was for 1,200 guineas, more than was originally expected, but Wilkie had arrived at the sum "after mature consideration." Francis Chantrey, who was making a bust of the Duke, had already told him, at Wilkie's request, that "the sum named [earlier] for the picture would be a very slender remuneration for the time . . . bestowed" on it (Jones 1849, 110). The next day Sir Willoughby Gordon told Wilkie that the Duke was satisfied with the price. On July 25 Wilkie

was summoned to Apsley House, where the Duke counted out the money in bank notes and gave it to him. This eccentric behavior may be explained in the light of an anecdote concerning William Allan, whose picture of the Battle of Waterloo was bought by the Duke for £600 in 1843. Allan went to Apsley House, where the Duke "began to collect bank-notes from several drawers in a table." When Allan suggested that a check would do, "the Duke, somewhat nettled, replied, 'Do you think I do not know what I am about? Do you think I want the clerks at Coutts's [Bank] to know that I have been such a damned fool as to give a thousand guineas [sic] for a picture?" (Hart 1882, 122).

Wilkie explained the basis on which he had arrived at the price in a letter of July 28: "The fixing of the price I had previously considered a good deal; and as my friends . . . have taken a good deal of interest about the question, I have heard every variety of opinion upon the subject. That of 2,000 guineas has been frequently mentioned, and had the same picture been painted for a public institution and for a public purpose, I do not know that I would have been contented with less. But being painted by order of a private individual, and being myself employed almost entirely by private individuals, I could not ask for this a much higher price than other private individuals would give for pictures [involving] the same [amount of] work. . . . The price I put upon the picture . . . was nevertheless greater than anything I or any other modern artists have had from any individual employer in this country, and . . . I have the satisfaction to state that it has this important confirmation that it has not only been asked but has been paid" (Academy [1878]:346). Although Wilkie was not quite right in thinking that the price

paid for the present picture was the highest paid to a modern British artist, it was certainly most exceptional. However, the cavil is scarcely relevant. The point Wilkie was making—in the implicit context of the argument over the relative justification for spending money on Old Masters or for spending it on the work of living artists—was that to pay 1,200 guineas for the work of a modern British artist was to recognize its value in the monetary scale more usually applied to works by the Old Masters. In other words, the Duke's payment of so large a sum was a tribute to the living, national school as a whole.

For the Duke of Wellington, see cat. no. 33. How he came to be interested in Wilkie, other than through his taste for Dutch pictures, may only be surmised. When they met for the first time, in Wilkie's studio on 17 August 1816, the intermediary was Lord Lynedoch (formerly the General Graham mentioned in Wilkie's description of the present picture). There is no sign of previous—or indeed subsequent—contact between Wilkie and Lynedoch, but he, apart from being a fellow Scot, had served at one time under one of Wilkie's devoted early patrons, Lord Mulgrave (see cat. no. 8, under Comments).

Drawings
Aberdeen, Aberdeen Art Gallery; Amherst, Mass., Amherst College; Birmingham, Birmingham City Art Gallery; Edinburgh, National Gallery of Scotland; London, British Museum, Royal Academy, and Victoria and Albert Museum; Paisley, Paisley Museum and Art Gallery; Oxford, Ashmolean Museum; Stanford, Calif., Stanford University Museum; private collections.

It should be noted here that there are some eighty surviving drawings connected with the development of the present picture—far more than for any other. They testify to Wilkie's attentiveness in finding a coherence for each group within a composition that "contains sixty figures" (Wilkie's count), as well as to find a unity

for the whole. A full discussion of the formation of the present picture would of course involve a close examination of these drawings.

Engravings

1. By John Burnet, published by Henry Graves & Co., 10 September 1831, and dedicated to the Duke of Wellington by the proprietors; 43.8 × 71.5 cm. Wilkie wrote to the Duke on 30 July 1828 asking to borrow the picture for the purpose of engraving; permission was granted there and then. In his next letter he said that "to complete so extensive an engraving" would take "from three to four years," and wondered whether this would cause the Duke inconvenience. To this Wilkie got a good-naturedly blunt reply on September 17: "The Duke will lend the Picture at periods at which it will not be inconvenient to him to part with it. On the day that he will require it he must have it again." About a month later it was agreed by Moon, Boys, & Graves and by Burnet, on the one hand, and by Wilkie, on the other hand, that he would be paid £1,200 for the copyright, and that Burnet would undertake the engraving for £1,575 plus one-third of the profits. The final cost of the publication turned out to be more than 4,000 guineas. By 1 January 1829 the engraving was said (surprisingly) to be "far advanced"; early impressions, without letters, were being taken by 15 September 1831. On December 1 it was said that "a fine impression is, even now, not easily to be procured."

2. By W. Greatbach; 14.2 × 23.6 cm. In the *Wilkie Gallery* (1848–50).

24. Frederick, Duke of York

Wood; 24½ × 20¾ in. (62.2 × 52.7 cm.)
Signed, and dated 1823.
Lent by the National Portrait Gallery, London.

History and Provenance
Materially painted in 1822, for Sir Willoughby Gordon.
When he died in 1851 the portrait passed to his son,
Sir H. P. Gordon, and then from him to his daughter,
Mary, the wife of General R. W. D. Leith, and so down
to their son, A. H. Leith, later Lord Burgh; his sale at
Niton, Isle of Wight, 7 February 1938, bought by
Leggatt Bros. for the Gallery.

Exhibitions
Royal Academy 1823; Edinburgh and London 1958.

Literature
Cunningham, 2:14–15, 72, 93, 3:526.

Formation
On 1 December 1818, Wilkie had a letter from
Gordon, asking whether he would paint the
Duke "in small," should the Duke be willing to
sit. Some thinking must have followed from this
suggestion, for, on December 21, Wilkie wrote
to Gordon: "I thank you for your kind note
with the sketches. The figure can be changed
without disadvantage to show the star [of the
Garter] on the other side by reversing the
picture. I perfectly understand from your sketch
the situation of the objects in the [Duke's] room
[at York House], and would wish to introduce as
much of the real apartment and the
dress . . . as possible: a rich and pleasing and
characteristic picture, however, must be the
chief object. It is a picture I should certainly
like to do. . . . When leave is obtained [from
the Duke] I would begin the picture at home,
and advance it some little way before requesting
to have a sitting" (NLS: in Acc. 7901).

Wilkie heard from Gordon on 23 January
1819. The Duke was willing to be painted, so
Wilkie and Gordon arranged to meet on
January 26 at York House in Whitehall "to look

at the apartment that is to be the scene of the
picture." If Wilkie made drawings of this archi-
tectural setting, as is likely, they have not
survived. The Duke had consented to go to
Wilkie's own house for the sittings. The price of
the portrait was to be 100–150 guineas (150 in
the event).

The first recorded sitting was not until 18
May 1822, when Wilkie wrote: "I painted in
the eyes, nose, and forehead." There was
another sitting on June 3 (HL: MS 1075), and
on July 28 Wilkie wrote: "The Duke of York I
have had another letter of; and that goes on
well: only there is still the want of style about
the inner part of the dress" (*Academy*
[1878]:346). On August 4 Wilkie wrote to
Gordon: "The portrait remains as it was. The
head, excepting a few touches, is nearly right.
The figure appears somewhat too tall, and I
have still some doubts about the dress; but
these do not occur to other people, and the
accompaniments, when painted all round, will
probably set everything to rights" (NLS: in
Acc. 7901). Wilkie left for Scotland on August
7, and did not return until just before
September 13. On September 23 he had no
more to say to Gordon than, again, "The
portrait . . . remains nearly as it was" (NLS: in
Acc. 7901). It is not known when it was
finished.

There is a possibility that some alteration
was made to the picture in 1836. Wilkie had
painted for Gordon a companion picture of the
same size as this, representing the Duke of
Wellington writing a dispatch (Aberdeen Art
Gallery). On July 22 of that year, Wilkie wrote
to Gordon about the new picture: "In order
that it may agree in tone and in strength with
its companion, that of the Duke of York, may
I . . . send . . . for that picture [so] that, on
your seeing them together, we may judge what

may be required to make them suitable in effect to one another" (NLS: in Acc. 7901). If any alteration was made, it was likely to have been on the present picture in order to bring it into accord with the darker tones of the picture of Wellington.

Version

A small sketch of the composition was known up to 1886, but has since disappeared. See further under Comments, below.

Comments

Frederick Augustus, Duke of York (1763–1827), was the eldest of the brothers of George IV. Although his active military service was not notably successful, from 1798, as Commander-in-Chief, he was a popular figure who did much to reform the discipline and moral tone of the army. His connection with the "events and individuals" commemorated in the *Chelsea Pensioners* (cat. no. 23) was alluded to at the time.

The uniform he is shown in here is that of a field marshal; he wears the Star of the Order of the Garter, and appears to be reading an army order.

The sketch referred to under Version, above, may have been the subject of a recollection by Katharine Thomson: "[Wilkie] showed me the sketch of the Duke of York. . . . 'I had sad trouble,' he observed . . . 'with the duke's face, his mouth especially; he is a little underhung'" (Thomson 1854, 2:165).

Sir (James) Willoughby Gordon (1772–1851), who commissioned the portrait, had held the important post of Military Secretary to the Duke, and then became Quartermaster-General. He ordered his first picture from Wilkie in 1814, and came to own a number of them, including cat. nos. 28 and 32; another, the *Duke of Wellington Writing a Despatch* of 1829–30 and 1835–36, he seems to have commissioned as a pendant to the present picture. For more on Gordon and Wilkie (and on Wilkie and Gordon's daughter), see Miles 1981.

Drawings

Edinburgh, National Gallery of Scotland; New York, Metropolitan Museum (Lehman Collection); Stanford, Calif., Stanford University Museum; The Binns (National Trust for Scotland); private collections (one drawing dated 1823).

24. Frederick, Duke of York

25. The Gentle Shepherd

Wood; 13 × 17 in. (33 × 43 cm.)
Signed, and dated 1823.
Lent by Sir Andrew Forbes-Leith, Bt.

History and Provenance

Painted in 1823 for Sir Robert Liston, of Millburn Tower, near Edinburgh, who died in 1836; acquired by Sir J. Gibson Craig, of Riccarton, near Edinburgh, by 1857; sold after the death of his son, J. T. Gibson Craig, 23 April 1887, bought by Lesser, £204—15—0; Charles Butler 1896 and 1898; with Agnew in 1902; A. J. Forbes-Leith (later Lord Leith), 1903, and thence by descent.

Exhibition

Edinburgh, Royal Institution, 1824.

Literature

Cunningham, 3:526.

Formation

Wilkie wrote to Lady Liston on 4 December 1821: "The picture Sir Robert has been so obliging as to request me to paint for him I still keep in mind. There are some little subjects by me that might be taken up for this purpose. Of these one from the Gentle Shepherd of Allan Ramsay you might perhaps like, but this we can discuss" (NLS: MS 5666/212–3). Nothing more is known of the expected discussion and of Wilkie's subsequent action. That the picture was essentially painted in 1823 is assumed from the date inscribed on it.

Versions

Two other extant versions are virtually exact repetitions of the present picture, and are painted on panels of much the same size. The first, also signed and dated 1823, is in the Aberdeen Art Gallery; the second, unsigned and of lesser quality, is in the National Gallery of Scotland.

On 18 July 1833, Wilkie wrote of having "a little picture from the Gentle Shepherd in a state of great forwardness" (Cunningham, 3:70). This has not been further identified.

An upright variant of the subject, with only two figures, is in a private collection. It is very possibly the picture exhibited at the Royal Academy in 1840.

Comments

The subject is taken from Act I, scene 1, of *The Gentle Shepherd* (1725), a pastoral comedy in verse, by Allan Ramsay (1686–1758). Roger, "a rich young shepherd, in love with Jenny," speaks:

> "Last night I play'd, ye never heard sic spite,
> O'er Bogie was the spring, and her delyte;
> Yet tauntingly she at her cousin speer'd,
> Gif she cou'd tell what tune I play'd, and sneer'd."

Jenny is on the left; her cousin, Peggy, has her arm over her shoulder. The tune of "O'er Bogie" is printed in the musical supplement to the edition of the play printed at the Foulis Press in Glasgow in 1788—one cherished by Wilkie for its twelve illustrations by David Allan.

Wilkie's life-long interest in *The Gentle Shepherd* is well attested. It provided the subject for an early drawing (cat. no. 47). In 1823–24 he painted another scene from it, of comparable size to the present picture, for the Duke of Bedford. It is now known as the *Cottage Toilet* (Wallace Collection; see fig. 13).

Sir Robert Liston (1742–1836), a diplomatist, had retired from his last post abroad, as ambassador to Constantinople, in 1821. He had been a friend of Wilkie's father, and so the relationship between Wilkie and the Listons continued.

Drawings

Edinburgh, National Gallery of Scotland.

25. The Gentle Shepherd

Engravings

1. By James Stewart, published by Moon, Boys, & Graves, on 12 August 1828, and dedicated by Wilkie to Sir Robert Liston; 15.5 × 20.9 cm. There seems to have been some delay in the actual publication, for Wilkie wrote on 27 November 1828 that the print was not yet out.
2. By P. Lightfoot; 16.3 × 21.9 cm. In the *Wilkie Gallery* (1848–50). Probably a copy from the above.
3. By Lumb Stocks, 1862; 29.4 × 39.6 cm.

26. Sir Walter Scott

Wood; 17 × 14 in. (43.2 × 35.5 cm.)
Lent by the Faculty of Advocates, Edinburgh.

History and Provenance
Painted in 1824 and 1828–29. Probably acquired by Sir
William Knighton in 1825, but the portrait was
returned to Wilkie for the purpose of engraving after his
return from the Continent in 1828; he also did further
work on it. Knighton died in 1836, and the portrait
passed to his son, Sir W. W. Knighton; his sale, 23 May
1885, bought by Agnew, £115—10—0; Sir Donald
Currie by 1888 (he died in 1909); G. E. O. Walker,
Q.C., who gave it to the Faculty of Advocates in 1955
(Scott had been a member of the Faculty).

Exhibitions
Edinburgh and London 1958; Edinburgh 1975; Edin-
burgh 1981.

Literature
Bewick 1871, 1:252–53: Cunningham, 2:122, 131,
132–33, 3:9; Partington 1930, 250; Scott 1932–37,
8:340, 9:146, Scott 1972, 525.

Formation
Wilkie was in Edinburgh during the autumn of
1824, gathering information for his large
painting of *The Entrance of George IV at Holy-
rood House* (Royal Collection; see cat. no. 32).
Scott had been largely responsible for the
pageantry of the royal visit and, according to
Cunningham, it was Scott who in 1822—the
year of the King's visit to Edinburgh—had
encouraged Wilkie to proceed with the episode
of the King's entrance into Holyrood as the
appropriate subject for a painting. In the course
of composing this elaborate composition Wilkie
made a number of oil studies, which included
portraits of some of the more important
members of the King's entourage on the
occasion. On 26 September 1824 he wrote:
"The likeness of Sir Walter Scott is the only
one now wanting to complete my studies for
the picture."

In Wilkie's first comprehensive definition of
the composition (cat. no. 32), a portrait of
Scott was not included. The decision to do so
in the large final version was almost certainly
not Wilkie's own, for Scott had written on 1
August 1824: "Our gracious Sovereign has been
very civil to me [in] desiring Wilkie to
introduce my ancient figure in the large picture
he is painting." Wilkie himself declared that to
"get a sitting of Sir Walter Scott for my picture"
was "one of my objects in coming to Scotland"
in 1824.

On November 1 Wilkie wrote from
Edinburgh: "Sir Walter Scott . . . expects me
at Abbotsford, and is ready to sit. He has,
however, sat so frequently of late to artists [to
the Americans, G. S. Newton and C. R.
Leslie, in August and September; to Landseer
in October; William Bewick was at Abbotsford
at the same time as Wilkie] . . . that I grudge
going upon such an errand; however, it is a
matter of duty rather than a choice with me."
On November 11 Scott wrote that he had
"been sitting to Wilkie these two days past."
Wilkie was at Abbotsford for three days, and
was back in London on November 12.

That there was only a single sitting at
Abbotsford is clearly implied by Bewick's
description of it: "Wilkie . . . placed Sir
Walter in a broad light, in front of a large
window . . . as he said he wanted liitle shadow
on the face, for he had in mind the picture of
Goldsmith by Reynolds, and thought there was
a great resemblance between the two authors.
. . . Sir Walter sat in his usual costume, green
coat, yellowish waistcoat, and black neckcloth
. . . and, although conversing all the time,
contrived to keep his head in one position. The
house was full of company, and they all crowded
to the library to witness the sitting. Wilkie
seemed annoyed by the movement . . . he bit

his lip and fidgeted [he was anyway in poor health] . . . and had not advanced very much by the end of the sitting." Scott offered further sittings in London, but they did not take place, although Wilkie doubtless did some further work on the portrait.

Wilkie went abroad in 1825, having left the portrait, as it would seem, with Sir William Knighton. After his return in mid-June 1828, as Wilkie later recounted, Knighton offered it to him "to get it engraved, thinking it a favourable subject for engraving" (NLS: MS 3917/154). Knighton's thought was evidently to help Wilkie to make some money through the sale of prints after his portrait of so popular a figure. Perhaps with the intention of bringing the portrait to an appropriate state of finish before passing it to the engraver (see Engravings, below), Wilkie did further work on it. In December 1828 the work was virtually completed, for he wrote then to Sir William Knighton: "The head of Walter Scott I am proceeding with. It comes better than I expected. I have ordered a frame, and hope to have it nearly done by the time you see it." Wilkie wrote to Scott, on 10 January 1829: " . . . the portrait of yourself which I began when last at Abbotsford . . . I am just finishing for . . . Sir William Knighton, with whom I have just agreed to engrave it large."

Comments

Sir Walter Scott (1771–1832), novelist, poet, and historian, was Honorary Antiquary to the Royal Academy and a friend of some of the leading, and lesser, artists of his time. But he confessed, with a degree of truth: "I do not in the least understand the fine arts nor am I in the habit of interesting myself about them." Wilkie he met for the first time in 1809. In his novel *The Antiquary* (1816) he drew an implicit

parallel between Wilkie's art and his own; Wilkie painted a picture of Scott and his family in 1817 (Scottish National Portrait Gallery; fig. 40). The affinity between the work of the writer and of the painter was a subject of remark in their own day, and is a subject for dissertation still.

Charles Heath, the Annualist, was associated as an engraver with the production of the uniform edition of Scott's novels, the "Magnum Opus." He wrote to Scott on 23 February 1829: "I saw at Mr. Graves's [the print publisher] a portrait of yourself by Wilkie. . . . If my advice is worth anything I should say do not engrave it—*there is no resemblance*. Mr. Edwin Landseer has the finest likeness of you in the world [probably that in the National Portrait Gallery, London]" (NLS: MS 3908/99). Scott, although unnerved by this, nevertheless wrote in his journal: "Wilkie behaved in the kindest way, considering his very bad health, in agreeing to work for me at all, and I will . . . not wound his feelings by rejecting what he has given in such kindness." Scott then asked his son-in-law, J. G. Lockhart, to look at the portrait and give his opinion. What that opinion was at the time is not known, but when Lockhart came to publish his biography of Scott in 1839 he could not speak favorably of the head as it appeared in *The Entrance of George IV at Holyrood House* (Lockhart 1839, 10:263). It may be deduced that his view of the present portrait was equally unfavorable, since it was not used as an illustration for the "Magnum Opus" (see Engravings 2, below). In 1835, Scott's daughter, Mrs. Lockhart, told George Ticknor of Boston that the portrait of Scott by Leslie was considered in her family to be "the best one extant," but she may have been speaking tactfully about an American to an American who was also the owner of the portrait.

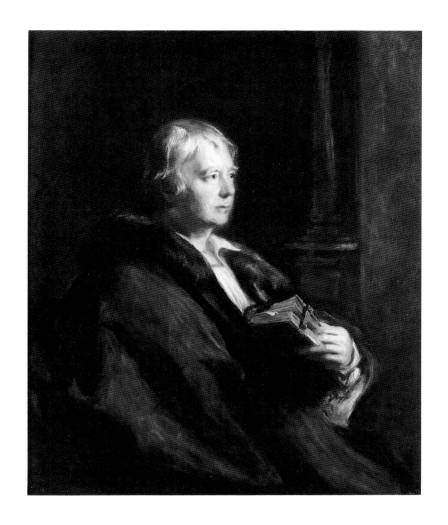

26. **Sir Walter Scott**

The relationship of Wilkie's portrait of Scott to the portrait of Goldsmith by Reynolds was first observed in print in 1842 (*Fraser's Magazine* 1842, 270). A version of the Reynolds was at Woburn, where Wilkie had been (not for the first time) in September 1823; the image was anyway familiar through engravings.

Engravings

1. By Edward Smith, published by Moon, Boys, & Graves, 1 June 1831; 23.7 × 19.4 cm. This was the "large" engraving alluded to in Wilkie's letter to Scott of 10 January 1829, quoted under Formation above. Not until 9 February 1831 was it nearing completion; Wilkie was able to send proof impressions to Scott on March 29.

2. By Edward Smith; 9.5 × 7 cm. In December 1828, Scott was in correspondence with Wilkie over illustrations for the the "Magnum Opus," published by Robert Cadell in Edinburgh. In his letter to Scott on 10 January 1829, just mentioned, Wilkie added further that the portrait he had begun in 1824 "might . . . be also engraved small on steel." Scott wrote back that he would be delighted to have his portrait appear as a frontispiece. The first of the volumes that made up *Old Mortality* appears to have been its destination—until Charles Heath interfered, on which see more under Comments, above. This engraving was probably begun before the larger one. Impressions were taken from the plate, but it was not published in the "Magnum Opus."

27. The Pifferari

Canvas; 18⅛ × 14¼ in. (46 × 36.2 cm.)
Signed, and dated 1827.
Lent by Her Majesty Queen Elizabeth II.

Exhibited at Yale only.

History and Provenance
Painted in Rome, and perhaps begun in December 1826, the picture was probably completed by 8 March 1827 and certainly by April 27. A few days later it was sent to Wilkie's brother Thomas, in London. Himself in London again, Wilkie reported on 1 July 1828 that the King had requested "to see me and my Italian studies; and the result is that he has bought the one of The Pifferari," as well as another. On August 8 Wilkie gave his receipt for £420 for the two pictures, of which £150 was for this one. By August 30 they had been framed and were ready for delivery. The picture went to Carlton House, and was at St. James's Palace in 1835. Since then it has been at Buckingham Palace.

Exhibitions
Royal Academy 1829; British Institution 1842.

Literature
Cunningham, 2:194, 414, 424, 3:3, 4, 527. Millar 1969, 138–9; Uwins 1858, 2:26.

Formation
When Wilkie went to Rome in 1825 it was not to paint but to recover his health (see the essay by Batchelor in this catalogue). Although at first scarcely able to work, his capacity to interest himself in works of art and in people was undiminished An aspect of Roman life that struck him on his arrival he described in a letter of November 28: "Great doings are expected here in the Holy Week [he must have meant the climactic Christmas week of the Jubilee, or Holy Year, which was particularly elaborate in 1825 under Leo XII]. . . . Multitudes of pilgrims from all parts of Italy are assembled in the streets, in costumes remarkably fine and poetical. . . . Each party of pilgrims is accompanied by one whose duty is to give music to the rest. This is a piper, or pifferaro, provided with an immense bagpipe,

of a deep rich tone . . . ; while another man plays [the melody] on a smaller reed. . . . In parading the streets they stop before the image of the Virgin, whom they serenade, as shepherds, at this season, previous to Christmas, in imitation of the shepherds of old, who announced the birth of the Messiah." Wilkie made a drawing of the subject (see under Drawings, below), and evidently wrote to Beaumont about what he had seen, for Beaumont replied on 25 April 1826, saying that he was "pleased to hear that you were sketching from pilgrims."

A year later, on 27 April 1827, although yet not recovered, Wilkie nevertheless wrote: "Although I am not sensible of any return in the power of application, which is still exerted with pain and fatigue, I have within the last five months completed two small pictures [this one and the *Confessional* (National Gallery of Scotland)], and carried on a large one near to completion [cat. no. 28], by little and by little, half an hour at a time, and three hours a day." Again he wrote of his labor over these pictures: "To do this all my ingenuity was put on the stretch. Every figure and every group required to be pre-conceived and pre-arranged—no changings, no rubbings out, no repetitions—every touch was final."

Comments
The subject of the picture has been described. Wilkie exhibited it under the title "The Pifferari. Calabrian shepherds, playing their hymns to the Madonna when arriving with the pilgrims in Rome." His treatment of the subject suggests that he may have remembered David Allan's drawings and prints of pilgrims, including pifferari, done in Rome some fifty years earlier. The composition also contains what may be an echo of some High Renais-

sance design involving the motif of adoration; Titian's *Vendramin Family* would be an example.

Pifferari were much commented upon by travelers to Rome, and they were also painted, by visiting artists especially, until well into the nineteenth century.

Wilkie painted four Roman subjects while he was abroad: the present picture; the *Confessional* already mentioned; and the *Roman Princess Washing the Feet of Pilgrims* (Royal Collection). The fourth Roman subject is cat. no. 28.

Drawing
Private collection (dated 1825).

Engravings
1. By H. Rolls, published 1 July 1829; 11.9 × 9.4 cm. Possibly made from a watercolor copy of the picture by James Stephanoff.
2. By J. C. Armytage; 21.3 × 16 cm. In the *Wilkie Gallery* (1848–50).

The composition was parodied in a lithograph by John Doyle, published on 1 March 1832—a tilt against Queen Adelaide.

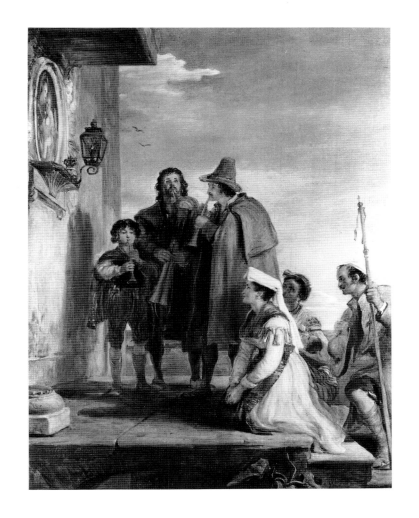

27. **The Pifferari**

28. Cardinals, Priests, and Roman Citizens Washing the Pilgrims' Feet

Canvas; 20 × 29 in. (50.8 × 73.7 cm.)
Signed, and dated 1827; inscribed over the doorway:
SANTA TRINITA DEI PELLEGRINI.
Lent by the Glasgow Art Gallery and Museum.

History and Provenance
Begun in Rome in 1827 and completed in London in
1828–29. Sir Willoughby Gordon agreed to buy it on
30 August 1828. Wilkie was still working on the picture
on 26 March 1829; it was presumably delivered to
Gordon after the exhibition at the Royal Academy. The
picture passed by descent to Lord Burgh, in whose sale
at Niton, Isle of Wight, it was on 9 July 1926, bought
by Mitchell, £92—8—0. Given to the Glasgow Art
Gallery by the Hamilton Trust in 1927.

Exhibitions
Royal Academy 1829; Edinburgh 1985.

Literature
Cunningham, 2:210–11, 414, 424, 476, 3:527; Uwins
1858, 2:26.

Formation
This was the last of the three pictures that
Wilkie painted in Rome during the five months
preceding 27 April 1827 (see cat. no. 27), and
he may have stopped work on it by March 8,
although still incomplete. In a letter of April
27 Wilkie wrote of this: "The third, as large as
both the others, I . . . expect, when equally
finished, to turn to as good an account. I now
send it, with the rest, by sea, to be completed
when occasion serves in London." Its unfin-
ished state was reverted to in a later letter:
"The last of the three was painted up at once
upon the bare canvas, and was left in that state
when packed off for London." He had no buyer
in mind.

Wilkie returned to London in mid-June
1828. On August 28 he wrote to Gordon:
"Lady Gordon has done much honor by her
approval of my subject of Washing the Pilgrims'
Feet. The price I have put upon that in
proportion to the others that are sold [see cat.

no. 27] is 300 guineas, but it would be more
likely to come more within your views were I to
say pounds instead of guineas, and to include
with it (what I have not done with the others)
the gilt frame . . . and to be completed and
delivered after [the] next Exhibition" (NLS: in
Acc. 7901). Gordon accepted the offer on
August 30 as "a purchase which will be very
gratifying to Lady Gordon" (NLS: in Acc.
7901). On 26 March 1829 Wilkie wrote to
Gordon that he had been "preparing the Feet
Washing that it might be ready to send [to the
Royal Academy] by the 6th or 7th April"
(NLS: MS 9836/8).

Comments
The subject of the picture has its source in
events witnessed by Wilkie in Rome. He was
there at the end of the Holy Year of 1825, and
he was much taken with the picturesqueness of
the pilgrims and the ceremonies attached to
the occasion. He wrote on 27 December 1825
of the "patriarchal custom, revived on these
occasions, of entertaining [the pilgrims] for
three nights at the Convent of Santa Trinita,
with previous washing of their feet!" His letter
continued: "We went to see this sacred
ceremony, found a great multitude . . . for
whom suppers were laid out; soups, fish, and
vegetables, in great abundance; and in another
room were ranges of seats, and buckets, where
they previously underwent the rite of ablution.
This was performed by a fraternity of citizens,
clerical dignitaries, and even princes, arrayed in
a loose red gown, with sleeves tucked up, and
bearing towels upon their shoulders for ther
work. . . . The look and savour of these lowly
guests were anything but seemly for religious
service. As they took off their sandals and
stockings, much as washing seemed needful, it
yet seemed so severe a task, that from the

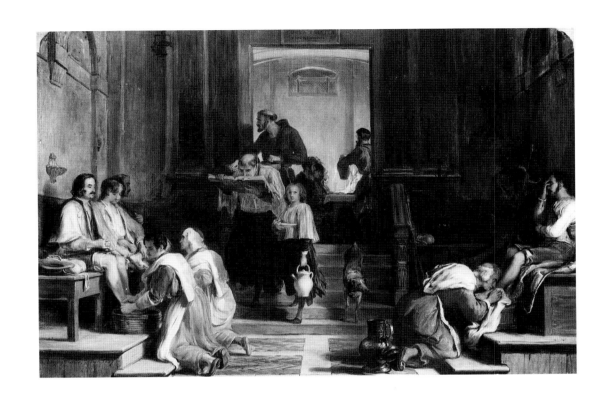

28. **Cardinals, Priests, and Roman Citizens Washing the Pilgrims' Feet**

hands of their noble serviteurs the mere will-
ingness to perform would, one would think,
have been accepted in lieu of the duty itself.
But quite otherwise was the fact. I saw a young
person, of respectable appearance and educa-
tion, proceed, in real earnest, and with bare
hands, while this pilgrim was crossing himself,
and muttering a prayer: he washed one foot and
then the other, dried them carefully with a
towel, and, after pronouncing a benediction,
kissed with his mouth each of the pilgrim's
feet!!" Wilkie also saw the separately performed
washing of the feet of female pilgrims, and of
this he painted a smaller picture while at
Geneva in 1827 (Royal Collection).

The centralized formality of the composition
reflects Wilkie's study of Raphael's frescoes at
this time.

29. Thomas, 9th Earl of Kellie

Canvas; 95 × 68 in. (241.3 × 172.7 cm.)
Signed, and dated 1828.
Lent by the Fife Regional Council, from the County
Hall, Cupar.

History and Provenance
Painted in 1824–25 and in 1828 for the County Hall at
Cupar; delivered in 1829 and still in its predestined
place.

Exhibitions
Royal Academy 1829; Edinburgh and London 1958.

Literature
Cunningham, 2:119, 122–23, 124, 128, 530, 3:527;
Fraser 1890, 2:334–35.

Formation

When, in 1824, the "Noblemen and Gentlemen of Fife" wished to have a portrait of the Earl of Kellie, the newly appointed Lord-Lieutenant of their county, the names of two Edinburgh painters, William Nicholson and John Watson (Gordon), were put forward (ERH: GD. 26.13.310/1). At the center of the arrangements was the 8th Earl of Leven, whose father had given Wilkie encouragement in his youth. It further happened that at the beginning of September in the same year, Wilkie was in Edinburgh, principally to gather material for *The Entrance of George IV at Holyrood House* (see cat. no. 32). Leven called on him "some days" before September 15 and "seemed desirous" that Wilkie, "as a native of the county" of Fife, should undertake the portrait, and invited him to Melville House to think over the matter. On September 26 Wilkie had "still to consider the expediency of undertaking the portrait for the County Hall" at Cupar; he added: "If my terms are agreed to, I shall stay a short time to take sittings." He was able to report that on October 5 Leven's committee had "acceded to the terms and the price I proposed, and allowed me my own

time. . . . I accordingly proceed in a few days to [see the Earl of Kellie at] Cambo House, where I expect to be detained a fortnight." It was then agreed that he should prepare for work there on October 11 and start the portrait the following day.

On October 14 Wilkie described his beginnings: "I am painting [Kellie] sitting in his peer's robes, transacting business—with a dog, a fine greyhound, sitting beside him. . . . He is frequently from home on public business. . . . There is one room or gallery [in the house] both lofty and wide [which] . . . I have converted . . . into a painting room, as it has a capital light. . . . When I finish the head and hands, and perhaps the dog, I mean to proceed . . . to London. My new rooms [at 7 Terrace, Kensington] will be extremely useful . . . [the] portrait . . . could not have been stowed any where in the old house." Before October 25, when he expected to leave Cambo, he wrote of his progress: "The portrait . . . so far as I have proceeded, seems to give satisfaction. I have painted in the hands, and a large greyhound. . . . His Lordship is to have his peer's robes on which will give a showy effect to the whole. His head is very venerable, but, from the great change in his features at every moment, and from his habit of stooping, I have had a good deal to do to give it air so as to suit the style of such a picture. The head however looks well."

Wilkie was in London again on 12 November 1824, the portrait having presumably been sent after him. He continued to work on it—as will become clear—despite a serious decline in health. There is a drawing for it, dated "March 1825," which was presumably done early in the month, before Wilkie left for Cheltenham to rest. He was back in London by May 25, but it may be doubted whether his

health allowed him to do any substantial work on the portrait between then and his departure for the Continent about July 24.

On 18 June 1827 Wilkie wrote to Leven from Geneva, asking for a payment in advance of £100. He continued: " . . . meaning next winter to return to London, it is my intention, this picture being already advanced, and more near completion than any of my other works now on hand, to proceed with it, that it may be forthwith brought to a conclusion." The committee in Fife assented. Kellie died on 6 February 1828, while Wilkie was still on the Continent. Shortly before his return to London, which was between 15 and 27 June 1828, Wilkie wrote to Leven with a request "that the peer's robes of the Earl of Kellie might be sent to me at Kensington." On July 5 he wrote of the portrait as "lately finished" (NLS: MS 3812/14–15). On August 21 he suggested having a frame made for it in London, because one "like" that on Raeburn's portrait of the 4th Earl of Hopetoun, already in the County Hall at Cupar, would be cheaper there than in Edinburgh (ERH: GD. 26.13.310/6). Wilkie informed Leven on September 8: "The portrait of the late Earl of Kellie . . . is now finished, and . . . as soon as the frame . . . is completed, which will take a month, it will be all ready to send to Scotland." Wilkie went on to express regret for the delay that his illness had caused to the completion of the portrait, and his desire to send it to Cupar as soon as possible in order "to gratify a wish I understand has been expressed by the Countess of Kellie to see the portrait to 'retrace in it the features of him whom she mourns' [a misquotation from Byron?]," but that it could not be sent before September 20 because of the making of the frame. Finally, in the same letter, he hoped the portrait could be returned to him for exhibition at the Royal Academy in the following spring.

It was evidently in the light of this letter that David Erskine, the brother of the succeeding Earl of Kellie, wrote to Lord Leven on September 25 that "the sight of [the] portrait might be too much for [Lady Kellie's] frail form"; he also wanted to find through Wilkie "a proper person to take a copy of . . . [the] portrait for myself" (ERH: GD. 26.13.310/12). A partial copy was made by an undisclosed hand (private collection), and Wilkie was allowed to keep the original portrait in London until the exhibition was over (ERH: GD. 26.13.310/9). On 10 April 1830 Wilkie received the last of three payments totaling £499—2—0, the odd pounds and shillings being for the frame.

Version

A repetition of the head, signed and dated by Wilkie in 1829, is in Lille (Musée des Beaux-Arts; 30¼ × 25¼ in.).

Comments

Thomas, 9th Earl of Kellie (c. 1745–1828) was about seventy-nine when this portrait was begun. He was at Gothenburg from 1775 as British consul for the western ports of Sweden, and fostered commercial links between the two countries. He succeeded to the title in 1799 and was Lord-Lieutenant of Fife from 1824 until his death.

The portrait was of special importance to Wilkie. He is known to have valued the commission as a tribute from the county in which he was born, and with which he still had family ties. A year earlier, in 1823, he had succeeded Raeburn as the King's Limner for Scotland and he was aware that his portrait of Lord Kellie was to hang in the company of one of Raeburn's last major works, the portrait of

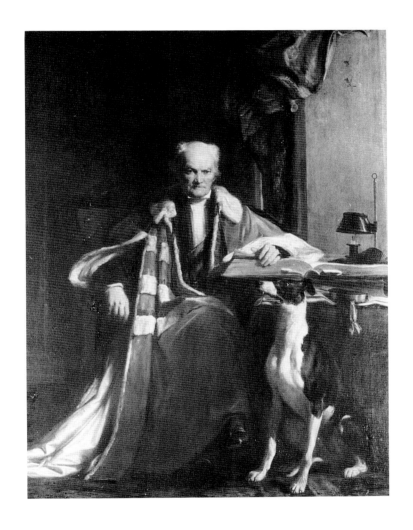

29. Thomas, 9th Earl of Kellie

the previous Lord-Lieutenant of the county, the 4th Earl of Hopetoun—itself commissioned by Kellie. These were considerations of sentiment. Above them was an important practical consideration. Wilkie knew himself to be a novice in large-scale, formal portraiture of the kind that would be expected of him now as the King's Limner. He acknowledged that one of his motives in undertaking this portrait was the "wish to have the practice in painting large, in case I should have anything to paint for the King in the same way." Before going to Cambo, he had evidently discussed this crucial step in his career with the painter William Allan in Edinburgh, to whom he later wrote: "I remember you encouraged me when I went to paint Lord Kellie." The large portrait of George IV in Highland dress (Edinburgh, Palace of Holyrood) was the first royal portrait to devolve from his new office, and Wilkie wrote of it in 1830: "Having tried it in the Lord Kellie, of last year, I have made this [the George IV] the most glazed, and deepest-toned picture I have ever tried, or seen tried, in these times."

The exceptional nature of the present portrait, "the only picture of the kind I have yet painted," was further alluded to by Wilkie on 5 July 1828: "Not to be restrained by size, I have lately finished a whole-length of the Earl of Kellie . . . in which I find that the brushes and quantity and thickness of colour being increased in proportion, the size [makes] no difference. My friends with one voice urge me to hazard this picture at Somerset House [the Royal Academy], unfitted as I know its low tone is to contend with the newness and brightness of modern art" (NLS: MS 3812/24–5). (Wilkie was not alone in commenting at the time on the "brightness of modern art"—meaning the high tonality of pictures in the exhibitions at the Royal Academy.) Robert Ferguson of Raith,

with whom Wilkie stayed briefly after leaving Cambo in 1824, wrote to Lord Leven on 1 October 1828 that Wilkie was "very anxious . . . to have [the portrait] back before the exhibition [at the Royal Academy] as he hopes to rest his reputation as a portrait painter on that picture" (ERH: GD. 26.13.310/7). For more on the importance of this picture, see the essay by Miles above.

Drawing
Edinburgh, National Gallery of Scotland.

30. The Defence of Saragossa

Canvas; 37 × 55½ in. (94 × 141 cm.)
Signed, and dated 1828.
Lent by Her Majesty Queen Elizabeth II.

Exhibited at Yale only.

History and Provenance
Begun in Madrid by 17 March 1828 and unfinished
when Wilkie left there on April 2. This picture and two
others may not have arrived in London before July 18,
but by August 30 they were there and ready to show to
the King. On September 10 Wilkie was commanded to
complete the three pictures (and to paint a fourth
Spanish subject). By 28 January 1829 the pictures were
in their frames and ready to be submitted; on February
12 they were seen and accepted by the King. Wilkie
sent in his bill on March 2. This picture was first at
Carlton House; in 1835 it was at St. James's Palace; and
afterward at Buckingham Palace.

Exhibitions
Royal Academy 1829; Edinburgh, Royal Scottish
Academy, 1840; British Institution 1842; Edinburgh
and London 1958.

Literature
Cunningham, 2:507, 509, 510–11, 3: 4, 5, 10–11, 13,
527; Millar 1969, 139–40.

Formation
Wilkie arrived in Madrid on 9 October 1827. If
the evidence of a drawing (cat. no. 65) is to be
relied upon, he had worked out the essence of
this composition by November 19. However, it
would appear that he did not immediately
transpose it to canvas, for on 17 March 1828
he wrote: "I have finished two Spanish subjects
[*The Spanish Posada* and *The Guerilla's
Departure*, both also to be bought by the King]
and begun a third [evidently this]." Although
on March 31 he wrote that he was
"proceeding" with the picture, on March 13 he
had written: "I pack up my pictures for Bilboa,
to send off [by sea to London] by the end of
this month." In any event he left Madrid for
Seville on April 2 and returned to Madrid for
only a matter of days before leaving again for
London, which he reached in mid-June.

A month later, on 18 July 1828, Wilkie
wrote: "The King, on hearing of my arrival, of
himself sent for me to come to St. James's and
to bring whatever pictures I had made on my
travels. I went and was very graciously received.
Of the pictures I had made in Italy he selected
two for himself [i.e., cat. no. 27 and *The
Roman Princess Washing the Feet of Pilgrims*], and
gave me strict injunctions to come to him with
those I have made in Spain the moment they
should arrive" (NLS: MS 5678/37). On August
30 Wilkie was able to say: "The pictures I
painted at Madrid . . . I . . . am ready to
submit to his Majesty's inspection." On
September 10 he had a message to say that "it
is his Majesty's pleasure I should complete . . .
the . . . Spanish subjects."

The pictures were framed and ready to be
submitted to the King on 28 January 1829
(ML: in MS 308895). On February 12 they
were shown to the King at Windsor. Wilkie
sent a bill of 1,250 guineas for the three
pictures on March 2 (YBL: in Za Irving 29),
but his receipt was for 2,000 guineas. According
to Cunningham, the present picture was put
down at 800 guineas.

Version
A "Sketch for the Maid of Saragossa. Canvas,
11 inches high, 9 wide" was in the Ralph
Fletcher sale on 9 June 1832. What may have
been the same sketch reemerged in 1923, and
was then said to be dated 1827, but nothing
more is known of it.

Comments
During the Spanish rising against the French
occupation the "the Maid of Saragoza, . . . by
her valour elevated herself to the highest rank

of heroines," — in Byron's words. Her exploits were described by Wilkie in his catalogue note at the Royal Academy exhibition: "The defence of Saragossa [June to August 1808]. The heroine, Augustina, is here represented on the battery, in front of the convent of Santa Engratia, where, her husband being slain, she found her way to the station he had occupied, stept over his body, took her place at the gun, and declared she would avenge his death. [This was on 2 July.]

"The principal person engaged in placing the gun is Don Juan Palafox, who commanded during the memorable siege, but who is here represented in the habit of a volunteer. In front of him is the Rev. Father Consolacion, an Augustin Friar, who served with great ability as an engineer, and who, with the crucifix in his hand, is directing at what object the cannon is to be pointed. On the left side of the picture is to be seen Basilico Boggiero, a priest who was tutor to Palafox, celebrated for his share in the defence, and for his cruel fate when he fell into the hands of the enemy. He is writing a despatch to be sent by a carrier pigeon, to inform their distant friends of the unsubdued energies of the place."

Wilkie's express intention in going to Spain was to see the pictures in Madrid and in the Escorial. How he came to seize upon the Spanish struggle for independence as the theme of the pictures he painted there is not exactly known. He had been interested in the news from Spain in 1809, and had known Sir John Carr and might have read his *Travels in Spain in 1809*, which contains a description of the siege — but the episode was anyway much written about. More generally, Spain provided "a patriotic puppet show" for the cause of libertarian and anti-Napoleonic feeling in England, and inspired a plentiful literature in poetry and prose. For two or three years before Wilkie left London, Spanish refugees were a fashionable subject of interest, and a newspaper was provided for them in their own language. A play called *The Siege of Saragossa* was presented at the Coburg Theatre in 1823.

In the painting of this picture, Wilkie saw the subject as "capable of a striking and uncommon effect both of composition and colour," and in the assembling of its elements he enjoyed the advice of Prince Dolgoruki, who was attached to the Russian legation at Madrid. To him Wilkie wrote from London on 27 September 1828: "I find the subject of Saragossa is more liked here than it was at Madrid, and the portrait of the Marshal [Palafox] appears to add greatly to it. It is to you . . . that I owe this additional cause of interest. The name of Palafox is as familiar here as that of Wallace or William Tell, and appears to give an historical importance to the whole series" (YBL: in Za Irving 29). Again to Dolgoruki Wilkie wrote in recollection of their friendship in Madrid: "You will remember . . . [that] you suggested the introduction of Palafox and brought him to my house for that purpose. We had some discussions about the dress of the Marshal; I have made him as a Volunteer dressed in a dishabille well suited to the chief figure of the picture" (YBL: in Za Irving 29). Palafox sat to Wilkie (presumably for drawings only) in this dress "and putting his shoulder to the wheel," although when painting the picture Wilkie tried to restore to him an appropriate youthfulness. (But at about the time of the siege Palafox does not appear to have had a mustache: compare the earlier of Goya's portraits of him.)

Cunningham called the picture "Velasquez revived." Though it is true that in Madrid Wilkie was indeed a determined and patently

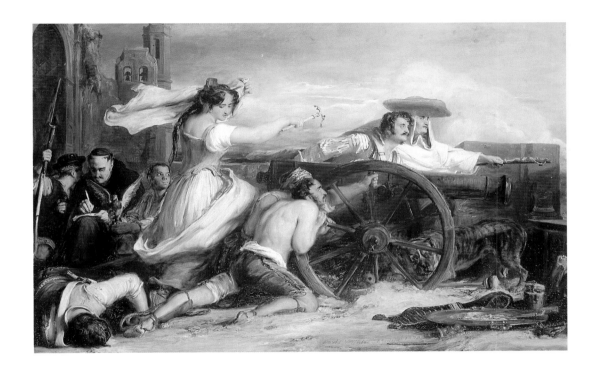

30. The Defence of Saragossa

receptive student of Velázquez and Murillo, he was nevertheless clear on his particular object of emulation when painting the present picture. He wrote to Dolgoruki on 20 April 1829: "I have tried without reserve the deep contrasts we used to admire in Titian—the deep blue sky and draperies against the brown shadows and sun-burnt flesh of a warm climate. The Bacchanal of Titian in the Museo del Prado we so often admired was my chief model" (YBL: in Za Irving 29).

Wilkie's illness put an end to his early, painstaking style, even though latterly, under the influence of Rembrandt in particular, this had become broader as increasingly he moulded his subjects in light. The physically dictated need to seek after larger forms and a more rapid manner of execution had a bearing on the interest he took in the works of the great masters that he saw during his journeys on the Continent. Correggio and Titian, and Velázquez and Murillo, were the decisive exemplars. On the eve of the exhibition of the fruits of his travels at the Royal Academy in 1829, Wilkie wrote: "All [who had seen the pictures in advance] appear to remark a change, and they say for the better, in the colouring and larger style of execution. I wish to prove that I have not seen Italy and Spain for nothing; and it now only remains to prove whether this improvement will be acknowledged in a place where the public eye has been tampered with like our Exhibition."

That by no means everybody saw an improvement is another matter, although in passing it must be allowed that Thackeray was to speak for many contemporaries when he said of Wilkie's later style: "If Sir David has taught us to like good pictures, by painting them formerly, we cannot help criticising if he paints bad ones now." If from 1829 Wilkie was in a manner disadvantaged by his earlier success, and perhaps by an altered public eye, it must also be suggested that in his new pictorial behavior he was braver in contemporary European terms.

Wilkie had last exhibited at the Academy in 1825, and so during his absence abroad he had been out of the public eye for three exhibitions. In 1829 he exhibited eight pictures, for him an unprecedented number. They were: four Italian subjects (including cat. nos. 27 and 28); three Spanish subjects (including the present picture); and a portrait (cat. no. 29) begun in 1824 and to some extent worked over on his return, but anyway marking a substantial development toward the style he discovered while abroad and in itself a challenge to his devotees. Before the exhibition, three of these pictures had been bought privately. The King had bought the remaining five.

This extraordinary act on the part of the King was the subject of notice at the time: "There are some instances of patronage . . . which . . . we are at a loss to decide whether our pleasure is most derived from the character of the patron or the merits of the patronised. This delightful dilemma will be appreciated when we state that his Majesty has purchased all Mr. Wilkie's Spanish pictures . . . besides two of the Italian subjects. . . . The matter must be altogether gratifying to all lovers of our native school" (Literary Gazette 1828, 748).

To Wilkie this royal patronage was invaluable, not only in terms of the undiminished esteem reflected upon him publicly by the highest patron in the land, but also economically. The King paid him 2,400 guineas, and since Wilkie had been under a financial burden when he left England—the result of family affairs—and had since then suffered a further setback with the bankruptcy of his print publisher, this gave him

a foundation for his new start. How the King's generosity came about is not known, but the advice of Sir William Knighton, his physician and confidant, may have played its part. In Wilkie's later career Knighton was to occupy a place corresponding to, although not like, that of Sir George Beaumont in his earlier career.

Drawing
Blackburn, Blackburn Art Gallery (dated 29 November 1827), cat. no. 65.

Engravings
1. Mezzotint by Samuel Cousins, published by F. G. Moon, on 1 May 1837; 48.5 × 71.8 cm. Wilkie collected the picture from St. James's Palace on 3 November 1835 for the purpose of giving it over to the engraver, and showed an impression of the print to the King on 6 February 1837.
2. By W. Greatbach; 17.4 × 25.4 cm. In the *Wilkie Gallery* (1848–50).

31. Washington Irving in the Archives of Seville

Canvas; 48¼ × 48¼ in. (122.5 × 122.5 cm.)
Lent by the Leicestershire Museums and Art Galleries, Leicester.

History and Provenance

Painted in 1828–29, probably as a commission from Sir William Knighton, who died in 1836. The picture then passed to his son, Sir W. W. Knighton, and it was in his sale on 23 May 1885, bought by McLean, £75—12—0; W. H. Matthews 1888, McLean again, and bought from him by the Museum in 1890.

Literature

Myers 1958, 463.

Formation

Wilkie arrived in Seville from Madrid on 6 April 1828. He went there to further his knowledge of Murillo, but also to meet again his companion in Madrid of the previous winter, Washington Irving. Irving's reason for going to Seville was to search for material for a revised edition of his *Life and Voyages of Christopher Columbus*, and for a new work, the *Chronicle of the Conquest of Granada*. The two men met in Seville on April 14, and Wilkie left for Madrid and London on April 24.

During those ten days together they explored churches, monasteries, and private collections. Writing from London on 30 January 1829, Wilkie told Irving: "One day at Seville, when you were examining an old book which a monk was showing you in an old library, I remarked the striking effect your two figures made together. On my way to Madrid I made a drawing of the effect in colours, which is here thought so strong and simple that I have been induced to begin a picture of it on a half-length canvas. I call it the Archives of Seville. You are looking down upon the book in this position [here Wilkie made a small drawing of Irving's head in his letter]. If you were here I would take some pains to make it like—the drawing at Mr. Murray's will scarcely serve me. Could you get a drawing made in this view [i.e., with Irving's head at the same angle as in Wilkie's small drawing] in a letter or, what would be better still, are you likely to be in London within a reasonable time yourself?" The "drawing at Mr. Murray's" was a portrait of Irving in watercolor that Wilkie dated at Seville on 23 April 1828 (private collection). It was bought from Wilkie by John Murray, Irving's London publisher, with the intention that it should be engraved in some volume of his works. Wilkie did not wait until Irving got to London, which was in September 1829. Irving sent a likeness of himself by the Sevillian painter J. M. Escasena.

Wilkie wrote of having been "induced to begin a picture" on the basis of the drawing he had made on the way from Seville to Madrid. He must therefore have let the drawing be seen by somebody. Among the drawings by Wilkie that belonged to Knighton was one titled "Washington Irving at the Convent" (since lost). Knighton had been in Seville as physician to the Duke of Wellington, and he was, incidentally, a professed admirer of Murillo. Given the relationship between Wilkie and Knighton, and knowing Knighton's involvement in the King's acquisition of Wilkie's Spanish pictures (see cat. no. 30), it seems very likely that Wilkie had shown the drawings he had made in Spain to the man who thus had two directions of interest in commissioning a Spanish subject for himself.

Comments

Washington Irving (1783–1859), if nowadays largely unread, needs no introduction as the author of the story of Rip Van Winkle. He established his reputation in London, where he arrived from America in 1815. Wilkie had met him by 1823, and they met again in the Louvre

31. Washington Irving in the Archives of Seville

in 1825. They had mutual acquaintances in Andrew Wilson, the landscape painter; in the American painter G. S. Newton; and, from Irving's otherwise essentially literary circle, in John Murray and Walter Scott. That they were to meet again in Madrid was by chance, but it was there that they discovered their mutual congeniality.

The title given to the present picture when it was sold in 1885, hence probably the title by which Knighton knew it, was "Washington Irving, in the Convent at La Rabida, searching the archives for the life of Columbus." The reference to La Rabida is, however, a mistake —corrected in Wilkie's letter of 1829. Wilkie was anyway never at La Rabida. (For more on this, see Miles 1969(1).) Nevertheless the mistake serves to link this picture with cat. no. 36.

Sir William Knighton (1776–1836) was physician and man of business to the King while Prince Regent. When the Prince succeeded to the throne, Knighton was entrusted with the handling of his earlier debts. He was appointed private secretary to the King and keeper of the privy purse in 1822.

Knighton's son became Wilkie's pupil, and between them they had in their collection fifteen paintings by Wilkie (including cat. nos. 3, 26, 35) and numerous drawings.

Drawing
New York, New York Public Library (1829).

32. The Entrance of George IV at Holyrood House

Wood; 20 × 34 in. (50.8 × 86.4 cm.)
Signed, and dated 1828.
Lent by the Scottish National Portrait Gallery.

History and Provenance
Seemingly painted in 1823/24. Sir Willoughby Gordon
acquired the picture from Wilkie, possibly in or soon
after 1828 and certainly by 1839. It passed to his son,
Sir H. P. Gordon, and from him to his daughter, Mary,
the wife of General R. W. D. Leith, and next to their
son A. H. Leith, Lord Burgh; his sale, 9 July 1926,
bought by Mitchell, £94—10—0; with Simpson,
Glasgow, and bought from him by the Gallery in 1927.

Exhibitions
Edinburgh and London 1958; Edinburgh 1975.

Literature
Burnet 1848, 119; Cunningham, 2:104, 105–6, 3:9;
Errington 1975, 15. Gash 1961, 276–77; Haydon
1960–63, 3:383.

Formation
This is an earlier version, at a little under
half-size, of the picture of the same subject that
was exhibited at the Royal Academy in 1830
(Royal Collection; see fig. 20). The event
represented was seen by Wilkie in Edinburgh in
August 1822 (see Comments, below), but it
was in London and perhaps not before July
1823 that he chose this particular event as the
subject for a picture from among others he had
witnessed during the royal progress.

The choice seems to have been precipitated
by his appointment to the office of King's
Limner for Scotland. Giving news of this in a
letter of 26 July 1823, he added: "My vague
ideas . . . already so often discussed, of pictur-
ing some scene of the royal visit to . . . Scot-
land, have obtained a new force from the mark
of his Majesty's favour, and I am still engaged
with the different sketches [derived from the
pomp he had seen in Edinburgh] in hopes that
something may grow out of it consistent with

the ancient designation of my office." By
"sketches" Wilkie here meant almost certainly
drawings.

To paint a history picture that centered upon
the King meant getting his likeness. Wilkie was
already engaged for a portrait of George IV in
Highland dress (Royal Collection). The Duke
of York (see cat. no. 24) opened the way and
thus, on 26 July 1823, Wilkie was told that
"his Majesty has been pleased to say that he
will see you and inspect your sketch when he
comes to London next week" (NLS: MS
9835/169–70). Unfortunately it is not clear
from this whether the reference was to the
(lost) sketch for the portrait in Highland dress,
or to a sketch for the history picture. The latter
is possible; indeed Cunningham would have it
that "the middle of the year 1823 found Wilkie
with . . . The King's Visit . . . on his easel." It
is as possible that the sketch referred to was the
beginning of the present picture. Here, and in
relation to what follows, it may be added that
there is no evidence for there having been any
sketch of the whole composition other than the
present picture—an absence that tends to
support the identification of the present picture
with the "sketch" referred to on July 26.

Wilkie wrote on 31 October 1823: "I am
now beginning a picture, six feet long, of the
King entering Holyrood House [i.e., that now
in the Royal Collection]. The sketch I had the
pleasure of showing you I have since
been . . . to show to his Majesty . . . and the
King . . . gave me his commands to proceed,
and proposed to sit for his portrait when I have
got all the figures laid in, and his own figure
sufficiently advanced for that purpose. I have
therefore begun the picture somewhat larger
than the Duke of Wellington's [cat. no. 23],
and am in hopes, though it is still an
experiment, that with so many objects as it

contains . . . and with the interest of the portraits in action, and the associations connected with the scene itself, that I may be able to make it an effective subject." By 19 January 1824, Wilkie seems to have had the figures in what was presumably the large picture laid in and that of the King sufficiently advanced for him to be able to ask the King for sittings (NLS: MS 9835/178–9). Haydon, ever happy to record another's catastrophe, took up the story in his diary for February 7: "[Wilkie] had begun the King's entrance to Holyrood House, the King was to sit, and sent for Wilkie to come to Windsor. Wilkie went down and was introduced with his sketch by [Sir William] Knighton and [Sir Charles] Long. The King objected to the attitude of the legs, and said, 'You wish me to sit? I'll sit now.' Wilkie replied with his usual simplicity of mind, 'I have no [painting] materials, please your Majesty.'" It is likely that the sketch that Wilkie had referred to in October 1823 was the same as the one he took to Windsor Castle the following February, and that again it may have been the present picture.

If this was so, the present picture should not be regarded as a sketch in the usual sense of being a relatively rapid and relatively small summary of the content and effect of a larger composition to come. Rather, it would seem to have been for Wilkie an uncharacteristically substantial (though still portable) working model—an intermediary between his own uncertainties and the criticisms of the King, on the one hand, and the definitive work on the other. There are differences between the two: the final version, apart from being larger, was made more spacious by a greater completeness and a greater control in the handling of the light, an expansion and reproportioning of the architectural background, and an alteration in

the scale and position of the King and of the horse on the right; furthermore, there are improving shifts in action and interval —exemplified in the several children on the left; the girl between the mounted Sir Alexander Keith and the kneeling Duke of Hamilton; of the Duke himself; and the dog and page between the King and the horse on the right. (For the portrait of Sir Walter Scott in the final version, and its absence in the present version, see cat. no. 26.)

Yet all that is essential in the large final version is present in this one, which, although clearly not a fully finished picture, is nevertheless careful in execution. The present picture has the air of a final draft, incorporating amendments made in earlier drawings or oil sketches. After it had served its practical purpose, it should have been quite easy to put such a working model into a presentable state and so make it fit for sale—a transformation and a transaction ratified by the signature and the date 1828.

In the circumstances it seems unlikely that the present composition could have been assembled, with its ingredients close to finality, much before August 1823. However, there is evidence from a recent patron, Robert Peel, which suggests that it was substantially worked out by the twenty-ninth of that month: "[Wilkie] has quite failed in his likeness of the King and will never succeed. . . . He has introduced several intended likenesses into the sketch but I defy you to guess one of them."

By late July 1824 Wilkie had had sittings from the King and the Duke of Argyll (HL: MS 1066), and both of them here look rather more as they do in the final version than can be said of the other principal protagonists—for whose heads Wilkie had not by then made studies. Drawings, including that for the Earl of Morton

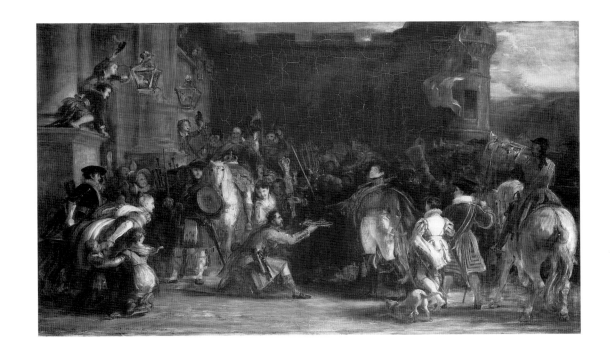

32. The Entrance of George IV at Holyrood House

(cat. no. 60), followed when Wilkie was in Edinburgh in September that year. The absence from the present version of the head of Sir Walter Scott, who sat to Wilkie in November 1824, might be further evidence that this version of the composition had reached a fairly settled form by that date.

We have seen that Wilkie had started work on the final version, "six feet long," by 31 October 1823. The presumption must be that work on both versions went on more or less simultaneously thereafter, although it is to be doubted at equal speed. Burnet remembered that when Wilkie left for the Continent in July 1825 "all the centre figures were completely finished." This probably referred to the final version. Wilkie returned to London in mid-June 1828. On December 29 he wrote to say that he expected to complete some of his Spanish pictures for the King (see cat. no. 30) by mid-January: "I shall then be ready to recommence the Entry to Holyrood House. I think I am able [i.e., in good enough health] for this, it being far towards completion." This tends to strengthen the sense that in 1825 it was the final version which was then well on its way—and that toward the end of 1828 the present version was becoming redundant to its original purpose. A further hint of a picture left in a state of a forwardness in 1825 is to be found in Haydon's diary for 30 July 1829: "Called on Wilkie, who was finishing the Holyrood House picture [although in fact it was not to be ready for the King until February 1830]. . . . He is finishing it . . . [at a time] when he has entirely changed his style. The Duke of Argyll, the King's head, the man on horseback with the crown [Sir Alexander Keith], are in his first style; the trumpeters, the dress of the Duke of Hamilton, the woman &c. are in his last; and the mixture is very curious."

The description is not readily applicable to the present version, which again suggests that by this date it had been finished.

Versions
Two sketches survive which define arrangements for the figures in separate parts of the design (Manchester, City Art Gallery; and private collection). At least two other sketches of the sort have been lost.

Comments
The visit of George IV to his Scottish capital in Edinburgh from 14 to 29 August 1822 was an event of some symbolic and political importance, being the first by a monarch of the United Kingdom. It was with a keen sense of interest in the event that Wilkie traveled to Scotland that autumn. The pageantry attached to the royal visit, much of it devised by Sir Walter Scott—who also saw to it that Wilkie was able to observe the principal events—included on the afternoon of August 15 the presentation to the King of the keys of Holyrood House. This piece of ceremonial was more than one of welcome; it signified the King's formal admission to his official residence in his northern kingdom. Such is the subject of the picture.

When the final version of the picture came to be exhibited at the Royal Academy in 1830, the catalogue contained—after four dimpling lines of occasional verse by Scott—this description by Wilkie of the protagonists and their actions: "In the principal station . . . is represented the King [who wears the Star of the Garter as well as that of the Thistle], accompanied by a page and the exon of [i.e., the junior officer acting for] the yeoman of the guard, with horsemen behind, announcing by sound of trumpet, the arrival of the royal visitor

to the palace of his ancestors [*sic*]. In front of his Majesty, the Duke of Hamilton, first peer of Scotland, in the plaid of the Earls of Arran, is presenting the keys of the palace, of which he is hereditary keeper. On the right of the King is the Duke of Montrose, lord chamberlain, pointing towards the entrance of the palace, where is stationed the Duke of Argyle, in his family tartan, as hereditary keeper of the household. Behind him is the crown of Robert the Bruce, supported [on horseback] by Sir Alexander Keith, hereditary knight-marshal, attended by his esquires [Lord Francis Leveson-Gower, representing the Countess of Sutherland, and the Earl of Morton] with [respectively] the sceptre and the sword of state. Near him is carried [on foot] the mace of the exchequer, anciently the chancellor's mace, when Scotland was a separate kingdom. On the left of the picture, in the dress of the royal archers, who served as the King's bodyguard, is [their captain-general] the late Earl of Hopetoun; and close to him [immediately to his right in the final version, but missing here], in the character of historian or bard, is Sir Walter Scott. These are accompanied by a varied crowd, among whom are some females and children, pressing forward with eagerness to see and to welcome their Sovereign upon this joyous and memorable occasion."

Wilkie wrote of the event at the time: "The day was exceedingly fine, and the . . . [royal] procession as it passed [through Edinburgh] . . . appeared amazingly striking. I saw the King alight [at Holyrood] . . . dressed in a Field Marshal's uniform, with a green ribbon of the Order of the Thistle. He was received by the Dukes of Hamilton and Montrose, and . . . [by] others, who were at the door to meet him; but upon the whole this point [in the proceedings], which was capable of producing great effect, was not arranged with sufficient regard to the importance of it."

It is not to be supposed that in painting this scene Wilkie presents us with a documentary account of it. The actors were there indeed, and Scott was their stage director, but Wilkie has remanaged the subject—corrected it to give more regard to its importance. In doing so, as an artist, he turned away from actuality to model the subject in terms of art.

What models he considered we do not know, yet it is difficult to think that he was not mindful of a great picture he had admired in Paris in 1814, Rubens's *Coronation of Marie de' Medici*—a picture of complex ceremony of which he wrote that it was "painted with such a relish for harmony as never was surpassed." To give harmony to his subject was indeed the essence of Wilkie's problem in transmuting the transitory reality of that day in Edinburgh into an image of lasting import. Whether successful in this or not, he showed a closer understanding of Rubens than William Hilton, the memory of whose *Entry of the Duke Wellington into Madrid*, exhibited in 1817, may have urged him at least to do better.

Drawings
Oxford, Ashmolean Museum; The Binns (National Trust for Scotland); Windsor, Royal Collection; private collection.

33. The Duke of Wellington as Constable of the Tower: Sketch

Wood; 24 × 18½ in. (61 × 47 cm.)
Lent by the Mellon Bank, Pittsburgh.

History and Provenance
Painted in 1832. The picture was in Wilkie's sale, 30 April 1842, bought by Hogarth, £17—6—6, perhaps for its first owner, Sir Henry Russell of Swallowfield (who died in 1852); by descent to Sir Arthur Russell (who died in 1964); sold by "A Lady," Glasgow, 2 April 1969, bought by McNicol, £1,995; with Spink & Son in 1970; private collection; with Spink & Son in 1977; with the Fine Art Society in 1978–80; with Noortman & Brod in 1983. Bought by the present owner in 1983.

Formation
This is one of three oil sketches preliminary to a life-size portrait of the Duke, which was painted for the Merchant Taylors' Company in the City of London (to whom it still belongs) and was exhibited at the Royal Academy in 1834. The finished portrait was painted from sittings given at the end of September and beginning of November 1832, and in May and September 1833. The sketches presumably belong before the first of these sittings.

The earliest sketch (private collection), a desultory thing, shows the Duke lounging against his horse in an unbecoming manner. In the present sketch—probably the second in sequence— the connection between the sitter and his horse has been rectified, and both of them made more heroic in appearance by a lowering of the perspective. The indefinite brush-marks beside the horse's withers suggest that Wilkie was looking for a way of breaking the rather static mass of the composition by introducing a source of energy at the left-hand edge of the picture. This was given form in the third sketch (private collection) through the introduction of the figures of two grooms (only the one standing at the left survives in the finished portrait). Among the differences between the present and the third sketch are a change in the relationship of the figures to the rectangle of the picture; a further lowering of the perspective; the transference of the plumed field marshal's hat from the Duke's right to his left hand, and with it alterations in the Duke's dress—all of which are carried into the finished portrait.

Comments
Arthur Wellesley, 1st Duke of Wellington (1769–1852), as the victor in the Peninsula and finally at Waterloo, was the hero of his age. When his active military career ended with the Congress of Aix-la-Chapelle in 1818, he remained in the public eye as a politician. Wellington had some literary and musical tastes, and he developed, apparently while in the Peninsula, a true regard for the visual arts. Europe must remain indebted to him for his scrupulous enlightenment in the matter of the return to their proper places of the works of art looted by the Napoleonic armies. His own collection of pictures began with the famous gifts to him from Spain in 1812 and 1816. To these he added a number of mainly Dutch pictures, bought notably in 1817 and 1818. The Duke was also a patron of contemporary British artists, collecting portraits and genre subjects especially.

Wellington's earliest significant act in this particular direction was the commissioning of the *Chelsea Pensioners* (cat. no. 23) in 1816. Wilkie was, indeed, the artist with whom Wellington had the most enduring relationship. In 1831 he bought a replica of Wilkie's portrait of George IV; in 1833 William IV presented the Duke with cat. no. 34. After the sittings for the Merchant Taylors' portrait, Wilkie had further sittings from the Duke in 1833 for the full-length at Hatfield House (Royal Academy

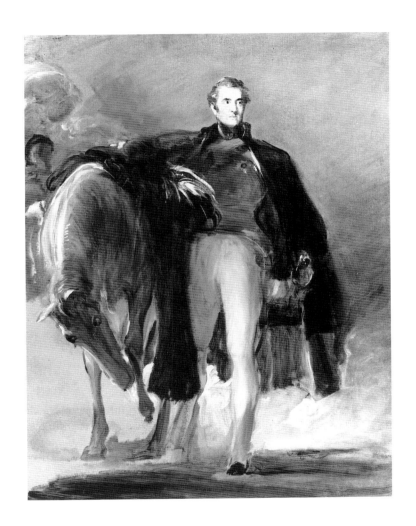

33. The Duke of Wellington as Constable of the Tower: Sketch

227

1835), and in 1835 for a small history picture—the *Duke of Wellington Writing a Despatch* (Aberdeen). Likewise in the earlier 1830s, there was a private order from the Duke to Wilkie to arrange tableaux vivants at Hatfield; the Duke also made a public acknowledgment of their relationship, which came to be reflected in cat. no. 44. For more on Wellington as a collector and patron, see Kauffmann 1982.

Wellington was gazetted Constable of the Tower of London in 1826. The ancient office brought with it command of the militia of the Tower division of Middlesex, but the practical truth of the appointment was explained in 1835 by an American visitor to London, George Ticknor: "It is one of the examples of the pleasant abuses with which England abounds, that the Duke of Wellington is Governor of the Tower, with a good salary, and knows nothing about it; that Sir Francis Doyle is his lieutenant, with another large salary, and resides there only two months in the year; and that somebody else, with a third salary, is the really efficient and responsible person."

Wellington's relationship to the Merchant Taylors' Company went back to 1813 when, after his victory at Vittoria, he was offered the Freedom of the Company—"as a Testimony of the Court's opinion of his unparalleled Merits as a General and a Soldier." The Court of the Company decided that they should have a portrait of the Duke in 1831, the choice of painter being left to his pleasure—as was, doubtless, the guise in which he chose to figure in the portrait.

In composing the portrait, Wilkie may have had an eye on W. W. Barney's mezzotint after the portrait by Hoppner, exhibited at the Royal Academy in 1806, of Wellington beside a horse held by an Indian servant.

34. William IV

Canvas; 105 × 69 in. (267 × 173 cm.)
Signed, and dated 1833.
Lent by the Victoria and Albert Museum, Apsley House.

History and Provenance
Painted in 1832–33. Given to the Duke of Wellington by the sitter in 1833, and included in the gift to the nation of Apsley House by the 7th Duke in 1947.

Exhibitions
Royal Academy 1833; British Institution 1842; Edinburgh and London 1958.

Literature
Cunningham, 3:529.

Formation
William IV came to the throne in June 1830. Wilkie's first portrait of him was the full-length in Garter robes exhibited at the Royal Academy in 1832, and destined for the Waterloo Chamber at Windsor Castle (where it still is). The King gave his first sitting for the Windsor portrait on 7 November 1831, and from that portrait were derived Wilkie's other portraits of William— including this.

In the present portrait the head, at least, was probably laid in on the basis of the Windsor portrait in or soon after August 1832. On December 24 Wilkie was at Brighton for the principal purpose of painting Queen Adelaide; he wrote: "I have also brought the two portraits of the King, and have submitted them for his Majesty's . . . instructions" (ML: MS 308895). The two portraits were the present one, and another (destroyed in 1877) for the Scottish Hospital, a charity in London of which the King was President.

Wilkie was at Brighton again on 2 February 1833, when he wrote: "The King has been pleased to sit the whole of last week, and the two days before, for the Scottish Hospital picture and for that for the Duke of Wellington.

This last is thought a *good likeness*, and his Majesty appears interested about it, [and] is to bring the uniform from town to put on [so] that I may paint from it on his return. This last is a strong and highly finished head. It is expected to be in the Exhibition" (ML: MS 308895). After the portrait was exhibited at the Royal Academy, Wilkie was instructed to deliver it to the Duke, "as a present from His Majesty." This was done on August 1 or 2, and the Duke left it to William Seguier "to fix upon a place for it" at Apsley House. Wilkie was paid 300 guineas.

Comments
The King is in the uniform of Colonel-in-Chief of the Grenadier Guards, with the belt and hat of a field marshal. He also wears the ribbon and star of the Order of the Garter, the badge of the Order of the Bath, and the star of the Grand Cross of the same Order. The Imperial Crown is on the left. Of Wilkie's ten or more portraits of the King (not all are extant), this is the only one in military dress—properly to its destination.

Drawings
Private collections (in one of them the King is seated).

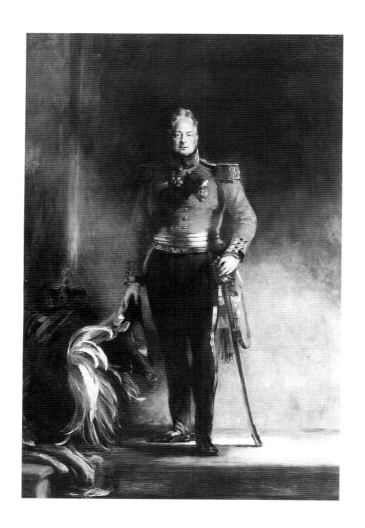

34. William IV

35. The Spanish Mother

Canvas; 39 × 50 in. (99 × 127 cm.)
Lent from a private collection.

History and Provenance
Painted in 1833–34 for Sir William Knighton. The picture passed on his death to his son, Sir W. W. Knighton, in whose sale it was on 23 May 1885, bought by McLean, £121—16—0; John Corbett; his sale, 18 June 1904, bought by Shepherd, £105; anonymous sale, 28 June 1912, bought by Amor, £588; Robert Fleming, who died in 1933, and from him by descent.

Exhibition
Royal Academy 1834.

Literature
Cunningham, 3:78.

Formation
Wilkie wrote to Sir William Knighton on 2 June 1833: "Considering your . . . proposition in regard to my wish to paint a subject of a Mother and Child &c. [for the "&c." see under Comments, below], which the absence of subjects of the kind in our Exhibition [at the Royal Academy] seems to make desirable, I cannot withold assuring you . . . how strongly I am disposed, if it can be made to chime in immediate work, to try to get such a picture [ready] for [the Exhibition] next year" (ML: in MS 308895). On December 29 Wilkie wrote again to Knighton: "For the present I proceed with the subject you have . . . commanded. . . . [I] have got the panel, and the subject looks well" (ML: in MS 308895). (The reference to a panel might suggest that Wilkie at first made a small sketch of the subject, but there is no other clue to this.) The picture was completed by 21 March 1834. After the exhibition the painting was returned to Wilkie so that he could arrange an engraving from it (see under Engraving, below).

Comments
It has been suggested under cat. no. 31 that Wilkie, on his return from Spain, may have shown the drawings he had made there to Knighton who commissioned that painting to be made from one of them. The present picture may represent another instance of the procedure.

In the Knighton sale there was a drawing described as "The Spanish Mother—dated 1828." This was almost certainly the drawing inscribed "Seville April—1828," now in the Ashmolean Museum at Oxford. This contains a mother and child disposed as in the present picture, but the drawing is fuller in that it shows a youth sitting on their right, and the group is placed under the shadow of a cannon; further to the right there stands a military officer. When Wilkie wrote on 2 June 1833 (see under Formation, above) of "a Mother and Child &c.," by the "&c." he may well have been referring to the other figures, and the cannon, in the drawing. It is even possible that the first intention had been to develop the whole of the composition presented in the drawing, and that it was later decided that the mother and child constituted a sufficient subject in themselves.

Whatever the truth of the matter of the composition, when it came to thinking of the exhibition of the present picture Wilkie evidently felt that the subject would need some gloss in the exhibition catalogue. He wrote to Knighton on 2 April 1834: "I have not yet found a title either [in] Spanish or English to the picture of the Lady and Child, though some very clever verses have been sent me, giving a rather animated description of it" (ML: in MS 308895). These were probably the lines by an unidentified hand that eventually appeared in the catalogue:

"Come, thou child of life and light,
Come with kisses, come with smiles,
With thy sallies of delight,
Freaks and fantasies and wiles—
Come, in pretty sportive fear,
Hide thy face and nestle here."

But Wilkie must have had earlier thoughts on an epigraph for the picture, and had been asking for help. There are hints that finding one had even become an amusement in polite drawing rooms. T. F. Dibdin, the bibliographer, wrote to Wilkie saying he was going to bring "the tenth Muse" to see the picture, while Maria Callcott, the author, and wife of the landscape painter, sent him a free translation of lines that are identifiable as from, or derived from, stanza 20 of Garcilaso de la Vega's *Egloga primera* (written in the 1530s).

Knighton's commission of the picture seems to have had an element of the provisional about it, for on 21 March 1834 Wilkie wrote to him in terms that suggest that Knighton might have had a picture of Columbus (cat. no. 36) instead.

Engraving
By Abraham Raimbach, published by F. G. Moon, 30 June 1836, and dedicated to Sir William Knighton by Wilkie and Raimbach; 30.3 × 38.1 cm. Wilkie was in touch with Raimbach over the question of making the engraving on 2 August 1834. On 13 April 1835 he observed to Raimbach: "The etching is . . . much improved by what you have done. . . . I hope you will proceed with the engraving. In this plate let the first thing be to give as much beauty or handsomeness to the woman and child as possible. . . . As female beauty is helped by colour, and where colour cannot be given, a greater degree of softness and delicacy should be attempted than there is in the picture to make a compensation." The "last touches" were given to the plate by 15 March 1836, and Moon paid 800 guineas for the plate and the copyright, of which 700 guineas went to Raimbach.

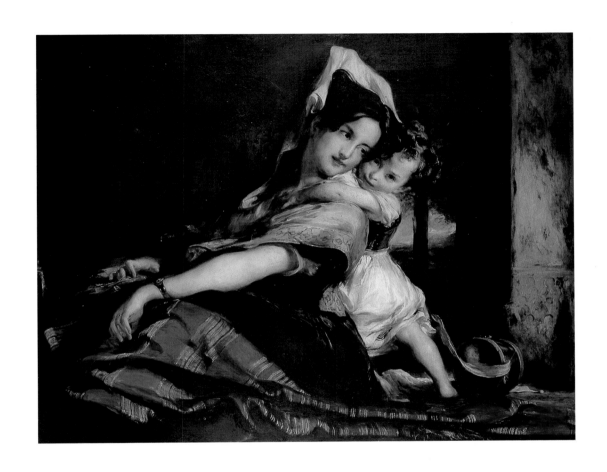

35. The Spanish Mother

36. Columbus in the Convent of La Rábida

Canvas; 58½ × 74 in. (148.6 × 188.3 cm.)
Lent by the North Carolina Museum of Art.

History and Provenance
For the commissioning of the picture see under
Formation, below. The painting was begun after 5 April
1834. It was in train by 10 July 1834, and was still so
on December 15. It may have been finished by 1
January 1835. Robert Holford became its first owner.
He died in 1838, and the picture passed to his nephew,
R. S. Holford, who died in 1892. His son, Sir George
Holford, sold the picture to Agnew & Son in 1895, and
they sold it that year to A. J. Forbes-Leith. It was later
with Wallis & Sons. On 10 May 1907 it was in an
anonymous sale, bought by White, £315, and was with
Wallis & Sons again in 1911. From London it passed to
New York, where it was in the Blakeslee Gallery sale of
21 April 1915, and was bought by the Minneapolis
Institute of Arts. Sold by the Institute to Victor Spark,
and given to the Museum by Hirschl & Adler in 1959.

Exhibitions
Royal Academy 1835; British Institution 1842.

Literature
Constable 1962–8, 3:121, 5:43, 1975:317; Cunning-
ham, 3:77–78, 89–90, 93; Haydon 1960–63, 4:216;
Leslie 1951, 238; Robinson 1869, 3:42.

Formation
The history of the commisssioning of this
picture is not straightforward. Cunningham was
present when his friend William Ritchie, the
founder of the newspaper *The Scotsman*, visited
Wilkie "soon after his return from Spain,"
which was in mid-June 1828. Cunningham
continues: "[Wilkie] was speaking of his
journey and showing us his sketches, [and] I
was struck with the historic truth and character
of this composition, and advised Wilkie to
expand the subject to the size of life: Ritchie
took the artist aside and whispered, 'Do what
Allan says; name your price, and I will buy the
picture.' My friend did not live . . . to see his
commission complete." Ritchie died in 1831.

The drawing he saw was almost certainly the
one now in the Leicester Museum, which is
dated as from Madrid, 13 October 1827.

The picture is next heard of in a letter from
Wilkie to Sir William Knighton, written on 21
March 1834: "Mr. Holford of the Isle of Wight
asked me last autumn to paint him Columbus."
Wilkie had been staying on the Isle of Wight
with Sir Willoughby Gordon (see cat. no. 24)
from about 23–29 September 1833, at which
time Holford must have spoken. Wilkie's letter
goes on to report the conversation: "On answer-
ing [I said] that I was not at liberty to engage
for this subject (you, sir, having spoken to me
about painting this the size I wished). He then
asked me if I would paint him the Pope and
Napoleon [Dublin, National Gallery of Ire-
land], that I might paint either the size of life,
but that whichever I painted must, on account
of his advanced period of life, be begun
immediately. . . . I told him my engagements,
if immediately, would not permit me, and so
the matter dropped. Now, dear sir, as you did
me the great favour some time back to speak of
the Columbus as one you might employ me
upon—the size of life—this matter must
entirely rest with you . . . and as you subse-
quently to speaking about the Columbus, gave
me the very handsome order for the Mother
and Child [cat. no. 35], already done, and may
perhaps in that have answered the purpose you
intended by the Columbus, I make bold to
ascertain your pleasure upon the subject; and in
case you should not particularly want the
Columbus, I might offer it to Mr. Holford."

Knighton ceded to Holford by return of post.
On 5 April 1834 Wilkie wrote to Gordon: "Mr.
Holford has, since I wrote to him, come to
town almost on purpose to give me the order
for the picture, which he has finally determined
to be the Columbus, and has insisted on paying

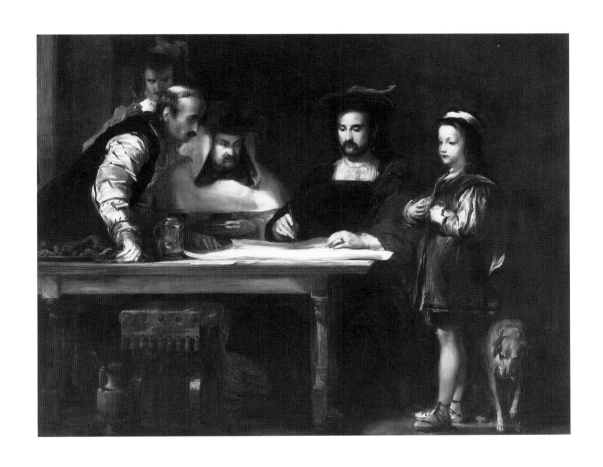

36. **Columbus in the Convent of La Rábida**

half the price, £250, before beginning it—expressing himself gratified by an arrangement begun under your friendly auspices" (NLS: in Acc. 7901). As a result of this, Wilkie was able to refuse on November 17 an offer for the picture made by Robert Vernon, through the painter George Jones.

Henry Crabb Robinson, the diarist, noted on July 10 that he had seen the picture— "Only the philosopher's head and the figure of an interesting youth were finished. It is a promising beginning"—and Haydon found Wilkie working on it on August 10. Constable sat to him on December 15 (see under Comments, below), and wrote on December 18 in terms that suggest that Wilkie was then still at work. On 1 January 1835, Wilkie reported that Holford "has seen and approves . . . of the picture, and leaves me to order a frame." It may not then have been quite finished, however. On February 13 C. R. Leslie wrote: "I went not long ago to Wilkie's to see the picture he is painting. It is Columbus" (MS: Private).

Comments

The subject of the picture—one that was of much interest to painters and writers in the earlier nineteenth century—was more particularly described by Wilkie in the catalogue entry for the exhibition at the Royal Academy:

"Christopher Columbus explaining the project of his intended voyage for the discovery of the New World, in the convent of La Rabida.

"'A stranger, travelling on foot, accompanied by a young boy, stopped one day at the gate of a convent of Franciscan friars, dedicated to Santa Maria de Rabida, and asked of the porter a little bread and water for his child; while receiving this humble refreshment, the guardian of the convent, Friar Juan Perez de Marchena, happening to pass by, was struck by the appearance of the stranger, and observing from his air and accent that he was a foreigner, entered into convensation with him. That stranger was Columbus.'

"The conference which followed, remarkable for opening a brighter prospect in the fortunes of Columbus, forms the subject of the picture, in which he is represented seated at the convent table, with the prior on his right, to whom he is explaining on a chart the theory upon which his long contemplated discovery is founded. At his left is his son Diego, with a small Italian greyhound at his feet, supposed to have accompanied them on their voyage from Genoa.

"At the other side of the picture, resting on the table, is the physician of Palos, Garcia Fernandez, who from scientific knowledge, approved of the enterprise, and whose testimony has recorded this event. Behind him, with the telescope in his hand, is Martin Alonzo Pinzon, one of the most intelligent sea-captains of his day, who, though tarnished in his fame by subsequent desertion, concurred in the practicability of his plans, assisted in the outfit of the expedition, and sailed with Columbus. With this support in confirmation of his own judgment, the prior Juan Perez became the friend and benefactor of Columbus, received his son into the convent to be educated, and furnished to himself a recommendation to Fernando de Talavera, confessor to the Queen, which eventually obtained for him the assistance of the Court in his adventure, and to Spain the credit of his great discovery.

"The above particulars were first made known to the English reader in the recent Life of Columbus, by Mr. Washington Irving."

Wilkie acknowledged that he himself, as much as the English reader at large, owed the

source of his subject to Irving. In a letter of 5 November 1834 to Prince Dolgoruki in Madrid he wrote: "[The] subject . . . which I owe to Mr. Washington Irving . . . he gave me almost on the same day I first made your acquaintance on my arrival in Madrid" (YBL: in Za Irving 29). Leslie, in his biography of Constable, said that Constable sat for the head of Garcia Fernandez. This is borne out by a letter from Constable to Leslie, written on 15 December 1834, in which he says that he will "be all this day with Wilkie." This was evidently at a late stage in the painting of the picture. The dog may have been Lady Blessington's Italian greyhound. In 1842 it was observed—surely correctly—that the composition is "an adaptation from a Titian in the Louvre" (*Fraser's Magazine* 1842, 270). The Titian in question was the *Supper at Emmaus.*

By the beginning of 1835, Wilkie was thinking of a companion picture on the subject of Columbus: "The only one I can think of from the same history is that of Queen Isabella . . . offering to pledge her jewels for the outfit of Columbus, but I fear there is something wanting to make it effective." His thoughts in this direction were given strength when he heard from Irving in February 1836 that a friend of his, Henry Cary of New York, had seen the present picture in London, and was prepared to offer Wilkie £500 to make a copy of it for him. To this Wilkie replied that he would instead paint an original composition, without specifying the incident in the life of Columbus he intended to depict. He ordered a canvas for it, measuring 6 feet 6 by 4 feet 6, but it came to nothing. The untouched canvas was used in 1837 for *The First Council of Queen Victoria* (Royal Collection).

Of Robert Holford very little can be said. He bought a "marine villa" near to Gordon's on the Isle of Wight sometime between 1808 and 1813. Writing of him in 1834, Wilkie said that he probably chose the present picture because, "possessing a yacht and being himself a navigator," its subject thus suited him. He seems to have had no occupation and to have collected pictures and books. When he died in 1838 he left £1,000,000 to his nephew R. S. Holford, well known as the proprietor of Dorchester House in Park Lane and its collection of Old Masters.

For more on this picture, see Miles 1969(2) (the omissions are the publisher's) and Campbell 1969.

Drawings
Edinburgh, National Gallery of Scotland; Leicester, Leicester Museum and Art Gallery; London, British Museum, and Victoria and Albert Museum; San Marino, Calif., Huntington Art Gallery; private collection.

Engraving
Mezzotint by H. T. Ryall, published by F. G. Moon, March 1847.

Wilkie borrowed the picture from R. S. Holford on 17 July 1839 in order to allow a copy to be made from it by the miniaturist S. P. Denning. The copy—which was made—was to be the basis of a line-engraving to be published by Moon. He, however, failed to offer satisfactory terms to the engraver to whom he applied, Abraham Raimbach. That, and a depressed market, brought the matter to an end until after the deaths of both Wilkie and Raimbach.

37. **Sancho Panza in the Days of His Youth**

Wood; 22½ × 19 in. (57.1 × 48.3 cm.)
Lent from the FORBES Magazine Collection, New York.

History and Provenance
Painted between 1833 and 1835 for Henry McConnell, from whom it was bought by John Naylor (1856–1906). The picture passed to his son, J. M. Naylor, and was in his sale, 19 January 1923, bought by Sampson, £15—15—0; anonymous sale, 14 July 1972, bought for the Forbes Magazine Co. of New York.

Exhibition
Royal Academy 1835.

Literature
Cunningham, 3:529.

Formation
On the evidence of the drawings in the Ashmolean Museum (for one, see cat. no. 66), the picture was being planned in October and December 1833, but it is likely that it was painted a good deal nearer the time of its exhibition in May 1835. That it was painted for McConnell is Cunningham's information; he also gives the price as £150.

Comments
The subject is taken from the romance of *Don Quixote* by Cervantes. In the catalogue of the Royal Academy exhibition the title was tagged with a quotation: "Agua limpia a la Oveja, y Vino rubio para el Rey respondio Sancho." The sentence was, in Wilkie's words, "happily selected" for him by Mrs. Edward Cheney. When it came to proofreading the catalogue entry, Wilkie, not knowing Spanish, consulted the Spanish ambassador. The exact source of the sentence has not been identified, and in the iconography of Don Quixote, as treated by British painters at least, this scene may be unique.

The strong diagonal in the composition, from lower left to upper right, which leaves a relative vacancy in the upper left part of the picture, is a markedly Correggiesque device. The composition might be regarded equally as a diminution of Reynolds's portrait of Lady Elizabeth Keppel, which Wilkie is likely to have seen at Woburn Abbey.

Henry McConnell was a manufacturer of textiles in Manchester. He was collecting the work of contemporary, though established British artists from the 1830s to the 1850s; he sold a number of his pictures to Naylor.

Drawings
London, Courtauld Institute; Oxford, Ashmolean Museum (drawings dated 1833).

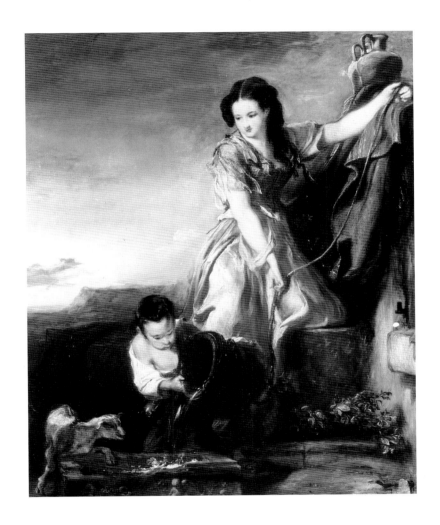

37. Sancho Panza in the Days of His Youth

38. The First Ear-ring

Wood; 29¼ × 23¾ in. (74.3 × 60.3 cm.)
Lent by the Tate Gallery.

History and Provenance
Probably begun in 1834; finished by May 1835. Painted for the Duke of Bedford, who had it still in 1840. The picture later came into the possession of Robert Vernon, who presented it with his collection to the nation in 1847. The pictures were removed from his house to the National Gallery by February 1849, then moved again to Marlborough House in 1850 and to the South Kensington Museum in 1859. The present picture may have been among those which went back to the National Gallery in 1869. It was transferred to the Tate Gallery in 1897.

Exhibition
Royal Academy 1835.

Literature
Cunningham, 3:529.

Formation
The subject was conceived by 1821 (see under Versions, below). On the evidence of drawings (see cat. nos. 70 and 71), the present composition was being considered actively in June and July 1834. C. R. Leslie saw Wilkie at work on the picture on 13 February 1835 (MS: Private). According to Cunningham, the picture was painted for the Duke of Bedford at a price of 260 guineas.

Versions
On 23 June 1821, Wilkie noted in his diary that Lord De Dunstanville had called and "fixed upon the subject of The Girl getting her Ears Pierced for a companion picture." The picture that De Dunstanville already had, and for which he was looking for a companion —presumably of the same size (18 × 14 in.)—was the *Wardrobe Ransacked* (perhaps burnt in 1934). That the companion picture was painted seems certain since a picture of the subject was in his widow's sale in 1842, but it has since disappeared.

A repetition of the present picture, saving a few small differences, but of half its size (private collection), was exhibited at the Royal Academy in 1836. To exhibit a repetition was an odd thing to do, and it attracted no critical attention (the present picture itself had attracted little enough).

Comments
When the small version of the picture was exhibited in 1836, Wilkie attached to the title the old saying: "Il faut souffrir pour être belle." The costume looks Spanish.

John, 6th Duke of Bedford (1766–1839) was a politician and an agriculturalist, as well as a patron of contemporary artists. He commissioned a small picture, *The Cottage Toilet* (Wallace Collection), from Wilkie in 1823, and Wilkie visited him at Woburn Abbey in 1824, the year when it was finished.

Drawings
Cambridge, Fitzwilliam Museum (one dated 28 June 1834); Edinburgh, National Gallery of Scotland; London, British Museum (one dated December 1837— presumably the date on which it was given away or sold, and not that of its execution), Tate Gallery (dated 5 July 1834), Victoria and Albert Museum (one dated June 1834); Nottingham, Castle Museum; New Haven, Conn., Yale Center for British Art; Princeton, N.J., The Art Museum, Princeton University; San Marino, Calif., Huntington Art Gallery (one dated April 1825, another dated 1833); private collection.

Engravings
1. By William Chevalier, published by F. G. Moon, 2 April 1838; 37.9 × 30.6 cm.
2. By W. Greatbach; 24.1 × 19.1 cm. In the *Wilkie Gallery* (1848–50).

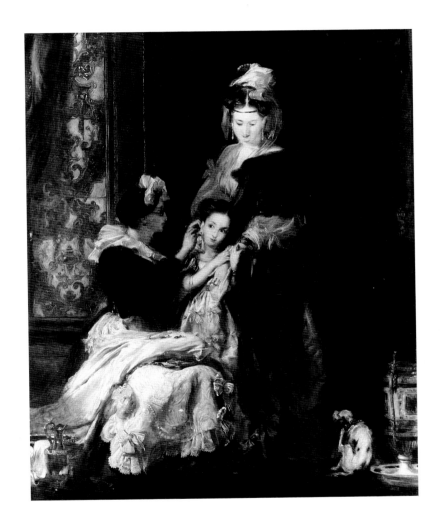

38. **The First Ear-ring**

39. The Peep-o'-Day Boys' Cabin, in the West of Ireland

Canvas: 49½ × 69 in. (125.7 × 175.2 cm.)
Lent by the Tate Gallery.

History and Provenance
Begun after 15 October 1835 and finished by 13
February 1836. The picture was painted for Robert
Vernon, who gave his collection to the nation in 1847.
The pictures had been taken from his house to the
National Gallery by February 1849. From there they
went to Marlborough House in 1850, and to the South
Kensington Museum in 1859. This picture was lent to
the National Gallery of Ireland in 1883, and when it
was returned in 1926 it was to the Tate Gallery.

Exhibitions
Royal Academy 1836; British Institution 1842; Edin-
burgh and London 1958.

Literature
Cunningham, 3:100, 105, 216, 530.

Formation
Wilkie wrote to Vernon on 15 October 1835:
"Your most kind request . . . [that I should]
think of a subject to paint for you induces me
to submit . . . the following. Being greatly
impressed, in my late journey to the recesses of
Ireland, with the fitness and novelty of Irish
scenes for representation, I wish to get *one*
done for [the] next Exhibition. [It is] The
Sleeping Whiteboy. . . . I find people inter-
ested in this as a subject of expression and [as]
connected with public events. This suggests
that it should be painted larger than a merely
domestic subject. . . . Should you be in town I
should be proud to show you a slight drawing of
the intention of the picture" (NLS: MS
10995/29–30). The drawing may have been
that dated from Dublin on 12 August 1835
(National Gallery of Scotland). It was publicly
reported on 13 February 1836 that the picture
had "just been finished" (*Fraser's Literary
Chronicle* 1836, 173). The price was 350
guineas.

Comments
The Peep-of-Day Boys were a secret and lawless
society of Irish Protestants formed to protect
the Protestant peasantry and to avenge their
wrongs on the Catholic population. They were
active from about 1785 to 1795, chiefly in the
north of Ireland, and were the progenitors of
the Orangemen. They were so named because
it was their practice to raid Catholic villages at
dawn. The Catholics replied by forming a
society known as The Defenders—whose
successors in the early nineteenth century were
known as the Ribbon Society from the green
ribbons worn by its members.

Wilkie exhibited the picture under its
present title, but it will have been noticed that
when Wilkie first proposed to paint the picture
in October 1835 he called it "The Sleeping
Whiteboy." In his letter he went on to describe
the ingredients of his subject: "[It] is a young
Irishman asleep on the floor of his cabin, his
wife seated at his head watching him, while
behind her is a girl [who has] just entered the
door whispering to her some tidings of alarm,
the apartment filled with untidy furniture—the
implements of husbandry and fishing character-
istic of this mode of life. From the colours they
wear and the hues with which they are
surrounded [they] appear capable of brilliancy
and effect."

The Whiteboys were another outlawed rural
society, formed in 1761 to redress grievances
against landlords. They made their raids at
night, and got their name because on these
occasions they wore white outer shirts. Their
name was also given to a series of Acts of
Parliament that, from 1775 to 1831, gave
powers for the suppression of like societies.

It is hard to say what Wilkie's picture repre-
sents in these terms. His avowed concern as a
painter was with "brilliancy and effect," and

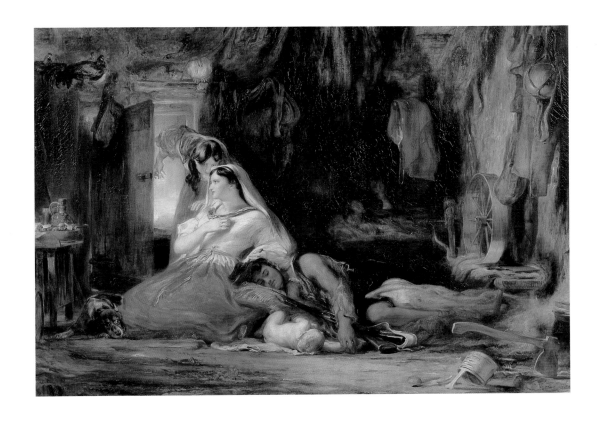

39. The Peep-o'-Day Boys' Cabin, in the West of Ireland

probably he felt as bemused by Irish politics as had Sir Walter Scott in another context: "Ireland (the more is the pity) has never been without White Boys, or Defenders, or Peep-of-Day Boys, or some wild association or another for the disturbing the peace of the country." Perhaps ironically, it was seeing this picture that led the Rev. Horace Cholmondely to commission Wilkie's portrait of Daniel O'Connell (National Bank of Ireland), the "Liberator" whose agitation within constitutional limits did much to subvert Anglo-Protestant supremacy.

Wilkie went to Ireland in 1835, arriving in Dublin on August 10. About a week later he left for the northwest coast, near Sligo, and from there he traveled south through Tuam, Galway, and Limerick, to reach Killarney by August 31. The west of Ireland provided the materials he reassembled into the present composition. This he must have done in essence—as we shall see—by September 12, when, on his way back to Dublin he stopped for a day at Edgeworthstown to visit Maria Edgeworth, the novelist of Irish life. They had met in London in 1819, if not in 1818, and through her Wilkie had become interested in the particularities of Irish manners. He consulted her on the subject of Irish soldiery while painting the *Chelsea Pensioners* (cat. no. 23).

When Cunningham solicited information from Miss Edgeworth for his biography of Wilkie, she recalled the visit: "The sketch for The Peep-of-Day Boy I perfectly recollect. It struck us that the dress and expression were not characteristically Hibernian—too neat, too nice, too trim and orderly for [the] Irish and Ireland—the wife's handkerchief [round her neck] too well put on and headgear ditto . . . much more English or Scotch than Irish. The Peep-of-Day boy himself sketched on the floor asleep, having thrown off his big coat and his upper coat, and having his arms beside him—an excellent sleeping boy—but suspenders, or braces, or whatever you would call them, out of character for his situation and circumstances. . . . I honestly told Wilkie our objections in the particular instances, but it would have been cruel . . . to have told him that I did not think any of the figures characteristically Irish—excepting always the servant girl who is watching at the open door with her finger up and gives warning to the wife of approaching danger [not her stance in the picture]. That is [an] exquisitely natural and Irish gesture, and [the] expression, costume, etc. [are] all right. He was much pleased with the dyes of Connemara and Mayo—certain red dyes for petticoats and blue for bodices—all painters' colors. . . . I think Wilkie answered to our recommendation of more negligence, more slovenliness and recklessness in the costume" (NLI: M. Edgeworth to A. Cunningham, 25 July 1842).

Wilkie was much struck by the picturesqueness of western Ireland: "The clothes, particularly of the women . . . brighten up the cabin or landscape like Titian or Giorgione"; loitering groups reminded him of "the works of Murillo, Velasquez, and Salvator Rosa." He insisted that in Ireland he had rediscovered something of the flavor of Spain, and, as he had in Spain, he wondered why that Ireland, "untouched and new," had "not been long before the object of research among painters."

Wilkie knew of the public interest in the political affairs of Ireland, and of "the craving of the public for variety, and of the publishers for new thoughts." In the year he went there, Thomas Moore's *History of Ireland* and H. D. Inglis's *Ireland in 1834* were published, and in

the year his picture was exhibited there appeared John Barrow's *Tour Round Ireland*—with illustrations by the Irish painter Daniel Maclise—and Leith Ritchie's *Ireland, Picturesque and Romantic*. A reviewer of this last enlarged the present point by observing that "it must have been difficult for Mr. Ritchie once again to tread ground which Miss Edgeworth and Lady Morgan, and the later host of novelists—Banim, Carleton, Griffin, Lover—had made familiar." Also in 1836, it was even facetiously wondered what effect an intended Poor Law for Ireland "would entail on the numerous artisans who make a livelihood of the present state of things—Wilkie, by painting 'Peep-o'-Day Boys;' or Maclise, by 'installing Captain Rocks [a reference to his Irish picture at the Royal Academy in 1834];' Banim, by the heart-rending fidelity of his graphic scenes; or Lover, by the arch waggery of his prose." The name of Mrs. S. C. Hall might have been added.

Yet Wilkie may have noticed relatively little of this for he was not a bookish man. What took him to Ireland may have been a suggestion from Lord Mulgrave, the son of his patron in earlier years (see cat. no. 8) and the newly appointed Lord-Lieutenant of Ireland, whom he joined in Dublin and Galway.

Robert Vernon (1774–1849), a self-made man, amassed a fortune as a horse-jobber to the army during the Napoleonic wars, and did not lose the habit of haggling over terms. In the 1820s he began collecting the work of contemporary British painters, and in doing so contributed much to their professional standing. In 1847 he gave 157 pictures by seventy artists to the National Gallery, with the wish that his name should be forever attached to them, and in the hope that they would become the center of a separate gallery of British art.

They were ungraciously received. Some thought, with reason, that the gift was made for the sake of his own social advancement, but it remains true that he collected with concern and discrimination.

Drawings
Edinburgh, National Gallery of Scotland (one dated 12 August 1835); London, British Museum (dated 30 October 1835), and Victoria and Albert Museum; Oxford, Ashmolean Museum (see cat. no. 69).

Engraving
By C. W. Sharpe; 18.4 × 25 cm. In the *Wilkie Gallery* (1848–50).

40. **Thomas Wilkie**

Canvas; 30 × 25 in. (76.2 × 63.5 cm.)
Lent by Mr. and Mr. Fayez Sarofim.

History and Provenance
Painted for Wilkie's sister Helen, probably in the winter
of 1836–37. The picture was not in the Wilkie sale of
1860 after her death and was kept in the family;
anonymous sale, 15 April 1929, bought by Victor,
£11—11—0; C. H. Rotch; J. Ramsay Macdonald
(died 1937), thence to his son Malcolm Macdonald
(died 1981); with Thomas Agnew & Son 1984, and
sold to the present owners in 1984.

Exhibitions
Royal Academy 1837; British Institution 1842.

Literature
Cunningham, 3:530.

Comments
First exhibited as a "Portrait of a Gentleman
Reading," but a reviewer at the time revealed
the sitter's identity as Thomas (1787–1865),
Wilkie's younger brother. He was a merchant in
the City of London, and sometimes in Wilkie's
later life his amanuensis.

The design is based on Reynolds's portrait of
Joseph Baretti (private collection), of which a
mezzotint was published in 1780. But Wilkie
knew the original when it was at Holland
House. Macaulay, who also enjoyed the hospi-
tality of the house, wrote of the library there a
few years after the portrait was painted:
" . . . the last debate was discussed in one
corner, and the last comedy of Scribe in
another; while Wilkie gazed with modest admi-
ration on Sir Joshua's Baretti; while Mack-
intosh turned over Thomas Aquinas to verify a
quotation; while Talleyrand [whose portrait
Wilkie painted (private collection)] related his
conversations with Barras."

The quality of the light in the portrait
suggests that it may have been painted by
gaslight.

40. Thomas Wilkie

41. The Bride at Her Toilet on the Day of Her Wedding

Canvas; 38¼ × 48¼ in. (97.2 × 122.6 cm.)
Signed, and dated 1838.
Lent by the National Gallery of Scotland.

History and Provenance
Commissioned by Rudolf Arthaber in February 1836.
Completed by April 10. The picture came back to
Wilkie after the Royal Academy exhibition on August
1, and thence it went on August 7 for shipment to
Vienna for Arthaber. He kept it in his summer resi-
dence at Dobling, nearby. The picture was in his sale in
Vienna on April 20–21, 1868, bought by Lepke. It was
presumably he who put it into a London sale on 6 June
1868, where it was bought by Armstrong, £315; David
Price, 1886; his sale, 2 April 1892, bought by McLean,
£735; Arthur Sanderson by 1901; his sale, 3 July 1908,
bought for Sir T. Glen Coats, £945. At his sale on 2
July 1920 the picture was bought by the Gallery.

Exhibitions
Royal Academy 1838; Edinburgh and London 1958
(Edinburgh only).

Literature
Boner 1868, 71; Collins 1848, 2:135–36; Cunning-
ham, 3:247, 252, 530; Haydon 1960–63, 4:392.

Formation
According to Boner, Arthaber "commissioned
a friend in Manchester to speak with Wilkie
about a picture from his hand." On 8 February
1836, Wilkie wrote to Messrs. Schunck,
Mylins, & Co.: "I have the honour to
acknowledge your letter of the 29th [sic] of
February [for January?], informing me of the
wish of a friend of yours at Vienna to possess
one of my pictures, and inquiring if there are
any now to be disposed of. . . . In answer,
permit me to state that I have no picture by me
to be disposed of . . . but feeling most proud to
have one of my works deposited at Vienna . . .
I shall be most happy, though extremely pressed
by engagements, to undertake to paint one
expressly for this purpose. With this view I may
be allowed to submit a subject, which is new, of

a pleasing character, and of that general
interest that may be understood in all
countries—'The Attiring of a Bride on her
Wedding Day.' . . . The picture would be an
upright, of the size of 3 feet 4 inches by 4 feet 2
inches, would consist of the Bride with three
other figures and a dog, and the price would be
four hundred guineas. . . . Should your friend
be pleased to accede . . . I should . . . begin
the picture, which I should hope in twelve or
fifteen months to have finished." It will be seen
that the picture turned out to be horizontal,
rather than vertical, and that it has more
figures than Wilkie promised; it is, however, of
more or less the same size.

Haydon wrote in his diary on 22 December
1836: "Called on Wilkie. . . . He was occupied
with . . . Sir David Baird finding Tippoo [cat.
no. 42], Mary Queen of Scots' escape [missing
since 1920], Cotter's Saturday Night [Glasgow
Art Gallery, or a version of it], and an English
Bridal Morning—all of which he is as fit for as
his footman." There are drawings dated 1837,
one of them (National Gallery of Scotland)
from December that year. On 5 February 1838,
Wilkie wrote of the picture as "nearly done"
(ML: in MS 308895). It was sent to the Royal
Academy on April 9 or 10, and came back to
Wilkie on August 1 (NLS: MS 3219/14).
Thence on August 7 it went for shipment to
Arthaber in Vienna. The price was £400, plus
£15—10—0 for the frame.

Versions
Thomas Wilkie lent a sketch of "Two figures in
the picture of The Bride" to the exhibition at
the British Institution in 1842.

An additonal lot in the Wilkie sale in 1842,
"The Bride. Black lead on panel very [word
illegible]," was noted in the auctioneer's copy of
the catalogue. This, which must have been a

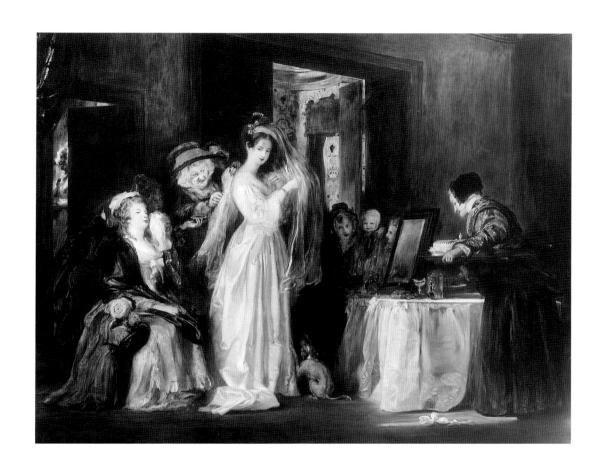

41. **The Bride at Her Toilet on the Day of Her Wedding**

preliminary under-drawing for a fairly small version of the subject, was bought by Richard, £1 — 1 — 0.

In the same sale the auctioneer made an alteration in the catalogue entry for lot 635. In print it read: "Jane Shore, the subject sketched in chalk and the head begun." The manuscript alteration substituted "The Bride" for "Jane Shore."

Comments

Rudolf Arthaber was a merchant whose collection was chiefly of pictures by contemporary German, Austrian, Belgian, and French artists. Wilkie was to meet him in Munich in 1840, and at Vienna later in the year he visited the collection and took pleasure in pictures by M. E. Ainmiller, "Ganermann", August Riedel, and Natale Schiavoni. His own picture looked to him "slighter than I expected after the many objects of the minor Dutch we had been seeing."

Wilkie had two other pictures in the German-speaking world. The *Reading of a Will* (Munich, Neue Pinakothek) was bought by the King of Bavaria in 1820, and in 1821 *Guess My Name* (private collection) went to Erwin, Count Schönborn, at Frankfurt.

Drawings

Cambridge, Fitzwilliam Museum; Edinburgh, National Gallery of Scotland (one dated December 1837); New York, Metropolitan Museum; private collections.

Engraving

When Wilkie dispatched the picture he sent a letter on August 8 to W. Beneeke that included this paragraph: "As a strong wish has been expressed to get the picture engraved, may I hope . . . to submit to Mr. Arthaber that if he would permit it to be engraved for this country, a distinguished publisher has offered to me to send an artist to Vienna to make a drawing of the picture in water-colours, to bring back to this country to do the engraving from." No more is heard on this.

42. Sir David Baird Discovering the Body of Sultaun Tippoo Saib

Canvas; 137⅞ × 105½ in. (350.4 × 268 cm.)
Signed
Lent by the National Gallery of Scotland.

History and Provenance

Probably commissioned by Lady Baird in June 1834, the picture was begun by 7 August 1835 and finished in December 1838. The delay over the engraving of the picture (see Engraving, below) is likely to have meant that it may not have reached Lady Baird at Fern Tower before 1841. The picture passed by descent to the present Sir David Baird, and it was given to the Gallery by Irvine Chalmers Watson.

Exhibition

Royal Academy 1839.

Literature

Cunningham, 3:92, 96–97, 98–99, 109, 110–11, 118, 120–21, 216–17, 222–23, 225–26, 255, 257–58, 260, 263; Haydon 1960–63, 4:392.

Formation

On 9 June 1834, Sir James McGrigor—whose portrait (Royal Army Medical College) Wilkie was probably painting at about this time—wrote a note from Campden Hill to Helen Wilkie: "My friend Lady Baird is extremely anxious to see your brother . . . and to dine *alone* with him here . . . when he returns from Oxford [see cat. no. 44] . . . [to] meet Lady Baird on business" (NLS: in Acc. 7972). This meeting was probably the exploratory beginning of what was evidently to be a difficult commission in a sense wider than that imposed by the ambitious nature of the eventual picture. Lady Baird was the widow of its hero.

From about September 4 to 18, Wilkie stayed with Lady Baird at her home at Fern Tower, just outside Crieff in Perthshire, and, as he wrote to Sir William Knighton on September 20, he " . . . had much discussion about the proposed picture of Sir David Baird. . . . I have already stated to you that I have never been so inter-ested as I have been to undertake this picture. Her Ladyship has already reared a monument in Aberdeen granite upon a mount near her to commemorate her departed husband, and seems to fancy my art [which], if successfully applied might, though less durable by far, yet give a minute detail of one of the most remarkable passages of his life, and seems to think that . . . [by making it refer] alone to himself and to his previous history . . . [the picture] might be painted in such a way as to give no offence nor umbrage to any living being. Indeed so satisfied with the sketch I have been making, so willing to accord with me in any ideas of the character and size required to give [the picture] importance, that I must consider this commission . . . as of first rate consequence" (ML: in MS 308895).

On December 29, Wilkie wrote to Lady Baird from London to say that he was making drawings—"trying changes and re-arrangements in the details of the groups, or, what is more the case, trying to give form and shape to what in the first sketch was vague and confused. Of the figure of Sir David I have also been making a separate sketch, chiefly from the drawing made in Dublin [unidentified], which your Ladyship recommended."

It would seem that by 14 April 1835 little, if anything, had yet been painted. On that day Wilkie wrote to Lady Baird: "I have lately painted in the large picture of Napoleon and the Pope [National Gallery of Ireland], and have had the occasional advice and review of friends who knew them. The likenesses are, I am assured, successful. In this way I could draw in [on the canvas] the figure of Sir David Baird, and with your Ladyship's eye to direct me, I think a near approach may be made to a likeness. Indeed Raeburn's portrait, with the hat on the head, and the eyes looking down,

would be almost exactly what is wanted. The figure may be supplied greatly from the small drawing made in Dublin. For the native Indians I can procure models in London. I have just come from the India House, where I saw four military characters . . . in face and dress perfect for what I want. Of these, as they are to sit to me, I shall make a variety of studies." Although he ended the letter by saying that "all who see my picture are pleased with it," at this stage he is likely to have meant no more than that they liked the idea of the picture as drawn and perhaps partly roughed in on the canvas, and supplemented by a sight of the drawings.

Wilkie reported his progress—not great—to Lady Baird on August 7: "The figures I have drawn in with the chalk upon the canvas. . . . With the principal figure I have tried some deviations from the original sketch . . . giving [it] more animation and command. . . . In the likeness, Macdonald's bust will help me most essentially. The eyes, at such a moment [in the drama], can only be turned down to the fallen monarch." The Indians, in the meantime, had refused to sit, for a reason to be repeated. A bust of Baird by Lawrence Macdonald had been exhibited at the Royal Academy in 1828. On the day Wilkie wrote to Lady Baird he also wrote to the painter Andrew Wilson in Rome: "Will you . . . ask Mr. Lawrence Macdonald . . . if he has a cast . . . of his bust of Sir David Baird; if [so] . . . I wish to possess it, at his own price" (NLS: MS 3812/45–6). The wish was not to be so fulfilled. Wilkie must have had a reply instructing him to find a cast in London, and he wrote again to Wilson on November 3 to say that he had failed—but that "Lady Baird obtained me leave about three weeks ago to get a mould . . . made of [the] bust at Lord Ailsa's at Isleworth. Of this I am to

have two casts [they were in Wilkie's sale on 4 May 1842]" (NLS: MS 3812/49–50). Until he had the bust he felt himself "at a stand," and he was anyway to be in Ireland until mid-September (see cat. no. 39).

On October 15, Wilkie told Lady Baird: "I have given to the figure of Sir David Baird more movement and command than there was in the first sketch, and more action to those around him, as if he were about to order the body to be removed to the palace. . . . Three Hindoo cavalry soldiers . . . consent[ed] to sit to me . . . in their native dress. . . . [I] put them on a platform in a group, the Jemidar [the equivalent of a lieutenant] as Tippoo, reclining with his head supported by one of his lieutenants, and his hand held by the other, with his finger on his pulse. . . . The group was magnificent, and I was all ecstasy to realise such a vision of character and colour." But it was "a vision only," for the Jemidar left the group saying "No Tippoo I!," and the others with him. One agreed to pose standing, however, and Wilkie "put a sword in his hand and placed him in the attitude of an assailant." But by the time Wilkie wrote this they had ceased to come altogether.

Haydon saw Wilkie at work on the picture on December 22. On 10 July 1836, Wilkie was able to write: "I feel . . . gratified by your Ladyship's approval of the likeness. . . . The portrait by . . . Raeburn I shall see returned before the summer is over. It may help me in finishing, though certainly not in altering that which is done." Again Wilkie wrote, on July 29: "I have worked at the head . . . from Raeburn's picture. . . . Sir Willoughby Gordon and Sir James McGrigor . . . think it a most perfect likeness [and] I shall now do no more" —although he wondered about bringing the hat lower down on the head. Wilkie continued:

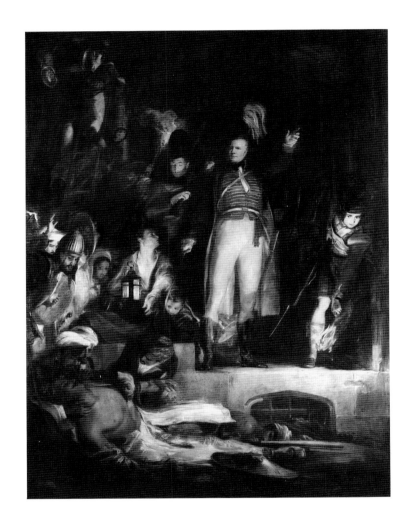

42. **Sir David Baird Discovering the Body of Sultaun Tippoo Saib**

"I have taken the two dogs out of the picture, as your Ladyship is pleased to request." But clearly he did so with regret: "It has been suggested to your ladyship, that the admission of dogs into the picture is offering a sort of disrespect to a fallen enemy. Trifling as these animals are, they serve a purpose in pictorial effect, by affording a lively . . . relief to the austerity inseparable from the objects that compose the lower part of the picture; and give a variety . . . , being of that class of accessories which all classes of spectators are pleased and interested with, even in combination with the greatest personages and events." In his apologia for the introduction of dogs, one of his common vehicles for emotional counterpoint, Wilkie may have had the precedent of Rubens in mind, but in an Indian subject they would have been particularly inappropriate.

Six months later, on 30 January 1837, Wilkie told Lady Baird: "The figure of Sir David Baird is entirely painted in . . . : the dress I had made up for the purpose. Sir James McGrigor . . . bears his testimony to the entire resemblance; he approves, too, of the dress, which is like that he recollects Sir David wearing in Egypt. . . . The figures of the orderly and the Pioneer are also painted in. . . . I have taken out the dogs . . . but have as yet devised nothing to supply their place." On April 24 he expressed his hope of being able to "get the back-ground figures advanced as far as possible . . . [and] I think that by the end of May I shall have the effect at least, if not the details, a good way on." "The picture now proceeds apace," he wrote on June 18: "Besides the figure of Sir David Baird, several of the European group are painted in; and having found some native Lascars, who have been sitting to me daily for some weeks past, I am getting the chief of the Indian heads painted in. . . . The interest of the subject I find grows as I proceed. The subordinate figures and the back-ground I generally leave till the principal figures are painted in."

In the last two months of 1837 the picture was more or less laid aside for the sake of finishing *The First Council of Queen Victoria* (Royal Collection; see fig. 24). When the picture was seen by an American visitor to London on November 8, it was observed: "Though some parts of the picture were bare and others slightly outlined with charcoal, other portions of the work were not only advanced but apparently finished!!" (MS: Private). But on 2 February 1838, Wilkie could report again to Lady Baird: "Since . . . seeing you in London, the picture has made a very great advance; and, excepting the Highlander stooping with the torch . . . and the figures in the distance behind him, all the other figures are painted in. . . . The figure of Tippoo Sahib I have taken great pains with, and I have been making a model of the scene for the light and shadow." This device he had already written about on August 16 the previous year: "I am making a small model to be lighted by a lamp" (ML: in MS 308895). When it came to the private view at the Royal Academy, Wilkie wrote: "While those around me cry out for more light [in the picture], I only wish I could have more shadow."

Wilkie announced to Lady Baird on 20 August 1838: "The picture . . . is entirely painted in; so that I have now only the agreeable task of finishing some parts more highly, and, by a general working, to give keeping and effect to the whole." On November 12 he wrote to Sir William Knighton the younger that the picture was "now brought near a close, and, fortunately, to the satisfaction of Lady Baird."

But this was not to be the end. Two days later Wilkie wrote to Lady Baird: "The drawing room at Fern Tower . . . is fourteen feet nine inches high. This, though limited, will still admit the addition to the height of the picture we want. If six inches can be added to the height, may I ask why six inches cannot be added to the width . . . ? If six inches can be allowed each way, which will keep its present proportion, I propose to add three inches at the top . . . at the bottom and . . . on each side. This will serve to give the figures a little more quiet space all round the edge of the picture. This . . . can be done without . . . joining, as there is canvas to spare, now turned in behind the picture. . . . The increase in height is what is wanted most. . . . I have given the man who touches the heart of Tippoo [instead of feeling his pulse] a black dress—a great improvement." With Lady Baird's permission the surface of the picture was enlarged by six inches in height and five in width, and Wilkie wrote to her that "the effect of the enlargement goes even beyond my own expectation."

Versions

What may be presumed to have been two oil sketches are referred to under Formation, above (20 September and 29 December 1834; 7 August and 15 October 1835). Nothing more is known of them.

Comments

Wilkie's exposition of the subject was given in the catalogue of the Royal Academy exhibtion:

"Sir David Baird discovering the body of Sultaun Tippoo Saib, after having captured Seringapatam, on the 4th of May, 1799.

"'The division of the besieging army destined for the assault which Major-General Baird had volunteered to command, having become masters of this important fortress, the fall of which involved the ultimate settlement of the British power in India, still General Baird considered the victory incomplete until the personal fate of Tippoo could be ascertained.

"'About dusk General Baird, in consequence of information he had received at the Palace, came with lights to the gate, accompanied by the late Killadar [Governor] of the Fort, and others, to search for the body of the Sultaun; and after much labour it was found, and brought from under a heap of slain to the inside of the gate. The countenance was in no way distorted; but had an expression of stern composure. His turban, jacket, and sword-belt were gone; but the body was recognized by some of his people who were there to be the Sultaun.'—*Vide Life of Sir David Baird by Theodore Hook*, vol. i [1832], p. 197.

"General Baird, who is standing in the gateway under which Tippoo received his death wound, is supposed to be giving orders that the body should be carried to the Palace; and below his feet, in the parapet wall, is a grating here introduced as giving light to the dungeon in which he had been immured for nearly four years by Hyder Ally and his son, the same Tippoo Sultaun, who, by a remarkable dispensation of Providence, he now finds prostrate at his feet, bereft of his crown, his kingdom, and his life."

Wilkie had provided further explanation of the picture which was not included in the Royal Academy catalogue entry: "On the foreground of the picture is represented the body of Tippoo, with the amulet on his right arm found to contain some manuscript in Magic, Arabic, and Persian characters, removing any doubt, if it had remained, of his identity. His head is supported by the Circar Brahmin who, with a domestic, is recognising the features of their

late master. Over the body is the Huqueem, or surgeon, with his hand on the Sultaun's heart to ascertain if it still beats, death having so little changed his appearance as to leave it a question if life were yet extinct. Over this group, on the left with the helmet, is the Killadar by whom the General had been conducted to the spot; behind him is a Mussulman soldier and, further in the distance, a Hindoo man and woman attracted to the gate by their interest in the fate of their friends and defenders. In the background and on the wall is represented the closing efforts of resistance of the native troops to their European assailants.

"In the centre of the picture is Sir David Baird who, having captured the city and seeing his unrelenting enemy at his feet, is supposed to have given orders that the body should be carried into the Palace. On his right is a Pioneer with his lanthorn, pointing to the object of their search. Behind him with a carbine is an orderly, and in front on the General's left hand, bending forward with a torch is a Highlander, a McLeod of the old 71st [the Highland Light Infantry] who, with his comrades on leaving the trenches, were reminded by the General of the old scores they had now to settle for the severe imprisonment they had formerly endured as captives at Seringapatam."

We have seen Wilkie at pains to reconstruct the likeness of the dead Sir David. In the eyes of contemporaries, including the Duke of Wellington who was present at the discovery, he was held to have been successful. If Baird looks overlarge in the picture it is because in life he was six feet two inches tall.

For the likeness of Tippoo, Wilkie was less well provided. In the museum at India House he found "no picture of Tippoo Saib, and no likeness but a small drawing, of which I have got a print." This was presumably the frontispiece to James Hunter's *Picturesque Scenery in Mysore* (1805). But for the accessories, the spoils of war were abundantly to hand. Lady Baird had material at Fern Tower; Wilkie was given access to Tippoo's arms and accoutrements in the royal collection (see cat. no. 80); "Mrs. Parker . . . brought me a dress, consisting of pelisse and trowsers, actually worn by Tippoo Saib himself!! . . . Mrs. Charles Russell has also sent me a coach-load of turbans, pelisses, trowsers of the richest stuffs, with matchlocks, scymitars, and a superb shield." British weapons were lent by the makers; Tippoo's amulet was lent by Mrs. Young of Aberdeen.

Wilkie possessed a print after Robert Kerr Porter's once-famous heroical picture of the storming of Seringapatam, exhibited in 1800. Indeed, on the suggestion of drawings, his very earliest thoughts about the commemoration of Baird may have lain in a storming scene (residually represented in the upper left background of the present picture), which in turn may have been derived from early thoughts about *The Siege of Saragossa* (cat. no. 30). Perhaps the only previous representation of the specific subject of the finding of Tippoo's body was by A. W. Devis, painted by 1810 (private collection).

For a chapter on Tippoo and British artists, see Archer 1979 pp. 408 ff.

In the conception of the subject, Wilkie must surely have had some Rembrandtesque Raising of Lazarus partly in mind, and his thoughts for the figure of Baird may also have been guided by such pictures as Lawrence's portrait of Kemble as Coriolanus (London, Guildhall).

The capture of Seringapatam, and with it the annexation of Mysore, was not without its

repercussions in military and East India politics. Lady Baird was evidently aware that the subject of the picture was potentially delicate. Tippoo's body was discovered by Baird and Wellington (then Colonel Wellesley)—also by Major Beatson, who published a circumstantial account of the event in his *View of the Origin and Conduct of the War with Tippoo Sultaun* (1800). But the picture, in concentrating on Baird, naturally diminished the military role of Wellington, who had since become the national hero. He is discernible behind Baird and to his right, but conspicuously not mentioned in Wilkie's description of the picture quoted above.

Yet the picture was, after all, a widow's domestic (if large) memorial to a husband felt by some to have been ill-judged in favor of Wellington, and not a piece of military history. It was certainly not seen as history by reviewers of the exhibition (who cared little for it as a picture); forty years had passed, and what may have been the last public exploitation of the story had been in the London theater in 1828.

Drawings
Cambridge, Fitzwilliam Museum, cat. no. 79; Edinburgh, National Gallery of Scotland, Scottish National Portrait Gallery; and Royal Scottish Academy; London, British Museum, Courtauld Institute, National Portrait Gallery, and Victoria and Albert Museum, cat. no. 78; Oxford, Ashmolean Museum (cat. nos. 76, 80, 81; one dated November 1837); Philadelphia, Philadelphia Museum of Art, cat. no. 77; San Marino, Calif., Huntington Art Gallery; The Binns (National Trust for Scotland); private collections.

Engraving
By John Burnet, published by F. G. Moon, 1 May 1843, and dedicated to The Honorable East India Company. Impressions from the private plate were priced at £—10—0 (see cat. no. 97).

In September 1840, Wilkie had written: "I made . . . arrangements with Mr. Moon [the print publisher] that the moment Mr. [S. P.] Denning has finished the drawing, the picture should be removed from Dulwich [where Denning was curator of the Gallery] to the studio of Mr. Burnet, that he may etch the principal parts of it at once." Lady Baird was in the meantime anxious to have the picture, but there were delays in the engraving lasting at least into March 1841.

43. John Knox Dispensing the Sacrament at Calder House: Sketch

Wood; 17¾ × 24 in. (45.1 × 61 cm.)
Lent by the National Gallery of Scotland.

History and Provenance
Painted in 1839, the picture was in the Wilkie sale on 30 April 1842, bought by Grundy, £84. It was in the sale at Manchester of the late Benjamin Hick of Bolton on 21 February 1843. In 1848 the it belonged to John Clow of Liverpool, and was in his sale there on 20 April 1852, bought by Graves, £86—2—0. John Naylor had the picture in 1854, and from him it descended to his grandson J. M. Naylor, who gave it to the Gallery in 1953.

Exhibitions
Edinburgh 1975; Edinburgh 1985; Edinburgh and London 1986.

Literature
Cunningham, 3:246–48, 256, 276–78, 282–83; Errington 1975, 25.

Formation
The development of this picture cannot be disentangled from that of the larger, unfinished picture in the National Gallery of Scotland (see fig. 44).

Wilkie began in 1822, and completed in 1831, a picture of John Knox preaching (Tate Gallery; see fig. 17). Arrangements to have an engraving made after it were begun in 1834, and in 1836 there were high hopes of its commercial success. Wilkie started to interest himself in a second Knox subject by early December 1837, that of Knox administering the sacrament at Calder House. The engraving of Knox preaching was published on 1 May 1838 (see cat. no. 96), and on June 11 Wilkie wrote: "The print of Knox is out and thought successful. A companion is called for, for which Knox and the Sacrament now occupies my thoughts."

By June 29, Wilkie was "trying to collect the material and the thought for the subject." In

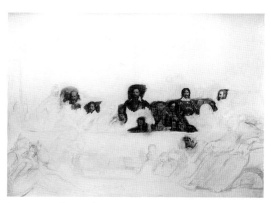

Fig. 44 Wilkie, *John Knox Dispensing the Sacrament at Calder House*, 1839–40, National Gallery of Scotland

September he visited Calder House, in Midlothian, "to see the hall where John Knox first administered the sacrament." An announcement was made of the forthcoming companion engraving "as a warning to interlopers" into the market, but for a year no more was heard of the picture. Then the foreseen danger to the economic interest of the matter came about, and forced Wilkie on. The warning itself had "set a rival publisher to work, to get up a similar subject of Knox administering the sacrament in the Castle of St. Andrew's." Wilkie wrote of this on 30 October 1839, and continued: "I have therefore made a sketch, with an arrangment of the figures, and am now drawing in the characters in the picture." The sketch was presumably the present picture. The rival publisher was Hodgson & Graves, who, on September 19, had commissioned for the purpose of engraving a picture of Knox administering the sacrament from William Bonnar.

When Wilkie wrote on 25 May 1840 that "the picture proceeds, and, as it advances, improves by details and incidents casting up," it is likely that he was then referring to the larger

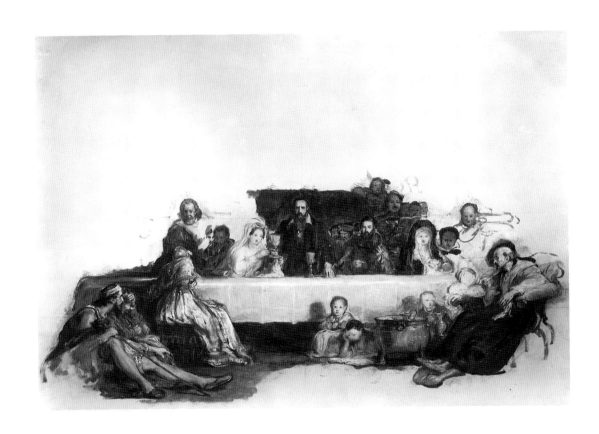

43. **John Knox Dispensing the Sacrament at Calder House: Sketch**

version. This remained unfinished on Wilkie's departure for the Near East on August 15 that year, and the intended engraving did not appear, although announced in 1841.

Version
The larger version, roughly three times the size, is referred to under Formation, above.

Comments
The occasion depicted, which took place in 1555, was one of significance in the history of the Reformation in Scotland. Wilkie's literary source must have been Thomas McCrie's *Life of John Knox* (1812) which he had used for his earlier picture of Knox preaching. He was also helped in this picture by reading the *Account of the Parish of Mid-Calder* (1838) by John Sommers, the minister and historian of the parish in which the event took place; by Sommers in person; and by the Sandilands family whom Wilkie had visited at Calder House.

Knox had recently returned from Geneva and was laboring to persuade those Protestants who attended the Roman mass, mainly for social reasons, that they should desist from doing so. At Calder House it was believed that there, for the first time in Scotland, communion was given according the Calvinist rite.

Wilkie knew the portrait of Knox at Calder (engraved as the frontispiece to McCrie, vol. 1), on the back of which, McCrie tells us, was inscribed: "The Rev. John Knox—The first sacrament of the supper given in Scotland after the Reformation, was dispensed in this hall." Symbolically the occasion might be seen as the sacramental beginning of the Reformed church in Scotland.

When writing of the progress of the picture on 25 May 1840, Wilkie elaborated on its content: "I find . . . that a good deal of contrivance is required to fill up the expected material of such an event. . . . With a certain class of subjects it is necessary to put in much that is imaginary. . . . The hall . . . [which had been modernized] I am obliged to restore to what will recall an ancient hall of that period: the chimney I ornament; decorate the walls with the pilasters now there to suit; and I must try to renew the carved screen which you . . . say divided the room, in old times, from the entrance. I also put in more people, and those more varied in rank than could well have been there. I mean to put in the Lord and Lady Lorn, the Regent Murray [possibly identifiable, on the basis of the engraved portrait of him in McCrie's vol. 2, as the man to the left of the woman taking the cup], perhaps also Morton, and the aged Earl of Argyll. I also wish to introduce, in a prominent place, the knight of St. John (Sir James Sandilands), and, whether right or wrong, in *armour*. A large wine-cooler is also made prominent; and, as suggested by Dr. Sommers's account of the parish, a Calder witch is to be placed conspicuous. This, you will doubtless say, *is* a mixture; but it is of that sort which, whether consistent with truth or not, is certainly required to make up that kind of compound that goes to the formation of what we call a picture."

In writing that "a good deal of contrivance" was needed in composing the picture, Wilkie must have meant that the subject was difficult because it was one of interior import rather than one of external action. It is in this sense that the present picture differs from—and equally makes a companion to—his picture of Knox preaching. This was a picture of rebellious action dramatically expressed, signifying

the breaking down of the old religious, and indeed social, order. The present picture is meditative in a manner not wholly remote from his own early portrait of his parents (cat. no. 7), and clearly meant to convey the socially unitive nature of the act.

On Wilkie's own religious views it is hard to be precise because on all personal matters he was reticent. Yet lest his interest in Knox should suggest otherwise, it should be said that he enjoyed the ease of the Church of England and shared none of McCrie's Presbyterian intolerance.

In constructing the picture, the element of "contrivance" that Wilkie found necessary included scarcely disguised reference to established pictorial prototypes for such a grouping —all of which Wilkie had seen while on the Continent. Leonardo's refectory table is there, and so too is something of the arrangement of the figures; the equilibration in the weighting of the figures stems from Raphael's frescoes; furthermore Wilkie had admired in the Escorial the grand, if now battered development of both of these in Titian's *Last Supper*.

Drawings (for both pictures)
Edinburgh, National Gallery of Scotland, and Royal Scottish Academy; private collections.

Engraving
By J. T. Smyth, published for and in the *Art-Union* 10 (1848): f.p.97; 16.6 × 25 cm. Reissued in the *Wilkie Gallery* (1848–50).

44. Self Portrait

Canvas; 29 × 24½ in. (73.7 X 62.2 cm.)
Lent by the Yale Center for British Art, Paul Mellon Fund

History and Provenance
Begun in 1840 and abandoned when Wilkie went abroad later that year. On Wilkie's death the portrait passed into his family. By 1872 it belonged to the painter's nephew, Colonel David Wilkie, and from him it passed to his cousin, the Rev. David Wilkie; anonymous sale, 16 January 1920, bought by Paul, £19—19—0; Charles Shannon and Charles Ricketts by 1927; their sale, 1 December 1933, bought by Wilson, £28—7—0; the portrait passed from the Saville Gallery (i.e., Wilson) to Knoedler & Co. and to Thomas Agnew & Son in 1934; sold then to Sir Thomas Catto, who died in 1959; anonymous sale, 11 July 1984, bought by the Center.

Literature
Cunningham, 3:280.

Formation
Begun before 20 April 1840 for Sir Robert Peel, to whom Wilkie wrote on that day in terms suggesting that he was working on alternative versions of a self-portrait, of different sizes, one of them showing him with "a doctor's cap," the other without: "For some days I have been proceeding with it, and do not see any difficulty in finding space for the hand in the present size; the introduction of the doctor's cap being one reason why a hand may be desired. I hope shortly to have it advanced so far as to submit it for your obliging counsel in this as well as in the likeness." This letter may have been in reply to an undatable letter from Peel: "If you find any difficulty in completing the portrait as you should wish it to be completed, on account of the limited size of the canvas, I hope you will not hesitate to make the requisite addition. I recollect you mentioned the hand would not come in well. A portrait of you with your hand invisible would be an unpardonable solecism"

(MS sold 23 March 1981). There is no cap in either version of the portrait.

Wilkie wrote to Peel again on July 10: "The portrait I have proceeded with, but more slowly than I wish owing to uncertainty about the likeness, which only others can judge of. I have begun it twice, but am advancing what is thought the best one" (IN: MS 9182). Both versions were unfinished when Wilkie left London for the Near East on 15 August 1840.

Version
The rather larger version referred to above (Pau, Musée des Beaux-Arts) was lent by Peel to the Wilkie exhibition at the British Institution in 1842, and was sold with the Peel heirlooms in 1900.

Comments
Wilkie's concern over "a doctor's cap" becomes intelligible in the light of the self-portrait at Pau, which shows him wearing an academic gown. He had received an honorary Doctorate in Civil Law at Oxford in 1834, on the occasion of the installation of his old patron the Duke of Wellington as Chancellor of the University.

The two self-portraits of 1840 were Wilkie's last (since 1813), and the only ones that he painted for a patron. Cunningham knew one or the other version and did not think it over-like. In 1838 the vulturous Haydon had reported that Wilkie was "looking very old . . . weak and fat." For an early self-portrait, see cat. no. 3.

When the present portrait was sold in 1920 it was stated in the auction catalogue that the "coat, &c." were painted by "J. Fraser." A. (Alexander) Fraser (1786–1865) was probably meant. He had been an assistant to Wilkie, and remained in his own painting very strongly influenced by him. The filling in of unfinished

44. **Self Portrait**

portraits in this manner was a common practice.

Sir Robert Peel (1788–1850), a Tory politician and the foremost British statesman of his age, was twice Prime Minister. He became interested in Wilkie's work when the two met in Edinburgh in 1822, and it was he who wrote in 1823 to inform Wilkie of his appointment as King's Limner for Scotland. His preeminent picture by Wilkie was the *Knox Preaching* (Tate Gallery) exhibited at the Royal Academy in 1832. The other version of the present self-portrait went into the portrait gallery that Peel built at Drayton Manor. Peel was not a significant patron of contemporary painters; his interest was chiefly in collecting Dutch and Flemish pictures. Two important Van Dycks were bought for him by Wilkie at Genoa.

45. The Turkish Letter Writer

Wood; 27⅞ × 21⅛ in. (70.8 × 54.3 cm.)
Signed, and dated 1840.
Lent by the Aberdeen Art Gallery and Museum.

History and Provenance
Painted from October to December 1840, and sent to London in January 1841. The picture was in Wilkie's sale on 30 April 1842, bought by Lord Charles Townshend, £446—5—0. It belonged to Thomas Baring in 1853, and passed by inheritance to the 1st Earl of Northbrook, who had the picture in 1874. Anonymous sale, 8 June 1882, bought by Agnew & Son, and sold by them to James Price in the same year; his sale, 15 June 1895, bought by Agnew's for Sir Donald Currie, who died in 1909; Mrs. M. V. Smith Cunninghame sale, 1 May 1959, bought for the Gallery.

Exhibitions
British Institution 1842; St. Andrews and Aberdeen 1985; Edinburgh 1985.

Literature
Cunningham, 3:320, 330, 331, 336, 345, 361–62, 363.

Formation
When Wilkie was at Constantinople he noted in his journal on 6 October 1840 that at Tophanna, near the European quarter of Pera, he "saw at the outer court of a mosque a scribe of the most venerable appearance. He was reading a letter . . . he had been writing for two Turkish young women—one very handsome: the way they were placed made an excellent composition for a picture." Two drawings (one of them in the Ashmolean Museum; cat. no. 86) probably record Wilkie's first impression, and a highly worked drawing (lithographed in Nash 1843, plate II) gave definitive form to the group.

Wilkie began the picture on 26 October 1840, and in his journal he records further work on it on October 29, November 3, and, probably, November 13. When, on December 1, it was shown to Lady Londonderry, it was presumably in an intelligible form, although still, as now, unfinished.

On 12 January 1841, the eve of his departure from Constantinople, Wilkie wrote in his journal: "I took two packing cases, one containing . . . on the lid the Scribe; and delivered them . . . to be sent to England, each case to go by a separate ship [prudence indeed!]." According to W. S. Woodburn, the picture dealer and Wilkie's traveling companion, the price "put upon it at Constantinople" was 350 guineas—presumably meaning the price of the picture when it came to be finished.

Comments
In a letter of 12 January 1841, Wilkie called the scribe a Dervish, the letter a love-letter, and the girls Turkish and Greek. Of the letter writer it was observed in 1842 that he "seems to have made the pilgrimage to Mecca, if we may so judge from the green band round his cap" (*Art-Union* 1842, 111).

Wilkie painted the beginnings of two pictures while he was in Constantinople from 5 October 1840 to 12 January 1841. They were this one and the *Tartar Messenger* (Sir James Hunter-Blair). He went there on his way overland to Palestine, and not with the intention of staying. He was delayed there because of the war with Egypt, and only became free to leave for Syria after the fall of Acre on 4 November 1840 and with it the domination of Mehemet Ali (see cat. no. 46). A month later it was felt safe to think of moving on.

In Turkey, "this strange, passing strange, land," he found himself, however, among an "exuberance of paintable matter." As always with Wilkie, it was the people who interested him most, and through that which was simply exotic be began to discern ways of living that had "continued from an earlier time than our

own." The surviving people in whom Christianity had its roots were the chief object of his voyage to the Holy Land, and apparently of his hopes for a fresh direction to his career.

Drawings
Aberdeen, Aberdeen Art Gallery (dated 10 January 1841); Oxford, Ashmolean Museum; private collection.

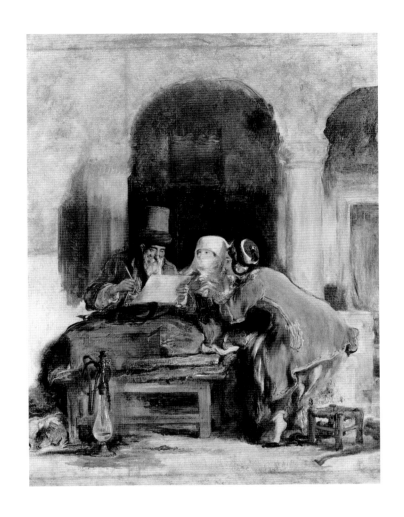

45. **The Turkish Letter Writer**

46. Mehemet Ali

Wood; 24 × 20 in. (61 x. 50.8 cm.)
Signed, and dated Alexandria May 11th 1841
Lent by the Tate Gallery.

History and Provenance
Painted in 1841 and presumably sent to Wilkie's family
with his other effects after his death at sea on June 1
the same year. The portrait was in the Wilkie family
sale, 21 June 1860, bought by Edinborough,
£54—12—0; anonymous sale 28 November 1919,
bought by Petmain, £42; Henry, 4th Earl of Effingham,
and bequeathed by him to the Gallery in 1927.

Exhibitions
Royal Academy 1842; Edinburgh and London 1958.

Literature
Cunningham, 3:462—66, 467, 468—69.

Formation
Wilkie's intention had been to leave Jerusalem
for Beirut, and thence for home, early in April
1841. Reports of plague at the port led to an
unplanned passage from Jaffa to Alexandria,
which he reached on April 26. The steamer
having left for London a few days before, Wilkie
decided to wait there for the next one. (The
alternative, by packet to Malta and Marseilles,
thence overland, was undoubtedly tiresome.)

Wilkie wrote: "On our arrival [at Alexandria,
William Woodburn was with him], Mr. Green
[the local agent for the P. & O. steamers]
informed me that he had mentioned me, with
the object of my journey to . . . Mehemet Ali,
and that his Highness was desirous of seeing
me." (These circumstances belie contemporary
belief that Wilkie went to Alexandria expressly
to paint the Pasha.) On May 5 Wilkie and
Woodburn went to the summer palace, where
in "a fresh-looking garden . . . in which was
an open chiouch [kiosk] . . . the Pacha was
seated." They were presented to him. Wilkie
continued: "On being told I had painted the
Sultan [of Turkey, Abd-ul-Mejid, at Constanti-

nople the previous year (Royal Collection)] he
asked if I had it here; on telling him it was
gone to England, said he was desirous of having
a copy of it. . . . His Highness then desired I
would make a picture for him of himself; asked
how many sittings? I said three. . . . I was first
asked if I could paint in the chiouch . . . but I
objected to the light; so we were taken to a
large Turkish room in the palace."

The next morning Wilkie found the Pasha as
appointed, "sitting upon a divan, most
picturesque; but as I thought to European eyes
this wanted dignity, he was placed upon a large
elbow chair." "Although friends had said I
would find him a restless sitter, it appeared
quite the contrary." This first sitting was of two
and a half hours. On May 8 Wilkie noted:
"sitting of upwards of two hours: advanced the
head greatly." On May 10 he "had a sitting of
the Pacha: painted in the hands, dress, and
sword." The final two-and-a-half-hour sitting
was on May 11: "I painted in the head, which,
with glazings, I carried as far as I could. He
looked at it occasionally himself, and said I had
made it too young for him. I answered, that I
was positive it was not so [although in the
drawing he looks older]. He thought the marks
in the brow and round the eyes ought to be
made stronger; but I requested it to be
explained to him [who only spoke Turkish] that
I did not want to paint minute details, but the
expression of the face. He seemed satisfied;
. . . I made a change in the legs which was
thought a great improvement. I requested to
know if I had his leave to make a copy of it in
England . . . to which he consented. . . . The
original I am to finish in London, to be sent to
his Highness." The sittings over, Wilkie had,
again in his own words, "the head and hands
painted, and the figure and dress entirely
rubbed in. . . . I am to take [the portrait] back

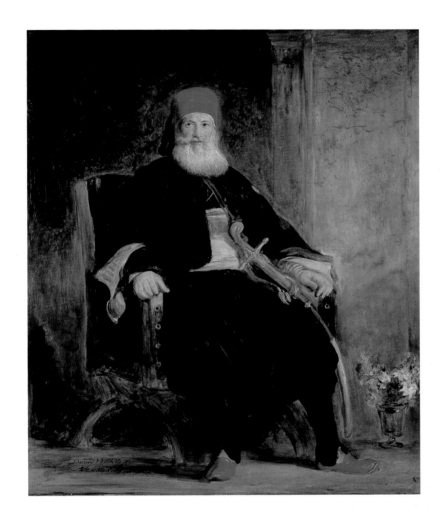

46. Mehemet Ali

to England there to be finished, framed, and sent back to his Highness." A London newspaper reported in September that the portrait was sent to the sitter, with a price of 200 guineas, and that it was returned by him. On the whole this seems unlikely.

The portrait was seen in London in December 1841 by C. R. Leslie, who described it as "somewhat sketchy, but beautifully painted." When it was exhibited in 1842, a commentator considered understandably that, unlike the portrait of Abd-ul-Mejid, it had been completed by Wilkie.

Comments

Mehemet Ali (1769–1849) was established as the Turkish pasha of Egypt in 1806. He revolted in 1831, overrunning Palestine and Syria. Four European powers, including Britain, were involved in the resistance to his military prosperity, which collapsed suddenly with the surrender of his Syrian citadel at Acre in November 1840. It was this event that allowed Wilkie to leave Constantinople for the regained territories. After compromise between the European powers and the Sultan of Turkey, Mehemet Ali was restored to the pashalic of Egypt in February 1841. These occurrences brought him a great deal of attention in Europe, where reports of his social and economic reforms, including the revival of Alexandria, caused admiring surprise. In his seventies when Wilkie saw him, he was "fond of receiving travellers, whom he overwhelms with questions."

Wilkie wrote of the sitter: "His Highness is an interesting character . . . and I think makes the best portrait I have met with in my travels." In the year when the portrait was painted, Mehemet Ali was thus described: "His stature is undersized [5 feet 2 inches], and his figure . . . is now rather stooped, and corpulent. . . . He has . . . [a] lofty forehead and aquiline nose, with the flexible brow, so strongly indicative of quick changes of thought and passion." A year earlier his surgeon drew attention to his prominent and open forehead, markedly curved eyebrows, deeply-seated, light chestnut eyes, the nose a little flat at the end, small mouth, upward-curling mustaches, the beard white and not thick, small hands and feet—adding that his headgear was generally inclined toward the right.

News of the portrait reached the London press by 19 May 1841 (on which day Turner also wrote of having heard of it)—that is twelve days after the first of the sittings. When it was posthumously exhibited at the Royal Academy an appreciative critic remarked: "It was a refined piece of coquetry . . . to introduce the glass full of innocent flowers so near the sword point of the peremptory Lion of Alexandria."

Drawing
London, Victoria and Albert Museum (lithographed in Nash 1843, title page).

Catalogue of Drawings

47. A Scene from "The Gentle Shepherd"

Ink and watercolors on card: 9⁷⁄₁₀ × 13 in. (24.5 × 33 cm.)
Inscribed on the backing: *Designed and Drawn by David Wilkie Esqr. R.A. when a schoolboy at Pitlefsie, and, along with some others, presented by Mifs Helen Wilkie, his sister to I. D. Kirkcaldy in 1807.*
Lent by the Kirkcaldy Museum and Art Gallery.

Provenance
Helen Wilkie; I. D. Kirkcaldy.

Literature
Cunningham, 1:49–50, 70.

Exhibitions
St. Andrews and Aberdeen 1985 (2).

The inscription would date this watercolor to before 1797, thus establishing it as one of Wilkie's very earliest drawings. It is presumably the "scene from the Gentle Shepherd, in watercolours, drawn when he was at school," described by Cunningham. Allan Ramsay's pastoral drama *The Gentle Shepherd* (1725) was among Wilkie's favorite reading as a boy. He used the 1788 edition with illustrations by David Allan, whose use of color, style of narrative, and characteristic spindly figure types in his own Scottish vernacular subjects have strongly influenced Wilkie in this drawing.

Wilkie painted the same subject, from Act 3, scene 2, of *The Gentle Shepherd*, in an oil sketch of 1802. Cunningham describes the scene thus: "Sir William returning from exile in the guise of a seer or spaeman, finds his only son, who had been for safety educated in ignorance of his birth by Symon and Elspa, dancing in a group of rustics, and offers to tell his fortune."

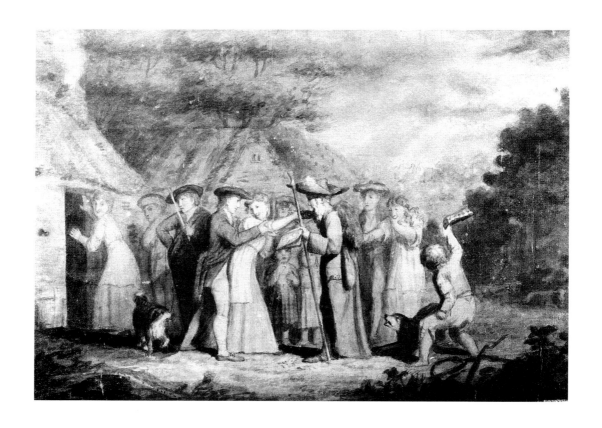

47. **A Scene from "The Gentle Shepherd"**

48. Sketch for "Pitlessie Fair"

Black chalk; 13 1/10 × 11 2/5 in. (33.2 × 29 cm.)
Lent by the National Gallery of Scotland.

Exhibitions
Edinburgh 1975 (1b); London 1986.

The only surviving composition sketch for
Pitlessie Fair (see cat. no. 4), this drawing is
related to the left side of the picture. Addi-
tional sketches of figures and cattle appear on
the reverse. The exhibited side presumably
belongs to an early stage in the evolution of the
composition, when Wilkie was working out the
general deployment of a large crowd of figures.
His habit of building up his designs section by
section, working across the composition, was
evidently already established. In comparison to
similar designs for subsequent pictures, however,
this drawing is extraordinarily vague and
uncoordinated, lacking all definition of light
and shade as well as any attempt to identify or
isolate focal characters and gestures. Yet mean-
while Wilkie was apparently already making
studies for individual figures, collecting a cast
of characters from local people, some of whom
he sketched in church on the flyleaves of his
Bible (National Library of Scotland) — the
kind of practice only followed in the future
when he had a much clearer idea of where they
might fit into the design. The jumbled crowd of
figures sketched here bears no relationship to
the painting, although the disposition of the
buildings was retained in it. The background of
Pitlessie village was studied in a large drawing
also in the National Gallery of Scotland.

Wilkie's early drawing style, as exemplified
here, has none of the elegance and sureness of
touch of his mature hand, although it is natu-
rally more robust than his schoolboy work. The
willowy awkwardness of the figures in the *Gentle*
Shepherd watercolor has disappeared for good.

275

48. Sketch for "Pitlessie Fair"

49. Sketch for "The Village Politicians"

Pencil; 9⁷⁄₁₀ × 12⅘ in. (24.5 × 32.6 cm.)
Inscribed on verso, not in Wilkie's hand: *London 1806, and Drawn by D. Wilkie his first idea of his / first picture of the Village Politicians.*
Lent by the Visitors of the Ashmolean Museum.

A slight but fairly complete composition sketch for the picture, which, in John Julius Angerstein's words, "had all the sport of Teniers and the humour of Hogarth" (Cunningham, 1:115), and as Haydon justly observed in 1830, "changed the whole system of Art in the domestic style." The 3rd Earl of Mansfield (1777–1840), one of Wilkie's earliest patrons in London, commissioned *The Village Politicians* (private collection) on the basis of a study he saw on a visit to Wilkie's lodgings. The picture was the subject of "a great deal of cavilling about the price," the sum first named by Wilkie, but not at the time agreed to in as many words by the Earl, being fifteen guineas, but then raised to thirty by the artist following advice, and commissions for other pictures at higher prices by Sir George Beaumont and Lord Mulgrave while it was still being painted. Exhibited at the Royal Academy in 1806, it won a great *succès d'estime* (for the engraving, see cat. no. 90). Mansfield paid the thirty guineas, urged on by another of Wilkie's patrons, Samuel Whitbread (see cat. no. 11), who pleaded the artist's case with "much spirit and energy," while Wilkie consoled himself with the conclusion that "his Lordship, for the sake of getting it a few guineas cheaper, has done himself more injury than he has done me" (Cunningham, 1:110–11).

The subject is taken from "Scotland's Skaith, or the History o' Will and Jean," a ballad written by Hector Macneill in 1795. Contrary to the inscription this drawing cannot be Wilkie's "first idea," for according to Cunningham it had already preoccupied Wilkie before his move to London, and "in the early studies of the picture the range of characters was limited; and to impersonate Willie Gairlace and his tippling companions seemed his sole aim" (Cunningham, 1:112). This sketch on the other hand shows most of the principal characters present at center and left of the painting, though the Highland drovers and companions in the background and other elements farther to the right are absent or only faintly indicated. The subject matter of a heated debate around an alehouse table and the character of a newspaper reader on the far left—based on a habitué of an eating house in Poland Street where Wilkie and Haydon used to dine together—are already quite clearly worked on here, and the expressions of the protagonists, so striking a feature of the painting, have taken distinct forms. Wilkie had by now formed the habit of studying his own features for pictures, and the standing figure behind the table is apparently a caricature of himself. The psychological insights in the picture, immediately recognized, contributed greatly to its originality and showed the value of Wilkie's study of human expressions and passions, begun in Edinburgh and encouraged in London by Charles Bell's lectures.

Although this is an early example of the type of composition study Wilkie made for most of his later pictures, its style is still graceless and hesitant. Tonal definition is markedly absent. He later sketched such working designs usually in pen and ink and on a smaller scale, reserving larger sheets for more finished studies of details. Other drawings for *The Village Politicians* are in the British Museum and the Glynn Vivian Art Gallery, Swansea.

49. **Sketch for "The Village Politicians"**

50. Lady Beaumont's Maid on the Staircase at Coleorton Hall

Pen and brush in brown ink, over pencil, heightened with white, on buff paper; 3⅗ × 2½ in. (8.5 × 6.3 cm.)
Lent by Dr. D. B. Brown.

Provenance
George Shirley; John Bryson.

Exhibitions
Rembrandt Gallery 1930 (28); Edinburgh and London 1958 (55); St. Andrews and Aberdeen 1985 (11); Oxford and London 1985 (1).

In 1809 Wilkie and Haydon spent a fortnight as the guests of Sir George Beaumont at his country seat in Leicestershire, Coleorton Hall; as Haydon recalled, they "did nothing, morning, noon or night, but think of painting, talk of painting, dream of painting and wake to paint again" (*Autobiography*, ed. Tom Taylor [1853], 1:134ff.). Beaumont was an admirer of Rembrandt and was urging his guests to study effects of light and shade: "We lingered on the stairs in going up to bed and studied the effect of candlelight upon each other, wondering how the shadows would be best got as clear as they looked. Sometimes Sir George made Wilkie stand with the light in a proper direction and he and I studied the colour; sometimes he held the candle himself and made Wilkie join me." One evening Haydon, who was already planning a large picture of Macbeth for his host, "made Lady Beaumont's maid stand on the staircase with a light behind her, so as to cast a good shadow on the wall, and from her I painted an excellent study for Lady Macbeth." In a letter of 16 September 1809, Wilkie reported to Beaumont that Haydon "has put in the effect of the staircase into his picture and it suits it amazingly well" (PML, MA 1581). His own sketch, evidently made on the same occasion, is one of his earliest exercises in Rembrandtesque chiaroscuro, and manifests a new freedom of handling that would soon inform his larger drawings as well.

50. Lady Beaumont's Maid on the Staircase at Coleorton Hall

51. Study for "Blind Man's Buff"

Pen and brown ink; 5⅔ × 9¹⁄₁₀ in. (13.6 × 23.2 cm.)
Signed: *D. Wilkie*.
Lent by the National Gallery of Scotland.

Literature
Millar, 1:137, vol. 2, fig. 40; Brown 1985 (cat. no. 2, fig. 1).

Exhibitions
St. Andrews and Aberdeen 1985 (14).

This is one of two highly finished ink studies for *Blind Man's Buff* (see fig. 5 and cat. no. 91), the other being in the Castle Museum, Nottingham. The drawing closely anticipates the picture, save for the area drawn on the sheet inserted over the lower left half, in which two boys overturning a chair are omitted. The tight ink hatching, used in both studies in preference to wash to create density of shadow, is reminiscent of etching. The drawings probably predate the oil sketch in the Tate Gallery.

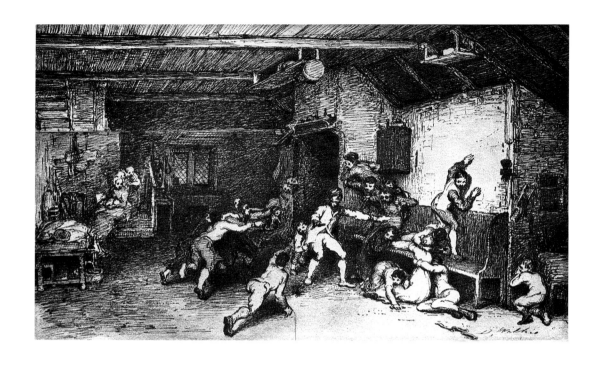

51. Study for "Blind Man's Buff"

52. Portrait of Benjamin Robert Haydon

Black chalk and pencil, heightened with white, on gray paper; 7½ × 5⅔ in. (19.1 × 13.6 cm.)
Dated: *Octbr* 30th 1815.
Lent by Dr. D. B. Brown.

Provenance
B. R. Haydon, by whom presented to Mrs. Dawson Turner, October, 1816; Dawson Turner; "J. W. B."

Exhibitions
St. Andrews and Aberdeen 1985 (20); Oxford and London 1985 (6).

An inscription in Dawson Turner's hand on the back of the original frame gives the history of this drawing: *Portrait of B. R. Haydon Esq. the author of / several works on painting, and the painter of / the Judgement of Solomon, &c., drawn by / D. Wilkie Esq. R.A. & given by Mr. Haydon / to Mrs. Turner Oct. 1816 in consequence of / the etching she had made of him from / the sketch by J. R. Davis.* This is repeated in a later hand, with the following: *The sketch was kindly bequeathed to me by M. A. T.[urner] who / entered into rest at Yarmouth, at about 2 o'clock on the 29th September, A.D. 1874. I wish / it to be possessed by W. F. R. after my death— & / I beg he will cherish it, as I have done / J W B.*

An identical drawing of Haydon in the Ashmolean has always been regarded as by Wilkie (i.e., in the 1958 Wilkie exhibitions at Edinburgh and London, and reproduced in the Harvard edition of Haydon's *Diary*, vol. 1, frontispiece). It is, however, much less sensitively drawn and must now be considered a replica, most probably by Mrs. Turner herself in preparation for her print of Haydon, made after her own drawing by Wilkie described here. Her etching after Davis's drawing, mentioned in her husband's inscription, was made in 1816.

Benjamin Robert Haydon (1786–1846), celebrated for his martyrdom to the cause of history painting that ended with his suicide, and for his *Autobiography* and *Diary*, was a close friend of Wilkie's from their student days at the Royal Academy. He at first feared Wilkie would rival him as a history painter, but this was not to be, at least for many years. Largely unsullied by professional rivalry despite Haydon's occasional bouts of jealously, their friendship only cooled over the issue of money borrowed by Haydon. Even so, Haydon always remained attached to the "cold, calculating, cautious, clear-headed Scotchman" (*Diary* 1:65), and went into a deep and self-recriminating depression at his death.

The two painters visited Devon and Coleorton in 1809 (see cat. no. 50). Five years later, in 1814, they traveled to Paris, and the following autumn they spent a holiday together at Brighton. Haydon, himself "determined on a change to the sea," invited Wilkie to join him "as [he] had met with a singular character . . . the Rev. Mr. Douglas author of 'Naenia Britannica', an antiquary and an original" (*Autobiography* 1:314). Haydon arrived early in October and a letter from Wilkie to Haydon of the fourteenth speaks of joining him four or five days later; they returned to London on the thirtieth. This profile, drawn on the last day of the holiday, must have been in tune with Haydon's own idealized image of himself; it shows the rather long and undressed hair that he affected as a young man, in imitation of portraits of Raphael.

52. **Portrait of Benjamin Robert Haydon**

53. **Benjamin Robert Haydon Asleep**

Black chalk heightened with white; 4¾ × 7½ in.
(12.1 × 19 cm.)
Inscribed: *Sir David Wilkie,* and *a drawing of Sir David
Wilkie of B. R. Haydon asleep. Lodging Clarence Place at
Brighton* 1815.
Lent by the National Portrait Gallery, London.

Provenance
F. A. White.

Drawn during the same holiday at Brighton,
this more intimate study of Haydon asleep, still
wearing his spectacles, forms an amusing
contrast to Wilkie's formal profile portrait. It is
also, however, a reminder that Haydon's "eyes
from imprudent work had again given away"
and "feared the blessed light of heaven"
(*Autobiography* [1853], 1:314, 317).

Sir David Wilkie

a drawing of Sir David Wilkie of B. R. Haydon asleep. Lodging Charming Place at Brighton 1815.

53. **Benjamin Robert Haydon Asleep**

54. **Study of a Female Nude**

Black and red chalks, heightened with white, on buff paper; 12⅗ × 10⅗ in. (32 × 27 cm.)
Signed in ink: *D. Wilkie.*
Lent by the Visitors of the Ashmolean Museum.

Provenance
Wilkie Sale, Christie's, 25 April 1842, lot 8; Percy Moore Turner.

Exhibitions
Rembrandt Gallery 1939 (31); St. Andrews and Aberdeen 1985 (45); Oxford and London 1985 (58).

After his student days, and his very early *Diana and Callisto* (see cat. no. 1), the nude was not the preoccupation for Wilkie that it was for his friend William Mulready, who drew from the model throughout his career. Wilkie only very occasionally painted the nude, for example in a pair of small panels of *Susannah* and *Bathsheba Bathing*, dated 1815, and perhaps the two "Academy figures" about which Wilkie wrote to his frame-maker that year (private collection, San Francisco). This drawing may well be associated with these as its precise and immaculate handling in Rubensian "trois crayons" argues for a date rather considerably earlier than the nude drawings of 1840 (see cat. no. 85).

54. **Study of a Female Nude**

55. View of Cults

Watercolors on card; 6⁷⁄₁₀ × 10⁷⁄₁₀ (16.9 × 27.2 com.)
Signed in ink: *D. Wilkie / f. 1817*.
Lent by the Visitors of the Ashmolean Museum.

Provenance
David Wilkie, the artist's nephew; Gilbert Davis;
Francis Falconer Madan.

Literature
Cunningham, 1:480.

Exhibitions
Edinburgh and London 1958 (62); Oxford and London
1985 (7).

Cults, Fife, was Wilkie's home village. Wilkie
visited Scotland late in the summer of 1817
and was at Cupar at the end of September. His
intention was to refresh his art with imagery
drawn from his own roots, which he was
conscious of forgetting in London. As a result
of that visit, Wilkie produced drawings of
Scottish characters like *Blind Alick* (Ashmolean
Museum; fig. 35) and of customs like *Tent
Preaching at Kilmartin* (Christ Church College,
Oxford) as well as this relatively unusual
finished watercolor. Various views of Cults are
recorded. Cunningham owned some sketches of
the village in a folio of drawings done by
Wilkie when a boy, circa 1797–98 (Cunning-
ham, 1:19, 21ff.). These must have provided
the foundations for the first of two views of
Cults exhibited at the British Institution in
1842: (1) *E. of Church and Manse of Cults as
they appeared in 1792 — drawn from recol-
lection*, and (2) *W. of Church as they now
appear* (both belonged to the Wilkie family).
Wilkie's style as a landscape watercolorist is
here seen to be conventional, and somewhat
reminiscent of Thomas Girtin. Another
drawing of the countryside of Fife, rather more
freely handled, is at the Yale Center for British
Art.

55. View of Cults

56. **Portrait of the Dowager Duchess of Buccleuch**

Black and red chalks; 11 × 8 in. (27.9 × 20.3 cm.)
Inscribed (on separate label): *Elizabeth Duchess of Buccleuch by D. Wilkie 1819. Ditton.*
Lent from a Private Collection.

Literature
Cunningham, 2:16.

Exhibitions
Edinburgh and London 1958 (58).

On 25 January 1819 Wilkie "Went by coach to Ditton to make a sketch of the Duke of Buccleuch for Geddes . . . Made a drawing of the Duke in black, red and white chalk; and also of his mother, the Dowager Countess, a very fine old lady." The portrait of the 4th Duke is in the Ashmolean (Brown 1985, cat. no. 24). Rather reminiscent of Ingres, Wilkie's use of chalks in the portrait of the duchess is particularly bold and mature. Both drawings were perhaps made for Wilkie's friend Andrew Geddes (1783–1845), a painter and etcher who may have intended to reproduce the portraits. (For Geddes's portrait prints, including those after Wilkie, see C. Dodgson, *The Etchings of Sir David Wilkie and Andrew Geddes* [The Print Collector's Club, 1936], 29ff.) Elizabeth, wife of Henry, 3d Duke of Buccleuch, died in 1827, and her son died in Lisbon very soon after Wilkie made his drawings.

56. **Portrait of the Dowager Duchess of Buccleuch**

57. Sketch for "Chelsea Pensioners Reading the Gazette of the Battle of Waterloo"

Pen and brown ink; 8 × 6¾ in. (20.3 × 17.2 cm.)
Lent by the Visitors of the Ashmolean Museum.

Exhibitions
Oxford and London 1985 (23).

Free and fluent in its penmanship, this sheet is typical of the countless studies of groups of figures that Wilkie made for many of his pictures and throws interesting light on the way he developed his compositions section by section. The majority of the eighty or more drawings surviving for *Chelsea Pensioners* are slight trial-and-error sketches such as this.

In his oil sketch of 1818 (see cat. no. 22) Wilkie included a "man with ophthalmia" at the right of the composition (Cunningham, 2:18), but in July 1819 the Duke of Wellington objected to the figure. It must have been then that Wilkie began planning to replace it with the Sergeant of the Oxford Blues who, with his wife and small child, and an associated figure of a woman tiring her hair, preoccupied him through a long sequence of drawings. This sheet shows two alternative ideas for the sergeant and child, together with the woman dressing her hair in the rather brazen attitude, facing almost to the front and wearing a low-cut dress, that recurs in a number of sketches in Oxford and elsewhere. In time Wilkie himself rejected this motif as too prominent and likely to distract attention from the central incident of the reading of the dispatch. In the painting he turned the sergeant to the front, with his head looking into the picture, and made him hold the child aloft to see the dispatch-reader better, while amalgamating the two female figures drawn here, placing the woman tiring her hair on the chair in front in the profile position of the sergeant's wife. However, the woman's pose was obviously one of which

Wilkie was especially proud, for it recurred on a larger scale in one of his finest drawings (see cat. no. 60) and in *The Cottage Toilet* of 1824 (Wallace Collection, London; fig. 13).

57. **Sketch for "Chelsea Pensioners Reading the Gazette of the Battle of Waterloo"**

58. Going to the Drawing Room, Holyrood House

Pen and brown ink; 11⅕ × 17⁷⁄₁₀ in. (28.5 × 45 cm.)
Signed and dated: *D. Wilkie 1822*.
Lent by the National Gallery of Canada, Ottawa.

Provenance
The artist's sale, Christie's, 25 April 1842, lot 68,
bought by Nieuwenhuijs, £10—10.

Exhibitions
Detroit and Philadelphia 1968 (139).

With the royal commission that would materalize into *The Entrance of George IV at Holyrood House* (see fig. 20 and cat. no. 32) in mind, Wilkie made a number of drawings while in Edinburgh in 1822. In court dress, "with hair-powder and all the et-ceteras," he watched the King's arrival at Holyrood from a privileged vantage point, but although the procession to the palace was "exceedingly fine," he thought the presentation itself "was not arranged with sufficient regard to the importance of it" (Cunningham, 2:84–85). This disappointment perhaps colored his drawings, and Sir Robert Peel, to whom he showed them on his return to London, "did not think them capable of making a picture" (ibid., 96). Subsequently, Wilkie's protracted difficulties over the picture were to spring from his search for a suitably significant and emphatic composition, and a grand historical style to match.

Although it shows a different occasion during the royal visit, this design contributed several elements to the final picture, chiefly the horse and the Highlander with the shield. Wilkie's subject is the arrival of guest at the levee at Holyrood described by him in an uncharacteristically lively letter to Perry Nursey: "The drawing room was extremely interesting, the dresses were as splendid and as well put on as any assemblage at St. James's, in jewels and diamonds however it fell far short of it. . . . The drawing room itself was very imposing. I saw the Ladies enter one by one with their trains sailing as they advanced to his Majesty, and to see their faces as they approached was truly curious, the sort of flutter and change of colour, the evident terror they were in, and at the same time the sort of beauty of behaviour that all of them instinctively showed on being saluted by the King made it really one of the most interesting sights that could be witnessed" (BM: Add. MS 2999:1 3 34–35).

Staying with his friends the Gordons at Niton on the Isle of Wight in October the same year, Wilkie made three drawings of the Drawing Room; dated October 7 (Huntington Art Gallery, San Marino), October 10 (Royal Collection, Windsor; Oppé, 664, repr. pl. 103), and October 14 (Tate Gallery). In view of the similarity of handling, especially in the use of hatched shading rather than wash, the Ottawa drawing may well derive from the same period; it is clearly not a drawing made on the spot, but a development from a more condensed sketch dated *Edinburgh* 1822 (Oxford, Ashmolean Museum). That autumn Wilkie was still undecided as to which Edinburgh subject to choose; in November he told Nursey he had made "multitudes of sketches, with the King and without the King, but as yet without hitting on anything to satisfy me" (BM: Add MSS. 2999:1/36–37). Probably the Drawing Room sketches were made as much to seek his host's advice as to describe what he had seen; and as Quartermaster-General, Gordon had access to the King through the Duke of York (cf. Miles 1981).

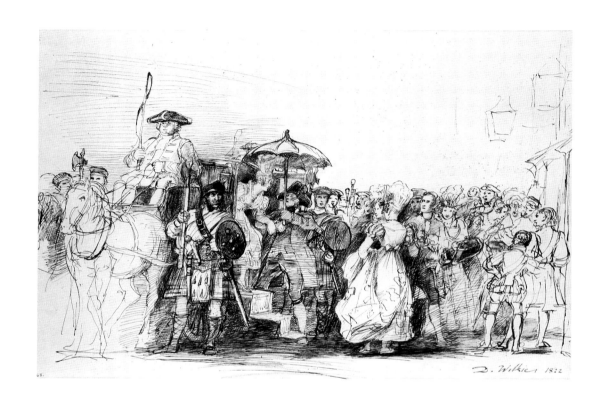

58. **Going to the Drawing Room, Holyrood House**

59. **Study for the Duke of Hamilton**

Black and some red chalk on gray paper; $17\frac{1}{5} \times 12\frac{2}{5}$ in. (43.7×31.5 cm.)
Lent by the Visitors of the Ashmolean Museum.

Provenance
? Wilkie Sale, Christie's, 27 April 1842, lot 357: Percy Moore Turner.

Literature
Millar, 1:142, fig. 55.

Exhibitions
Rembrandt Gallery 1939 (25); Edinburgh 1975 (4j); St. Andrews and Aberdeen 1985 (33); Oxford and London 1985 (33).

A study for the pose of the Duke of Hamilton in *The Entrance of George IV at Holyrood House* (see fig. 20 and cat. no. 32). Alexander, 10th Duke of Hamilton (1767–1852), was hereditary Keeper of Holyrood House, and knelt to present the Key of the Palace to the King. He appears in the picture in essentially the same pose as he does in this drawing, wearing full Highland dress and the tartan of the Earls of Arran. These particulars are not apparent in the drawing; nor are the Duke's features, which Wilkie studied in an oil sketch now at Lennoxlove (repr. by Millar, fig. 54). A similar pose for the Duke of Argyll in *The Entrance* is at Windsor (Oppé, 665). The pose drawings were perhaps made from recollection—their size leaves no possibility of their having been made on the spot—during Wilkie's stay in Edinburgh in 1822. The oil sketch of Hamilton's features, along with the portrait study of the Earl of Morton (see cat. no. 62), was probably made during Wilkie's visit to Scotland in 1824.

59. **Study for the Duke of Hamilton**

60. A Woman Tiring Her Hair

Black and red chalks touched with ink, over indications in pencil on buff paper; 13⅔ × 10⅔ in. (34 × 26.5 cm.)
Lent by the Visitors of the Ashmolean Museum.

Provenance
Wilkie Sale, Christie's, 25 April 1842, lot 83, bought by Thomas Wilkie, the artist's brother, £10—10; Percy Moore Turner.

Literature
E. Croft-Murray, *Burlington Magazine* 74 (1939): 91; Campbell (1971), 418, pl. 6

Exhibitions
British Institution 1842 (˚19); Edinburgh and London 1958 (68); St. Andrews and Aberdeen 1985 (26); Oxford and London 1985 (32).

As already remarked (see note to cat. no. 57), the figure of a girl tiring (adorning) her hair had been a problematical element in *Chelsea Pensioners* (see cat. no. 23). Though recognizing that her more frontal pose was too assertive for the picture, Wilkie was obviously particularly proud of it. He had a tendency to construct compositions on designs already tried and tested, and the figure was laid aside, to reappear as the chief protagonist in *The Cottage Toilet*, evidently begun in 1823 for the Duke of Bedford and signed and dated the following year (Wallace Collection, London; see fig. 13). For this painting Wilkie returned to a favorite text, Allan Ramsay's *Gentle Shepherd* (see cat. nos. 25 and 47), taking for his inspiration the lines

> While Peggy laces up her bosom fair,
> Wi'a blue snood Jenny binds her hair;
> Glaud, by his morning ingle, takes a beek;
> The rising sun shines motley thro' the reek . . .

The drawing was first connected with *Chelsea Pensioners* by Croft-Murray and has usually been discussed in relation to it by subsequent commentators (e.g., Mrs. Campbell). This writer, however, believes it to have been drawn later, from life, as a development from the slighter sketches for the *Pensioners*, to portray Ramsay's Jenny in *The Scottish Toilet*. The lighting comes mainly from the left, and there is a strong shadow behind the figure, as happens in the later picture. The connection is further confirmed by the drawing's description in the Wilkie Sale as a "Study from the Gentle Shepherd." (See also Brown, in exh. cat., Oxford and London 1985).

As a finished and large-scale study for a single figure, the drawing might be compared to that of the Earl of Morton (see cat. no. 62). However, its handling is rather more delicate, the contours of the figure, especially of the upper body and arms, being as finely and sensitively outlined as the features; the explosive outbursts of heavier chalk around Morton's face are matched here only in the folds of the skirt; and even the shading of the background is more subtly achieved. The very faint initial outlines are in pencil, and the ample curves of the figure—which manifests a sensuality rare in Wilkie's work—are modeled in both hatching and fine stippling. Large areas of the paper are left bare to contribute to the variety of tone. Wilkie's mastery of contrasted chalks, in a tradition going back to Rubens, is seen here at its most refined.

60. **A Woman Tiring Her Hair**

61. The Greenwich Pensioner

Black chalk and watercolors; 14¾ × 9⅗ in.
(37.5 × 24.3 cm.)
Signed and dated: *D. Wilkie 1823*.
Lent by the National Gallery of Scotland.

Provenance
Edward Hawke Locker, Windsor (d. 1849).

Literature
Cunningham, 2:106–7.

Exhibitions
R.A. 1824 (445; "A study for Commodore Trunnion,
made in Greenwich Hospital"); Edinburgh and London
1958 (66); Detroit and Philadelphia 1968 (140).

Cunningham relates that during his protracted
labors on *The Entrance of George IV at Holyrood
House*, Wilkie began to seek refuge in
"sketching favourite heads and subjects, which
till now he found no time for. The Commodore
Trunnion of Smollett [from *Peregrine Pickle*] had
long haunted his fancy: and one day, on a
chance visit to Greenwich, he happened to
observe the looks of a singular old man-of-war's
man, and prevailing on him to sit, touched his
face into such a one as his fancy had
bestowed. . . . This he modestly called a
portrait of a Greenwich Pensioner, though it
rises out of the region of portraiture."
 Wilkie's drawing does not really epitomize
Smollett's Trunnion, a brave if temperamental
warrior who lost an eye and also a heel in
service, and his own title implies that he recog-
nized that the image was not complete. Despite
Cunningham's claims this is a tour de force of
direct and spontaneous portraiture, tran-
scendent in its penetrating characterization
rather than in its literary realization. The bold
and sweeping handling of the chalk, and the
vividness of color, scarcely matched outside
Wilkie's last Eastern drawings, put it in a class
apart. It is arguably the finest of all Wilkie's
drawings, showing him looking forward to
Degas rather than, as was more often the case,
back to Rubens and Rembrandt. It is one of
the few drawings Wilkie saw fit to exhibit; the
previous year the chalk portrait of his relative
George Young, in the character of one of the
Amsterdam brethren of St. Luke, was shown at
the Royal Academy.

Engraving: Aquatint by F. C. Lewis (1779–1856),
1826.

61. **The Greenwich Pensioner**

62. The Earl of Morton Carrying the Scottish Sword of State

Black and some red chalk, with water and body colors:
9⅘ × 14⅗ in. (50.3 × 37 cm.)
Lent by the Visitors of the Ashmolean Museum.

Provenance
Wilkie Sale, Christie's, 25 April 1842, lot 348⁻; J. C. Robinson (?); J. P. Heseltine (Lugt 1508); Sotheby's Sale, 29 May 1935, lot 374.

Literature
Cunningham, 2:122; Millar, 1:142; Brown, *Country Life* (1985), 375 repr.

Exhibitions
Edinburgh 1958 (46); Edinburgh 1975 (4h); St. Andrews and Aberdeen 1985 (32); Oxford and London 1985 (34).

George Douglas, 16th Earl of Morton (1761–1827), carried the Scottish sword of state on the occasion of George IV's entrance at Holyrood in 1822. He appears in *The Entrance* on horseback, somewhat obscurely toward the left rear of the composition, but the drawing shows a standing position. It was made on Wilkie's return visit to Scotland in 1824 to assemble further material for the picture; at that time, he also made studies of the Honors of Scotland, including the sword. On September 26 he wrote to his sister: "My labours in Edinburgh are now complete. I have been nearly four weeks here. . . . have painted . . . the crown, sceptre, and sword of state in the Castle. In addition, I have made a drawing of the Earl of Morton for the picture."

Although purely functional, this portrait ranks with *The Greenwich Pensioner*, exhibited in 1824 (cat. no. 61), as one of Wilkie's most magnificent drawings. The tense counterpoint between the robust handling of the chalks, sometimes rhythmical and in places almost harsh in its directness and spontaneity, and the sensitive modeling and characterization of the face is exceptional in the period. Wilkie has broken entirely free of the linear constraints of neoclassical portrait drawing, and begins to foreshadow the impressionists.

62. **The Earl of Morton Carrying the Scottish Sword of State**

63. A Coach and a Crowd of Passengers

Pen and brown ink and watercolors: 9½ × 11½ in.
(24 × 29.1 cm.)
Signed: *D. Wilkie 1823.*
Lent by Alexander B. V. Johnson and Roberta J. M. Olson.

This bold and spirited drawing is somewhat rare in Wilkie's work in its observation of the contemporary urban scene. It may be compared to some of Wilkie's drawings made in Edinburgh the previous year, from which indeed it was probably a development as the man on the right seems to wear a tam-o'-shanter. However, the figures drawn here are not elegantly dressed and can hardly have been directly associated with the royal festivities, except perhaps as onlookers.

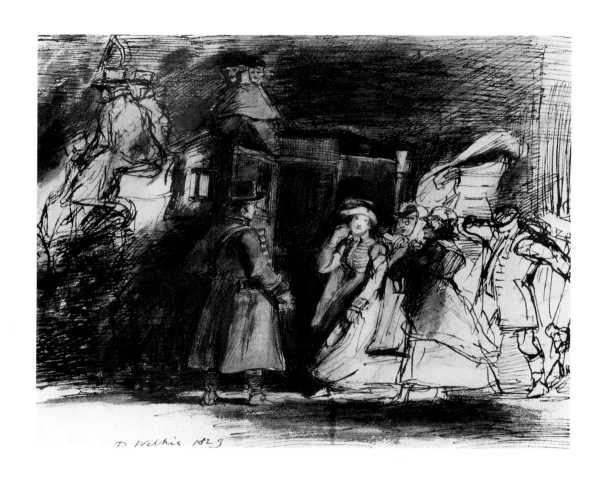

63. **A Coach and a Crowd of Passengers**

64. **Portrait of Perry Nursey**

Black and red chalks with gray and pink washes,
heightened with white, on buff paper; 14 × 11¾ in.
(35.5 × 29.8 cm.)
Signed and dated: *D. Wilkie Jany.* 10 1823.
Lent by the Visitors of the Ashmolean Museum.

Provenance
J. P. Heseltine (Lugt 1508); Sotheby's Sale, 29 May
1935, lot 376.

Exhibitions
Rembrandt Gallery 1939 (10); Oxford and London
1985 (31).

Nursey, of Little Bealings, near Woodbridge,
Suffolk, was a great friend of the Wilkie family.
Cunningham records that he 'had tried his
hand in the art of St. Luke, and was besides a
learned man' (Cunningham 2:81). Wilkie's
letters to Nursey are collected in *The Academy*
14, 1878. Wilkie stayed at Little Bealings in
the summer of 1822, writing thence to his
sister: "Our mother is extremely well, and
appears to enjoy this place and the society of
our good friends Mr. and Mrs. Nursey,
exceedingly" (Cunningham, 2:81). It is not
known whether Wilkie returned to Woodbridge
in January 1823; on the twelfth he was
certainly at home in Kensington. Possibly he
spent a winter holiday at Little Bealings, or
drew this portrait in London—Nursey appears
in elegant town clothes, with a winter
greatcoat. The previous summer Wilkie seems
to have planned a group portrait of the Nursey
family, for which a sketch in oil on panel in the
Tate Gallery has long been regarded as a study;
the sketch, however, does not appear to include
Mr. Nursey himself.

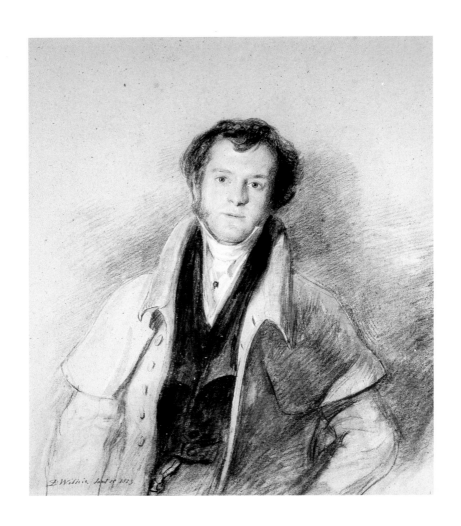

64. **Portrait of Perry Nursey**

65. **The Defence of Saragossa**

Watercolors over pencil and black chalk: 7 1/10 × 9 in.
(18 × 23 cm.)
Signed and dated: *D. Wilkie Madrid 29th Novbr. 1827.*
Lent by the Blackburn Museum and Art Gallery.

Provenance
Sir W. W. Knighton.

Literature
Millar, 1:139, repr. fig. 45.

Exhibitions
St. Andrews and Aberdeen 1985 (38).

This is a drawing for the third of the subjects
painted by Wilkie on themes from the Spanish
war of independence (see cat. no. 30). It is
typical of the small, complete, but freely
treated composition studies he drew while
abroad, apparently quite spontaneously and
without recourse to his usual profusion of trial-
and-error sketches in pen and ink. It was
followed quite closely in the picture, except for
an extension of the final composition at left to
include an additional figure of a soldier holding
a bayonet. Wilkie told his sister he was working
on the painting in Madrid the following spring
(March 31; Cunningham, 2:510). The Spanish
leader, General Palafox, had by this time been
brought to Wilkie's lodgings and had given a
sitting for the picture at the suggestion of
Prince Dolgorouki, of the Russian legation at
Madrid.

Colored drawings for two other Spanish
subjects, *The Spanish Posada* and *The Guerilla's
Departure* (Royal Collection; figs. 18 and 19),
are in the National Gallery of Scotland and at
Windsor (repr. Millar, vol. 1, figs. 41 and 46).
After the artist's death, Lord Mahon recalled
the genesis of the last drawing in a scene that
Wilkie observed in the streets of Toledo
(Cunningham, 3:521); the spontaneity of the
Saragossa study, in comparison to many of
Wilkie's earlier drawings, is the more remark-
able for its being a historical reconstruction of
an event from 1808. The purchase of both the
Saragossa and *Guerilla's Departure* studies by Sir
W. W. Knighton, at £21 and ten guineas
respectively, is recorded in Wilkie's account, 13
April 1837 (ML: in MS 308895).

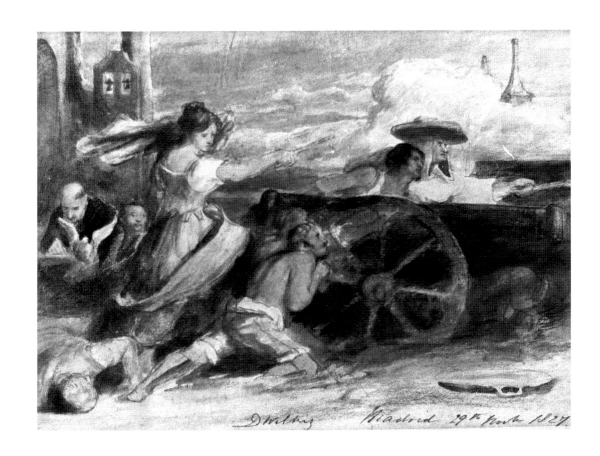

65. **The Defence of Saragossa**

66. A Young Woman and a Kid, for "Sancho Panza in the Days of His Youth"

Water and body colors over black chalk and pencil, heightened with white; 19⅕ × 12⅘ in. (48.8 × 32.5 cm.)
Signed and dated: *D. Wilkie October—1833.*
Lent by the Visitors of the Ashmolean Museum.

Provenance
Possibly B. G. Windus (Christie's Sale, 1 June 1842, lot 49).

Exhibitions
Edinburgh and London 1958 (70); St. Andrews and Aberdeen 1985 (42); Oxford and London 1985 (43).

The noble and statuesque pose of this figure —perhaps derived from Correggio's Christ in the Prado *Noli Me Tangere*, which Wilkie had copied in Madrid—and the beauty of its handling transcend the trivial incident portrayed in the picture (see cat. no. 37), just as the elegance of the *mise-en-page* goes beyond the function of the sheet as a working study. Although Wilkie had by now resumed his former practice of making elaborate studies of single figures for his pictures, those of the 1830s retain much of the breadth and simplicity of execution that his drawings had acquired during his Continental travels in 1825–28. The contours are clearly but subtly formed by a broken outline, while the drapery and shadows are more softly modeled than in drawings like *The Earl of Morton* (cat. no. 62) and even the *Woman Tiring Her Hair* (cat. no. 60). The chalks are used with greater restraint, touches of white creating the highlights while the shadows are discreetly indicated by wash instead of the energetic chalk hatching seen in earlier drawings.

A sheet of two studies of the kid is in the Ashmolean (Brown 1985, no. 44 repr.); a slight but vigorous sketch for the figure of Sancho with a pail is also in the Forbes Collection; and a more finished study of Sancho, comparable to the exhibited drawing, was in the Hart Sale, Christie's, 28 November 1927, lot 41, bought by Martin.

66. A Young Woman and a Kid, for "Sancho Panza in the Days of His Youth"

67. Portrait of the Artist's Sister Helen

Watercolors over black chalk; 18⅘ × 13¾ in.
(47.7 × 34.9 cm.)
Signed and dated: *D. Wilkie Decbr.* 1833.
Lent by the Visitors of the Ashmolean Museum.

Provenance
David Wilkie, the artist's great-great-nephew.

Exhibitions
Edinburgh and London 1958 (73); St. Andrews and
Aberdeen 1985 (44); Oxford and London 1985 (41).

This is one of Wilkie's most highly finished
large-scale chalk drawings. The artist's sister is
fashionably dressed in town clothes. Miss
Wilkie's first fiancé died in 1824, and she
remained the artist's devoted companion in
Kensington until his death, afterward marrying
Dr. William Hunter, surgeon-major in the
Coldstream Guards. She served as a model for a
number of Wilkie's pictures, and there are
portraits on panel in the Ashmolean (Brown
1985, no. 40 repr.), the National Gallery of
Ireland, Dublin, and the National Gallery of
Scotland—the last traditionally assumed, on
no particular evidence, to have been painted at
Perry Nursey's house at Woodbridge, in
1822–23.

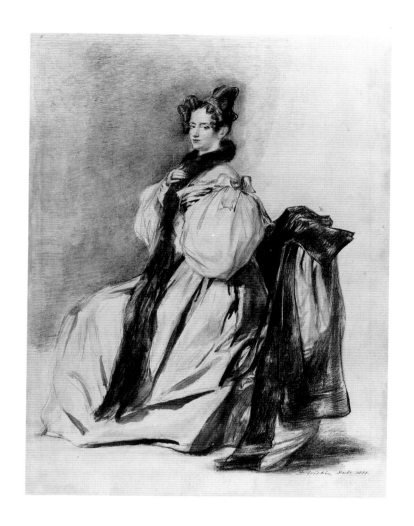

67. **Portrait of the Artist's Sister Helen**

68. The Hamilton Children

Black and red chalks and watercolors, heightened with white; 23⅕ × 18½ in. (59 × 47 cm.)
Signed and dated: *D. Wilkie f. Jany 7th 1835.*
Lent by the Minneapolis Institute of Arts.

Provenance
Lubrano Sale, Naples, 7–11 March 1932, lot 212;
Herbert Bier.

The subjects of this large and quite highly finished portrait have not been identified. They were presumably drawn in London, for Wilkie seems to have been at home in Kensington in early January 1835. Wilkie was by this time more actively involved in portraiture than formerly.

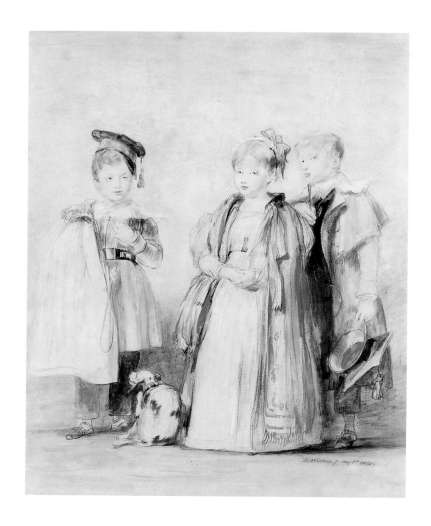

68. **The Hamilton Children**

69. A Young Man Sleeping, for "The Peep-o'-Day Boy's Cabin"

Black and red chalks heightened with white;
16½ × 11⅝ in. (41.8 × 29.6 cm.)
Lent by the Visitors of the Ashmolean Museum.

Provenance
A.P. Oppé

Literature
Cunningham, 3:100.

Exhibition
Oxford and London 1985 (47).

While in Ireland in 1835 Wilkie made various studies of figures and subjects for future pictures including *The Peep-o'-Day Boy's Cabin* (cat. no. 39). Among them was a study of a Peep-o'-Day Boy, which was perhaps identical with this drawing, or at least its initial inspiration. It may further be identified with one of several sheets in the 1842 Wilkie Sales: "The Peep o' Day Boy," lot 159 on April 26, or the "Figure for the Peep o'Day Boys," a chalk drawing, lot 326K on the following day. This is a very slight sketch save for the head, which is most expressively worked up in Wilkie's most delicate later manner. On the verso is a slight sketch in chalk and wash for the boat in the foreground of *Mary Queen of Scots Escaping from Loch Leven Castle* (see cat. nos. 74 and 75, and fig. 22). Wilkie's other Irish drawings included complete renderings of incidents that had impressed him, in a broad and free style similar to his Spanish drawings; examples are *The Elevation of the Host* and *The Irish Baptism*, both in the British Museum.

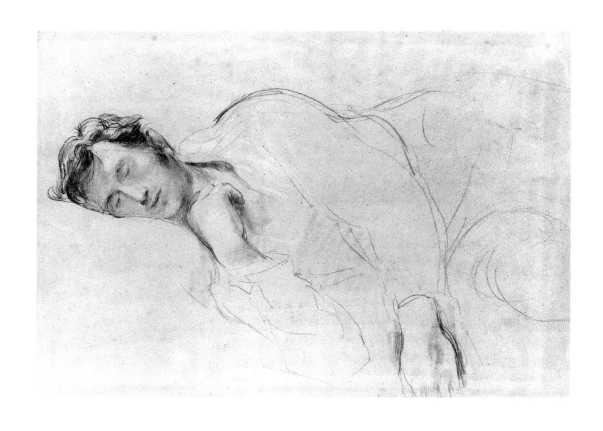

69. A Young Man Sleeping, for "The Peep-o'-Day Boy's Cabin"

70. **Study for "The First Ear-ring"**

Black chalk, water and body colors on buff paper;
21⅗ × 15⅛ in. (54.8 × 38.5 cm.)
Lent by the Yale Center for British Art, Paul Mellon
Fund

Provenance
Christie's Sale, 1 March 1977, lot 102.

No doubt because its effect depended so much
on the expressions of the characters, *The First
Ear-ring* (cat. no. 38) occasioned some particu-
larly large and splendid figure drawings whose
differences can at first glance appear very
subtle. The composition was worked out in
drawings now in the Huntington Library, San
Marino, and in a large and very refined chalk
study, dated 3 July 1834, now in the Tate
Gallery. The child, whose expression of
mingled innocence, apprehension, and incipi-
ent vanity is the key to the picture, is the focus
of several sheets. A highly finished colored
drawing for her, dated 1833, is in the Art
Museum, Princeton University (see fig. 45). It
shows her left hand clinging to a cloth or
shawl, but in this presumably later study it has
been joined with her right to clutch nervously
at the arm of her mother who stands behind
her in the picture; the hand of the older
woman piercing the ear is also visible. The
child's expression here is more intense and
touching than it is in the Princeton study, and
in its heightening with white and soft rubbings
of black chalk on buff paper, the sheet goes
further in its exploration of tonal values. A
drawing for the girl's head is in the British
Museum; one for the attendant was formerly
with Messrs. Colnaghi, London; and a study
for the dog, whose sympathetic expression
shows empathy with the girl's experience, was
on the art market in London and New York in
1978. See also the following.

Fig. 45 Wilkie, *The First Earring*, The Art Museum,
Princeton University

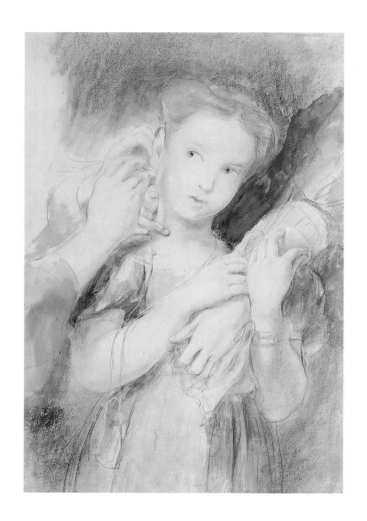

70. **Study for "The First Ear-ring"**

71. Study for "The First Ear-ring"

Black and white chalks and watercolors over pencil, on brown paper; 21⅝ × 14½ in. (55 × 36.7 cm.)
Signed and dated: *D. Wilkie / June* 1834.
Lent by the Syndics of the Fitzwilliam Museum.

Particularly freely and expressively drawn, this study concentrates on the intent and solicitous expression of the woman piercing the ear. The little girl is only lightly sketched, but Wilkie has devoted some attention to the background of the room and its patterned and paneled walls. The chalks stand out strongly against the brown paper.

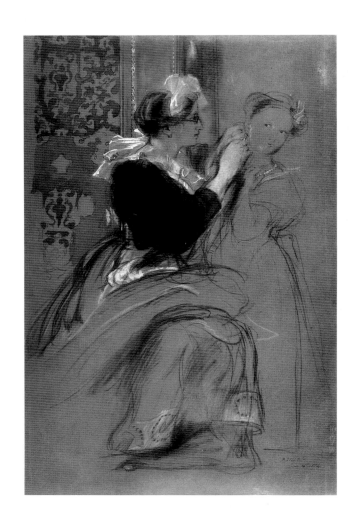

71. Study for "The First Ear-ring"

72. The Burial of the Scottish Regalia

Pen and ink and watercolors over black chalk;
12⁷/₁₀ × 8⅞ in. (32.2 × 20 cm.)
Lent by the Hunterian Art Gallery, University of
Glasgow.

Exhibitions
St. Andrews and Aberdeen 1985 (47).

In March 1652 the Scottish regalia was buried
in Kinneff church to protect it from seizure by
Cromwell's troops. Later, following the Act of
Union in 1707, it was returned to Edinburgh
Castle and placed in an oak chest. Unfortu-
nately lost or forgotten, it was rediscovered
through the intervention of Walter Scott, in
1817. Its reappearance led to great rejoicing in
Scotland, and wherever possible it was involved
in the ceremonial for George IV's visit to Edin-
burgh in 1822, the sword of state, for example,
being carried by the Earl of Morton and
included in Wilkie's drawing of him (cat. no.
62). The sword is also studied in a separate
sheet with the orb and scepter (Cunningham,
2:122).

A drawing of the regalia being unveiled from
beneath a cloth by a group of soldiers, in the
Scottish National Portrait Gallery, is dated
1828. It may perhaps be associated with a
projected picture of the rediscovery, but in view
of its considerably earlier date, and horizontal
format, cannot be regarded as a companion to
the subject of the *Burial*, which Wilkie seems
never to have worked up into a finished
painting. But he did address the subject in an
oil sketch (private collection) and in two quite
highly finished composition drawings, of which
the example in the National Gallery of
Scotland is dated 1835 or 1836.

This Rembrandtesque scene by lamplight has
features in common with *Baird Discovering the
Body of Tippoo Saib* (cat. no. 42), on which

Fig. 46 Wilkie, *The Burial of the Scottish Regalia*,
1835–36, National Gallery of Scotland

Wilkie was working at the same time, and like
the studies for that picture, the drawings for the
Regalia recall Rembrandt in both composition
and technique. The drawing in the National
Gallery of Scotland (see fig. 46) is somewhat
more finished, the background being filled in
with the church wall—and achieves greater
compositional concision through the omission
of one of the figures and the adjustment of the
position of the hound, which leads the eye to
the center of events. See also the following.

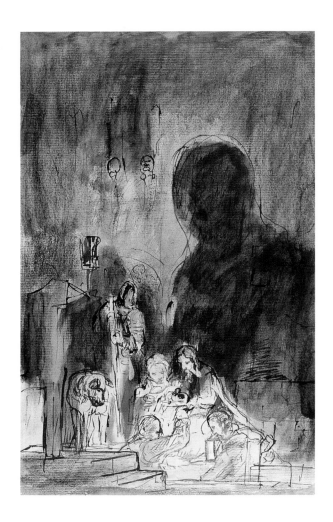

72. **The Burial of the Scottish Regalia**

73. Study of Two Figures, for "The Burial of the Scottish Regalia"

Black, red, and colored chalks, heightened with white,
brown wash, on light brown paper; 41$\frac{7}{16}$ × 18$\frac{7}{16}$ in.
(36.7 × 46.9 cm.)
Lent by Charles Ryskamp, New York City.

Comparable to the large studies of figures for
Baird Discovering the Body of Tippoo Saib (see
cat. nos. 78 and 81), this drawing was made for
the two principal protagonists in the composi-
tion sketched out in cat. no. 72.

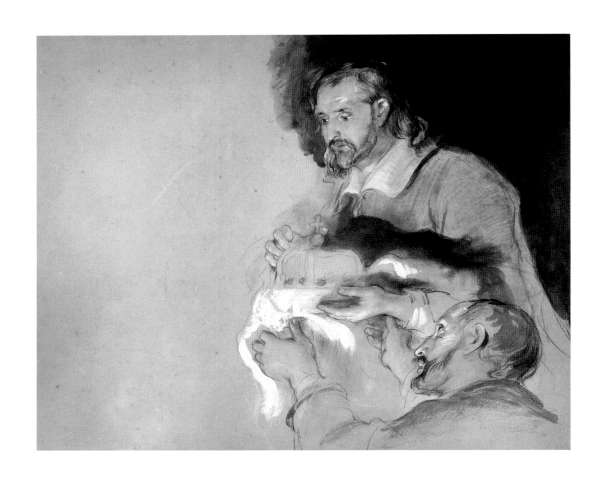

73. Study of Two Figures, for "The Burial of the Scottish Regalia"

74. A Highland Boatman and a Hand Holding a Lantern, for "Mary Queen of Scots Escaping from Loch Leven Castle"

Black chalk and pen, heightened with white:
15⅘ × 11³/₁₀ in. (40.1 × 28.7 cm.)
Lent by the City Museum and Art Gallery,
Birmingham.

Provenance
Wilkie Sale, Christie's, 27 April 1842, lot 326 L or N;
Sir Bruce Ingram.

Exhibitions
Edinburgh and London 1958 (91).

Mary Queen of Scots Escaping from Loch Leven Castle was painted for Edward Tunno and exhibited at the Royal Academy in 1837; it was last recorded in the collection of William Randolph Hearst. Episodes from the life of Mary were popular subjects with romantic artists in France as well as in England, having been inspired in large measure by the works of Walter Scott. Wilkie's own interest in Scottish history was apparent in his paintings of John Knox (see cat. no. 43) and sketches for *The Burial of the Regalia* (cat. nos. 72 and 73). In 1817, partly on Scott's advice, he had visited Mary's apartments at Holyrood with his friend William Allan. Wilkie later gave an extended critique of his fellow painter's picture of *Lord Lindsay Compelling Mary Queen of Scots to Abdicate* of 1824, which, along with Allan's *Knox Admonishing Mary Queen of Scots* of the previous year, was no doubt painted in close consultation with Wilkie. It was presumably the exhibition of Wilkie's own *Knox Preaching* in 1832 that spurred Allan to return to Marian themes with "the subject I mentioned to you, the murder of David Rizzio," finished for exhibition in 1833. Two of Wilkie's drawings dated 1836, now in the Ashmolean (Brown 1985, no. 49 repr.) and the National Gallery of Scotland, are probably variants of a projected subject of the Queen with her infant son (later James I) and a nurse. Haydon was to paint a picture of Mary showing the boy to the English ambassador, Sir Ralph Sadleir, in 1840–41 (Leeds City Art Galleries).

This drawing and the following, dated 1835, show Wilkie already well advanced with ideas for *The Escape*. The subject is the night escape of the Queen by boat from Loch Leven in 1568, with George Douglas, en route to Hamilton Palace to rally a force to her defense. It is based on Scott's account in his novel *The Abbot*. The figure drawn here is the boatman at the prow of the boat, of which a pulley from the rigging is also drawn; there is also a separate study for a hand in the same picture, and on the verso is a study for *The Empress Josephine and the Fortune-Teller*. Another drawing, for the attendant on the left of the Queen, is also exhibited (see cat. no. 75); a study for the Queen and another companion is in Birmingham; and a slight sketch for the boat is on the verso of the study for *The Peep-o'-Day Boy* (see cat. no. 69).

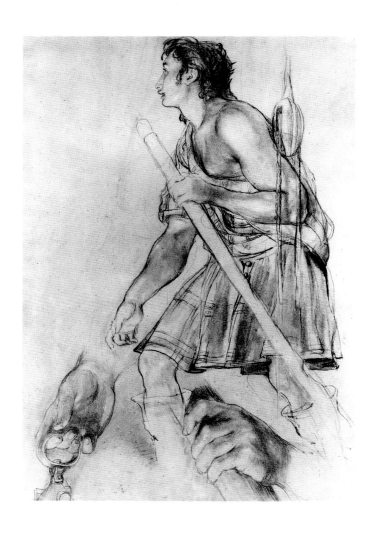

74. **A Highland Boatman and a Hand Holding a Lantern, for "Mary Queen of Scots Escaping from Loch Leven Castle"**

75. Study of a Girl, for "Mary Queen of Scots Escaping from Loch Leven Castle"

Black chalk and watercolors heightened with white;
17⅝ × 11⅝ in. (44.8 × 29.6 cm.)
Signed and dated: *D. Wilkie f 1835*.
Lent by the Visitors of the Ashmolean Museum

Provenance
Wilkie Sale, Christie's, 25 April 1842, ? Lot 326 Q.

Exhibitions
Oxford and London 1985 (48).

This finished study for the figure of an attendant at the left of the Queen in *The Escape* is another fine example of Wilkie's softer and more suggestive late style. The focus is almost entirely on the hands and face.

75. **Study of a Girl, for "Mary Queen of Scots Escaping from Loch Leven Castle"**

76. A Drummer-Boy, for "Sir David Baird Discovering the Body of Sultaun Tippoo Saib"

Watercolors, pen and ink, and black and red chalks,
heightened with white, on buff paper; 7⅔ × 7 in.
(19.5 × 17.8 cm.)
Signed and dated: *D. Wilkie Novbr. 1837.*
Lent by the Visitors of the Ashmolean Museum.

Provenance
G. T. Nicholson.

Exhibitions
Oxford and London 1985 (55).

A study for the right leg of Sir David Baird,
and the drummer-boy kneeling beside him at
the left of the composition. Also visible are the
drum behind Baird's legs, Baird's saber, the
head of the Indian who supports Tippoo's left
arm (for which see cat. no. 81), and the hand
of the figure who holds the lantern to light the
scene. The lantern itself is summarily
indicated. The drummer-boy's head is set at a
different angle in the picture. The drawing is
founded on a small ink sketch in the National
Gallery of Scotland, and must have been made
to help resolve one of the problem areas of the
composition: Wilkie had at one stage consid-
ered placing Baird's right leg up on a step and
was now accommodating adjacent figures to his
level stance on the parapet. Another study for
Baird's legs belongs to Mr. J. Grimond. The
lantern-bearer and two other figures farther to
the left are studied, on a larger scale and in
Wilkie's boldest manner, in cat. no. 78.

76. A Drummer-Boy, for "Sir David Baird Discovering the Body of Sultaun Tippoo Saib"

77. The Orderly of Sir David Baird and Three Companions

Black chalk and watercolor, heightened with white, on buff paper; 11⅓ × 16½ in. (28.5 × 42 cm.)
Inscribed on the mount: *This is a study of heads for the painting representing the discovery of the body of Tippoo Saib by Sir David Baird / Sir David Wilkie / 37.*
Lent by the Philadelphia Museum of Art: Gift of David Keppel.

Provenance
Probably Wilkie Sale, Christie's, 28 April 1842, lot 20, in the addenda of studies for Baird ("A Group of Four Heads, Coloured, very fine"); David Keppel.

Literature
Brown 1985, under no. 50.

Exhibitions
Detroit and Philadelphia 1968 (142).

This large drawing for the heads of a group Wilkie intended to place directly to the left of Baird is one of the most splendid and sensitive of his studies of human expression. Baird's orderly and the three other figures register attitudes of rapt concentration, terror, and awe that were clearly studied from specially posed models; they achieve a greater realism than the stereotypes promoted by the traditions of Le Brun and Lavater, which had provided several generations with images of the passions.

Wilkie used drawings like this as cartoons for specific areas of his picture, but did not necessarily remain bound by them. The position of the orderly at Baird's left was retained throughout—once, that is, Wilkie had settled on Baird's own position on the right of the composition, for in some drawings he was placed on the left—but the other three heads were omitted, while the orderly lost his mustache. These changes are anticipated in a watercolor of Baird and the soldiers round him, in the Witt Collection, Courtauld Institute, London. In that presumably later study, the

Fig. 47 Wilkie, *Study for Sir David Baird*, Witt Collection, Courtauld Institute

orderly's mustache has already vanished, as have the two heads on the right of the Philadelphia drawing, while the upturned head also seen here is only very faintly indicated (see fig. 47).

On 15 October 1835 Wilkie wrote to Lady Baird, "I have given to the figure of Sir David Baird more movement and command than there was in the first sketch, and more action to those around him, as if he were about to order the body to be removed to the palace" (Cunningham, 3:110). This would presumably date the exhibited drawing, for the agitated and expectant expressions of the faces would fit the motif described here.

The drawing is as much a study of lighting as of form and expression. The group at Baird's left was to be double-lit by a torch borne by a Scottish guardsman on the right and a lantern held by a kneeling man in front of the orderly. The play of light and shadow across the faces is most beautifully suggested by fine shading, white heightening, and a passage of wash to indicate the deeper shadow falling across the lower half of the orderly's face. Wilkie retained this effect in the picture (cat. no. 42). Power-

fully expressive in its characterization, this
drawing is remarkable for its technical restraint,
only two colors, orange and white, having been
added to the black chalk on paper of a
brownish hue.

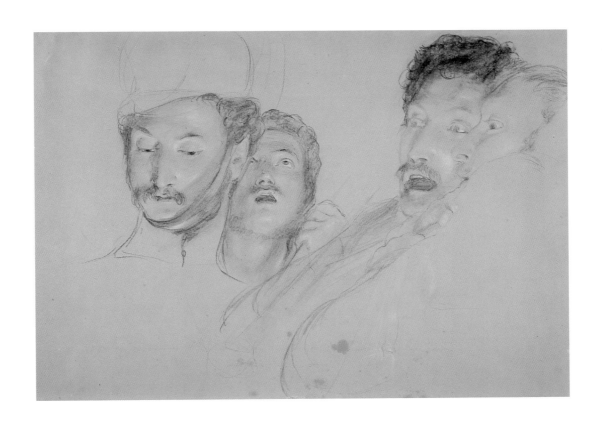

77. **The Orderly of Sir David Baird and Three Companions**

78. A Lantern-Bearer and Figures

Chalks and watercolors; 18⁹⁄₁₀ × 23 in. (48 × 58.5 cm.)
Lent by the Victoria and Albert Museum, London.

Provenance
C. T. Maud.

Literature
Brown 1985, under no. 50.

A study for four figures to the side of Baird, immediately above the slain Tippoo and below the groups drawn in cat. nos. 77 and 79. The man holding the lantern, who gestures toward the body and looks up for guidance to the general, and the woman peering forward intently were painted much as they appear here, but the figure on the left was replaced by an Indian soldier in a pointed helmet. Another drawing of a turbaned man, from the same provenance and also in the Victoria and Albert Museum, appears to be a variant of this fourth figure, both studies anticipating the bearded man who supports Tippoo's head in his cap.

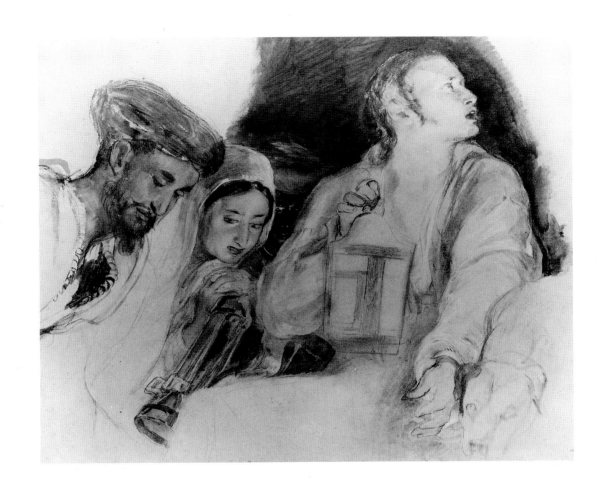

78. **A Lantern-Bearer and Figures**

79. Three Figures on a Ladder

Chalks, pen and dark brown ink, and watercolors;
18⁷⁄₁₀ × 11⁹⁄₁₀ in. (47.4 × 30.3 cm.)
Lent by the the Syndics of the Fitzwilliam Museum.

Provenance
H. S. Reitlinger.

Literature
Brown 1985, under no. 50.

This is a study for the three shadowy figures on a ladder at the upper left of Sir David Baird (cat. no. 42), completing with cat. nos. 77 and 78 a sequence of finished cartoons for that side of the picture. The motif and execution are reminiscent of Rubens.

79. **Three Figures on a Ladder**

80. **Arms and Armour of Tippoo Saib**

Black and red chalks and watercolors on buff paper;
14³⁄₁₀ × 20⁷⁄₁₀ in. (36.3 × 52.6 cm.)
Inscribed in pencil: *Study for the finding the body of . . .*
Lent by the Visitors of the Ashmolean Museum.

Provenance
Wilkie Sale, Christie's, 25 April 1842, Addenda, lot
16; Percy Moore Turner.

Exhibition
Rembrandt Gallery 1939 (29); Edinburgh and London
1958 (8); Oxford and London 1985 (53).

This is a study for the foreground of *Sir David
Baird*. In the painting, specimens of Tippoo's
armor lie at his feet beneath the step on which
the general stands. Wilkie's explanation in the
Academy exhibition was as follows: "below
[Baird's] feet, in the parapet wall, is a grating
here introduced as giving light to the dungeon
in which he had been for nearly four years
immured by Hayder Ally and his son, the same
Tippoo Sultaun." Baird had been captured with
Colonel Baillie at Pollilur in 1780, during the
second Mysore War. He was released in 1784,
fifteen years before he finally took Seringapatam.
After the victory, Tippoo's arms and armor,
together with his throne, jewels, and manu-
scripts, and the celebrated working model of a
tiger devouring a British soldier now in the
Victoria and Albert Museum, London, were
seized and sent back to England.

As was his practice, Wilkie went out of his
way to study the details he needed for the
picture from the originals. On 29 December
1834, he wrote to Lady Baird: "I have been
promised free access to the armoury of the late
King [George IV], formerly at Carlton House,
containing a superb collection of the arms and
accoutrements of Tippoo Sahib" (Cunning-
ham, 3:92). Lady Baird also lent Wilkie items
from her own collection of Indian trophies at
Fern Tower, and among the objects lent to the
artist by Mr. Charles Russell were "scymitars,
and a superb shield" (see Wilkie's letter to Lady
Baird, 20 August 1837; Cunningham, 3:225).

80. **Arms and Armour of Tippoo Saib**

81. Head and Shoulders of an Oriental

Black and red chalks with oil pigment on brown paper;
14½ × 11⅛ in. (36.8 × 28.3 in.)
Lent by the Visitors of the Ashmolean Museum.

Provenance
Wilkie Sale, Christie's, 27 April 1842, ? lot 326; W. B.
Carpenter.

Exhibitions
Oxford and London 1985 (54).

A study for the head of the Oriental supporting
Tippoo's left arm, a figure first created during
the abortive sitting Wilkie amusingly described
to Lady Baird, 15 October 1835, (Cunning-
ham, 3:110–11):
"... while engaged in collecting studies for
the picture, I was told that there were three
Hindoo cavalry soldiers every day at the India
House.... I obtained their consent to sit to
me, and they came, a Jemidar and two inferior
officers, in their native dress. I explained to
them, by the interpreter, what I wanted, and
put them on a platform in a group, the Jemidar,
as Tippoo, reclining with his head supported by
one of his lieutenants, and his hand held by
the other, with his finger on his pulse, to know
if he were alive or dead. The group was
magnificent, and I was all ecstasy to realise
such a vision of character and colour. It was,
indeed a vision, and a vision only; for, all of a
sudden, the youngest of them said, 'Me no
Tippoo!' and sprang from his position, while
the others repeated, 'No Tippoo I!' and, to my
surprise, left their places also, and no
persuasion I could use could induce them to
resume them."
The grouping must have stuck in Wilkie's
mind, however, because this description accords
perfectly with the picture as finally painted.
Later, Wilkie may have used Lascar models for
this and the other two figures in this group, as
recounted in June 1837 (Cunningham, 3:223):
"having found some native Lascars, who have
been sitting to me daily for some weeks past, I
am getting the chief of the Indian heads
painted in." These were completed by August
(see Wilkie's letter to Lady Baird, ibid., 225).
By this time Wilkie had also had the benefit of
"a coach-load of turbans, pelisses, trousers of
the richest stuffs" with which to attire the
Indian figures.

81. Head and Shoulders of an Oriental

82. **Portrait of Sir William Knighton**

Black chalk and watercolors; 20½ × 15 in. (52 × 38.1 cm.)
Lent by the University of Dundee.

Literature
Cunningham, 3:222.

Exhibitions
R.A. 1837 (719); St. Andrews and Aberdeen 1985 (46).

Knighton (1776–1836) was a devoted friend and patron of Wilkie, and in later years a valuable contact at court. Originally trained as a surgeon and in 1810 physician to the Prince of Wales, he later rose to be Keeper of the Privy Purse when George succeeded as King. As well as managing the King's financial affairs, he undertook various confidential missions on his behalf both at home and abroad. George IV considered him his 'dearest friend,' and Knighton's influence and trust at court earned him some ill-will in London. He had excellent taste and was an active collector. This affectionate portrait was no doubt exhibited the year after his death as a memorial.

82. **Portrait of Sir William Knighton**

83. The Empress Josephine and the Fortune-Teller

Pencil, pen, and watercolor, on paper laid on card;
9⅗ × 7⅗ in. (24.3 × 19.3 cm.)
Signed and dated: *D. Wilkie f. 1836.*
Lent by the City Museum and Art Gallery,
Birmingham.

Provenance
? Sir W. W. Knighton.

Exhibitions
Edinburgh and London 1958 (103); St. Andrews and
Aberdeen 1985 (55).

This is a composition sketch for *Josephine and
the Fortune-Teller,* painted, apparently through
the intervention of Sir William Knighton, for
John Abel Smith, M.P., and exhibited at the
Royal Academy in 1837 (National Gallery of
Scotland; see fig. 23). The subject was an
incident from Josephine's youth on the island of
Martinique. Wilkie's source, quoted in the
catalogue, was a passage from Louis-Antoine
Fauvelet de Bourrienne's *Mémoire . . . sur
Napoléon,* first published in 1829 and translated
into English in 1830: "When fortune placed a
crown on Josephine's head she told me that the
event, extraordinary as it was, had been
predicted. It is certain she put faith in fortune-
tellers." This terse and prosaic passage was no
doubt quoted for its brevity, but as Frederick
Cummings has plausibly suggested (exh. cat.
Detroit and Philadelphia, 1968, 221, no. 143),
Wilkie probably took the details of his picture
from the more graphic account of John Memes,
who in his *Memoirs of the Empress Josephine*
(1831 and subsequent editions), assumed the
voice of his subject herself:

"One day, some time before my first marriage
while taking my usual walk, I observed a
number of negro girls assembled round an old
woman, engaged in telling their fortunes. I
drew near to observe their proceedings. The old

sibyl, on beholding me, uttered a loud
exclamation, and almost by force seized my
hand. She appeared to be under the greatest
agitation. . . . 'What do I see in the future?
You will not believe me if I speak.'—'Yes,
indeed, I assure you. Come my good mother,
what am I to fear and hope?'—'You will be
married soon; that union will not be happy;
you will become a widow and then—then you
will be *Queen of France!*'"

The drawing is a quite complete study for the
composition, anticipating its rhythmical struc-
ture and to some extent its freedom of
execution. The somewhat arch expressions and
the languid and sensual pose of Josephine stray
as near as Wilkie ever came to excessive
sentiment, but the sober coloring and richly
fluent, Rubensian brushwork of the picture give
it a grandeur of its own, justifying the high
praise bestowed upon it by Cunningham who
compared it with *The Escape of Mary Queen of
Scots* (see fig. 22). Wilkie's biographer
implicitly recognized the effective combination
of history and intimate genre when he
remarked that the more striking of the artist's
historical pictures tend to be "those with
humbler names, or whose subjects are
sufficiently remote to justify a more poetic
treatment." Cunningham went on to comment:
"Josephine and the Sorceress of St. Domingo is
a romantic scene: the tawny sybil is opening to
the lovely and blushing maiden, a page of fate
in which her magnificent destiny is dawning;
while the lily hue of the future Empress is
contrasted in beautiful gradation with the
complexions of the Sorceress herself, and the
dark African tint of the negro attendant. The
perfect loveliness of these compositions, and
the clear elegance and harmony of the
coloring, place these amongst the finest
pictures of the British school."

83. **The Empress Josephine and the Fortune-Teller**

Some fine drawings are associated with the picture. In addition to the famous study for the Negro servant (see fig. 34), a drawing for the head of the fortune-teller is in the National Gallery of Scotland. The present study is presumably the drawing about which Wilkie wrote to the younger Knighton on 13 April 1837, after his father's death: "The Drawing of the Josephine the Sketch I beg to be allowed to present to you as it was through Sir William's kind attention I was enabled to make a picture of it" (ML: MS 308895). Knighton's exact role in the creation of *Josephine* is unclear, although it is probable that he discussed the subject in general, having visited Malmaison, "once the happy abode of Josephine," in 1828, and found it "sad and melancholy, a complete emblem of fallen greatness" (Knighton, *Memoirs* [1838], 2:13−14).

84. A Woman with Two Children, for "Grace Before Meat"

Brown and gray washes, black and red chalks, over
pencil, heightened with white, on buff paper;
11³/₁₀ × 9⁷/₁₀ in. (28.7 × 24.7 cm.)
Lent by the Visitors of the Ashmolean Museum.

Exhibitions
Edinburgh and London 1958 (102); Oxford and
London 1985 (56).

Grace Before Meat (City Art Gallery, Birming-
ham; see fig. 14) was painted for an American
friend of Wilkie's, Glendy Burk of New
Orleans, and exhibited at the Royal Academy
in 1839 (154) with a mawkish quotation from a
poem by the Countess of Blessington:

A lowly cot where social board is spread
The simple owner seated at its head;
His bonnet lifts and doth to Heaven appeal,
To grant a blessing on the humble meal . . .

Among the figures sitting down to eat, Wilkie
included the small but touching tableau studied
here, of a mother guiding her baby in the
gestures of the grace—another minor essay on
the theme of a child's apprehension of
adulthood that he had treated, higher up the
social ladder, in the *First Ear-ring* of 1835 (see
cat. no. 38). The group appears behind the
table near the center of the composition, imme-
diately beside the father of the house. A
drawing for a child in the left foreground of the
picture is also at Birmingham, and another for
the room setting was in the Wilkie Sale,
Christie's, 25 April 1842, lot 118 (untraced). A
further drawing was on the London art market
in 1971, and an oil sketch belongs to Lady Mary
Howick.

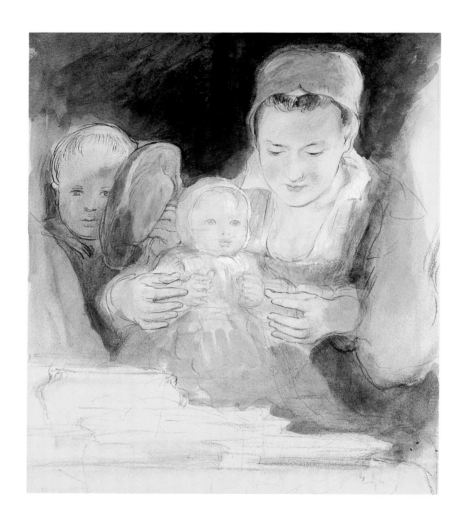

84. A Woman with Two Children, for "Grace Before Meat"

85. The Penitent Magdalen

Red and black chalks and watercolors over pencil, heightened with white oil pigment; $11\frac{1}{4} \times 9\frac{3}{8}$ in. (28.6 × 23.8 cm.)
Signed and dated: *D. Wilkie 1840—July 22.*
Lent by the Visitors of the Ashmolean Museum.

Provenance
Dr. Perry (Lugt 1504); Colonel Cunningham; Sotheby's Sale, 11 May 1876, lot 731; J. P. Heseltine (Lugt 1508); Sotheby's Sale, 11 March 1925, lot 47; A. G. B. Russell.

Exhibitions
Oxford and London 1985 (59)

This is a particularly highly finished example of Wilkie's rare nude studies, to be characterized rather as a "presentation drawing." The subject and sentiment recall the work of his contemporary William Etty, and to some extent the composition anticipates the biblical subject matter Wilkie hoped to pursue in the Holy Land. The drawing must have been one of the last he made before his departure for the Middle East the following month.

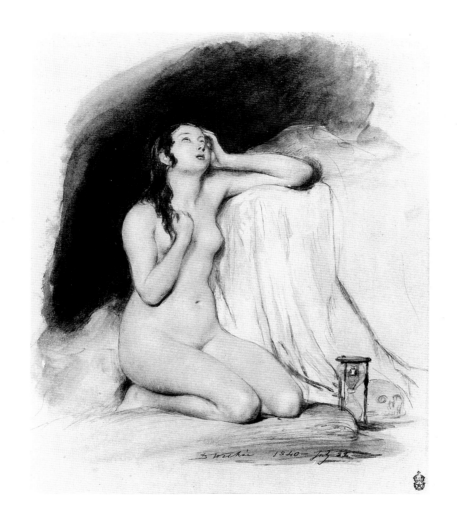

85. **The Penitent Magdalen**

86. The Turkish Letter Writer, Constantinople

Black chalk and watercolors, heightened with white;
14⅗ × 11⅝ in. (37.1 × 29.6 cm.)
Lent by the Visitors of the Ashmolean Museum.

Provenance
Wilkie Sale, Christie's, 28 April 1842, lot 446; bt. C.
R. Leslie; W. R. Russell.

Literature
Cunningham, 3:320; K. Bendiner, "Wilkie in Turkey:
The Tartar Messenger Narrating the News of the
Victory of St. Jean d'Acre," *Art Bulletin* 63 (1981): 267.

Exhibitions
Edinburgh and London 1958 (111); St. Andrews and
Aberdeen 1985 (68); Oxford and London 1985 (60).

The body of work surviving from Wilkie's final
trip to the Holy Land consists chiefly of studies
and portraits of notables and interesting char-
acters encountered in his various ports of call,
principally in Constantinople. These were
mostly drawings, but two pictures were brought
some way to completion, one a subject of
contemporary history, *The Tartar Messenger
Narrating the News of the Victory of St. Jean
d'Acre* (Sir James Hunter-Blair), and the other
a genre piece, *The Turkish Letter Writer,
Constantinople* (see cat. no. 45), for which this
is a highly finished drawing.

On his outward journey, Wilkie reached
Constantinople on October 4, and found a
hotel in the European quarter of Pera. He was
at once fascinated by the people of the city
"with dresses splendid and dwellings wretched,
still recalling, in all their doings, a race and
time from which civilization had sprung"
(Cunningham, 3:320). Two days later he came
across the scene shown here in one of the most
splendid compositions he drew in the East.
Another drawing of the scene was lot 385 in
the 1860 Wilkie sale; it is now in the Aberdeen
Art Gallery. The echo of Rembrandt—both
his somberness and exoticism—profoundly
affected Wilkie's perception of the East and is
very evident in this composition.

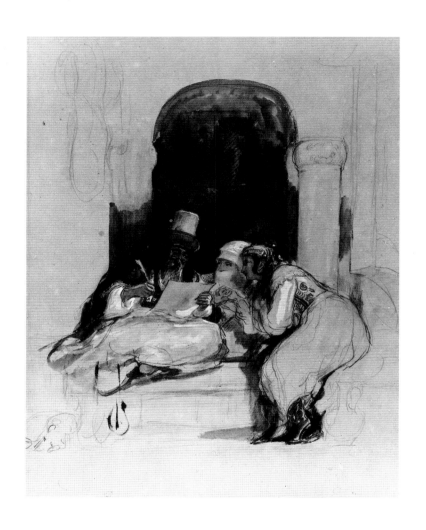

86. **The Turkish Letter Writer,** Constantinople

87. Portrait of Sotiri, Dragoman of Mr. Colquhoun

Water and body colors and oil, over pencil, on buff paper; 18⁷⁄₁₀ × 12⁹⁄₁₀ in. (47.5 × 32.8 cm.)
Lent by the Visitors of the Ashmolean Museum.

Provenance
Wilkie Sale, Christie's, 25 April 1842, lot 467; Messrs. Graves and Warmsley.

Literature
Cunningham, 3:331.

Exhibitions
Edinburgh and London 1958 (113); St. Andrews and Aberdeen 1985 (71); Oxford and London 1985 (61).

Lithographed by Joseph Nash in *Wilkie's Sketches in Turkey, Syria and Egypt*, 1840 and 1841 (1843), no. 12, this is one of the most splendid of the portrait drawings Wilkie made during his stay in Constantinople. Its bold use of bright body colors is almost without precedent in his work before his Eastern journey.

Wilkie was delayed in Constantinople by the war between Turkey and Egypt resulting from Egyptian ambitions in Syria and the aim of the Egyptian pasha, Mehemet Ali, to create a hereditary pashalic in Egypt. With British support the Turks crushed the Egyptians at St. Jean d'Acre on November 4, but Syria was not open to travelers until the following year. In the meantime Wilkie had occupied himself making portraits. His journal entry for 30 October 1840 says: "Began drawing of dragoman of Mr. Colquhoun at Constantinople, and proceeded with it on the next day." Sotiri, an Albanian, was in the service of Mr. Colquhoun, British consul-general at Bucharest. As Nash recorded in the text to his lithograph, the other figures are also portraits: "The boy is the son of Mustafa, the Janissary of Mr. Cartwright, the Consul-General at Constantinople; and the female figure is Madame Giuseppina, the landlady of Sir David Wilkie, while resident at Pera. The background is closed by a view of the suburbs of Constantinople looking over the Campetto, or 'Petit champ des Morts.'" Wilkie had apparently intended to give this drawing to Colquhoun, whom he had known previously. Another drawing of Madame Giuseppina, "a celebrated beauty, and . . . known to, and admired by, all European travellers who have voyaged to the banks of the Bosphorus," was lithographed by Nash (no. 24).

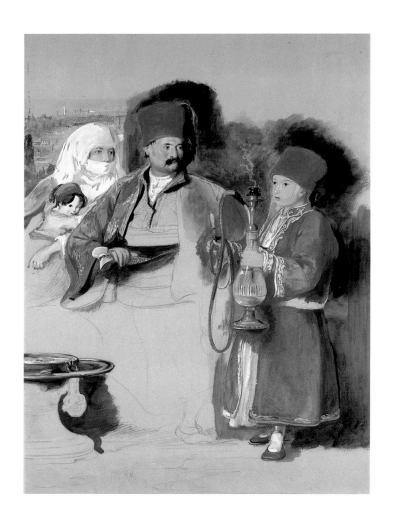

87. **Portrait of Sotiri, Dragoman of Mr. Colquhoun**

88. Captain Leigh and His Dragoman

Black chalk, pen and ink, and watercolor heightened with white; 16½ × 12½ (42 × 31.8 cm.)
Lent by the Yale Center for British Art, Paul Mellon Fund

Provenance
Wilkie Sale, Christie's, 29 April 1842, lot 588 ("Captain Leith with his Dragoman, fine"), bought by Simpson; Sir George Campbell, Garscube, Glasgow; Lady Campbell; Victor D. Spark, New York.

Literature
Cunningham, 3:336; Sutherland Gower, 116.

On 10 November 1840 Wilkie "Went to Constantinople with Captain Leigh." The following day he "had a dinner; invited Captain Leigh and Mr. Worthington upon the great occasion; passed with the friends in the house a jolly evening" (Cunningham, 3:336). This portrait of the captain, with his Turkish servant, was probably made at the time.

88. **Captain Leigh and His Dragoman**

89. **The Dragoman of Mr. Allison at Pera**

Black and red chalks, oil pigments, and body colors, on buff or brown paper; 17⅔ × 10⁷⁄₁₀ in. (44.3 × 27.2 cm.)
Lent by the Visitors of the Ashmolean Museum.

Provenance
R. S. Holford.

Literature
Cunningham, 3:341.

Exhibitions
Oxford and London 1985 (62)

Lithographed by Joseph Nash in *Wilkie's Sketches in Turkey, Syria and Egypt,* 1840 and 1841 (1843), with the underline *David Wilkie ft. Constantinople 1840—The Dragoman of Mr. Allison at Pera.* On 21 November 1840, Wilkie recorded in his journal: "Made sketch of an Egyptian servant of Mr. Allison." Cunningham mentions that while in Constantinople Wilkie made "fifty three [drawings] in the city itself, and six in the suburb of Pera, representing persons, single and grouped, on which the grave and suspicious character of the people is stamped in the artist's clear and decided way." Nash describes this subject as a Nubian, and adds that "the original drawing was made by Sir David Wilkie upon tinted paper, at which he was much disturbed, and expressed his dissatisfaction, thinking himself worthy of white at least." In England, however, Wilkie had used similar paper, no doubt to act as a foil to strong colored washes.

89. **The Dragoman of Mr. Allison at Pera**

Catalogue of Engravings

90. The Village Politicians

Abraham Raimbach after David Wilkie, 1814

Engraving on heavy laid paper, trimmed within the plate mark: 19⅞ × 24 in. (50.5 × 61 cm.)
Inscribed lower left: *DAV: WILKIE R.A. PINXIT.*; lower right: *ABR: RAIMBACH SCULPSIT*; lower center: *VILLAGE POLITICIANS. / Engraved from the Original Picture in the Collection of the Rt. Honble. the Earl of Mansfield; / to whom the plate is respectfully dedicated by his Lordship's obliged Servts. / David Wilkie & Abraham Raimbach. / Published Jany. 1st by D. Wilkie, Kensington & A. Raimbach, Warren Street, Fitzroy Square, London.*
Lent by the Yale Center for British Art, Paul Mellon Collection

91. Blind-Man's Buff

Abraham Raimbach after David Wilkie, 1822

Engraving on India proof paper on heavy wove paper; plate: 19⅞ × 25¼ in. (50.5 × 64.1 cm.); sheet: 21 × 26⅓ in. (53.3 × 67.3 cm.)
Inscribed lower left: *PAINTED by DAVID WILKIE R.A.*; lower right: *ENGRAVED by ABRAHAM RAIMBACH, / Hony. Member of the Imp. Academy at St. Petersburgh*; lower center: *BLIND-MAN'S BUFF / PUBLISHED 1st Jany. by D. WILKIE and A. RAIMBACH. LONDON*
Lent by the Yale Center for British Art, Paul Mellon Collection

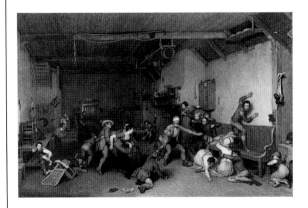

92. Distraining for Rent

Abraham Raimbach after David Wilkie, 1828

Engraving on India proof paper on heavy wove paper;
plate: 20 × 26 in. (50.8 × 66 cm.); sheet: 21⅝ × 28 in.
(55 × 71.1 cm.)
Inscribed lower left: *PAINTED BY DAV: WILKIE,
R.A.* lower right: *ENGRAVED BY ABR: RAIMBACH /
Honry. Member of the Academies at St. Petersburgh &
Geneva*; lower center: *DISTRAINING FOR RENT /
Engraved from the Original Picture, in the possession of the
Engraver. / Published May 31st 1828. by D. Wilkie,
Kensington & A. Raimbach, Warren Street, Fitzroy Square,
London.*
Lent by the Yale Center for British Art, Paul Mellon
Collection

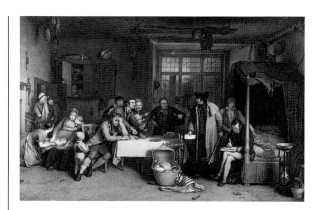

93. The Chelsea Pensioners Reading the Gazette of the Battle of Waterloo

John Burnet after David Wilkie, 1829

Engraving on heavy wove paper; trimmed within the
plate mark: 21 × 29⁷⁄₁₆ in. (53.3 × 74.8 cm.)
Inscribed within the image, lower left: *David Wilkie
1822*; lower right: *Engraved by J. Burnet*; lower center:
*THE CHELSEA PENSIONERS READING THE
GAZETTE OF THE BATTLE OF WATERLOO. /
London. Published 18th June 1829. by Messrs. Boys &
Graves, Printsellers to His Majesty. 6 Pall Mall*
Lent by the Yale Center for British Art, Paul Mellon
Collection

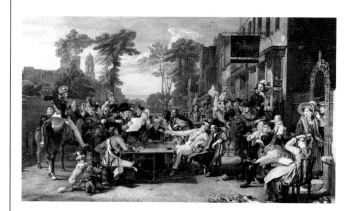

94. Chelsea Pensioners Reading the Gazette of the Battle of Waterloo, Key

Anonymous
Lent by the Yale Center for British Art, Gift of David Alexander

Engraving and letterpress, trimmed within the plate mark: 16¾ × 22½ in. (42.5 × 57.1 cm.)
Inscribed: *This picture was painted for his Grace the Duke of Wellington, in the year 1822, and commemorates that great and final Victory which, at Waterloo, closed our triumphs over Napoleon on land, as that of Trafalgar closed them by sea. The scene is laid in that picturesque street or way leading from Pimlico to Chelsea Hospital, in which trees, public-houses, and the fine architecture of Wren intermingle; and the time is the season when Pensioners receive their pay, and indulge themselves with spending it in the open air. The Painter has gathered together veterans and invalids of all regiments, of all countries, and of all campaigns, from the days of Wolfe to those of Wellington; he has seated them, with their wives and their companions, at a social carouse; the flagon is busy, cheered on by the fife and bagpipe; and the whole are excited by the hourly expectation of news from abroad of a great and decisive battle between the British and the French. Into the midst of this scene a soldier of the Lancers comes on the spur, with the Gazette of Battle of Waterloo. The revelry ceases, only for a more joyous renewal; windows and doors are filled by eager and gaping listeners; while a veteran soldier of Wolfe reads the account aloud. Such is the general character of the Picture; many of the groups and individuals deserve a more particular description.*

1. An orderly of the 7th Lancers, at that time the Marquess of Anglesley's regiment, who has just arrived with the Gazette of the Battle, to the joy of all assembled.

2. An Artilleryman, who has thrown down his knapsack, and is addressing the Lancer, to whom refreshments are eagerly offered from several hands.

3. A Sergeant of the 42nd regiment, of the name of McGregor, a Glengary Highlander, who served under General Graham, at Barossa; he appears anxious to hear the comments of the Lancer, as well as to listen to the

Gazette, which he may be descanting upon, or perhaps alluding to the courage of his countrymen.

4. A trumpeter of the Life Guards waves his trumpet in the air, and proclaims the victory to his comrades on the opposite side of the way.

5. A Soldier of the Hanoverian Legion, – a corps distinguished at Waterloo.

6. A Life Guardsman, whose regiment united with the "Greys" the "Blues" and the "Inniskillens," in repelling the repeated and desperate charges of the Cuirassiers.

7. An old Pensioner, a survivor of the seven year's war, who was at the taking of Quebec with General Wolfe, and is now reading aloud the Gazette detailing the Victory of Waterloo; this, as well as many others, is a portrait.

8. A soldier's Wife – she presses eagerly forward to look at the returns of the killed and wounded; and from her wild, sad looks, and unconsciously pressing her baby till it cries, the artist indicates her alarm for her husband, whose regiment she sees has been a great sufferer; and also impresses on the mind, that private sorrow mingles with public rejoicing, and that victory, as well as defeat, leaves

*"Many a sweet babe fatherless,
and many a widow mourning."*

9. A Veteran, whose appetite has survived all the vicissitudes of war, and whose love of good cheer is only for a moment suspended by the great news. – his mouth seems evidently opened for the oyster, which is on its march upward.

10. One of the Band of the 1st regiment of Foot Guards, a native of St. Domingo, who was in France during the Revolution, was present at the death of Louis XVI, and was afterwards servant to General Moreau during his celebrated retreat through the Black Forest.

11. An old Soldier from India, who fought under the Victor of Waterloo at the Battle of Assaye. He seems touched alike with age and climate, and his joy at the triumph of his old Commander is accordingly of a subdued kind. He also served under the old Marquess of Granby.

12. & 13. An Irishman of the 12th dragoons, in a light dress, explaining the news to an old Veteran who was with General Elliot during the bombardment of 21 months and 21 days, at the memorable Siege of Gibraltar. They are interrupted in their carouse by the reading of the Gazette, and probably in a discussion on the merits of the elder and the later days of war: the younger seems exclaiming, "Elliot and his Siege was but a cock-fight compared to

Waterloo;'' while the senior, one of the "rock scorpions,"
as Heathfield called his soldiers, is so far overcome by good
drink and good news, that pot and pipe are alike
neglected—it is evident, though unable to speak, that he
believes in the superior glory of his old master in war.

14. A Sergeant of the Oxford Blues, who was at the Battle
of Vittoria: at his feet is a Black Dog, known to the officers
and men by the name of "Old Duke," who followed that
regiment all over the Peninsula. The Sergeant holds up
his little son, and his looks, as well as those of his
wife, seem to say, "An if he live to be a man."

15. A Soldier of the Foot Guards, stretching himself
anxiously out from a window of the Duke of York public
house, to hear what all this may mean. The eager crushing
of his comrades behind him seems likely to precipitate
him from his advanced post.

16. An out-door Pensioner, on his way to have his keg
and can replenished, stops to hear the news. His wounded
head and wooden leg denote that he has been where blows
and shot were plenty; and the empty vessels indicate that
he is still able and willing to carry on the war under
the standard of conviviality.

Of the subordinate personages, the chief contributors to the
general joy are, an oyster-woman in the full height of
business, to keep pace with the demand which liquor
increases; and a Highland Piper marching up the street
with his bagpipe, till he rouses the inmates of the
neighbouring houses, and sets the children a dancing.
Forward, on the left, appear the domes and pinnacles of
Chelsea Hospital, with its gates and pleasure-grounds; while
on the right is that irregular line, or rather clump of
houses, called Jew's Row, where ale-houses, old clothes'
houses, and pawnbrokers' shops abound. Here, at the sign
of the Duke of York, and of General Elliot, and in the
open space in front, the Pensioners, In and Out together,
with the disbanded Soldiers, frequently assemble; the joy is
always great—the liquor abundant—and the scene, from the
mixture of soldiers of the three kingdoms, of all ages and of
all regiments, with companions of both sexes and all
conditions, is sufficiently picturesque.

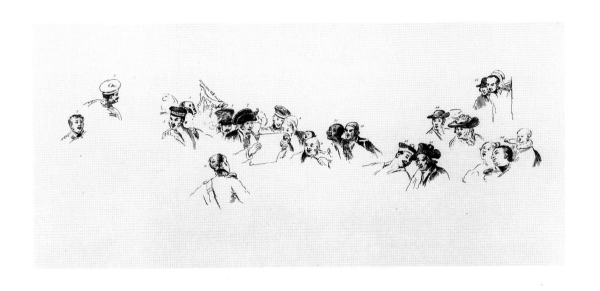

95. Penny Wedding

James Stewart after David Wilkie, 1832

Engraving on India proof paper on heavy wove paper,
plate: 19⅞ × 26 in. (50.5 × 66.1 cm.); sheet:
20½ × 26¾ in. (52 × 68 cm.)
Inscribed, within the image, lower left: *David Wilkie
1818*; lower right: *Engraved by James Stewart*; lower
center: *London Published April 16th 1832 by Moon Boys
& Graves Printsellers to the King, 6 Pall Mall*
Lent by the Yale Center for British Art, Paul Mellon
Collection

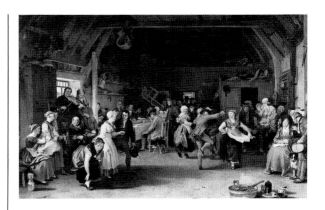

96. Knox Preaching

George Doo after David Wilkie, 1838

Engraving on India proof paper on heavy wove paper,
plate: 24 × 30 in. (58.4 × 76.2 cm.); sheet: 25 × 31¾
in. (63.5 × 80.6 cm.)
Inscribed lower left: *Painted by David Wilkie R.A. Princi-
pal Painter in Ordinary to His late Majesty William the
Fourth; May 1st. 1838*; lower center: *London May 1st
1838 Published by F. G. Moon by Special appointment
Printseller in Ordinary to Her Majesty and H.R.H. the
Duchess of Kent*
Lent by the Yale Center for British Art, Paul Mellon
Collection

97. **Sir David Baird**

John Burnet after David Wilkie, 1843

Mezzotint on India proof paper on heavy wove paper,
plate: 33½ × 23¹³⁄₁₆ in. (85 × 60.5 cm.); sheet:
36¾ × 27 in. (93.3 × 68.6 cm.)
Inscribed lower left: *Painted by Sir David Wilkie, R.A. /
Printed by R. Lloyd*; lower right: *Engraved by John
Burnet, F.R.S.*; lower center: *London, Published May 1,
1843, by F.G. Moon, Printseller by Special Appointment
to Her Majesty & H.R.H. Prince Albert, 20,
Threadneedle Street*
Lent by the Yale Center for British Art, Paul Mellon
Collection

Bibliography

Books

Abrams, Ann Uhry. 1985. *The Valiant Hero: Benjamin West and Grand Style History Painting.* New York and Washington, D.C.: Smithsonian Institution Press.

Alexander, David, and Richard T. Godfrey. 1980. *Painters and Engraving: The Reproductive Print from Hogarth to Wilkie.* Exh. cat. New Haven: Yale Center for British Art, 26 March–22 June 1980.

Altick, Richard. 1957. *The English Common Reader: A Social History of the Mass Reading Public, 1800–1900.* Chicago: University of Chicago Press.

Archer, Mildred. 1979. *India and British Portraiture 1770–1825.* London and New York: Sotheby.

Bayne, William. 1903. *Sir David Wilkie, R.A.* London: The Walter Scott Publishing Co.; New York: R. Scribner's Sons.

Bewick, William. 1871. *Life and Letters of William Bewick (Artist).* Ed. Thomas Landseer. 2 vols. London: Hurst & Blackett.

Brown, David Blayney. 1985. *Sir David Wilkie: Drawings and Sketches in the Ashmolean Museum.* Exh. cat. Oxford: Ashmolean Museum, 10 July–25 August 1985. London: Morton Morris & Co.

Burnet, John. 1848. *Practical Essays on Various Branches of the Fine Arts. To Which Is Added, A Critical Inquiry into the Principles and Practice of the Late Sir David Wilkie.* London: Bogue.

Clark, Henry N.B. 1982. The Impact of Seventeenth-Century Dutch and Flemish Genre Painting on American Genre Painting. 1800–1850. Ph.D diss. University of Delaware.

Clarke, Michael and Nicolas Penny. 1982. *The Arrogant Connoisseur: Richard Payne Knight 1751–1824.* Exh. cat. Manchester: Whitworth Art Gallery, 5 February–3 April 1982.

Collins, William Wilkie. 1848. *Memoirs of the Life of William Collins, Esq., R.A.* 2 vols. London: Longman. [Reprinted with an index. East Ardsley: E. P. Publishing, 1978.]

Constable, John. 1962–68. *Correspondence.* Ed. Ronald B. Beckett. 6 vols. Vol. 1. London: H.M.S.O. Vols. 2–4; Ipswich: Suffolk Records Office.

Constable, John. 1975. *Further Documents and Correspondence.* Ed. Leslie Parris & Conal Shields. London: Tate Gallery; Ipswich: Suffolk Records Office.

Cummings, Frederick, and Allen Staley. 1968. *Romantic Art in Britain: Paintings and Drawings 1760–1860.* Exh. cat. Philadelphia: Philadelphia Museum of Art. Catalogue of an exhibition held 9 January–18 February 1968 at the Detroit Institute of Arts and 14 March–21 April 1968 at the Philadelphia Museum of Art.

Cunningham, Allan. 1843. *The Life of Sir David Wilkie: With His Journals, Tours, and Critical Remarks on Works of Art: and a Selection From his Correspondence.* 3 vols. London: Murray.

Delacroix, Eugène. 1971. *Eugène Delacroix: Selected Letters, 1813–1863.* Selected and translated by J. Stewart. London: Eyre & Spottiswoode.

Deuchar, Stephen. 1984. *Paintings, Politics & Porter: Samuel Whitbread II (1764–1815) and British Art.* Exh. cat. London: Museum of London, 21 February–29 April 1984.

Dodgson, Campbell. 1936. *The Etchings of Sir David Wilkie and Andrew Geddes: A Catalogue.* London: Baynard Press.

Edgeworth, Maria. 1971. *Letters from England 1813–1844.* Ed. Christina Colvin. Oxford: Clarendon Press.

Eitner, Lorenz E.A. 1983. *Géricault: His Life*

and Work. London: Orbis Publishing.

Errington, Lindsay. 1975. *Work in Progress. Sir David Wilkie: Drawings into Paintings.* Exh. cat. 13 August–24 September. Edinburgh: National Gallery of Scotland.

Errington, Lindsay. 1985. *Tribute to Wilkie.* Exh. cat. Edinburgh: National Gallery of Scotland, 26 July–13 October 1985.

Evans, Dorinda. 1980. *Benjamin West and His American Students.* Exh. cat. Washington, National Portrait Gallery, 16 October 1980–4 January 1981. Washington, D.C.: Smithsonian Institution Press.

Farington, Joseph. 1978–84. *Diary.* Ed. Kenneth Garlick & Angus Macintyre. Vols. 1–6. Ed. Kathryn Cave. Vols. 7–16. 16 vols. New Haven & London: Yale University Press.

Finley, Gerald. 1981. *Turner and George the Fourth in Edinburgh 1822.* The Tate Gallery in Association with Edinburgh University Press.

Fraser, William. 1890. *The Melvilles, Earls of Melville, and the Leslies, Earls of Leven.* 3 vols. Edinburgh: Privately printed.

Fry, Roger. 1934. *Reflections on British Painting.* London: Faber & Faber Ltd.

Gash, Norman. 1961. *Mr. Secretary Peel.* London: Longman.

Godfrey, Richard T. 1978. *Printmaking in Britain: A General History from its Beginning to the Present Day.* New York: New York University Press.

Gordon, Ian A. 1972. *John Galt: The Life of a Writer.* Edinburgh: Oliver & Boyd.

Gower, Sir Ronald Charles Sutherland. 1908. *Sir David Wilkie.* London: George Bell and Sons.

Gower, Ronald Sutherland. 1902. *Sir David Wilkie.* London: Bell.

Hart, Solomon Alexander. 1882. *The Reminis-cences of Solomon Alex. Hart, R.A.* Ed. Alexander Brodie. London: Privately printed.

Haydon, Benjamin Robert. 1950. *Autobiography and Journals.* Ed. Malcolm Elwin. London: Macdonald

Haydon, Benjamin Robert. 1926. *Autobiography and Memoirs.* Ed. Aldous Huxley. 2 vols. London: Davies.

Haydon, Benjamin Robert. 1876. *Correspondence and Table-Talk: with a Memoir by His Son, Frederick Wordsworth Haydon.* 2 vols. London: Chatto & Windus.

Haydon, Benjamin Robert. 1960–63. *Diary.* Ed. Willard B. Pope. 5 vols. Cambridge: Harvard University Press.

Haydon, Benjamin Robert. 1853. *Life of Benjamin Robert Haydon. Historical Painter, From His Autobiography and Journals.* Ed. Tom Taylor. 3 vols. London: Longman, Brown, Green.

Hazlitt, William. 1819. "On the Works of Hogarth—On the Grand and Familiar Style of Painting." Lecture VII in: *Lectures on the English Comic Writers.* London: Taylor and Hessey.

Hunnisett, Basil. 1980. *Steel-Engraved Book Illustration in England.* London: Scolar Press; Boston: Godine.

Immel, Ute. 1967. Die deutsche Genremalerei des 19 Jahrhunderts. Ph.D diss., University of Heidelberg.

Irwin, David & Francina. 1975. *Scottish Painters at Home and Abroad 1700–1900.* London: Faber.

Jones, George. 1849. *Sir Francis Chantrey, R.A.: Recollections of His Life, Practice, and Opinions.* London: Moxon.

Kauffmann, C.M. 1982. *Catalogue of Paintings in the Wellington Museum.* London: HMSO.

Keyes, Donald D. 1973. Aspects of the Development of Genre Painting in the Hudson

River Area Before 1852. Ph.D diss. New York University.

Knighton, Sir William W. 1838. *Memoirs of Sir William Knighton, Bart, G.C.H.* 2 vols. London: R. Bentley; Philadelphia: Carey, Lea and Blanchard.

Leslie, Charles Robert. 1951. *Memoirs of the Life of John Constable.* Ed. Jonathan Mayne. London: Phaidon Press.

Lockhart, John G. 1839. *Memoirs of the Life of Sir Walter Scott, Bart.* 2nd. ed. 10 vols. Edinburgh: Cadell; London: Murray.

Meisel, Martin. 1983. *Realizations: Narrative, Pictorial and Theatrical Arts in Nineteenth-Century England.* Princeton, N.J.: Princeton University Press.

Miles, Hamish. 1981. *Fourteen Small Pictures by Wilkie.* Exh. cat. London: Fine Art Society, 5–30 October 1981.

Millar, Oliver. 1969. *The Later Georgian Pictures in the Collection of Her Majesty the Queen.* 2 vols. London: Phaidon Press.

Millar, Oliver. 1971. *Dutch Pictures from the Royal Collection.* Exh. cat. London: Queen's Gallery, Buckingham Palace, 7 May 1971–1 October 1972.

Nash, Joseph. 1843. *Sir David Wilkie's Sketches in Turkey, Syria & Egypt, 1840 & 1841. Drawn on Stone by Joseph Nash.* London: Graves & Warmsley.

Opie, John. 1809. *Lectures on Painting . . .* London: Longman, Hurst, Rees and Orme.

Partington, Wilfred. 1930. *The Private Letter-Books of Sir Walter Scott.* London: Hodder & Stoughton.

Pointon, Marcia. 1986. *Mulready.* Exh. cat. London: Victoria & Albert Museum, 1 July–12 October 1986; Dublin: National Gallery; Belfast: Ulster Museum.

Raimbach, Abraham. 1843. *Memoirs and Recollections of the Late Abraham Raimbach, Esq.*

Engraver . . . *Including a Memoir of Sir David Wilkie, R.A.* Ed. M.T.S. Raimbach. London: Privately printed.

Rix, Brenda D. 1983. *Pictures for the Parlour: The English Reproductive Print From 1775 to 1900.* Exh. cat. Toronto: Art Gallery of Ontario, 12 March–1 May.

Robinson, Henry Crabb. 1869. *Diary, Reminiscences, and Correspondence.* Ed. Thomas Sadler. 3 vols. London: Macmillan.

Scott, Walter. 1972. *Journal.* Ed. W.E.K. Anderson. Oxford: Clarendon Press.

Scott, Walter. 1932–37. *Letters.* Ed. H.J.C. Grierson. 12 vols. London: Constable.

Sharpe, Charles Kirkpatrick. 1888. *Letters from and to Charles Kirkpatrick Sharpe.* Ed. Alexander Allardyce. Edinburgh: W. Blackwood.

Shee, Martin Archer. 1860. *Life of Sir Martin Archer Shee: President of the Royal Academy, F.R.S..* 2 vols. London: Longman and Roberts.

Strong, Ray. 1978. *And When Did You Last See Your Father? The Victorian Painter and British History.* London: Thames and Hudson.

Thomson, Katherine. 1854. *Recollections of Literary Characters and Celebrated Places.* 2 vols. London: Bentley.

Tytler, Sarah. 1873. *Modern Painters and Their Paintings for the Use of Schools and Learners in Art.* London: Strahan.

Uwins, Sarah. 1858. *A Memoir of Thomas Uwins, R.A.* 2 vols. London: Longman. [Reprinted with an index, East Ardsley: E.P. Publishing, 1978].

von Erffa, Helmut, and Allen Staley. 1986. *The Paintings of Benjamin West.* New Haven: Yale University Press.

Whitley, William T. 1928. *Art in England 1800–1820.* Cambridge: The University Press.

Wilkie Gallery. 1848–50. [W.H. Bartlett] *The*

Wilkie Gallery: A Selection of the Best Pictures of the Late Sir David Wilkie, R.A.: With Notices Biographical and Critical. London: Virtue.

Wordsworth, William and Dorothy. 1969. *Letters.* Ed. E. de Selincourt II. Vol. 2., 2nd. edn. Revised M. Moorman. Oxford: Clarendon Press.

Exhibitions to 1842 and Selected Exhibitions from 1958

Great Britain

Birmingham, Society of Arts, 1832: *Exhibition 1832. Modern Works of Art*; Birmingham, Birmingham Society of Arts, 1832.

British Institution: The entries in the catalogue of the annual January exhibitions of the British Institution are reordered under the names of the exhibitors in Algernon Graves, *The British Institution 1806–1867: A Complete Dictionary of Contributors and Their Work from the Foundation of the Institution.* London (Bell & Graves), 1908. 1842: *Catalogue of the Works of the Late Sir David Wilkie. R.A. Together With a Selection of Pictures by Ancient Masters, With Which the Proprietors Have Favoured the Institution*; London, British Institution, 7 June–27 August 1842. (The largest exhibition of Wilkie's paintings–165 pictures and oil sketches—but incorrect dates given in the catalogue caused a contemporary to warn: "Such oversights render almost disserviceable a compilation that will be appealed to as an authority.")

Edinburgh 1975: *Work in Progress. Sir David Wilkie: Drawings into Paintings*; Edinburgh, National Gallery of Scotland, 13 August–14 September 1975.

Edinburgh 1981: *Masterpieces of Scottish Portrait Painting*; Edinburgh, Talbot Rice Art Centre, University of Edinburgh, 28 March–9 May 1981.

Edinburgh 1985: *Tribute to Wilkie*; Edinburgh, National Gallery of Scotland, 26 July–13 October 1985.

Edinburgh and London 1958: *Paintings and Drawing by Sir David Wilkie 1785–1841*; Edinburgh, National Gallery of Scotland, 16 August–21 September 1958 and London,

Royal Academy, 17 October–10 December 1958. (This pioneering exhibition by John Woodward, the stem of the modern appreciaton of Wilkie, was the first before this exhibition to present Wilkie as a whole; it was, indeed, the first one-man exhibition of his work since 1842.)

Edinburgh and London 1986: *Painting in Scotland: The Golden Age*; Edinburgh, Talbot Rice Art Centre, University of Edinburgh, 9–30 August 1986 and London, Tate Gallery, 15 October 1986–4 January 1987. (This exhibition opened after the present catalogue was written, so that no account of it has been taken in our text.)

Edinburgh, Royal Institution.

Edinburgh, Royal Scottish Academy. The Institution was the precursor of the Academy. The entries in their annual exhibiton catalogues which record works by their Members and Associate Members—or, as in the case of Wilkie, Honorary Members—are reordered in William D. McKay and Frank Rinder, *The Royal Scottish Academy 1826–1916*, Glasgow (Maclehose), 1917.

Museum of London 1984: *Paintings, Politics and Porter: Samuel Whitbread II (1764–1815) and British Art*; London, Museum of London, 21 February–19 April 1984.

Oxford and London 1985. *Sir David Wilkie Drawings and Sketches in the Ashmolean Museum.* Ashmolean Museum, Oxford, 10 July–25 August 1985; Morton Morris and Company Ltd., 7 November–6 December 1985.

Royal Academy: The entries in the catalogues of the annual Summer Exhibitions of the Royal Academy of Arts are reordered under the names of the exhibitors in Algernon Graves, *The Royal Academy of Arts: A Complete Dictionary of Contributors and Their Work From Its Foundation in 1769 to 1904*, 8 vols., 1905–6.

St. Andrews and Aberdeen 1985: *Sir David Wilkie: Sketches and Studies*; St. Andrews, Crawford Centre for the Arts, University of St. Andrews, 15 February–17 March 1985 and Aberdeen, Aberdeen Art Gallery , 23 March–13 April 1985.

Wilkie's Exhibition 1812: *A Catalogue of the Pictures, Painted by D. Wilkie, R.A. Now Exhibiting at No. 87, Pall Mall*; London, 87 Pall Mall, 1 May–20 June 1812. (Reprinted in Cunningham, I, 351–3.)

United States

Detroit and Philadelphia 1968. *Romantic Art in Britain/Paintings and Drawings 1760–1860.* Detroit Institute of Arts, 9 January–18 February 1968; Philadelphia Museum of Art, 14 March–21 April 1968.

Journal Articles

Andrews, Keith. 1966. "A Sheet of Early Wilkie Sketches." *Scottish Art Review* 10: 6–9, 28.

Art Union. 1844. Mangin, Edward. "The Blind Fiddler." *Art Union* 4: 19–20.

Bendiner, K. 1981. "Wilkie in Turkey, 'The Tartar Messenger Narrating the News of the Victory of St. Jean of Acre." *Art Bulletin* 63: 259–268. Vol. 63, no. 2, June 1981.

Boner, Charles. 1868. "Vienna and its Environs. The Arthaber Picture Gallery—Two Letters of Wilkie." *Art Journal* NS 7: 71.

Brown, David Blayney. 1985. "Scottish History in Paint and Prose: David Wilkie and Walter Scott." *Country Life* (August 8, 1985): 375.

Burnet, John. 1850. "Autobiography." *The Art Journal* 12: 275–77.

Campbell, J.P. 1969. "Drawings Related to Wilkie's Painting of *Columbus at the Convent of La Rábida*." *North Carolina Museum of Art Bulletin.* 8: 16–26.

Campbell, P. 1971. "Pictures of the Waterloo Era, Wilkie and Burnet at Apsley House." *Country Life* 25:416.

Didbin, T.F. 1807. *Director* 1: 12–13.

Elliott, Bridget J. 1984. "The Scottish Reformation and English Reform: David Wilkie's Preaching of Knox at the Royal Academy Exhibition of 1832." *Art History* 7: 313–328.

Examiner. 1812. R.H. (probably Robert Hunt) "Fine Arts. Mr. Wilkie's Exhibition." *Examiner,* 268–9, 282–3, 327.

Examiner. 1822. "Fine Arts. Royal Academy Exhibition." *Examiner,* 301, 331–2, 364–5, 380–1, 397, 412–3, 428, 442–3.

Hoover, Catharine. 1981. "The Influence of David Wilkie's Prints on the Genre Paintings of William Sidney Mount." *The American Art Journal* 4:33. Vol. 13, no. 3, 1981. 4–33.

Literary Gazette. 1838. "Fine Arts. New Publications. *The Card Players.*" *Literary Gazette* (17 November 1838): 732.

Literary Gazette. 1828. "Fine Arts. Wilkie's pictures, &c." *Literary Gazette* (22 November 1828): 748.

Marks, Arthur S. 1968. "David Wilkie's 'Letter of Introduction.'" *Burlington Magazine* (March 1968): 125.

Marks, Arthur S. 1974. "David Wilkie's Portraits of His Parents." *Burlington Magazine* 116: 202–9.

Marks, Arthur S. 1981. "Rivalry at the Royal Academy: Wilkie, Turner, and Bird." *Studies in Romanticism* 20: 333–62.

Megaw, B.R.S. 1966. "The Topography of 'Pitlessie Fair.'" *Scottish Studies.* 10: 178–80.

Miles, Hamish. 1969. "Adnotatiunculae Leicestrienses: Wilkie and Washington Irving in Spain." *Scottish Art Review* 12: 21–5, 28.

Miles, Hamish. 1975/77. "John Graham and the Trustees' Academy." *Scottish Art Review* 14: 17–20 and 15: 19–23.

Miles, Hamish. 1973, 1974. "Raeburn's Portrait of the 4th Earl of Hopetown." *Scottish Art Review* 14 (2): 30–36, 14/3: 28.

Miles, Hamish. 1969. "Wilkie's *Columbus.*" *North Carolina Museum of Art Bulletin* 8: 2–15.

Murray, Edward Croft. 1939. "An Exhibition of Drawings by Sir David Wilkie, R.A. (1785–1841)." *Burlington Magazine* 74:91–92.

Myers, Andrew B. 1958. "Washington Irving's Madrid Journal 1827–1828 and Related Letters: Part IV." *Bulletin of the New York Public Library.* LXII. 463–7.

New Monthly Magazine. 1822. S.B. "Digressions in the Two Exhibition Rooms." *New Monthly Magazine* 5: 218–22.

Olson, Roberta J.M. 1986. "Representations of Pope Pius VIII. The First Resorgimento Hero." *Art Bulletin* 67: 77–93.

Pointon, Marcia. 1984. "From 'Blind Man's Buff' to 'Le Colin Maillard: Wilkie and his French Audience." *The Oxford Art Journal* 7: 15–25.

Thackeray, W.M. 1838. "Strictures on Pictures. A letter from Michael Angelo Titmarsh." *Fraser's Magazine* (June 1838).

Unsigned Journal Articles

Academy. 1878. "Wilkie's letters to Perry Nursey." *Academy* 14:323–4, 345–6.

Art Union. 1842. "The Works of the Late Sir Savid Wilkie." *Art Union* 4: 111.

Athenaeum. 1842. "Exhibition of Ancient Masters. Wilkie's Works." *Athenaeum* (18 and 25 June): 547–9, 565–7.

Athenaeum. 1837. R.A. review. (no. 497); 330.

Blackwood's Magazine. 1836. R.A. review. 40:550.

Blackwood's Edinburgh Magazine. 1837. R.A. review. 42: 336–37.

Blackwood's Edinburgh Magazine. 1839. R.A. review. 47:311.

The Court Journal. 1830. R.A. review. 297.

The Examiner. 1818. British Institution review. 107–108.

The Examiner. 1832. R.A. review. (June 3, 1832): 357.

Fraser's Literary Chronicle. 1836. "The Fine Arts." *Fraser's Literary Chronicle,* 173.

Fraser's Magazine. 1841. (probably W.H. Pyne), "Sir David Wilkie and His Friends." *Fraser's Magazine* 24: 443–54.

Fraser's Magazine. 1842. "Wilkie and His Works." *Fraser's Magazine* 26: 265–71.

Fraser's Magazine. 1832. R.A. review. 5:717–18.

Fraser's Magazine. 1835. R.A. review. 12:50–51.

Gentleman's Magazine. 1828. "Alfred in the Neatherd's Cottage." *Gentleman's Magazine* 98: 546–7.

Gentleman's Magazine. 1841. "Anecdotes of David Wilkie and his 'Blind Fiddler.'" *Gentleman's Magazine* NS 16: 35.

Gentleman's Magazine. 1823. "Mr. Alexander Davison's Pictures." *Gentleman's Magazine* 93: 64–5.

Gentleman's Magazine. 1841. Obituary of

Wilkie. n.s. 16:99.

John Bull. 1829. R.A. review. 9:157.

Leigh Hunt's London Journal. 1835. R.A. review.
2:167.

The Literary Gazette and Journal of Belles Letters.
1836. R.A. review. 298.

The Literary Gazette and Journal of Belles Letters.
1839. R.A. review. 298.

London Magazine. 1822. 6:323.

The National Register. 1808. R.A. review. 1 May,
1808. 1:286.

New Monthly Magazine. 1822. R.A. review.
6:258.

New Monthly Magazine. 1829. R.A. review.
27:252–53.

New Monthly Magazine. 1836. R.A. review.
47:225.

New Monthly Magazine and Literary Journal.
1832. R.A. review. 36:255.

Quarterly Review. 1838. 62:143.

The Spectator. 1837. R.A. review. 10:475.

The Spectator. 1839.

Times. 1841. Obituary of Wilkie. (15 June
1841):5.

Abbreviations of Frequently Cited Manuscript Sources

BL	British Library, London
DCT	Dove Cottage Trust, Grasmere
ERH	Register House, Edinburgh
FM	Fitzwilliam Museum, Cambridge
HL	Huntington Library, San Marino
IN	Institut Néerlandais, Paris
LRCS	Royal College of Surgeons, London
ML	Mitchell Library, Glasgow
NLI	National Library of Ireland, Dublin
NLS	National Library of Scotland, Edinburgh
PML	Pierpont Morgan Library, New York
SRO	Scottish Record Office
YBL	Yale University, Beinecke Library, New Haven

1996
O
√ MS VEN
√ ARE no UK